ORDERING THE FACADE

KATHERINE HENNINGER

Ordering the Facade

PHOTOGRAPHY AND CONTEMPORARY

SOUTHERN WOMEN'S WRITING

The University of North Carolina Press CHAPEL HILL

© 2007 The University of North Carolina Press
All rights reserved
Manufactured in the United States of America
Set in Quadraat and Scala types
by Tseng Information Systems, Inc.

The paper in this book meets the guidelines for permanence
and durability of the Committee on Production Guidelines for Book
Longevity of the Council on Library Resources.

Frontispiece: Eudora Welty, "Saturday Off/Jackson/1930s." Copyright
Eudora Welty, LLC; courtesy of Eudora Welty Collection, Mississippi
Department of Archives and History, Jackson.

Portions of chapter 2 appeared earlier as "The Death of the Southern
Male Gaze: Josephine Humphreys's Revisionings," Southern Quarterly 39
(Summer 2001). Portions of chapter 3 appeared earlier as "Zora Neale
Hurston, Richard Wright, and the Postcolonial Gaze," Mississippi Quarterly
56 (Fall 2003). An earlier version of chapter 4 was published as "Claiming
Access: Controlling Images in Dorothy Allison," Arizona Quarterly 60
(Autumn 2004).

Library of Congress Cataloging-in-Publication Data
Henninger, Katherine.
Ordering the facade : photography and contemporary southern
women's writing / Katherine Henninger.
 p. cm. — (New directions in southern studies)
Includes bibliographical references (p.) and index.
ISBN-13: 978-0-8078-3112-0 (cloth : alk. paper)
ISBN-13: 978-0-8078-5805-9 (pbk. : alk. paper)
1. American literature—Southern States—History and criticism.
2. Women and literature—Southern States—History—21st century.
3. Photography in literature. 4. Visual perception in literature.
5. American literature—Women authors—History and criticism.
6. Authors, American—Homes and haunts—Southern States.
7. Southern States—Intellectual life—1865- 8. Southern States—
In literature. 9. Aesthetics, American—Southern States. I. Title.
PS261.H46 2007
810.9'9287—dc22 2006028193

cloth 11 10 09 08 07 5 4 3 2 1
paper 11 10 09 08 07 5 4 3 2 1

To Joshua

CONTENTS

Foreword by Charles Reagan Wilson xiii

Acknowledgments xvii

Introduction. Visual Legacies of the South 1

1 A Short and Selected History of
Photography in the South 26

2 The Death of the Southern Male Gaze?:
White Ladies' Cultured Revisionings 85

3 Cameras and the Racial Real:
Photographs as Evidence and Assertion
in African American Southern Fiction 113

4 Envisioning "White Trash":
Excess and Access in Appalachia 136

5 Re-imaging Southern Communities, or,
Picturing the Post-South 156

Epilogue. *Buscando* New Orleans
(Looking for New Orleans) 182

Notes 187

Works Cited 207

Index 225

ILLUSTRATIONS

1 "Street Panorama in Wilmington, N.C.," 1865 49

2 Anonymous, portrait of Private William S. Askew, ca. 1861–65 50

3 George Barnard, "Bull Run, Va. Ruins of Mrs. Judith Henry's House," 1862
 51

4 Doris Ulmann, "Footwashing, South Carolina," ca. 1929–31 52

5 Margaret Bourke-White, "Happy Hollow, Georgia," ca. 1936 53

6 Walker Evans, "Bud Fields and His Family at Home," ca. 1935–36 54

7 Walker Evans, "Burroughs Family, Hale County, Alabama," 1936 55

8 Herbert Randall, "Sandy Leigh's MFDP Lecture (2)," 1964 56

9 "Emmett Till in His Casket, Rayner's Funeral Parlor, Chicago,
 September 1955" 57

10 Charles Moore, "Birmingham Alabama 1963" 58

11 "Refuse at the Montgomery Airport after the Selma to Montgomery March,
 March 25, 1965, Alabama Department of Public Safety" 59

12 Tintype of slave Catherine Hunt holding her master's child, Julia Tate Hunt,
 ca. 1852 60

13 J. T. Zealy, "Drana, Country Born, Daughter of Jack, Guinea, Plantation of
 B. F. Taylor," 1850 61

14 "Coon Serenade" sheet music, ca. 1913 62

15 Lynching of Jesse Washington, Waco, Texas, May 16?, 1916 63

16 "A Reply to Mr. Holmes from Alabama," 1912 64

17 "Negro Boy and Apes," 1915 65

18 Hair samples, 1932 66

19 "Carrie's baby, Charlottesville, with Mrs. John Dobbs, 1924" 67

20 "H. C. Anderson and His Photography Class, Southern University," ca. 1945–47
 68

21 Louise Martin, portrait of Coretta Scott King in mourning, ca. 1968 69

22 Prentice Polk, "Portrait of Mr. and Mrs. T. M. Campbell and Their Children, circa 1932" 70

23 George Cook, "Taken in Bon Air, Va. in the 1880s — Probably Ex-Slaves" 71

24 "Girls at Monument Marked 'Jackson,'" ca. 1950–60 72

25 J. Mack Moore, "Anti-Suffrage Demonstration, 1915" 73

26 Maggie Lee Sayre, "Pearl Dotson, Visiting," ca. 1940–50 74

27 Eudora Welty, "Saturday Off/Jackson/1930s" 75

28 E. J. Bellocq, "Storyville Portrait," ca. 1912 76

29 Mary Morgan Keipp, "Two Walking with Bags over the Shoulder," ca. 1891–1902 77

30 Alain Desvergnes, "Little Girl on Lamar Street North," ca. 1964 78

31 Ralph Eugene Meatyard, "Lucybelle Crater and her bearded brother-in-law Lucybelle Crater," ca. 1970–72 79

32 Tseng Kwong Chi, "Graceland, Tennessee, 1979" 80

33 Maude Schuyler Clay, "To the Memory of Emmett Till, Cassidy Bayou, Sumner, Tallahatchie County, Mississippi, 1998" 81

34 David Najjab, "Hanaan and Nora, Lexington, Kentucky," ca. 1990 82

35 Jane Rule Burdine, "Elizabeth Says Goodbye, Greenville, Mississippi," 1993 83

36 Lynn Marshall-Linnemeier, "On the Peak of Time, Page 1," ca. 1995 84

FOREWORD

The study of the American South is at another creative moment. Southern studies, the interdisciplinary project to document and interpret the South, has produced renowned scholars, classic books, and an institutional structure of regional centers, publishing venues, academic associations, and internet projects, as well as regular conferences and symposia that provide forums to exchange scholarly perspectives. Popular interest in the region remains high. Commentators, to be sure, periodically assert that the study of regions is out of date, given national homogenization, a new context of globalization, and new forms of electronic communication that seem to deny the importance of regionalism's emphasis on space and place across time. Regions, however, continue to be dynamic fields, mediating the global, the national, and the local. As their economic and political power has risen in the last two decades, southern regions have taken on added significance, making much conventional wisdom about those regions outdated. Demographic trends show unprecedented changes in the social and ethnic configurations of the South's population, most significantly rising Hispanic immigration, increased African American return migration to the South, and a generally expansive population, all of which make for new contexts for consideration of regional issues.

Scholars of southern studies are asking new questions, using new theoretical models, and putting forward revisionist interpretations. Critical literary, linguistic, and regionalist scholars are at the forefront of postmodern examinations of how language and ideology created metanarratives of a supposedly unified South that denied diversity and complexity. Geographers are redrawing their maps to locate emergent urban regions. Historians are deploying the familiar categories of race, social class, gender, and place, studying the South and its regions differently from earlier historians. Social memory's relationship to power, for example, has produced insightful studies about the ways in which place-based identities take shape. Anthropologists who once went to Southeast Asia or Africa for their fieldwork increasingly set their studies in southern locations long the territory of folklorists and ask questions that illuminate cultural variety. Theoretical models, cross-disciplinary borrowings, and comparative methods often rooted far beyond the U.S. South have helped scholars give new meanings and directions to southern studies.

The New Directions in Southern Studies series supports this new scholarship by providing a core of works that will play a role in defining a vibrant academic

field. By crossing lines of traditional academic disciplines and drawing from any useful methodological, theoretical, or interpretive model, scholars can contribute to remapping the South's position vis-à-vis other geographic and imaginative places.

Gender is fundamental to any revisioning of the American South, and *Ordering the Facade* analyzes how contemporary southern women writers are using the visual image to reimagine our ideas about "southern women." One of the resonant contributions that Katherine Henninger makes is to clarify the concept of a visual culture in the South. She pointedly takes issue with easy generalizations about the South's simply being an oral culture. Thinking of the power of "colored" and "white" signs as visual markers of the region's racial landscape, the visualizations of evangelical religion as a way of testifying to evangelical Protestantism's influence, or the rigid outward signs of beauty expected of idealized women in the South, observers can appreciate the power of a visual culture that has been little analyzed by scholars. As Henninger notes, the image associated with "the South" has often been female, whether that of Scarlett O'Hara, Aunt Jemima, or the NASCAR mom. The region has provided a rich landscape for photographs by natives and outsiders, but the richness of this visual archive has not been matched by serious study of its meanings. *Ordering the Facade* offers the most thorough scholarly study of the broad meanings of the visual culture of the South and points to how the camera's images have been refracted through the imaginations of contemporary women writers.

The governing assumption of the study, that there is no vision without mediation, adopts a central tenet of cultural studies, grounded in constructed cultures, and Henninger looks at the particular expressions of this idea in the cultural construction of the South. She explores the boundaries between photography and literature as they bear on ideological divisions in the South. She makes the compelling point that photography arose in the nineteenth century at the same time that the idea of the South arose, and photographic images created, as she writes, "the visual legacy of the gendered, raced, and classed hierarchies that characterized southern identity." But the accompanying point is the heart of why this study is so timely for the study of the South: photography also played a key part in nurturing different ideas of southern identity beyond the traditional hegemonic white man's/white supremacy South. Having established the significance of this visual legacy, Henninger proceeds to her main work, suggesting how contemporary southern women writers use fictional photographs that embody contested meanings of the South and ways to reimagine the South in our own time. Henninger's work is among the most provocative of recent studies that show how attention to the fluidity and multiplicity of race, class, and gender fundamentally

changes the way we see the American South. The author intentionally positions her work not only in cultural studies, feminist studies, and American studies but also in southern studies, affirming a reimagined South rich in metaphoric meaning.

Charles Reagan Wilson
Series editor

ACKNOWLEDGMENTS

There comes a point in every long project where you wish you had someone else to blame. I have had many "enablers" among my mentors, colleagues, friends, and family, each pushing me a little closer to insight and, most wonderful of all, completion. Their combined intellectual generosity, emotional energy, and plain good sense flow through the best parts of this book. Any stubborn blind spots are, unfortunately, wholly my own fault.

Warwick Wadlington and Ann Cvetkovich at the University of Texas at Austin shepherded the early versions of this project, and their personal, intellectual, and professional examples continue to show me the way. It would be impossible to overstate Wick Wadlington's untiring patience and generosity in reading this manuscript at every stage, even in his "retirement." Also at Texas, Helena Woodard, James Sidbury, and Ann Reynolds lent their expertise in African American literature, southern history, and feminist visual theory, respectively, along with invaluable encouragement for this type of interdisciplinary study. Charles Reagan Wilson, Tom Rankin (now director of the Center for Documentary Studies at Duke University), Susan Glisson, William Ferris (now at the University of North Carolina), and the staff at the Center for the Study of Southern Culture at the University of Mississippi were early supporters of this work; and when later I became a colleague as a visiting assistant professor of English and southern studies at Ole Miss, Ted Ownby, David Wharton, Katie McKee, Jay Watson, Ethel Young-Minor, Colby Coleman, Pete Froehlich, and Joe Urgo were always willing to indulge my questions and send me in the right direction for further research. Even before I arrived at Louisiana State University, my colleagues John Lowe, David Madden, and Peggy Prenshaw were convinced of the value of my project and made me feel welcome. LSU has proven an especially supportive and hospitable home base for this research. I am particularly grateful to LSU's Council on Research, the College of Arts and Sciences, the English Department, and the Louisiana Board of Regents for the research grants and invaluable leave time that made completing this manuscript possible. Special thanks to my research assistants, Terri Ruckel and Shane Wallace, for their competence and commitment.

I would also like to express my gratitude to the librarians and archivists at LSU's Hill Memorial Library; the Library of Congress; the Southern Media Archive and the Department of Archives and Special Collections at the University of Mississippi; the Charles E. Young Research Library Department of Special Col-

lections at the University of California, Los Angeles; the Harry Ransom Humanities Research Center at the University of Texas at Austin; Southern University; the Historic New Orleans Collection; the Texas Archive of African American Photography; the Old Depot Museum, Selma, Alabama; the M. E. Granander Department of Special Collections and Archives, University at Albany Libraries; and the Peabody Museum, Harvard University, all of whom made special and sometimes heroic efforts to help me track down specific images. I am much indebted to the many photographers who gave permission for their photographs to appear in this text, including Herbert Randall, Maude Schuyler Clay, David Najjab, Jane Rule Burdine, and Lynn Marshall-Linnemeier. Coming from France, Alain Desvergnes was on his way to deliver a copy of his photograph of the little girl in Mississippi (and a lecture) in person here in Baton Rouge. He was prevented by Hurricane Katrina, and his luggage, including prints, was lost in the evacuation. He did me the extraordinary kindness, once he finally made it back to France, of sending a new print to include in this book.

Charles Reagan Wilson commands another warm thanks for his role as editor of the New Directions in Southern Studies series. From the start, he has been a steadfast advocate and a voice of hope. I am glad he introduced me to the good people at the University of North Carolina Press, and I particularly want to thank my editor, David Perry, and the press's able staff for their help in transforming *Ordering the Facade* from manuscript to book. Thanks also to the anonymous readers for the press; their suggestions unquestionably improved the final product.

Out of sheer generosity, James Allen, Frances Robb, Susan Donaldson, Matt Wray, Tara McPherson, Sharon Colley, Riché Richardson, Suzanne Jones, Martyn Bone, Patricia Yaeger, and Jon Smith—along with receptive and challenging audiences at conferences including the Modern Language Association, the Modernist Studies Association, the Society for the Study of Southern Literature, the American Studies Association, and the Faulkner and Yoknapatawpha Conference—have shared their expertise and encouraging words. In addition to many of those mentioned above, John T. Matthews, Miles Orvell, Scott Romine, Anne Goodwyn Jones, Brannon Costello, Solimar Otero, Daniel Novak, William Boelhower, Robin Roberts, and Leigh Clemons read all or part of the manuscript and offered excellent advice. Sheila Kelly, Morri Safran, Michelle Ladd, and Katy Powell not only took time away from research only tangentially related to mine to read my work, but were also always willing to "listen to this." I could write a book of gratitude to each one for their keen intellects and even keener friendship.

My greatest continuing debt is to my parents, Robert and Renée Henninger,

who have inspired me with their example and love, and to my family, especially Karen, Kirstin, Emily, Lauren, Sarah, and Taylor, who have provided an endless source of things to think and laugh about. Without their support, and the love of my friends and extended family, this project could not have happened.

This book is dedicated to Joshua Leibner, favorite.

ORDERING THE FACADE

Against time and the damages of the brain
Sharpen and calibrate. Not yet in full,
Yet in some arbitrated part
Order the façade of the listless summer.
—James Agee, "(To Walker Evans. [sic]"

Picture a southern woman. If not a personal memory of your grandmother, chances are that what springs to mind is an image based on a photograph. "Southern belle," "mammy," "jezebel," "trash," "brown sugar," "lady"—southern women have been represented in prescribed ways, carefully stilled and silenced within cultural images, literally transformed into black and white.[1] And whether it be Scarlett O'Hara dancing across the screen, "Annie Mae Gudger" looking out from a Walker Evans photograph, Aunt Jemima grinning from a pancake box, an Atlanta "welfare queen" caught in the latest news exposé, or Miss Mississippi (or Miss South Carolina, Miss Virginia, Miss Florida, Miss Tennessee, Miss Alabama, Miss Kentucky, or Miss Arkansas) accepting the Miss America crown, popular, art, and journalism photographs have supplied the "real life" imagery to make the cultural image of the southern woman visible and concrete. Conversely, the personal "real life" memories of southern grandmothers, particularly as embodied in those familiar familial photographs of mothers, daughters, sisters, and other beloved women, form a powerful parallel—and often corrective—image of southern womanhood. Taken together, these photographs, and the cultural visions that create(d) them, constitute a central element in the visual legacy of southern culture: a legacy that helps constitute the very notion of "the South." And this visual legacy—so strong in cultural memory that it molds how the South can be seen, so undervalued critically that this same South is regularly declared an "oral culture"—has in turn helped to shape the lives of southern women from the nineteenth century to the present.

Ordering the Façade is an effort to trace the visual legacy of the U.S. South as it defines, and is defined by, contemporary southern women writers. For while looking at actual photographs of southern women may give some idea of the "what-where-and-when" of southern ideologies as they affect and are affected by women, the "how" and "why" of photography's role in this mutual shaping can best be understood in the realm of language. If a few photographs can supplant thousands of words, it is only because thousands of words have trained us to "read" photographs. Only when words identified the first photograph of a southern woman *as* a "southern woman" could photographs begin to show a visible "truth" of southern womanhood, to become the "natural" evidence supporting more words. Women writing in and of the South have understood that

power circulates in this dynamic. They have in turn created photographs in their writing—fictional photographs—to speak to, and with, that power.[2] That fictional photographs do not physically exist outside of the printed word (even if they refer to an actual photograph, which, interestingly, they rarely do) invites a host of questions about representation, reference, and ideologies of form. More readily than actual photographs, which work to naturalize a connection between "the real" and the facades they present, fictional photographs highlight their own status as representations, exposing the cultural work of facade-building as the very foundation of "the real" bases of community and identity. Analyzing fictional photographs in a specific gendered and regional context reveals the crucial role of culture in ostensibly natural technologies of vision, a connection between envisioning and power that "objective" technologies like photography are meant to disguise, but that southern women writers, for example, have noted since they became "southern women." Performing this analysis, *Ordering the Facade* necessarily uproots terms like "the South," "southern woman," and even "the visual" from any essentialist or autochthonous groundings. "Place" becomes a verb, not a noun, and "photography" shifts from "light-writing" to writing that sheds light on the ideological, political, and ethical functions of literacy and vision in a specific, multivalent culture.

An ever-increasing body of criticism on photography and literature has largely failed to attend to differences of region and gender in its account of photography's role in culture, or to note the specific photographic discourses that develop as a result of these differences.[3] The methodologies put forward in *Ordering the Facade* could profitably be applied to other regions, other nations, other rhetorics of identity. But they are perhaps particularly illuminating in the U.S. South, where visible attributes (such as skin color, external sex characteristics, or dress) are primary, even obsessive, markers of social "place." Since the mid-nineteenth century (almost immediately after photography was invented), southern women authors have employed fictional photographs as powerful figures of the markers and strictures of southern identity. These fictional photographs themselves have entered into a complex dialog of literary and historical imagery and, in turn, form an important part of the visual legacy that informs the work of contemporary southern women writers. Early in Zora Neale Hurston's 1937 novel *Their Eyes Were Watching God*, for example, storyteller Janie Crawford remembers the first time she sees herself in a photograph. Or rather, does not see herself. Raised in the backyard of the Washburns—the "quality white folks" who employ her grandmother, Nanny—six-year-old Janie plays so much with the Washburns' grandchildren that she is quite literally blindsided when an itinerant photographer delivers the group portrait the children have commissioned: "So when we looked at

de picture and everybody got pointed out there wasn't nobody left except a real dark little girl with long hair standing by Eleanor. Dat's where Ah wuz s'posed to be, but Ah couldn't recognize dat dark chile as me. So Ah ast, 'where is me? Ah don't see me'" (9). Both in the realm of letters, where she is called Alphabet ("'cause so many people had done named me different names"), and in the realm of image, Janie's social identity has been up until this moment blissfully unfixed, at least in her own mind. This childhood utopia comes to a crashing halt as Janie studies the photograph and learns to recognize herself culturally according to the visual clues therein: "Ah looked at de picture a long time and seen it was mah dress and mah hair so Ah said: 'Aw, aw! Ah'm colored!'" (9).

Published the very same year, Katherine Anne Porter's short novel *Old Mortality* also opens with young girls searching for traces of themselves in a photograph. Here, the portrait is of Miranda and Maria Gay's now-deceased Aunt Amy, "a spirited-young woman" of the late nineteenth century, with "a reckless indifferent smile" (9). Aunt Amy's photograph disturbs her young nieces, not only because it does not in fact reflect the standards of beauty that everyone in the family nevertheless ascribes to this tragically dead woman, but also because the smile seems at once to exist in the dead past and the alive present. Hauntingly, Aunt Amy sits "thus, forever in the pose of being photographed, a motionless image in her dark walnut frame with silver oak leaves in the corners, her smiling gray eyes following one about the room" (9). Despite their best efforts, none in the younger generation can live up to Amy's mythos: she was the finest horsewoman, the best dancer, beautiful "as an angel," the ultimate belle of the ball (12). Much to the children's consternation, none of this shows in the photograph, but they soon learn, like their father, to privilege legend over mere photographic fact and to share the family tradition of "loyalty . . . in the face of evidence contrary to [the] ideal" (11). Photographs, like other "visible remains," disappoint in comparison to the romantic stories created in "the breathing words of their elders" (11). And so eight-year-old Miranda resolves and believes "for quite a while that she would one day be like Aunt Amy, not as she appeared in the photograph, but as she was remembered by those who had seen her" (13).

More than a fictional painting, which might not evoke the "truth" of color so strongly for Janie, or a fictional mirror, which could not embody the past in the present under Miranda's gaze, these fictional photographs epitomize the power of visuality, and more specifically, visual traditions, to position female identities within southern culture. Like Miranda and Janie, contemporary southern women writers stand both as heirs and re-creators of the visual legacy of the South, by which I mean both a historical legacy of visual material expression in and of "the South" and a rhetorical dynamic of visual "placing"—an ongoing

contest to determine who and what will represent "the South" and its women. What, then, is the object of this inheritance, the subject of these writers' revisions? How best to understand what photographs mean in relation to southern culture, in relation to southern literature? The seventy years since *Their Eyes Were Watching God* and *Old Mortality* were published have supplied many fine theoretical lenses through which to read and understand fictional photographs such as Hurston's and Porter's. For instance, following photography theorists such as Susan Sontag, Roland Barthes, or Jonathan Crary, we might trace the ways these fictional photographs represent the turning of subject into object—Janie into a "colored" child, Miranda into an imitation of past romance—or meditate on the type of modernity into which each is initiated through photographic technology. Or like Marianne Hirsch or Jo Spence, we might analyze how the photographs figure family dynamics, "framing" Miranda and Janie within networks of gazes both private and public. Literary critics like Carol Shloss or Susan S. Williams might read these photographs within broadly American traditions of photography in literature, as perhaps reflecting Hurston's or Porter's anxiety about interpretive ambiguity or about the process of representation itself. Certainly feminist or postcolonial theorists of the visual (Robyn Wiegman, Kaja Silverman, and Deborah Poole, among them) would identify the visual economies of race and gender formation enacted around Janie's group portrait or Miranda's family photos.

Born of the broadly deconstructive and interdisciplinary movement that is cultural studies, all of these reading strategies are useful for gaining insight into how fictional photographs function in works like Hurston's and Porter's. Yet for all their emphasis on cultural milieu, none helps to account for what is arguably the most important context of these novels: their southernness. Just as Miranda's concern for the relation of past and present, and Janie's concession that she is indeed "colored," are illuminated in these scenes by knowledge of photography's power to "capture time" and to serve as evidence in a court of law, so the facts that the Washburns' backyard is in Florida, and that Miranda and Maria gaze at a southern belle, affect the way these fictional photographs can be properly "seen." Cultural dynamics of race, gender, family, and even representation itself are inflected by the South's peculiar and evolving regional history. And of course the reverse is true as well. When we read of little girls looking at family photographs, of themselves or other women, we know something. When we read that the girls and women are southern, we know something more.

Leaving aside for the moment the question of exactly *what* this "something more" is, *how* do we know it? Certainly, by reading. Literature by and about southerners has always been one of the chief sources, and reflectors, of southern cul-

in the photographs of the suicided mother that haunt Rosemary Daniell's mem-oir, *Fatal Flowers*, in the family albums that confound Jo Spencer in Jill McCorkle's *The Cheer Leader*, in the mother-daughter portraits that circulate in Josephine Humphreys's *Dreams of Sleep*, and as the ever-present contrast to the photographs of the Gibson women in Dorothy Allison's *Two or Three Things I Know for Sure*. Southern women wielding cameras in Julie Dash's *Daughters of the Dust*, Anne Tyler's *Earthly Possessions*, Ann Beattie's *Picturing Will*, and Natasha Trethewey's *Bellocq's Ophelia* and those who control the narrative display of photographs, like Aunt Alma in Allison's *Bastard out of Carolina*, and Quee Purdy in McCorkle's *Caro-lina Moon*, enact an ethics of representation that signifies upon the southern visual legacy, reflecting and revising the cultural visions that would define them.

Using examples from the history of actual photography in the South and from southern literature and history, *Ordering the Facade* delineates a contested field of southern representational politics, to provide a context for situating contemporary responses by southern women writers. By strategically redeploy-ing tropes and loci of vision, photography, and southern womanhood, I argue, these southern women writers "order the facade" of the South, challenging the dominant effects of being represented as "southern," and particularly as "south-ern women." Their works query what Tara McPherson has called the "lenticu-lar logic" of southern representations, a cultural, ideological schema by which diverse and coexisting images and histories are presented as discrete and unre-lated: a strategic "way of seeing" that would deny the inherent interdependence, the "productive overlap" of southern concepts of gender, race, and "place" (Mc-Pherson 7, 27).[4] In their explorations of the forms and contents of southern identities, these authors evoke the contested visual legacy of photography in the South to help signify the ethical encounters behind all representational politics: encounters not only in the existential (or artistic) sense of confrontation between subject and object, but also, more significantly, in the sense that the power to render one's vision visible to the world—to *make represent*—is always a negotiated power. Negotiated (or not) between the artist and her subject. Negotiated be-tween the desire of the artist and that of her audience, who may, after all, bring all sorts of narrative "readings" to a given image or text (or ignore it altogether). Negotiated between the ideologies or conventions of a culture—which seek to determine the possible forms and interpretations available to an audience in that culture, to determine what can represent, what can be made visible, what even can be seen—and positions of acceptance, ambivalence, or resistance to those conventions. In contemplating the role of photography in literature by south-ern women, it is not my primary purpose to query the ontological status of the photograph or of literary text, although in reading literature for how photog-

raphy means (and, ultimately, reading photography for how literature means), the question is bound to be explored. Rather, I am interested in the negotiations themselves: how a group of people so *visualized* by a culture, whose prescribed and proscribed images are so crucial to a dominant cultural narrative, as southern women, respond within and against that culture. The southern women writers included in this study narrate these negotiations; and the photograph, because it is so often regarded as the epitome of the visual image and visual culture itself, has proven an especially powerful figurative device through which they employ and interrogate paradigms of visual representation and power. *Ordering the Facade* aims to illuminate the processes by which these writers order photographic visions of and by women in literature—processes that form the very ground of photography's cultural meaning, in "the South" and elsewhere.

PHOTOGRAPHY, THE SOUTH, AND THE "PLACE" OF WOMEN

Every image of the feminine coded body is at the same time an image of woman and not an image of woman. It is never simply fetishized and phallic, nor a memory trace of the jouissance *imagined and desired in relation to maternal plentitude. Both and neither, the image is a field traversed by desiring subjects/viewers through whom meanings come into play only to be ceaselessly displaced by others. —Griselda Pollock, "Missing Women"*

Know a photo is from the South, and history and context start rushing in.
—David Madden, "The South and Photography"

Women growing up in the South learn early: representations matter. How they matter is no simple equation. When Wilbur J. Cash famously critiqued the "gyneolatry" of southern culture, he referred to the white South's history of using the bodies of southern white women to reflect its ideal self-image, to itself and to the rest of the nation (85–89).[5] Not all southern female bodies, as Cash would be the first to concede, have served such an exalted representational function. The picture that emerges of "southern woman" changes radically depending on where within the hegemonic boundaries of gender, race, class, religion, or even geographical history an individual woman is "placed." Conversely, the image of a southern woman can signal—in the condition of her dress, the color of her skin, the pose of her body—the very "place" of the South, a South aristocratic or poverty-stricken, mountain or tidewater, Scots-Irish or African or Scots-African. In both regional and national American culture, representations of southern women have served as visible, embodied boundary markers. The cultural history of creating and enforcing these boundaries in the South has

been well documented, ranging from the tragically serious, such as invoking the image of the wanton "jezebel" to justify raping black women or the image of chaste southern white ladyhood to justify lynching black men, to the tragically comic, as in this toast, ritually offered by white southern college men: "To Woman, lovely woman of the Southland, as pure and chaste as this sparkling water, as cold as this gleaming ice, we lift this cup, and we pledge our hearts and our lives to the protection of her virtue and chastity" (Carmer 15). Less well documented are the cultural histories of resistance to these boundaries by southern women: histories that reveal how thoroughly any discussion of a "visual legacy" of southern culture must be understood as a field of competing representations, an ongoing and, in the broadest sense of the word, *political* contest to define who and what may represent in the South.

Ordering the Facade thus pursues an interdisciplinary analysis of how certain recent southern women writers use photographic figures to revise exploitative representations of cultural identity in southern literature. In the chapters that follow, I argue that "the South" was itself one of the cultural ideas that arose in conjunction with photography and that the early decades of photography help constitute the visual legacy of the gendered, raced, and classed hierarchies that characterized southern identity. Whether employed to help essentialize and fetishize the image of the white southern lady or to naturalize racist anthropology or sexual stereotypes of "white trash" women, nineteenth- and early twentieth-century photography played (and continues to play) an important role in creating a hegemonic "South" — the fabled "white man's country." But photography has also played a crucial role within strategies of resistance to this version of the South and in the construction of differently imagined communities of southernness. Nineteenth-century self-commissioned *cartes des visites*, lynching photographs published in 1920s National Association for the Advancement of Colored People newsletters, and most self-consciously, contemporary southern art photography all engage discourses of southern definition and the ethics of belonging. Taken together, photographers and photographs in the South constitute a vast visual legacy: a complex series of continuities and ruptures that help to shape notions of southern identity.

The history of actual photography in the South is thus a key context for any study of photography's role in southern literature. Although there are several fine studies of American photography and literature, none employ region or gender as a primary frame of analysis.[6] It is my hope that the brief and partial history of photography in the South offered in chapter 1 will demonstrate the productivity of bringing region to bear in considering photography's role in American culture. I also maintain, however, that photography's role in a given region can-

not be fully grasped without an understanding of the various forms of discourse surrounding photography in that region. On their own, the photographs collected in chapter 1 suggest a range of gender, race, and class roles in the South, but without the words surrounding the pictures—as captions, newspaper items, diary entries, cultural criticism, or fictional narratives—the cultural meanings of these images remain largely obscure. Despite, or more deeply because of, their power, *Ordering the Facade* invokes these literal images to set them aside, instead to focus on their figurative presence in southern literature. Echoing generations of photo-critics, Barthes argued in *Camera Lucida* that the essence of actual photographs is their referential force: because the photograph is concrete evidence not only of an object but of time, "in the Photograph, the power of authentication exceeds the power of representation" (89). Fictional photographs, on the other hand, can be "seen" only as acts of representation; they thus invoke the cultural meanings and functions attached to photography and vision (such as authentication) in a way that lessens the temptation to naturalize or take for granted the referential qualities of a photograph—text is about photography in a way that the photograph itself often disguises. From an epistemological standpoint, fictional photographs up the ante: in the absence of an "objective" actual photograph against which to evaluate a given character's perception, for instance, we are left with the residue of evidence—our notion that the photograph refers.[7] As distinguished from actual photographs, fictional photographs separate the physical object we know as a photograph from its immediate cultural and material effects and re-embody these effects in a new object, the printed word. Paradoxically, eliminating the primary visual aspect of the photographic image may make the cultural dynamics of vision and visual representation more "visible." These dynamics, as portrayed in literature by certain southern women, are the subject of my analysis.

This, then, is a book about how a group of recent southern women writers has responded to and reordered the vast, inordinately complex, and often contradictory representational legacy of the South. As such, it participates in an ongoing feminist project of analysis and critique of cultural, including literary, images. I focus on southern women writers rather than southern writers in general for two reasons. First, because visual representational power struggles, as numerous feminist critics have pointed out, have so often occurred on and through the female body, at the cost, it would appear, of even the theoretical possibility of female subjective expression.[8] *Ordering the Facade* examines recent work by southern women writers in light of current feminist theories of photography and the visual, as well as feminist criticisms of southern culture and literature, but with a focus on discovering what the work itself may offer for revising and expanding

these theories. Second, I have focused on southern women authors because recent southern women's writing so often explicitly and effectively responds to the representational legacies of southern history and its literary renascence. Perhaps because these representations have so frequently worked to essentialize southern women as embodiments of southern race, class, gender, and religious ideologies, southern women's writing often works against such essentialism. My own title is derived from James Agee's classic meditation on photography, literature, and the South, *Let Us Now Praise Famous Men*. Agee's stated project, "to perceive simply the cruel radiance of what is" (11), works rhetorically to essentialize the author's view of the South and its tenant farming system. But Agee's poetic injunction to northern photographer Walker Evans (to "in some arbitrated part / Order the façade of the listless summer") suggests that the crucial work of representation is to create order through arbitration—a mediation of truths that is ultimately about power, not essence. Though the rest of Agee's poem and much of his book work against this reading (facades in the poem are temporary masks disguising the "square" truth), I choose to reframe Agee's words to invoke a greater tradition of negotiation and revision from within and without southern culture. By referencing the great canonical photo-text on the South in this way, my title *Ordering the Facade* evokes the complex historical context of photography in the South, as well as raises issues of representational power, constructed surfaces, responding to "canons," artistic control, and personal command that are central in the work of many contemporary southern women authors.

For certain southern women writers, concerns about region and gender (and race and class) intertwine as these writers assert their active presence and voice within the literary arena—in the process disrupting traditional narratives about southern culture. Springing in part from the historical legacy of photographs in the South, the rhetorical use of photographs in this fiction speaks to an ongoing legacy of contesting representations in ways that illuminate and complicate notions of southernness. Recently, the field of southern studies has moved to theorize such gestures, expanding the definitions of "southern" and "the South" beyond traditional geographical borders, emphasizing transregional and transnational connections, and investigating both canonical and noncanonical literatures and histories for "new" configurations of culture and identity. From literary trade routes between the Caribbean and the Gulf South, to the influx of Mexican workers in poultry-processing towns, to debates over flying the "Stars and Bars" (in red, white, and blue or black, red, and green, in Mississippi or Brazil), topics in modern southern culture and history emphasize power struggles and resistances in fields of representation. Unsurprisingly, this work has been concomitant with a current regional, and even national, anxiety

over the "death of the South" in this "postmodern" era. As the South becomes increasingly "Americanized"—and America becomes transnationalized—what happens to women or, perhaps more accurately, to representations of southern women?[9] Who will represent the South in the contemporary arena, and what type of South will they construct? The ways in which southern women writers in their works employ and critique visual imagery, particularly photographic imagery, signal various strategies aimed at the deconstruction and reconstruction of narrowly conceived southern identities. In particular, *Ordering the Facade* examines the stakes of the current debates over postmodernism(s) as they relate to southern literature, especially in terms of the often-assumed loss of self and regional identity, the concern for surfaces and cultural constructions, and the potential strategic implications of each for southern women's writing and for representational politics in general. This analysis of the representational pressures felt so intensely in the South brings broader theories of visual representation into sharper relief and provides a model for further feminist and postcolonial analyses of visual culture and literature of the Americas.

FICTIONAL PHOTOGRAPHS AND A SOUTHERN ETHICS OF FORM

The human face and the human body are eloquent in themselves, and stubborn and wayward, and a snapshot is a moment's glimpse (as a story may be a long look, a growing contemplation) into what never stops moving, never ceases to express for itself something of our common feeling. Every feeling waits upon its gesture. Then when it does come, how unpredictable it turns out to be, after all. —Eudora Welty, One Time, One Place

For the temporal deferral that is the motor of narrative to work, the gaze in the text, like desire in general, must remain permanently unable to achieve its sought-after object. —Martin Jay, in Teresa Brennan and Martin Jay, Vision in Context[10]

"If I could do it," Agee writes near the beginning of *Let Us Now Praise Famous Men*, "I'd do no writing at all here. It would be photographs; the rest would be fragments of cloth, bits of cotton, lumps of earth, records of speech, pieces of wood and iron, phials of odors, plates of food and of excrement" (13). Short of "a piece of the body torn out by the roots," photographs are evidently the next best thing to unmediated physical truth: a representation as free as possible from the ethical quandaries of representation itself, an instrument, when used correctly, through which "everything is to be discerned, for him who can discern it, and centrally and simply, without either dissection into science, or digestion into art" (13, 11). For Agee—a romantic, but a skeptical, painfully self-conscious

one—photographs have a chance, in a way that writing never does, of settling the "curious, obscene, terrifying, and unfathomably mysterious" questions of representation through their indelible link to the essential (human) being and discernable truth key to understanding "the whole memory of the South" (8–9).

Eudora Welty appears to have reached the opposite conclusion. Herself an amateur photographer of poverty-stricken southerners in the Great Depression, Welty eventually gave up pursuing a photographic career in favor of writing precisely because of what she saw as photography's limitations in conveying the truth of human life. Like Agee, Welty was obsessed with the ethics of representation and human connection, describing her own project as "not to point the finger in judgment but to part a curtain, that invisible shadow that falls between people, the veil of indifference to each other's presence, each other's wonder, each other's human plight" (*One Time* 8). But, far from Agee's embodiment of transparent, democratic representations, Welty saw photographs as hopelessly restricted by their fundamental exteriority and remove from the temporal world. The crux for Welty lay not in epistemological questions of evidence or ways of knowing the "truth" but in an ethical encounter between author, subject, and audience: to her friend Hermione Lee she explained, "I had to go on to fiction from photographing. That's the only way you can really part the veil between people, not in images but in what comes from inside, in both subject and writer" (Prenshaw, *More Conversations* 151). Choice of form takes on an ethical valence here in terms quite contrary to Agee's, with images an inferior vehicle of living truth and photographs an embodiment of a "moment's glimpse" into that which only fiction can provide, "a growing contemplation . . . into what never stops moving" (*One Time* 8).[11]

But Welty eventually published several volumes of her early photography, and Agee's disclaimer against writing prefaces his four hundred–odd pages of text. The careful formal boundaries both authors attempt to erect collapse (perhaps purposely) in the execution of their respective works, but the attempts themselves lend insight into the southern arena in which both writers created. Agee's sharp contrast between photography and writing reflects two important and conflicting components of southern culture. First, a desire for formal purity, as a form of power: the power to represent essence or true knowledge. Second, a deep anxiety about that power: a tacit (in Agee's text, explicit) acknowledgment that even the most "neutral" technologies—the forms that should prove the truth of "truth"—are themselves deeply ideological and political, subjects, as Welty emphasized, of ethical encounter. As both Agee and Welty knew well, photographs are slippery things. As much as a photograph may anchor the "reality" of a cultural image, it may also unmoor that reality. It may fail to provide the desired

evidence that assures the visible truth of ideology. Or, it may provide evidence that can be read in radically different ways by different audiences, even in ways that directly undercut ideological power. As Barthes famously pointed out (and Marcel Proust poignantly illustrated), the photograph of a beloved grandmother will in a stranger's eyes represent the pathos of old age, or the injustice of poverty, or the status of Woman—but never the personal love of a grandmother.[12] The still, silent photograph no more captures the "essence" or "reality" of life than does a static word, printed on a page.

Fictional photographs, in which photographs *are* static words on the printed page, thus raise a host of interesting questions. What does it mean to "change" a photograph into words? What does it mean to change spoken words into print? What new knowledge, or new forms of knowledge, are created in the transformations? Where does the fictional photograph stand in relation to language? To "the oral"? To "the visual"? To be sure, these questions have a long rhetorical tradition behind them. They appear abstractly formal, but especially when asked within a gendered or regional context, they reveal themselves to be deeply cultural. The formal boundary between photography and literature or, more broadly, between image and language has proven one of the most contested fields of representational struggle, one that W. J. T. Mitchell has called a "fault-line in representation" (*Picture Theory* 5).[13] Analyzing fictional photographs as they are situated in (and in turn situate) a particular cultural context, *Ordering the Facade* examines the cultural and political interests at stake in maintaining this "fault-line," and in bridging it, shifting the grounds of formal debate from the scientific or "pure" pretenses of epistemology, ontology, and phenomenology to the social, political, hermeneutic realm of encounter—in short, to a study of the ethics of form.

As Agee's and Welty's meditations suggest, this sort of study has particular resonance in the South, an arena of tangible, sometimes violent, representational struggle. If, as Scott Romine has asserted, the South, like all communities, "coheres by means of norms, codes, and manners that produce a simulated, or at least symbolically constituted, social reality" (3), the formal structures underlying this "reality" are a particular site of contest and anxiety. Formal division often stands in for greater cultural tensions and the cultural desire for borders— between space and time, object and action, artifact and history, for example, or between groups of people. This is clear in the South, where formal divisions—especially the choice between visual or oral expression—are intimately intertwined in the constructions of gender, race, and class distinction so crucial to, and contested within, southern identities. Fictional photographs embody an image/text/oral nexus that can provide particularly useful insight into southern ethics of formal division and choice. These photographs stand for

the negotiation and ambiguity of formal conflict, and also as indicators of the politics behind the conflict itself. In certain contemporary southern women's works, fictional photographs configure intertwined issues of representational form and representational politics in ways that reveal formal ethics as shaped in and through trajectories of desire and power, which are inevitably cultural. At times in conjunction with and at others in opposition to (represented) orality and aurality, fictional photographs appear as complex figures of what I call "cultured vision" — gendered, racialized, strategic viewing. Performing so, they enact an ethical encounter of claim and acknowledgment between artist and creation, viewer and show-er, listener and hearer, artifact and story, that models the productive encounter of reader and text.

More than other regions of the United States, expressive form has been a matter of conscious identity formation in the South. "The South was truly an oral society," declares Waldo Braden in his 1983 study, *The Oral Tradition in the South* (ix), and he is certainly not alone in his conviction, or in the matter-of-fact, slightly assertive tone in which he delivers it. For southerners and southernists, the "great oral tradition" of the South regularly holds the status of a historical given, often noted in the service of explicating some other phenomenon of southern culture, such as literary technique or political campaigning, or, less positively, chronic struggles with illiteracy, or the (lack of) southern prowess in the beaux arts. Southerners, the companion compact disc to Norton's *Literature of the American South* rightly asserts, "are renowned for the distinctiveness and artistry of their oral traditions" (Andrews et al). These traditions are evinced in activities ranging from sermonizing to mule trading, quilting-bee gossip to oration, gospel singing to lynch-mob baiting, dialect writing to singing the blues. They are, a vast critical and historical corpus would have it, a cornerstone of southernness itself.

The foundations of this cornerstone are variously explained in terms of a "given" cultural background. The backgrounds of southern (implicitly) white male oral traditions are most often traced to early modern Scots-English traditions, where oratory provided a largely illiterate rural population with information, entertainment, communal bonding, and spiritual inspiration and where notions of honor that emphasized exterior, public indicators of public worth conferred "particular prominence on the spoken word and physical gesture as opposed to interior thinking or words and ideas conveyed through the medium of the page" (Wyatt-Brown 47).[14] Religion historian Samuel S. Hill has posited southern Protestantism as privileging the oral and aural over other sensations because it takes the notion of the "Word of God" as literal truth, where "speaking and hearing enable one to participate in reality in the most effective way" (Wilson and Ferris 1273), while Charles Reagan Wilson draws the trajectory of

influence in the opposite direction: "The South is an oral culture, and religion has reflected that" (*Judgment* 59).[15] Alternatively, W. J. Cash offers that the white southern "fondness for rhetoric" has roots in "the daily impact upon the white man of the example of the Negro, concerning whom nothing is so certain as his remarkable tendency to seize on lovely words, to roll them in his throat, to heap them in redundant profusion one upon another until meaning vanishes and there is nothing left but the sweet, canorous drunkenness of sound, nothing but the play of primitive rhythm upon the secret springs of emotion" (53).

If Cash's nod to black southern influence counters Euro-centered genealogies of orality, it ironically highlights the ethical questions of cultural acknowledgment and dis-acknowledgment behind formal choice: although Cash at least allows for "the Negro" in the southern cultural picture, it is to trace white southern hedonism and romanticism to the presence of a blackness drained of all semiotic meaning. African American critics from Frederick Douglass to Henry Louis Gates Jr. have elucidated these "meaningless" utterances as highly meaningful communicative acts within African American communities, although, significantly, most critical studies do not emphasize the southern context of the tradition. African American oral traditions are generally traced to Africa, where word-of-mouth transmission from generation to generation provided the basis for history, entertainment, law, and education. Gates's groundbreaking study *The Signifying Monkey* (1988) illuminates, as it enacts, an African American privileging of oral tradition. Of two African entities responsible for communication—Esu-Elegbara, a trickster figure and messenger of the gods who stands for "the origin, the nature, and the function of interpretation and language use 'above' that of ordinary language" (6), and Ifa, a mythic figure of phonetic scripts encoded in cryptograms who is a metaphor for text itself and the origins of traditional African forms of writing (10–15)—Gates offers Esu and oral traditions as the operative metaphor in African American literature. Strictures of southern slavery, including legal prohibitions on African American literacy and private property, may have contributed to this effect; slaves depended on less tangible, and thus less easily confiscated, forms of expression to keep their cultures alive.[16] As a matter of individual and communal survival, Esu's trickster traditions surfaced in southern oral/aural traditions from playing the dozens to "lying" (storytelling), from preaching to "signifying," from drumming (also outlawed in parts of the antebellum South) to spirituals, gospel, and the blues. Critic Robert Elliot Fox's assertion is representative: he finds African American "orature" and music constituted of a "sound system culture" that has traveled beyond Africa (9).

The extensive critical attention to southern oral traditions is clearly warranted. A comprehensive study of southern orality would be an extraordinarily

ambitious and worthwhile project, although its motivations and conclusions would need to be carefully examined and theorized. But the critical emphasis on southern orality and oral tradition, to the neglect and exclusion of other expressive forms, is worth scrutinizing. Even in light of such a rich and varied oral heritage, why make the critical leap of labeling the South "truly an oral culture"? Would it not be equally appropriate, given the visual legacy I so briefly outline in chapter 1, to proclaim the South "truly a visual culture"? In a culture where visual signs—the shape of a lip, a skin's shade, external sex characteristics, the carriage of one's body, the condition of one's clothing—determine "place" (and may literally mean the difference between life and death), surely the visual may be said to reign supreme. Are there particular interests at stake in maintaining a certain distance between representational-expressive forms (as I myself have done here, for the sake of argument)? Why has the notion of visual culture in the South seemed such an unfamiliar and unformulated one?

As I have suggested, this formal question has political and, ultimately, ethical roots. The beginnings of an answer lie in the competing desires of white and black southerners, as well as northerners, to construct and preserve "southern identity" and "the South" in the form of strategic, nationalist narratives. Benedict Anderson has famously defined "nations" as imagined political communities, "imagined as both inherently limited and sovereign," adding that "communities are to be distinguished, not by their falsity/genuineness, but by the style in which they are imagined" (6). Anderson's schema stops far short of creating a model for the conflicting self-imaginings within a nation, much less beyond nation, that characterize southern cultural history, but his emphasis on "style" points to the role of form in (always competing) attempts to "imagine" a coherent communal identity. Distinguishing and privileging one form above others, as southerners (and their interpreters) have the oral, has been a matter of nation-building strategy in the South; the ideological, political, and ethical effects of this strategy haunt southern culture(s) and contemporary southern women's fiction.

For white southerners, the effort to imagine a national identity, outside of or within an American nation, is said to have begun in the 1820s, with the legislative defeats and struggles of the Missouri Compromise.[17] For black southerners, it has been argued, efforts began much earlier, as survival strategies in the face of literal disfranchisement by white southerners and the greater political will of the United States.[18] For both black and white southerners, oral traditions figured prominently in emerging concepts of communal identity, though they performed different strategic functions for each group. Constructing and defending their difference from northern cultures, white southerners fell back, as

it were, on what they saw as their strengths: an organic, agrarian culture and an oral tradition that culminated in the high art form of political oration. Agrarians John Crowe Ransom and Donald Davidson defended southern artistic traditions, highlighting oral folk expressions and political oratory as examples of organic, antimaterial art practice (Twelve Southerners 12, 52–60). Such southerners might well have embraced the "psychodynamics of orality" outlined by Walter J. Ong as a welcome analog to the southern ethos: As opposed to the isolating, dissecting, analytic, abstract sense of vision and the printed word, which value impersonal, material things and falsify time by spatializing it, the oral and aural represent movement in time and constitute a unifying and harmonizing mode of action, "close to the living human lifeworld" and consonant with conservative holism, situational thinking, the mindset of the Bible, and an "empathetic, communal identification with the known" (49, 45, 69–77).

Black southerners and their critical observers might also acknowledge parts of Ong's portrait of powerful orality in their own narratives of personal and communal southern identity. Frederick Douglass's account of slave song is an early revelation of the subversive, unifying power of African American oral expression: the singing is misidentified by whites as evidence of contentment, but to Douglass's ear it conveys a "testimony against slavery, and a prayer to God for deliverance from chains" (38). To members of a given slave community, culturally equipped to hear and interpret such soundings, "meaningless utterances" were full of meaning. Tracing these soundings from ancestral African roots adds a powerful, nationalist cast to black southern orality, defining an incipient black southern national identity not only as a response to white oppression but also as the call to origins and claim to continuity that Anderson posits as essential to national imagining. So important is the oral/aural metaphor of voice in African American constructions of identity, that Gates (to take the most prominent example) insists on its primacy, even while (and because) he acknowledges writing as the "visible sign of reason" in Western culture. The primacy pertains even when analyzing black responses to stereotyped visual representations of blackness: "While this concern with features would imply a visual or facial priority of concern, it was, rather, the precise structure and resonance of the black *voice* by which the very *face* of the race would be known and fundamentally reconstructed" ("Trope" 143, emphasis in original). The cultural authority of black voice extends to musical traditions of spirituals, gospel, and especially the blues; most critics would agree with Robert Fox's claim for black music as "the most authentic example of continuity" in African American culture (7).

In the contexts of this southern privileging of the oral, and of these authors' avowed interests in matters of form and cultural politics, it is not sur-

prising that much contemporary southern women's fiction manifests tensions between orality and printed/literary text, between the oral and the visual, between image and word. Southern formal prejudices do not happen in a vacuum; internal "fault-lines in representation" between "the visual" and "the verbal" reflect and relay traditional Western formal divisions. The literary text has proven a pivotal figure in these debates. Arguments for the printed word's temporal or spatial status span the centuries, with Gotthold Lessing asserting in 1766 that inherently spatial plastic arts and inherently temporal literature should never "encroach" upon each other (110), and with Barthes arguing in *Image, Music, Text* that the inherently spatial literary "work" acts as a container or constraint for the fluid, temporary "text" of language (156–63, 70).[19] The rhetoric of purity, containment, and contamination is familiar to scholars of gender, race, and class divisions, and many critics have linked ostensibly neutral formal distinctions with cultural dynamics of desire and power. Clearly, southern cultural and literary tensions between spoken word and printed text, between visual, spatialized images and oral, sounded expression, take their place in greater cultural schemes of formal and social order: both the particular and the general cultural schemata may be read as strategic interventions in competing assertions of desire, power, and imagined identity.

In recent years, however, several critics, some prominent southernists among them, have questioned the validity, and even the strategic effectiveness, of traditional formal divisions and their implicit hierarchies. Challenging Samuel Hill's contention that, in southern Protestantism, "the visual sense [like taste and smell] is not highly cultivated because it too is not regarded as a potential link between the divine and the creation" (Wilson and Ferris 1273), Lisa Howorth points to the intertwining of religious words and imagery in southern "sacred art"; the tension Howorth notes is between Protestant disdain for "graven images" and the utility of images as a powerful teaching tool for illiterate parishioners (48). Delineating an Afro-Modernist aesthetic, Craig Werner illustrates how in African American literary criticism, the oral, musical, and temporal are aligned with African American expression, which is explicitly opposed to European visuality, instantaneity, and spatialization. Vision becomes a metaphor for Western imperialism—the colonizing gaze—and images appear as static, objectifying tyrannies that the fluid temporality of music and voice works to subvert. Werner, however, proclaims that this formal-cultural split is political, and he points to an "underlying similarity" in form (164). The real cultural-political benefits of privileging the oral and aural in African American criticism have come at the cost of a certain critical reluctance to see, critiqued by Michelle Wallace: "The necessity, which seems to persist of its own volition in Afro-American Studies, for drawing par-

ficient concern [that southern black autobiographies] repeat the same figure of the Talking Book that fails to speak" (131–32). Without discounting Gates's compelling account of voice in writing, I want to suggest a trope that more directly configures the dynamics and tensions triangulated above: the fictional photograph. Like writing, photography occupies an ambivalent, highly contested position in cultural theory: photographs straddle the representational "fault-lines" of the spatial and temporal, seen and unseen, natural and cultural, visual and textual. Actual photographs are literal, indexical series of transcriptions of light on film emulsion (Eco); the registers of an optical unconscious (Benjamin); and the epitome of visual evidence, messages "without a code," whose essence is to refer, not only to its subject in space, but to time's passing, the "that has been"(Barthes, *Image* 36; *Camera Lucida* 115). They are also utterly "surface" representations that shut down the possibility of narrative and history (Sontag); dead, static objects fatally "weak in intentionality" (Berger, *Another Way* 90); vehicles of power, whose force is the outcome of historical relations and institutional practices (Tagg), that must be considered not in terms of aesthetics but of social function (Benjamin), where every image is always already infused with writing (Krauss). Indeed, photography has made it "increasingly difficult for us to enforce the traditional distinction between the arts of showing and those of telling," asserts Stuart Culver, which forces us "to reconsider the difference between visual images and linguistic signs" (190). "Photography," writes Mitchell, "is and is not a language; language also is and is not a 'photography' " (*Picture Theory* 281).

Interactions between photographs and literature, where photographs are placed alongside printed text to create "photo-texts," or where text is incorporated into photographs as in the postmodern "photo-graphy" of Clarissa Sligh (discussed in chapter 1), partake in and complicate formal-ethical debate. Postmodern photography, writes Linda Hutcheon, links verbal and visual discourses to highlight "the theoretical implications of the differences between, on the one hand, meaning-producing within the two separate and differing discourses and, on the other, any meaning created through their interaction" (138). These "implications" are not only theoretical but also political, social, and ethical, as Mitchell asserts: "The relation of photography and language is a principal site of struggle for value and power in contemporary representations of reality; it is the place where images and words find and lose their conscience, their aesthetic and ethical identity" (*Picture Theory* 281). Photographs in literature, fictional photographs, figure this relation in ways that query not only "representations of reality" but also the cultural "realities"—dynamics, tensions, anxieties, and rewards—of representation, including the ethics of formal division and formal choice. Like the Talking Book that cannot speak, fictional photographs may stand in for the

elusive challenge of representing oral-reality in the visual realm, of capturing the temporality of life- and nation-sustaining speech in a spatial form. But in cultural, strategic debates over representational form, where the divisions between visual and verbal, temporal and spatial, icon (image) and *logos* (language) take on their ideological, ethical value, fictional photographs show a figural power that is in some ways more direct than the Talking Book or other metaphors of envisioned voice. Writing's ambivalent relation to voice is often subsumed in notions of *logos*, which includes verbal and written language. The photograph's stronger association with the visual, combined with its ambivalent status as icon and text, empowers fictional photographs to stand in for the visible/iconic/spatial aspect of written text, as well as for written text's "outside": narrative, voice, and time. In the triangulated relation shown below, fictional photographs represent a nexus, one that may "slide" toward figuring either icon or *logos* or both simultaneously.

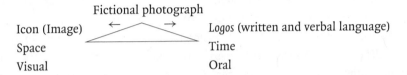

Fictional photograph

Icon (Image)	← ⟋\ →	*Logos* (written and verbal language)
Space		Time
Visual		Oral

Alternatively, in calling attention to the visual aspect of text, realigning written text with icon, fictional photographs may paradoxically then stand for what is outside the text, for what is beyond the power of the text to represent—a metaphor for the textual unrepresentability of time and voice. It is this extraordinary flexibility of representation, born of photography's formal ambivalence (which is of course only ambivalence in the face of imposed divisions), that enables fictional photographs so powerfully to serve as figures for ambiguous concepts such as space and time, memory, evidence, fetishism, modernity, and postmodernity—all of which will be explored in the following chapters.

CULTURED VISIONS AND THE CONTEMPORARY ARENA

The South is not inextricably mired in a familiar version of its history. That matters.
—*Tara McPherson,* Reconstructing Dixie

I have argued that, in the South, the formal boundary between visual and verbal, image and text, is grounded in, and in turn grounds, crucial divisions in southern cultural identities. For the reasons suggested here, and illustrated further in the history of photography and the South outlined in chapter 1, dominant

narratives of southernness, black and white, privilege oral over visual expression, word over picture. In a southern culture obsessed with visual notions of social "place," there is a simultaneous reliance on and deep suspicion of visual images and the power of vision itself. Markers of formal flexibility, fictional photographs are especially suited to figure this ambivalent "cultured vision" in southern literature. And they are equally suited to representing its re-vision. Claiming, and winning acknowledgment of, the utter contingency of visual and verbal representations alters the formal, as well as the political, identity of the South.[21] This is an alteration in which many southern women, long on the receiving end of constraining cultural visions, have had interest. The chapters that follow will show how certain contemporary southern women writers use fictional photographs as powerful figures of the South's visual legacies—both legacies of exploitation, objectification, and suspicion and legacies of resistance, empowerment, and renewal—to effect powerful re-visions of what it means to be a southern woman.

In putting forth such claims, I am making less an argument for southern distinctiveness than for southern representativeness. As critics like Mitchell and Jay have extensively documented, suspicion or "fear of imagery" is not confined to the U.S. South. Neither, as Edward Said, Jonathan Crary, and Luce Irigaray (among others) have shown, does the use of visual technology and metaphor to enforce, or subvert, gender, race, class, and colonial status have a southern origin. The South is particularly interesting for understanding such dynamics not because it is exceptional but because it represents a fairly typical but radically undertheorized intersection of identities; it is, simultaneously, as Jon Smith has asserted, "center and margin, colonizer and colonized, global north and global south, essentialist and hybrid" (144). The region's complex visual legacies speak powerfully to this simultaneity, particularly through the figure of the southern woman, in ways that invite a reconsideration of current feminist and postcolonial understandings of visuality, place, and the photographic gaze. Though southern literature has always, to greater or lesser extent, engaged questions of cultural heterogeneity and relationality (if only willfully to "forget" them), the contemporary southern women's writing featured in Ordering the Facade brings these crucial elements to the forefront, using visual culture as a lens. Although contained almost entirely within traditional southern geographic and gendered borders—precisely on the "home front"—the contemporary "South" projected by these writers is a self-conscious facade that engages, exploits, and sometimes explodes those borders. If in its contemporary arena this South seems less like "the South," it in fact may be more like the South that southern exceptionalisms have sought to disguise: a place made rather than sprung, visualized rather

than seen, under negotiation both within and without its borders. It is my hope that focusing on the regionally specific dynamics of visual culture in the South provides a model for considering both representational cultures and cultures as representations.

In taking as its focal point fiction written after World War II, and especially that written since 1980, this study explores literary uses of photography in a feminist, poststructuralist, postcolonial context—its assumption being that, as products of "post-everything" American culture, contemporary southern women writers are at some level familiar with historical representational power dynamics and of the political stakes of a representational theory that limits subjective and representative possibilities. This familiarity springs not from some postmodern suspicion of grand narratives (or not only from that), but from an experience of being represented by, and representing, the highly visualized category "southern woman." It is my contention that the "significant suspicion of the visual and a corresponding conviction of the biased and distorted nature of all observation," which Michael North (168) attributes to the early twentieth century, occurred much earlier in the U.S. South, as the result of a keen understanding of photography's ability to naturalize visions that both black and white southerners (for different reasons) "knew" to be unreal. The history of the South's relative self-consciousness vis-à-vis actual photographic representation is the topic of chapter 1, which draws on archival research and photographs to construct a previously unnarrated legacy of southern representational politics spanning from the first photographic portraits to present-day postmodern art photography. How this multifaceted legacy of contested, cultured visions of southern identity is engaged by contemporary southern women writers is the subject of the following five chapters. Chapters 2, 3, and 4 engage specific and interrelated visual legacies: the fetishized image of the white southern lady and the patriarchal family gaze upon her; the pseudoscientific anthropological gaze and the southern black female body; and the visualizing of southern "white trash" female sexuality, respectively. In each of these chapters, I analyze the power of specific cultured visions to define and naturalize political culture as "essence," drawing on precedents from southern history, culture, and literature to contextualize contemporary southern women's literary responses. The authors included in these chapters—Josephine Humphreys, Rosemary Daniell, Jill McCorkle, Julie Dash, Alice Walker, Dorothy Allison—exemplify a diversity in southern representations, as they answer specific legacies of objectification and use. From these different legacies a common strategy emerges: using fictional photographs to figure the power of representation to define cultural identity, and

then re-narrating the "evidence" those photographs offer. This strategy is espe-cially effective in light of the visual legacy of the South, for it replaces notions of essence, visual or otherwise, with a recognition that ordering "facades" is the crucial work of claiming representational power. Historically, southern women have been pictured in highly constraining ways, but here southern women pic-ture the picturing, critiquing and revising the cultural visions that would still and silence them.

Chapter 5 extends this analysis by shifting focus to several works that pic-ture women as picturers. Anne Tyler's *Earthly Possessions*, Ann Beattie's *Picturing Will*, and Natasha Trethewey's *Bellocq's Ophelia* each feature women characters who are photographers, each of whom, in different ways and to different de-grees, engages southern visual politics head-on. Placing cameras in the hands of their female protagonists, these authors draw pointed analogs to their own work as writers, recontextualizing the southern formal ethics outlined above in an explicitly gendered (as well as raced and classed) frame. Finally, by way of an epilogue, I explore Ronlyn Domingue's recently published first novel, *The Mercy of Thin Air*, where photographs serve as metaphors for the limits of human desire. Set in 1920s and pre–Hurricane Katrina New Orleans and Baton Rouge, Domingue's novel uses fictional photographs as the bridge of memory that connects southern women across generations and that ultimately enables greater self-understanding of their sexual and professional desires. Whether in the hands of the novel's ghostly protagonist or those of her descendant, who digitizes the photos to perfect their imagery, Domingue's fictional photographs make explicit a theme that underlies all the works in *Ordering the Facade*: In a south-ern frame, the crucial work of photographs is not to cement epistemological truths but to effect the ethical work of cultural representation, empowerment, acknowledgment, and trust.

If the latest wave of public southern photography—the torrent of images in the aftermath of Hurricane Katrina—teaches us anything, it is that (once again) photographs do nothing on their own. Rather, they build on visual lega-cies created not only from other images but also from ongoing negotiations of visual "place." They fulfill and sometimes frustrate the expectations of cultured visions, the very visions they in turn (re)create. But they do this only in conjunc-tion with words. What *Ordering the Facade* contributes, beyond a reappreciation of southern visual culture, literature, and history, is a concern for contemporary lit-erary responses to the no-longer-new but somehow always surprising notion of a photograph.[22] How does the visual legacy of the South shape and inform our readings of contemporary southern fiction? In light of the history of southern representational politics, how do southern women respond to and re-vision this

legacy in their writing? How do contemporary notions of and experiences with photography affect these re-visions and our readings of them, and how does this interaction of writing and reading complicate and expand ideas of photography and of southernness? Perhaps a closer reading of the interactions of words and images (and image-making words) in determining place in the South will facilitate a revised understanding of what the South's images and words are doing for the nation, in the world.

CHAPTER 1

A SHORT AND SELECTED HISTORY OF PHOTOGRAPHY IN THE SOUTH

There is no such unitary thing as "photography." Photography is a convenient way of referencing the diversity of practices, institutions and historical conjunctures in which the photographic text is produced, circulated and deployed. . . . Each practice, each placing, each discourse thus slides another layer of meaning across the frame.

—Stuart Hall, "Reconstruction Work"

There are images—especially, it seems to Southerners—that never go away; they do not even fade.

—Elizabeth Spencer, quoted in Sheree Hightower and Cathie Stanga, Mississippi Observed

Scarlett and Prissy. Daisy Duke and David Duke. KKK and MLK Jr. NASCAR Dad and Uncle Remus. Minnie Pearl, Hattie McDaniel, Dolly Parton, Roslyn Carter, Rosa Parks, Angela Davis, Britney Spears. *Driving Miss Daisy* to watch *Mississippi Burning* and *Steel Magnolias, Gone with the Wind.* The U.S. South's visual legacy is so strong, at least at the level of popular culture stereotypes, that the present study hardly needs to include an actual image.

But of course, as my introduction suggests, the visual legacy of the South and its women is more complex than the sum of its popular culture images. Though the contemporary southern women's writing analyzed in this study rarely, if ever, directly refers to a specific material photograph, the broader cultural legacy of the photographic in the South provides a key context for my analysis. To render this legacy more concrete, then, a short history and a few examples of actual photographs in the South may indeed be useful. My reading of southern photographic history here will of necessity be brief and incomplete—it will, for example, only barely touch on the vast collections of southern personal photographic archives, address not at all northern travel photos of the South, and no more than introduce the emerging tradition of southern fine art photography. Yet I believe that even this skeletal overview will show the value of applying a regional frame to photography, literature, and gender studies, as it works toward synthesizing the legacies of photographic and other visual dynamics in the South to help theorize the explicitly regional, visual tradition that informs the work of contemporary southern women authors.

REPRESENTATIONAL POLITICS AND
THE "PLACE" OF PHOTOGRAPHY

Given the proliferation of photographs across the entire United States, it is fair to ask whether the South's relation to photography is any different from, for instance, the Northeast's. In its "peculiar" intraregional dynamics of race, class, and gender and in its subnational status within the greater United States, the South epitomizes many of the "boundary" issues so crucial in American representational politics. As critics from Edward Said through Toni Morrison have pointed out, the boundaries within which a community or nation imagines itself are most often defined in resistance to that which the community or nation imagines it is not.[1] From the time it was conceived as a region until (to a much lesser extent) the present, the South's history within the national U.S. context has been one of self-representation against northern "aggression"—economic, cultural, military, and representational. As Richard Gray has so fortuitously put it, "The South has customarily defined itself against a kind of photographic negative, a reverse image of itself with which it has existed in a mutually determining, reciprocally defining relationship" (Jones and Monteith xvi–xvii). That reverse image is, of course, the North, or, more accurately, northern visions of the South. But in a "piquant reversal of customary cultural self-positioning," according to Gray, the southern strategy "usually begins from a consciousness of its own marginality"; "their arguments begin, as it were, *within* an argument already made that has shifted them on to the edge" (xvii). Southerners have often taken for granted, almost as a point of pride, that they are outside of the mainstream, advantaged culture—a colonized South economically, politically, and culturally.[2] The strategic elements of this self-designation become clear when considering the South's position within larger regional and transnational economies, as for example, in its relation to the Caribbean, where the South has often acted as a colonizing power.

Within U.S. nationalist discourse, however, the South before and during the Civil War functioned as a representational Other, against which the United States could be defined and refined.[3] Especially in the North, a civil war that pitted "brother against brother" captured the imagination (especially after the war was safely over), positing a stranger simultaneously inside and outside the nation's boundaries. Representing that stranger has been a longtime Yankee task; resisting that representation and re-representing the self has been a longtime southern task, a task that is often perceived and presented in terms of political power. Within the South, these representational power struggles are repeated, with re-

gional identity buttressed and challenged along lines of class, race, gender, sexuality, religion, and geographical history, in ways that parallel struggles within the country as a whole.

The South's relation to the visual, and to photography in particular, is inextricable from these intra- and extraregional dynamics (figure 1). In the field of representational politics—that is, the ongoing contest to assert what can and cannot be represented in a given culture—visual representations have played, and continue to play, an extraordinarily complicated, nuanced role in the South. For purposes of my broader argument, visual representations might include illustrations, paintings, fictional and nonfictional printed texts, film and television images, architecture, monuments, and myriad other cultural artifacts. Yet, with a history that parallels, and is in fact deeply implicated in, the South's own history as a distinct region, photography may encapsulate the complexities of southern representational politics better than any other medium. Photographs both chronicle and enact these politics, helping, as curator Ellen Dugan has suggested, "to shape the changing and often dichotomous idea of the South in the very act of seeing it and describing it" (14). What, then, is the southern experience of photography? While efforts to determine "southern attitudes" (or "Western attitudes" for that matter) inevitably face the hazards of overgeneralization, some common themes emerge from photo-history. The most sustained attempt to trace such themes remains David Madden's "The Cruel Radiance of What Is" (1984), which reveals what seems to be a paradox.[4] While Madden acknowledges the power photographs held for him (as repositories of cultural memory and inducements to storytelling) as a child and later as a novelist, he also suggests that the special relation of southerners to photographs is one of suspicion and even fear. For the southerner, who Madden believes "brings memory to bear more readily, more fully than non-southerners do" (28), there is "a sinister quality of photographs": "To the viewer, the photographer's attitude or intent may be sentimental or malicious, cynical or compassionate, to expose or to reveal, but somehow there seems behind all intentions to lurk an evil eye" (39). The memories that southerners bring to their reception of photographs, according to Madden —and we agree, though our reasons differ—are the ghosts of photographs past.

Madden locates the beginning of this southern ambivalence toward photography in the Civil War, which was chronicled by an estimated 1,500 photographers, most of them northerners, sometimes acting in an official war capacity.[5] Outside of the thousands of pre-battle portraits of Confederate soldiers (figure 2), photographs taken by southerners of the war or its aftermath are rare; since all but one of the photo supply houses were located outside the South, wartime blockades made shortages of paper, chemicals, and equipment acute.[6] In contrast, several

prominent northern photographers followed battles deep into southern territory to make photographs for sale in the North. Mathew Brady's staged tableaux of Gettysburg and other battlefields are legendary. Only slightly less known is the work of George Barnard, who was hired by the U.S. Army in 1863 as "official photographer," assigned to follow General William Tecumseh Sherman's "march to the sea" and to photograph the aftermath (figure 3). In 1866, according to curator Elaine Dunn, Barnard offered a portfolio of his finely constructed and beautifully printed photographs for sale to the "visually aware elite in the North" for the astronomical sum of one hundred dollars (*Southern Eye* 4). Despite excellent reviews, sales were weak (as they also were for fellow Civil War photographers Brady and Alexander Gardiner) until a generation or two later, "when nostalgia began to dilute clear memory" and some demand for the pictures developed (*Southern Eye* 5).[7]

The publication of the ten-volume *Photographic History of the Civil War* by Francis T. Miller in 1911 was actually an effort toward national conciliation, as the editors scoured the South for "Southern Mathew Bradys" and eventually purchased the archive of Andrew D. Lytle, a Baton Rouge photographer and probable spy whose photographs of Federal occupying troops may have aided the Confederate Secret Service. Yet the memory of the Civil War photographs as humiliation remains in the regional consciousness, according to Madden, and it colors all responses to later photographic representations, whether taken by insiders or outsiders: "Those photographs started an attitude against Yankees coming South, especially with cameras in hand. Even good intentions violate the unwritten law, and ignorance of that law is no defense against outraged sensibilities" ("Cruel Radiance" 11). In a war of representations, then, photography may represent objectification and defeat. Madden extends this dynamic to what he sees as the other two touchstone periods in southern photographic history, the Depression and the civil rights era.

Beginning in 1935, the U.S. government began sending photographers to document "the Nation's number one economic problem": the South. Every major Farm Security Administration (FSA) photographer came from outside the South: Walker Evans from Connecticut, Russell Lee from Illinois, Dorothea Lange and Marion Post Wolcott from New Jersey, and Margaret Bourke-White from New York City. Feature writers from all major newspapers and new photo-magazines such as *Life* and *Look* were also touring the South, so much so that "the sharecropper" became a common, almost clichéd topic (Stott 218). A new genre of photo-text documentary books arose, often pairing southern authors with northern photographers, such as New Yorker Doris Ulmann's 1933 collaboration with North Carolinian Julia Mood Peterkin, *Roll, Jordan, Roll* (figure 4). Ulmann's picto-

rialist studies of "vanishing types" of African American and Appalachian south-
erners eventually gave way to the distinctly modernist formalism of Walker Evans
and the "straight" documentary photography of his FSA coworkers.[8] In this ob-
session with documentation, according to William Stott, the camera was "the
prime symbol of the thirties' mind . . . less because the mind was endlessly frag-
mented than because the mind aspired to the quality of authenticity, of direct
and immediate experience, that the camera captures in all it photographs" (77).
Southern reactions to these documentary photographs, however, suggest that in
the South, the thirties' mind was of a different set. According to Stott, southern-
ers reacted to the outside "fetish for 'documents'" (138) in varied ways: in one
humorous response, related by Erskine Caldwell about his time on the southern
"filling station circuit," a weary gas attendant handed Caldwell a card with his
life story preprinted on it (Stott 257). In a more extensive response to Caldwell
and Margaret Bourke-White's *You Have Seen Their Faces* (1937), a popular docu-
mentary photo-text in which Bourke-White rearranged settings and subjects to
convey the image desired by her audience (figure 5), southern historian H. C.
Nixon published *Forty Acres and Steel Mules* (1938) as an "Agrarian" counterstate-
ment. Clearly understanding the power of photographs in defining the south-
ern image, Nixon chose from the FSA files hundreds of what Edward Steichen
called "tweedle dum documents" of farms and southern environs to counteract
Caldwell and Bourke-White's exposé (Stott 223–24). This strategy, no doubt in
combination with Nixon's dry social scientist's prose, may have relegated *Forty
Acres and Steel Mules* to obscurity.[9]

By far the most famous photo-essay on the South from this period (and one of
the classic meditations on the relation of photography, literature, and questions
of representational exploitation and responsibility) is James Agee and Walker
Evans's *Let Us Now Praise Famous Men* (figure 6).[10] Madden derives his own essay's
title from Agee's passionate declaration of his project as an "effort to perceive
simply the cruel radiance of what is" (Agee and Evans 11). Although it was a
commercial disaster on its release in 1941, audiences of the 1960s and beyond
found in Agee's text an expression of a growing concern with representation
and power; critic Stuart Culver has marked *Let Us Now Praise Famous Men* as an
embodiment and an endpoint for a "naive" tradition in American photography
and documentary criticism, a time "before the camera's documentary authority
was compromised by a sense of visual imperialism" (195). However, reception
of the book by the people it represented, both at the time it was published and
as recently as 1980, confirms Madden's sense that for some southerners, "those
photographs only kick us after we'd been down sixty years" ("Cruel Radiance"
13).[11] One 1980 interview with descendants of the photographed families reveals

that these descendants' complaints vary, corresponding to the imagined audience of the images. For a family audience, the pictures do not match family image or memory ("Mother didn't look like that"); for a southern audience, there is sensitivity about being represented as "white trash" in a book that, in these tenants' understanding, "would never be seen in the South"; and for a national audience, there is a sense of assaulted regional pride ("I just don't like everybody in the country reading that book and saying 'Well, look what they are down South'" [Raines 40, 34, 46]). Clearly, the world Evans represented in his photographs is different from the one these descendants would have represented. Indeed, *Let Us Now Praise Famous Men* is as interesting to study for the photographs that were left out—such as the photograph, commissioned by its subjects, of the "Gudger" (Burroughs) family looking proud and in command of their lives (figure 7)—as for the photos that were selected for the published text.[12]

Looking at photographs from the civil rights era, such as those by Gordon Parks (of Kansas), Danny Lyon (of New York), and presumably even those by Charles Moore (a white native of Birmingham, Alabama) and Ernest Withers (a black photojournalist from Memphis), Madden hears the cry, "'Here they come again!' with their cameras" ("Cruel Radiance" 13). Civil rights organizations such as the Student Nonviolent Coordinating Committee (SNCC), the Southern Christian Leadership Conference (SCLC), and the Congress of Racial Equality (CORE) understood well the power of photographs, purposefully staging protests that were accessible to photojournalists and eventually establishing well-oiled communications offices of their own. SNCC had among the first and best coordinated of the photographic units, recruiting northern photographer Danny Lyon and training about a dozen photographers and establishing darkrooms in Atlanta and at Tougaloo College in Mississippi. Reflecting consciousness within the movement both of the power and politics of mass media, SNCC's Mary King asserted, "It is no accident that SNCC workers have learned that if our story is to be told, we will have to write it and photograph it and disseminate it ourselves" (quoted in Kasher 16). The mainstream media, according to John Lewis, was eager for sensational images of violence (Watters 70); movement photographers, such Herbert Randall, who documented the Mississippi Freedom Summer Project in Hattiesburg in 1964 (figure 8), sought to capture the daily, more mundane activities, as well as "the charged spirit of the movement" (Kasher 17).[13]

There is little question that photographs contributed toward material, political, and psychological change during the civil rights movement. The famous photographs (published in black periodicals such as *Jet* and the *Chicago Defender*) taken in 1955 of Emmett Till's deformed corpse (figure 9) and of his granduncle courageously identifying the murderers in court have been credited with provid-

ing a crucial impetus for subsequent civil rights activities.[14] Photographs were used to publicize movement activities, expose brutalities by civil rights opponents, raise funds from outside the South, and, in a real sense, to protect movement workers: SNCC's Mary King later commented, "With the exception of those involved at the time, no one knows how important the effective use of the news media was to our safety, and even our lives. . . . The presence of a reporter at a jail or a telephone inquiry from a newspaper was often the only step that let a local sheriff know he was being watched" (King 215). The increasingly powerful medium of television provided national exposure of some of the most dramatic moments of the conflicts.[15]

Internationally published photographs of the southern struggle embarrassed federal politicians in their diplomatic relations, especially with Africa, and resonated in the antifascist climate of the 1950s to mobilize white American sympathy for the movement. Images of southern police using water hoses and dogs against Birmingham demonstrators (figure 10) inspired a flood of volunteers to come South from all parts of the country and prompted more African American southerners to join the movement. So powerful was the role of photography understood to be that several northern camera store owners made their contribution to the movement by collecting and repairing donated cameras to send South (Kasher 144). Southern whites opposed to the movement also understood and attempted to deploy the power of photography. In a direct effort to thwart that power, white college students from the University of Mississippi attacked photographer Charles Moore in his hotel room, threatening, "You goddamn *Life* magazine bastards, we found out who you were. You nigger lovers had better go home" (Moore and Durham 16). Other photographic countermeasures included using movement photographs to identify and persecute movement workers; minimizing coverage in local white-owned newspapers; barring or arresting photographers; and publicizing counterimages of a "dirty" movement, including one bizarre series by the Alabama Department of Public Safety of trash left at the airport after the Selma to Montgomery March (Kasher 14–15, 27) (figure 11).

Clearly, in the South, with its violent legacy of enforcing social boundaries (called "place" in the South) and with its complex history of photographic representation and counterrepresentations, photographs matter. But in what ways do they matter? From his reflections on photographs from the Civil War, Depression, and civil rights periods, Madden concludes that "from the start, many southerners feel, photographs exposed the South, at its most vulnerable, to staring, sometimes gloating, northern eyes. Little wonder it is difficult for the southerner . . . to view a southern photograph without an awareness of its reception

in the next county, the rest of the nation, even the world, as part of one's private response. . . . The problem of the invasion of privacy intrinsically posed by all photographs is compounded in the southern sensibility" ("Cruel Radiance" 13). A certain self-consciousness about photographic representation may indeed be the hallmark of the southern relation to photographs, though for reasons more complex than those offered in "The Cruel Radiance of What Is." Madden has written extensively and insightfully about the range of southern culture in his novels and critical works, but when he explains what he sees as the southern hostility to photography in terms of a "subconsciously guilt-ridden, and thus self-conscious and suspicious" people (15), who "flinch from the documentary evidence" (13) of civil rights photographs, he reinstates an equation historically all too familiar in southern studies: "southerners," in the final analysis, are white. They are also, most likely, middle class, since Madden is in this essay concerned mostly with art or documentary photography that is usually viewed in galleries, books, and newspapers. How is the southerner's relation to photography modified when the definition of "southerner" is expanded to include African Americans and lower-class whites (to take the most obvious examples)? How might subregional variations, in Appalachia or the Gulf South, for instance, affect that relation? How might it change again when the definition of "photography" encompasses self-commissioned and family photographs as well? In these more quotidian types of photography, I believe, the key to more empowering, or at least more complex, conceptions of photography in the South can be found, along with a deeper understanding of the different levels of cultural consciousness that may complicate a southerner's viewing of "a picture."

PICTURING THE SOUTH

Perhaps the most astonishing thing about the early history of photography in the South is how immediately the new technology reached even territories that were largely frontier, such as Alabama. News of daguerreotypy's invention in France reached the United States in September 1839, and by that winter Frederick A. P. Barnard and William H. Harrington of the University of Alabama were conducting experiments with the new medium; by 1841, they had opened their own daguerreotype gallery (Robb, "'Engraved'" 240). The first years of southern photography focused almost exclusively on portraits of notable, or wealthy, white patrons. Photography at this time was above all a commercial enterprise, and photographers were a part of the greater social system in which they worked, the racist structures imposed by a slave state included. The exception that illustrates the rule is Jules Lion, a French-born free black man, who became the first

photographer in New Orleans (and possibly the entire South, first exhibiting his work on March 15, 1840). Lion's daguerreotypes were highly prized by the "gentle class" (especially the French) of racially and culturally diverse New Orleans, itself an anomaly in the South (Smith and Tucker 3, 17–20). Outside New Orleans, some rare portraits of African American southerners, such as the one of freed Alabama bridge-builder Horace King taken in 1850, do exist; of these, some are portraits of family slaves, most often female slaves holding white children (figure 12). Sober prototypes of the Mammy-Scarlett relation in *Gone with the Wind*, these images straddle the genres of "family" photography and inventory-type photos of slaves.[16] These last reflect an interest in photography as a record-keeping device and as a tool for scientific research that, while more prevalent in the industrialized North, in the South combined with the institution of slavery to produce some of the most revealing studies in domination—representational and otherwise—that exist today. In a rare but telling photographic intersection of northern and southern racism, the celebrated Harvard natural scientist Louis Agassiz hired southern daguerreotypist J. T. Zealy in March 1850 to make photographs of African-born slaves in his Columbia, South Carolina studio. The photographs of naked slaves facing the camera were intended to provide visual evidence for Agassiz's theory of a "separate creation" of the black and white races, a theory that had "thrilled" southern audiences earlier in the year (Trachtenberg, *Reading* 53). Black women and men alike are disrobed for the camera: the daguerreotype of "Drana, Country Born, Daughter of Jack, Guinea" (figure 13) presents "Drana" as paradoxically sexual and unsexed, and firmly outside the boundaries of white "southern ladyhood." Though the photographs were not circulated widely in the South or the North, they represent an early use of the camera in the service of race and gender ideology, a use that would be repeated on a mass scale in years to come. As objects, the photographs exemplify a pure form of representational power: the literal use of force to make certain that bodies are represented according to the desires of the "master."[17]

Most racism in early southern photography, however, is embodied more subtly, in terms of economic access. As noted, the vast majority of photographs taken in the South during this period were studio-type portraits of the white southerners who could afford them (and there were many who could not). The southern photographer's business was a fairly tenuous one; it depended directly and immediately on the fortunes of his (almost all photographers during this time were male) customers (Robb, " 'Engraved' " 247). For enslaved African Americans, photographic mementos were an extreme rarity, obtained only with the permission of slave owners; there is nevertheless some evidence of demand (Moutoussamy-Ashe 6).[18] An anecdote cited by photo-historian Frances Osborn

Robb from an 1859 Alabama newspaper reveals that at least some white south-erners understood photography as a form of racial privilege and power:

> Warning to Evil Doers—We learn from a friend that a Deguarrean [sic] Artist, Robbins by name, was found on Sunday last in his room in Warsaw, busily taking pictures for Negroes. He was waited on forthwith, summary punish-ment was dealt out to him with a rope's end, and he was then ordered to pack up his traps and leave instanter. Which request was readily complied with.[19]
> (Shot in Alabama)

"Robbins" was perhaps typical of itinerant photographers in the South, search-ing for customers wherever he could create them—a practice that would, eventu-ally, find a sizable market for photographs among African American southerners. Though it is impossible to determine whether the "Negroes" in this story were free blacks or slaves, it is nevertheless clear that both whites and blacks had an understanding of the cultural significance of photography—a significance the white southerners in this case were, perhaps, attempting to reinforce and fur-ther racialize by restricting photographic practice to whites only.

In the South as in the rest of the nation, photographs became in the space of a single generation the most significant and desired aid to memory and commemoration. Antebellum newspaper advertisements indicate how south-ern photographers encouraged a public hunger for images as objects of remem-brance:

> DAGUERREOTYPE PORTRAITS—Only one week longer!!—Now is your time. Call immediately if you want accurate and beautiful Miniatures of yourselves or friends—for soon the raging epidemic may hurry many into the grave! and then oh! how you will regret that you had not obtained a true copy of those loved features, when you find them fading from your memory. Delay not then or you may spend years in unavailing sorrow when it is too late to repair the loss! Finished in the most elegant style for only $6, at No. 55 Royal street, up-stairs. (Robb, "'Engraved'" 250)[20]

The vast numbers of Civil War photographs of soldiers, obtained despite the shortage of supplies, evince the success of this pitch to associate photos and honored memory.

Further affirming this significance in the Reconstruction period is the fact that even under postbellum financial hardship, southerners followed the na-tional trend of purchasing and distributing increasing numbers of photographs. Photographs taken during Reconstruction of government functionaries are rela-tively scarce,[21] but whites and freed African American slaves who accumulated

some wealth quickly acquired photographic representations. In the late 1880s the development of faster and cheaper technologies made photographic reproduction practical within newspapers and other mass contexts, and affordable to all but the poorest southerners; this enabled photography to proliferate in the South as in the rest of the country. This mass consumption of photographs coincided with the end of Reconstruction and the beginning of a successful white southern effort to reassert dominance in the South. It was a success achieved through multiple fronts, some more violent than others, and few as powerful as the realm of popular images.

To the long southern memory of photographs past, we must add the myriad racist images that helped advertise everything from pancake flour to sheet music (figure 14), as well as the more "serious" photographs "documenting" racist science and lynchings—these last were found in newspapers and even sold as postcards (figure 15). Speculating as to why the idea of the "New Negro" was conceived through the trope of the "reconstruction" of the image of African Americans, Henry Louis Gates Jr. notes the "remarkable" extent to which blacks were stereotyped and caricatured in the visual arts: "By 1900, . . . it would have been possible for a middle-class white American to see Sambo images from toaster and teapot covers on his breakfast table, to advertisements in magazines, to popular postcards in drug stores. Everywhere he or she saw a black image, that image would be negative" ("Trope" 150). Of course, middle-class black Americans would have been inundated with these images as well. Inexpensive and accessible to the masses, postcard collecting became an extremely popular hobby in early twentieth-century America. At the height of the fad, between 1905 and 1915, almost 1 billion postcards were purchased annually (Baldwin 15). Popular and profuse postcards depicting African Americans largely portrayed stereotypically southern scenes, such as watermelon eating and cotton picking, although, as historian Brooke Baldwin has demonstrated, the sale, distribution, and appreciation of these images were by no means confined to the South. While nude or pornographic images of black women were common in Europe, in America southern black women were more likely to be depicted at work as maids, servers, farm workers, or washerwomen. Especially after Reconstruction, American popular imagery traded in the stereotypes that supported the reemergence of white southern power.

In his controversial exhibit and book of lynching postcards and photographs, *Without Sanctuary* (2000), Atlanta collector James Allen focuses on the actual, unbearable violence that undergirds such symbolic violence.[22] Although the images and narratives in *Without Sanctuary* shocked twenty-first-century American audi-

ences, a contemporaneous account of the 1904 lynching of Will Cato and Paul Reed in Statesboro, Georgia, reveals an openly acknowledged, hideous complicity of popular photography in racial terror. As narrated by Ray Stannard Baker in his study *Following the Color Line* in 1908:

> Men were sent into town for kerosene oil and chains, and finally the Negroes were bound to an old stump, fagots were heaped around them, and each was drenched with oil. Then the crowd stood back accommodatingly, while a photographer, standing there in the bright sunshine, took pictures of the chained Negroes. Citizens crowded up behind the stump and got their faces into the photograph. When the fagots were lighted, the crowd yelled wildly. Cato, the less stolid of the two Negroes, partly of white blood, screamed with agony; but Reed, black and stolid, bore it like a block of wood. They threw knots and sticks at the writhing creatures, but always left room for the photographer to take more pictures. (186–87)

Several of the photographs in *Without Sanctuary* were printed on cheap postcard stock, and some have postmarks and messages written on them, including one postcard of seventeen-year-old Jesse Washington's charred, hanging corpse on the back of which someone has scrawled, "This is the barbecue we had last night" (Allen et al. plates 25 and 26). Others, like the set of five prints found in the attic of a prominent white Savannah, Georgia, family, are mass-produced lynching souvenirs that evince the direct links between racial and gender terror that Grace Elizabeth Hale has discussed in *Making Whiteness*: on the back of one print is written, "Warning, The answer of the Anglo-Saxon race to black brutes who would attack the womanhood of the South" (Allen et al. plates 59–61). Thumbtack holes in the top of some of the photographs indicate that they were displayed; others were incorporated into scrapbooks and family albums. Photographs of lynchings were sometimes published in the white press, though usually not the most graphic photographs. Fast and cheap photographic technologies made these images instantly available for use as souvenirs, but they could also serve as evidence for protest. In an interview, Allen recounted how one African American man used such a postcard to bring news to Tuskegee Institute of a lynching that had happened in Mississippi the day before. Lynching photographs were sometimes published in the black press, most often in the North, and particularly in the pages of activist news forums such as the National Association for the Advancement of Colored People's (NAACP) journal, the *Crisis*. A reproduction printed in the January 1912 issue is of a postcard sent to activist John Haynes Holmes in response to Holmes's antilynching speeches (figure 16).

It is postmarked Alabama and reads, "This is the way we do them down here. The last lynching has not been put on card yet. Will put you on our regular mailing list. Expect one a month on the average" ("Holmes" 110).

That these varied types of racist photographs were so freely disseminated in mass culture is an indication of the widespread practice of (and resistance to) racism in both North and South. Racist views were further supported by the anthropological and eugenic science of the day, which in turn looked to photographs for supporting evidence.[23] Following Louis Agassiz's example in commissioning the Zealy slave portraits, anthropologists used photographs to measure and classify blacks and to compare them with apes (figure 17). Scientists eager to provide evidence supporting the "color line" of Jim Crow segregation published elaborate photographic studies of hair types, categorized by the fractions of "White," "Negro" and "Indian" blood (figure 18). Nor were such studies limited to African American southerners. In northern and southern Appalachia eugenicists in the late nineteenth and early twentieth centuries similarly cataloged visible "scientific" evidence of the different physiology of "cacogenic" (bad-gened) white degenerates, trying to render their findings visible through the medium of photography. Occasionally, when photographs did not adequately depict eugenicist "truth," they were doctored "by inserting heavy dark lines to give eyes and mouths their diabolical appearance" (Gould, Mismeasure 171). Perhaps because family portraits were insufficiently damning, eugenicist Arthur Estabrook's 1926 treatise, Mongrel Virginians, substituted photographs of dilapidated houses to illustrate the deteriorated genetic stock of their owners, the "triple mixtures" (white, black, and Native American) whom Estabrook chronicled in Virginia and North Carolina Appalachia. Virginia's campaign for the enforced sterilization of the "unfit," led by Estabrook and Walter Plecker, targeted mixed-race and mentally handicapped women from 1924 to 1972. In a test case for Virginia's law, seventeen-year-old Carrie Buck, raped by the nephew of her foster parents, was committed to the Virginia Colony for the Epileptic and Feebleminded in Lynchburg (where her mother was already incarcerated as a "defective person") and was ordered sterilized after giving birth to her daughter, Vivian, in 1924. To corroborate testimony that would be presented at the Supreme Court (Buck v. Bell) in 1927, that there was "a look about" Vivian Buck that was "not quite normal," Estabrook made a photograph of the six-month-old child allegedly showing that she could not follow a shiny coin with her eyes (figure 19). This testimony and photograph were enough evidence of inherited mental deficiency for Chief Justice Oliver Wendell Holmes to declare, "Three generations of imbeciles is enough," and uphold Carrie Buck's involuntary ster-

ilization. More than four thousand sterilizations were performed under the law in Virginia, the last in 1972, before it was overturned in 1974.[24]

The "verifying" role of photography in anthropology, the role of anthropology in legitimizing visual categories of race and "unfitness," and the violence with which racism has played out in the South would be enough to cause apprehension about photographers and photographs, especially among African American southerners. Resentment against "outsiders" who were photographing Appalachian poverty became fatal when Kentuckian Hobart Ison shot and killed Canadian filmmaker Hugh O'Connor in 1967, and it still roils in the controversy over Shelby Lee Adams's Kentucky photographs.[25] Yet southern self-consciousness about photography, for black southerners and for their white neighbors, involves a double understanding of photography's power. On the other side of any resistance to photography, the South joined the rest of the nation in its early embrace of photographic portraiture and in a post-Depression proliferation of personal cameras and family photography. For every lynching postcard there are literally thousands of self-commissioned portrait postcards, sent between friends and relatives within and outside the South. The act of seeing and representing the self can signify power, and for white and black southerners struggling to obtain political, economic, and social respect (facing some of the same obstacles, as well as many specific to their races), photographic self-representation was a way of claiming communal and self-identity. Against a backdrop of stereotyping postcard scenes of "darkies," "pickaninnies," "rubes," and "white trash," the contrast of these self-representations is striking. The formal studio portraits that represent the vast majority of photographs taken in the South between 1880 and 1930 are, for the most part, indistinct from those made in other regions; they may represent in their very sameness an effort to communicate self-sufficiency and self-possession in the national context. Searching for what is regional in photographs of this period, F. Jack Hurley points to the overarching concern of black photographers and their sitters to portray dignity and pride, even in informal portraits (*Southern Eye* 10). For black southerners, it must be remembered, the Civil War was not a defeat—even the bitter disappointment of the failed federal Reconstruction did not represent a return to the oppression of slavery. Indeed, black photography studios (several of which were operated or co-operated by women) were more successful in the South than elsewhere because segregation laws helped guarantee a steady clientele (Moutoussamy-Ashe 31).

The careers of Henry Clay Anderson of Greenville, Mississippi, and Louise Martin of Houston, Texas, are examples of segregation's multiple effects. Anderson studied at one of the few photography programs open to African Americans

in the South in 1945, at Southern University in Baton Rouge, Louisiana (figure 20). The segregated world of Greenville provided an entrepreneurial opening for Anderson, and, assisted by his wife and daughter, he became "black Greenville's 'official' photographer-in-residence" (H. Anderson 19–25, 30). Anderson's photographs portray a vibrant African American middle class, proud and flourishing despite the strictures of Jim Crow law. In the 1930s, Louise Martin left Texas to study photography at the Art Institute of Chicago and as the only black woman enrolled in Denver University's School of Photographic Arts and Sciences. Returning to Houston, she began a profitable business photographing World War II soldiers, and after ending a brief marriage to a man who opposed her career, she opened the Louise Martin Art Studio in 1946 to serve the schools, churches, and social organizations of Houston's black community (Moutoussamy-Ashe 122–26). Consequently, both Anderson and Martin were well positioned to cover the struggle for integration in their respective states. Anderson spent "one of the most fearsome nights in my life" photographing the aftermath of the 1955 murder of civil rights advocate Reverend George Lee in nearby Belzoni, Mississippi, and after these photographs were published by *Time*, *Life*, and *Ebony* magazines, Anderson was hired by the NAACP (H. Anderson 132–34). Martin's photographs of Martin Luther King's sermons and later funeral in Atlanta were also published in the national press (figure 21). But underlying both photographers' efforts was the core desire to make their sitters—especially the women, according to Martin—"look good" (Moutoussamy-Ashe 126). Like the work of Robert Hooks of Memphis, Wilhemina and Richard Samuel Roberts of Columbia, South Carolina, and Prentice Polk of Tuskegee, Alabama (figure 22), the photography of Anderson and Martin reflects the ways black southerners, many of whom were experiencing personal and familial self-determination for the first time, "wanted and *needed* to remember themselves" (*Southern Eye* 10).

White southerners, too, arranged themselves as they desired to be remembered. A sampling of studio and private photo collections of white southerners reveals that, like their black counterparts, these southerners were concerned with documenting personal and communal existence. In one of the most self-conscious personal efforts, Ella Costello Bennett of Memphis (born in 1859) created a scrapbook of family and regional photographs and artifacts, designed to perpetuate the region's history and identity in the memories of her descendants. Family portraits and autobiographical notes construct Bennett's personal memory for posterity; photographs of slaves, a Confederate five-dollar bill, and a portrait of Frederick Douglass construct a vision of her remembered "Old South" with a dual spirit of nostalgia and journalism (*Southern Eye* 18–19). The century-long photographic archive of father and son photographers George and Huestis

Cook, who ran prosperous studios in Charleston, South Carolina, and Richmond, Virginia, illustrates the typical oeuvre of the southern white community photographer: it consists of an overwhelming majority of studio personal and group portraits—including many of African Americans—with a photographic complement of public and domestic happenings, eminent buildings and persons, and character or "type" photos, occasionally intended to be comic. Like Louise Martin and Henry Clay Anderson, George Cook's chief aim was to find the *"beauty in every face"* to serve the representational needs and desires of his customers (Kocher and Dearstyne 14). However, when in the early 1950s part of this collection was arranged into a book (called *Shadows in Silver*) and traveling exhibition entitled "Southern Exposures," the Cooks' photographs were set explicitly to work as a "portrait of the Old Dominion" (Kocher and Dearstyne xxiii) and were accompanied by apologist, paternalistically racist text (figure 23).[26]

Photographs of plantation "pilgrimages," beauty pageants, or snapshots in front of Confederate monuments illustrate an analogous use of revered southern white female bodies to construct a visible self-consciously southern identity—the flip side, as it were, of the lynching postcards (figure 24). Extraordinarily popular films like *The Birth of a Nation* (1915) and *Gone with the Wind* (1939) provided indelible images of noble, pure ladies and tough, saucy belles. Such images might be read as evidence of a need to shore up southern white ideology (in the face of desegregation movements, for instance) or as a sign of confidence in its stability. One of J. Mack Moore's photographs from Vicksburg, Mississippi (figure 25), illustrates how in the post-Reconstruction period, especially in photographs of upper-middle-class white males, there was a renewed sense of southern white male security: jokes, such as dressing up as a female or a black minstrel, show that the photographs' subjects understood that "the subordinate status of the other two groups was nearly universally accepted" (*Southern Eye* 11).[27] Well into the twentieth century, portrait studios and photographers remained the primary source for family and community images. With the advent of cheap personal cameras (the one-dollar Kodak Brownie camera was introduced in 1900), increasing numbers of southerners began personal photography archives of one form or another. Black and white southerners took advantage of their (often separate) access to photography to construct a vision of the self and the South they wished to be.[28]

Whether professional or amateur, community photographers in the South play a significant role in the shaping of individual, communal, and regional identity. Of the many southern photographers who chronicle community celebrations, reflecting and reinforcing the pride, tradition, and the sense of place behind parades, graduations, reunions, and funerals, William Ferris asserts, "The

photographer and the world they photograph are inseparable. Each is a celebration of the other" (*Southern Eye* 26–27). This "insider" view may be the key difference between the Farm Security Administration documentary photographs and those made at roughly the same time by southerners such as Eudora Welty in Mississippi or "Deaf Maggie Lee Sayre" in Kentucky. As folklorist and photographer Tom Rankin recounts, Sayre, who was born deaf, used her photography as a type of language, to communicate her family's life on the Tennessee River to fellow students at the inland Kentucky School for the Deaf (thus representing and defining her world and her place in it) and to enter into dialogue with her family and neighbors on the river who did not know sign language (figure 26) (Sayre 7, 19, 22). Further, Sayre arranged her photographs, adding text and dates, in carefully constructed albums to form what Rankin calls "a pictorial narrative analogous to an oral autobiography" (Sayre 22). Welty's stunningly intimate and open photographs were taken as a personal project while she was employed as a writer for the Works Progress Administration in Mississippi in the 1930s (figure 27). Although she was unpaid for her image-making, Welty understood her photography in professional terms, and she knew very well the ocean of representational politics into which she waded when she aimed her camera at her southern subjects.

In particular, Welty had seen and disliked Doris Ulmann's sentimental photographs of African Americans in *Roll, Jordan, Roll* (Peterkin and Ulmann). By 1934, Welty had readied a book of her own photographs in response. Accurately reading the trend of times, Welty wrote a friend that she was "afraid somebody else will get out something like it or the publishers or the public will become saturated with photography books" (Marrs 13). Though she was unsuccessful in publishing either this or a later combination book of stories and photographs called *Black Sunday*, Welty did have two photographic exhibitions in New York City in 1936 and 1937: the first focusing primarily on black Mississippians and the second responding to a request from the gallery for "poor white" images of southerners (but not, apparently, of the Depression-struck New Yorkers whom Welty had also photographed) (Marrs 13–16). Welty actively pursued a career in photography, writing to Berenice Abbott about further study at the New School for Social Research in Manhattan and eventually publishing seven photographs in *Life*. Her stronger success in fiction-writing was paradoxically both the death and rebirth of her photographic career: Welty gave up on photography, eventually losing her camera, only to have interest in her photographs rise with her literary fortunes. Between 1971 and 2004, four books of Welty's photographs were published.[29]

In a 1989 interview Welty is careful to distinguish her own photographs from Walker Evans's, implying (tactfully) that Evans's are too overtly editorial and even exploitative of their subjects. Of her own work, Welty explains, "I think my

particular time and place contributed to the frankness, openness of the way the pictures came about. . . . There was no sense of violation of anything on either side. I don't think it existed; I know it didn't in my attitude, or in theirs. All of that unself-consciousness is gone now. There is no such relationship between a photographer and a subject possible any longer. . . . Everybody is just so media-conscious. Maybe it's television. Everybody thinks of pictures as publicity or— I don't know" (Welty, *Photographs* xiv–xv). Welty's photographs do stand in dramatic contrast to the majority of FSA works: her camera depicts stark poverty, yet it projects as well the self-possession and courage of a people who are aware of their situation but who nevertheless live and even hope. Enmeshed in a system of gross economic, racial, and gender exploitation, Welty's subjects refuse any easy or final designation as victims. They, rather, seem to collaborate with Welty in a forthright and sympathetic presentation of their human condition and dignity.

Yet from a broader perspective, Welty does appear to protest too much: her comments, though they may be perfectly true to her experience with her sitters, nevertheless reflect her specific status as a middle-class white woman in the South. This status gave someone like Welty a certain level of access, especially to poor southerners, whose poverty rendered their lives visually accessible to all sorts of outsiders. Of course, perhaps because of her "insider" point of view, Welty seems uninterested in depicting southerners, white or black, simply as "types" or "social problems." How much her photographs are the result of an intuitive or collaborative understanding of Welty's project, or how much they are the result of a racially prescribed inability to deny her gaze, is finally unknowable. Regardless, the issue of access is a crucial one in the context of southern representational politics. We do not find similar accounts of southern blacks who felt free and comfortable entering white neighborhoods to make photographs. If the selection of photographs published in her four volumes are an indication, Welty herself felt considerably less comfortable, or perhaps less interested in, accessing poor white southerners' lives on film.

The proliferation of mass media may have in fact engendered an increased awareness of photography's uses, but African American southerners—like their white counterparts in the context of northern representations of the South— have always been to some extent "media-conscious." The increasing awareness of media that accompanied the rising civil rights movement had less to do with consciousness-raising than with political organization and the increased empowerment to use the media that such organization enabled. For black southerners during the height of the civil rights struggle, photography played a crucial role in asserting identity and cause—for making visible what white southerners had carefully, violently, rendered invisible. What bell hooks writes about the

walls of photographs often found in blacks' homes in the South suggests that the public civil rights photographs merely extended private practice: "For black folks constructing our identities within the culture of apartheid, these walls were essential to the process of decolonization. Contrary to colonizing socialization, internalized racism, they announced our visual complexity. . . . Reflecting the way black folks looked at themselves in those private spaces, where those ways of looking were not being overseen by a white colonizing eye, a white supremacist gaze, these images created ruptures in our experience of the visual" (Willis, Picturing Us 50). Thus, far from flinching from the oppression and violence in civil rights photographs Myrlie Evers-Williams speaks of flinching, in the same way that a grandson of the Confederacy might, with a combination of horror and pride: "I must look. I must remember, as you must. For this was history in the making. Like it or not, you cannot hide from the camera's eye" (Kasher 7).

Evers-Williams and hooks reflect a modern understanding, where photography walks a double line. On the one hand, photographs retain their ancient referential force—they serve as evidence of the "that has been" of time and the visible world (Barthes, Camera Lucida 115). On the other, photography has lost any "innocence" it may have been thought to have had; photography is no longer a transparent technology, and photographs "are never 'evidence' of history; they are themselves the historical" (Tagg 65). Contemporary art photography in the South evinces this understanding in its reflections on and contributions to the South's visual legacy. Unlike in the fields of literature and politics, there was little self-conscious southern self-fashioning in the indigenous art photography in the South before 1950. Indeed, there were few "art photographers" who would have identified themselves as such. One exception might have been white Selma, Alabama, native Mary Morgan Keipp, whose impressionistic photographs of African American southerners were exhibited alongside those of other key members of Alfred Stieglitz's Photo-Secession movement in London and New York from 1899 until her permanent return to Alabama in 1904 (Robb, "Keipp"). Her contemporary, E. J. Bellocq, was known as a professional photographer in his hometown of New Orleans, though his now-famous photographs of mulatto prostitutes in the Storyville district were apparently taken only for his own pleasure and artistic aims. In addition to a disarmingly candid approach, Bellocq's Storyville portraits reflect a long tradition of sexual exploitation of light-skinned "black" women in the South that in New Orleans became a cultural institution (figure 28). By contrast, Keipp's photographs depict a romantic, if segregated, world of the plantation South, employing the pictorialist technique that Doris Ulmann would revive years later (figure 29). While Keipp's work was exhibited in New York and Lon-

don, neither Bellocq's nor Keipp's amateur art photography was known in the South outside their immediate circles. Not until American art photography came into its own with museum and market acceptance in the 1970s did the balance of southern artistic photography have southern rather than northern makers.

Like the documentarians, art photographers from the North and around the world were attracted by the visuality of the southern landscape and social traditions, and by the written words southern authors used to depict them. At the same time that Charles Moore and Ernest Withers were chronicling the civil rights movement, photographers such as Martin J. Dain (of Massachusetts) and Alain Desvergnes (of France) were looking to photograph Faulkner's fictional Yoknapatawpha County, to provide visual evidence of its continued existence (figure 30). More recent photography by southerners Clarence John Laughlin (Louisiana), William Christenberry (Alabama), Eugene Meatyard (Kentucky), and Sally Mann (Virginia), to name only the most famous artistic examples, either makes the continuing/disappearing South an explicit theme, or it is critiqued in those terms. Whether working in modernist "straight photography" (like Mann and Christenberry) or surrealist (like Laughlin and Meatyard) modes, these artists are self-conscious about the facades—of the family, the physical landscape, the social architecture—that make up the South. Christenberry's book *Southern Photographs* causes a shock of recognition: in it the black-and-white Alabama landscapes and buildings featured in *Let Us Now Praise Famous Men* are represented in full and lush color, losing none of Evans's formalism. Like Sally Mann's recent work on decomposing bodies and Civil War battle sites, Christenberry's yearly re-photographing of the same buildings and signs is a study on the decay of southern spaces, and perhaps memory. Mann's earlier, controversial work featuring her children joins Eugene Meatyard's as a rumination on the mythic structures and sexual dynamics of southern family and childhood (figure 31). Like Meatyard, Clarence John Laughlin fused realist and surrealist elements in his photographs of southern spaces and their haunts, shrouded and mysterious women. Drawing on the iconography and myth of (white) southern womanhood and the grotesque, Laughlin created elaborate scenes and collages of southern constructedness and decay.

Indeed, the visual legacy of the South, and especially southern women, haunts contemporary photography by southerners and nonsoutherners alike. Writing about postmodern photography in America, Miles Orvell identifies "two contrary impulses in the contemporary moment" embodied in (1) photographs that deconstruct their own status as photographs, photo-reflexively, and (2) photographs made up of the self-reflexive appropriation and reuse of found images

(192). Contemporary photography in and of the South shows both of these impulses, along with a third: regional reappropriation. Tseng Kwong Chi's 1979 self-portrait in a Mao suit in front of Graceland's gate (complete with visible shutter release cord) is a study of image-making, pointedly referring to visual legacies of the South—in its insertion of a racial Other outside the black/white southern dyad and in its evocation of Elvis's glitzy facade—of China's Cultural Revolution, and of Chinese immigration to America (and to the South, in particular, a largely invisible legacy) (figure 32). Wendy Ewald's work in Appalachia has centered on giving cameras to Appalachian schoolchildren and encouraging them to represent themselves and their environment. The resulting images, which are sometimes scratched or drawn on, are a postmodern reflection on self and, by extension, regional image construction (*Portraits and Dreams*).[30] By contrast, at first glance there seems not much postmodern about Maude Schuyler Clay's "To the Memory of Emmett Till, Cassidy Bayou, Sumner, Tallahatchie County, Mississippi, 1998" (figure 33) or David Najjab's "Hanaan and Nora, Lexington, Kentucky" (figure 34). Here it is the interplay of image and caption that evokes visual and historical legacies, in both cases (though in different ways) to assert the rightful and integral place of excluded Others in the southern landscape, to visually rewrite the story of southern culture. The extra-photographic knowledge that Clay is herself a white woman from Mississippi, born shortly before Till's murder in a town nearby, makes the act of regional re-visioning—the disruption of southern "master narratives"—even more clear.

Unlike Najjab's photograph, Jane Rule Burdine's photo of a southern woman, "Elizabeth Says Goodbye, Greenville, Mississippi" (1993) (figure 35), projects a familiar image of southern womanhood: a white, proud, older woman with a "genteel profile" that, "like the raised portraits on Roman coins . . . leaves an impression of strength, courage, and endurance," according to one exhibition catalog (McDaris 24). But knowing from the caption that Elizabeth hails from Greenville—the same source-town of Henry Clay Anderson's photographs of segregated African American culture—and that she is visibly old enough to have experienced that time, gives her tranquil gaze new layers of signification. Southern photographers Fay Fairbrother (Oklahoma), Lynn Marshall-Linnemeier (North Carolina), and Clarissa Sligh (Virginia) approach the visual legacies of race and gender in the South more directly. After discovering that lynched black men were often wrapped in family quilts for burying, Fairbrother created the *Quilt Shroud Series* (1991–92), incorporating "found" white and black family photographs alongside lynching and Klan images printed onto quilted panels (Neumaier 90–91). Using a traditionally feminine art form learned from her southern

white female ancestors, Fairbrother graphically illustrates the connectedness of white and black, particularly of white women and black men, both in domesticity and violence. The painted photographs in Marshall-Linnemeier's series *Sanctuary* and *The Annotated Topsy Series* re-employ the photographic iconography of black slaves holding white children, of World's Fair anthropological studies, and of Sojourner Truth and other black ancestors to visually rewrite the narratives that have contained them, such as Harriet Beecher Stowe's *Uncle Tom's Cabin* (figure 36). Caretaker of the family photo album as a child, Clarissa Sligh integrates family snapshots, found objects, and text to conduct a "visual investigation" of patriarchal family and societal dynamics (Marks). Sligh's "Waiting for Daddy" (1987) depicts the moment of being photographed: mother and daughter are sandwiched between two brothers "waiting for daddy to take our picture," but though the woman and girl seem hemmed in by text and perhaps by the photographic act itself, the text reveals what is not shown in the photo, a well of cool water enclosed by the porch, and the fact that "in this house, Grandma is in charge." Partly in response to her own photographic misrepresentation as a plaintiff in a school desegregation suit and partly in response to the effect of male domination in her early life, Sligh uses images to counteract "the distortion of our identity and the exclusion of our reality" (quoted in Willis, *Reflections* 181).

With their various approaches, all of these photographs represent purposeful interventions into southern and, by extension, American representational politics.[31] Photo-historians Deborah Willis and Carla Williams have asserted that "Photography is the perfect medium for revisiting and reinterrogating the black female body, for tracing a history coded in images bound by fear and desire, the contradictory emotions that Frantz Fanon argues 'lie at the heart of the psychic reality of racism' "(x).[32] One could argue further that the visual tradition of the South—especially as it is embodied in photographs—is the great source of these "contradictory emotions" in American culture, both for the black female body and the white. In few places is America's doubled vision—its dialectic between fear and desire, tradition and change—more evident than in the complex and contradictory role of photography in both constructing and deconstructing raced and classed ideologies of southern womanhood. This role reflects a dual understanding of photography's power: photos can serve as tangible evidence of personal, family, and regional history and at the same time must always be scrutinized for their ability to bear false witness, to disguise their own historicity. It is an understanding born of cultures like the South's, an arena of tangible, even violent, representational politics. Where a visible characteristic (be it skin color, body type, or the condition of one's clothing) is the central marker

FIGURE I. "Street Panorama in Wilmington, N.C.—The Natives Yielding to the Attractions of Yankee Enterprise." From Frank Leslie's Illustrated Newspaper, April 1, 1865, 25. (Courtesy of North Carolina Collection, University of North Carolina Library at Chapel Hill)

FIGURE 2. Anonymous, portrait of Private William S. Askew, Company A (Newman Guards), 1st Georgia Infantry, CSA, ca. 1861–65. (Courtesy of Prints and Photographs Division, Library of Congress, Washington, D.C., LC-B8184-10604)

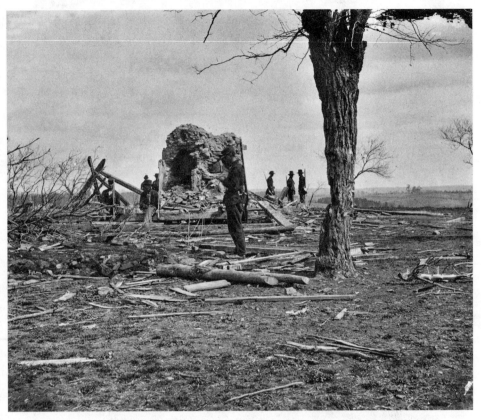

FIGURE 3. George Barnard, "Bull Run, Va. Ruins of Mrs. Judith Henry's House," March 1862. (Courtesy of Prints and Photographs Division, Library of Congress, Washington, D.C., LC-B811-320)

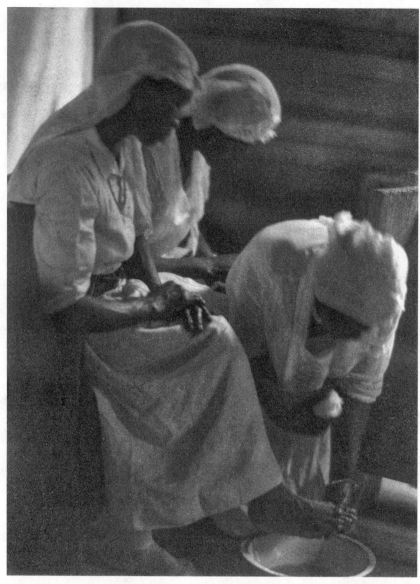

FIGURE 4. Doris Ulmann, "Footwashing, South Carolina," ca. 1929–31. (Courtesy of the Collections of the South Carolina Historical Society, Charleston, no. 33-21-5)

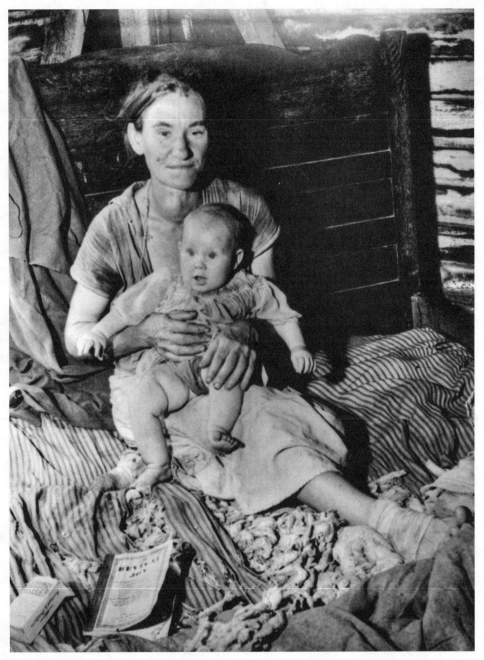

FIGURE 5. Margaret Bourke-White, "Happy Hollow, Georgia," ca. 1936. (Courtesy of Bourke-White Collection, Special Collections Research Center, Syracuse University Library, and Jonathan Toby White)

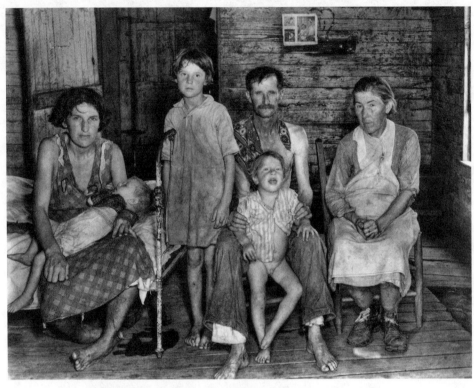

FIGURE 6. Walker Evans, "Bud Fields and His Family at Home," ca. 1935–36.
(Courtesy of FSA/OWI Collection, Prints and Photographs Division,
Library of Congress, Washington, D.C., LC USF342-008147-A)

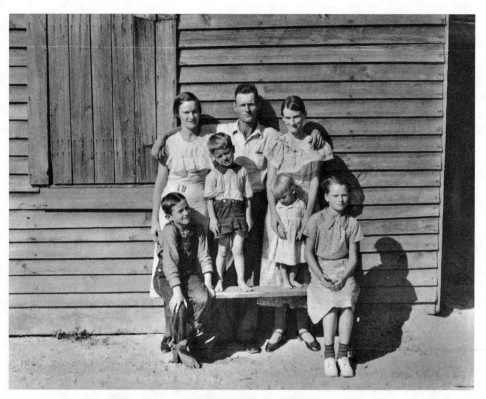

FIGURE 7. Walker Evans, "Burroughs Family, Hale County, Alabama," 1936.
(Courtesy of George Eastman House, Rochester, N.Y.)

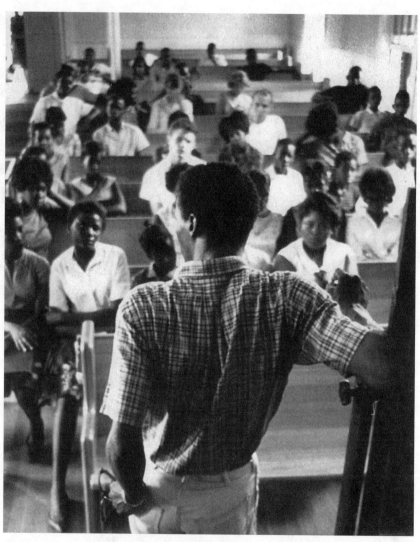

FIGURE 8. Herbert Randall, "Sandy Leigh's MFDP Lecture (2)," 1964. (Courtesy of McCain Library and Archives, University of Southern Mississippi, Hattiesburg; courtesy of artist)

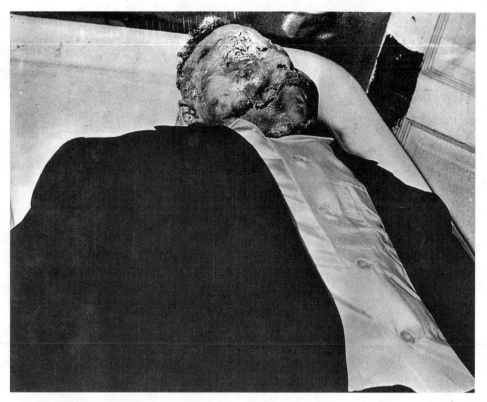

FIGURE 9. "Emmett Till in His Casket, Rayner's Funeral Parlor, Chicago, September 1955." (Courtesy of Chicago Defender)

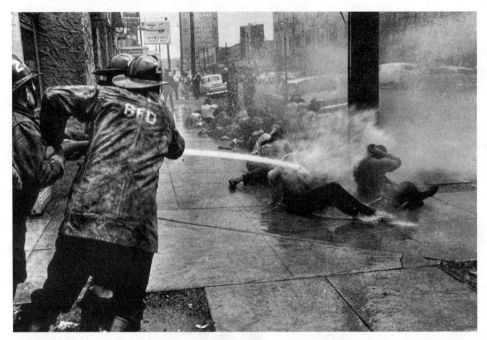

FIGURE 10. Charles Moore, "Birmingham Alabama 1963." (Courtesy of Charles Moore/Black Star)

FIGURE 11. "Refuse at the Montgomery Airport after the Selma to Montgomery March, March 25, 1965, Alabama Department of Public Safety." (Courtesy of Alabama Department of Archives and History, Montgomery)

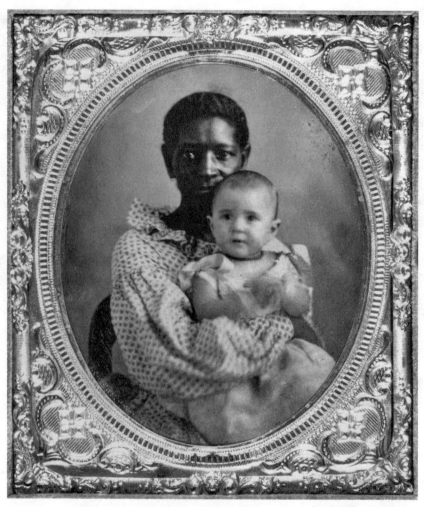

FIGURE 12. *Tintype of slave Catherine Hunt holding her master's child, Julia Tate Hunt, ca. 1852.* (*Courtesy of Tennessee State Museum Collection, Nashville*)

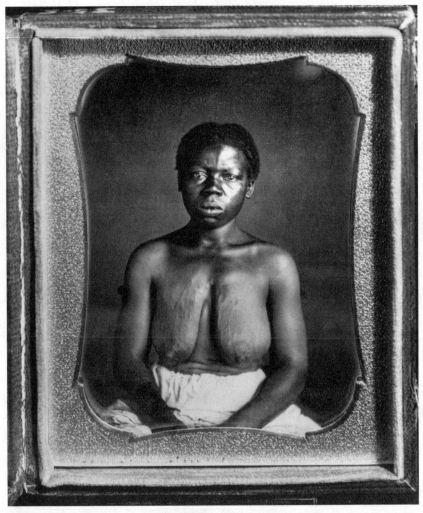

FIGURE 13. J. T. Zealy, "Drana, Country Born, Daughter of Jack, Guinea, Plantation of
B. F. Taylor," 1850. Daguerreotype, Columbia, South Carolina. (Courtesy of Peabody Museum,
Harvard University, Cambridge, Mass., photo 35-5-10/53041 N34310)

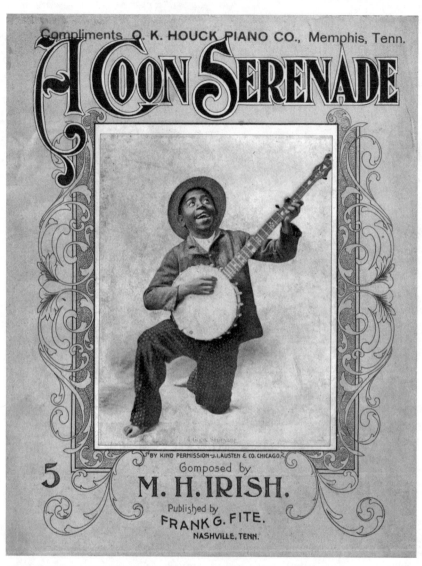

FIGURE 14. *"Coon Serenade" sheet music, ca. 1913. (Courtesy of Department of Archives and Special Collections, University of Mississippi, Oxford)*

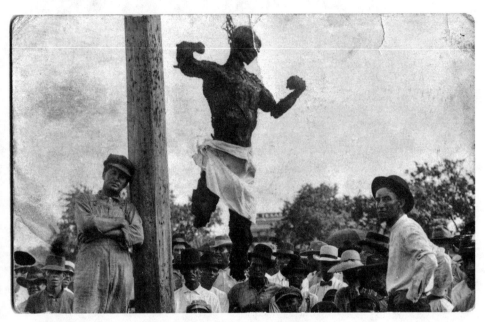

FIGURE 15. *Lynching of Jesse Washington, Waco, Texas, May 16?, 1916.*
(Courtesy of the Allen-Littlefield Collection)

POST CARD

This Space For Writing Messages

Printed in Germany.

This is the way we do them down here. The last lynching has not been put on card yet. Will put you on our regular mailing list. Expect one a month on the average.

A.15716

Rev. John H. Holmes,
Pastor Unitarian Church
New York City.

18 Gardew Place
Bklyn N.Y.

This side for the Address only.

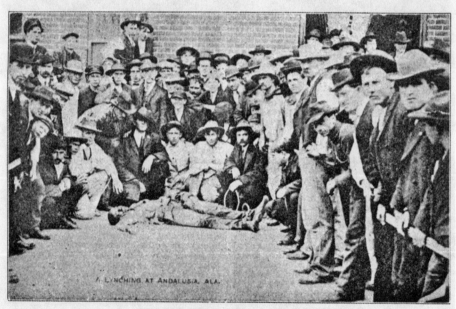

A LYNCHING AT ANDALUSIA, ALA.

A REPLY TO MR. HOLMES FROM ALABAMA

FIGURE 16. *"A Reply to Mr. Holmes from Alabama," postcard. From* The Crisis, *January 1912.*

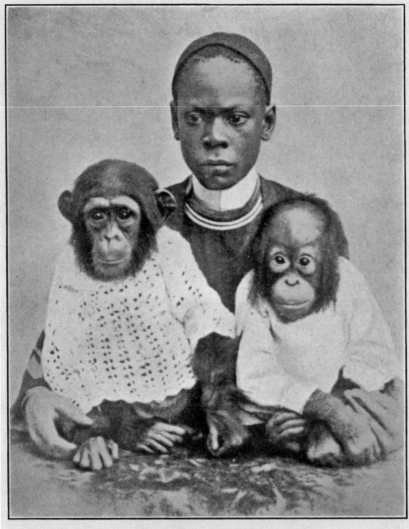

FIG. 4.—NEGRO BOY AND APES.

On the left side of the figure there is a young Chimpanzee, and on the right a young Orang-utan. This is a wonderfully interesting comparison.

FIGURE 17. *"Negro Boy and Apes." From Robert W. Shufeldt,*
America's Greatest Problem, The Negro (1915).

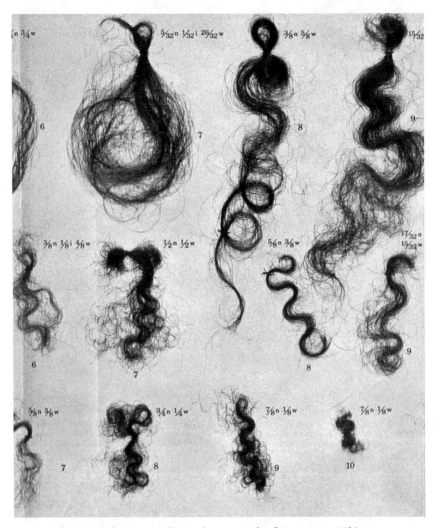

FIGURE 18. *Hair samples.* From Caroline Bond Day, A Study of Some Negro-White Families in the United States, *Harvard African Studies, vol. 10, Varia Africana V (1932).* *(Copyright President and Fellows of Harvard College)*

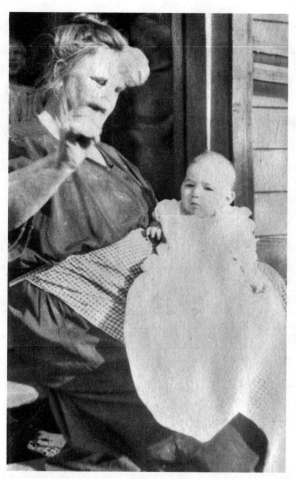

FIGURE 19. "Carrie's baby, Charlottesville, with Mrs. John Dobbs, 1924."
(Courtesy of Arthur Estabrook Papers, M. E. Granander Department of
Special Collections and Archives, University of Albany)

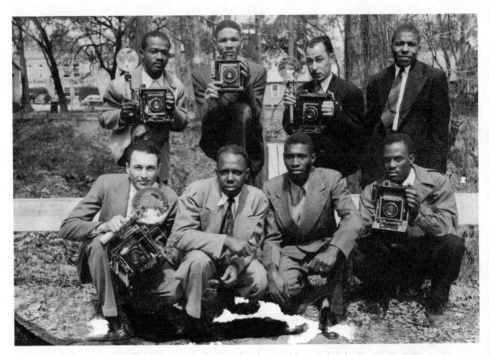

FIGURE 20. "H. C. Anderson and His Photography Class, Southern University," ca. 1945–47. (Courtesy of Anderson LLC)

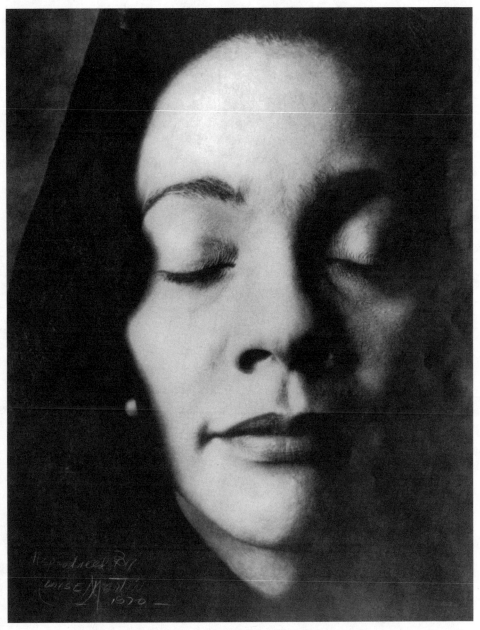

FIGURE 21. Louise Martin, portrait of Coretta Scott King in mourning, ca. 1968.
(Courtesy of Texas African American Photography Archive, Documentary Arts, Inc., Dallas)

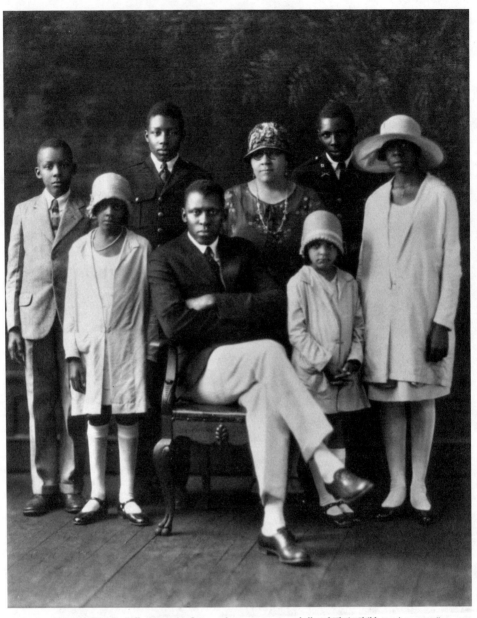

FIGURE 22. Prentice Polk, "Portrait of Mr. and Mrs. T. M. Campbell and Their Children, circa 1932." (Courtesy of University Museums, University of Delaware, and Donald L. Polk)

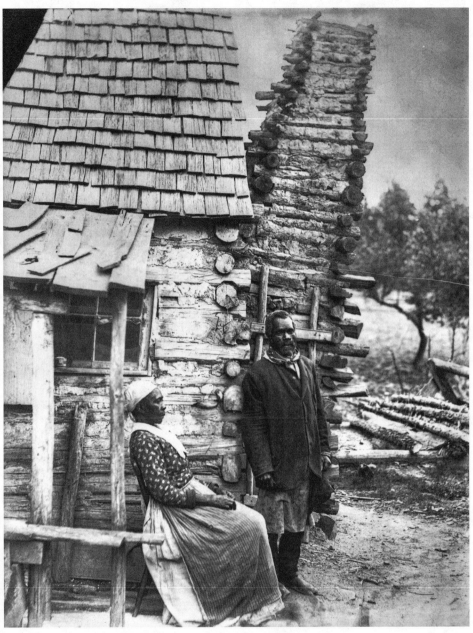

FIGURE 23. George Cook, "Taken in Bon Air, Va. in the 1880s—Probably Ex-Slaves."
(Courtesy of Cook Collection, Valentine Richmond History Center)

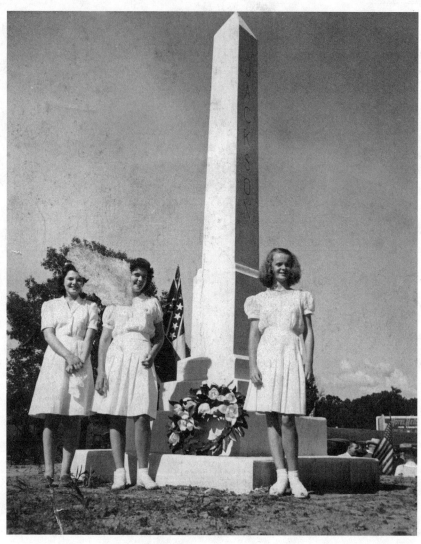

FIGURE 24. "Girls at Monument Marked 'Jackson,'" ca. 1950–60. (Courtesy of Eron Rowland Collection, Department of Archives and Special Collections, University of Mississippi, Oxford, 76-8)

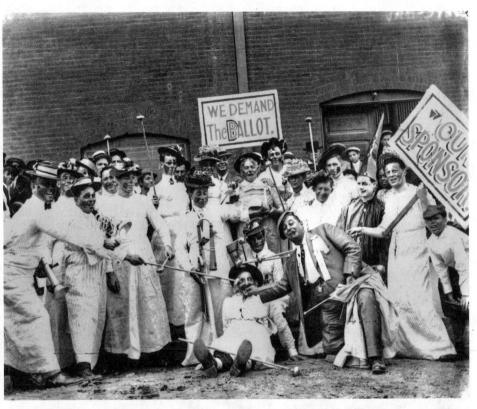

FIGURE 25. J. Mack Moore, "Anti-Suffrage Demonstration, 1915."
(Courtesy of Collection of the Old Court House Museum, Vicksburg, Miss., JMM-398)

FIGURE 26. Maggie Lee Sayre, "Pearl Dotson, Visiting," ca. 1940–50. From Maggie Lee Sayre, "Deaf Maggie Lee Sayre": Photographs of a River Life, edited by Tom Rankin (1995). (Copyright Maggie Lee Sayre; courtesy of Tom Rankin)

FIGURE 27. Eudora Welty, "Saturday Off/Jackson/1930s."
(Copyright Eudora Welty, LLC; courtesy of Eudora Welty Collection,
Mississippi Department of Archives and History, Jackson)

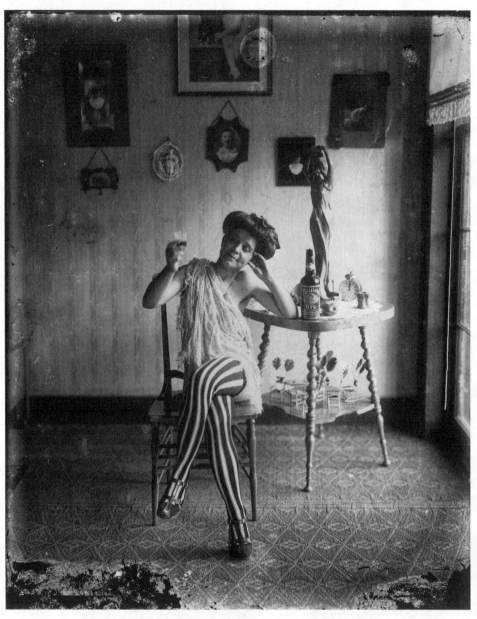

FIGURE 28. E. J. Bellocq, "Storyville Portrait," ca. 1912.
(Copyright Lee Friedlander; courtesy of Fraenkel Gallery, San Francisco)

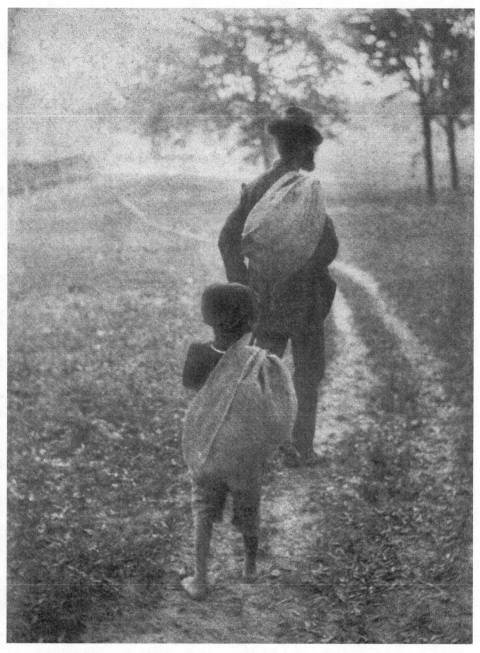

FIGURE 29. Mary Morgan Keipp, "Two Walking with Bags over the Shoulder," ca. 1891–1902. (Courtesy of Old Depot Museum, Selma, Ala.)

FIGURE 30. Alain Desvergnes, "Little Girl on Lamar Street North," ca. 1964. (Courtesy of artist)

FIGURE 31. Ralph Eugene Meatyard, "Lucybelle Crater and her bearded brother-in-law Lucybelle Crater," ca. 1970–72. (Copyright The Estate of Ralph Eugene Meatyard; courtesy of Fraenkel Gallery, San Francisco)

FIGURE 32. Tseng Kwong Chi, "Graceland, Tennessee, 1979." (Copyright Muna Tseng Dance Projects, Inc., New York; all rights reserved; courtesy of Muna Tseng)

FIGURE 33. Maude Schuyler Clay, "To the Memory of Emmett Till, Cassidy Bayou, Sumner, Tallahatchie County, Mississippi, 1998." (Copyright Maude Schuyler Clay; courtesy of artist)

FIGURE 34. David Najjab, "Hanaan and Nora, Lexington, Kentucky," ca. 1990. (Courtesy of artist)

FIGURE 35. Jane Rule Burdine, "Elizabeth Says Goodbye, Greenville, Mississippi," 1993. (Courtesy of artist)

FIGURE 36. Lynn Marshall-Linnemeier, "On the Peak of Time, Page 1," ca. 1995. Color illuminated photograph. (Courtesy of artist)

CHAPTER 2

THE DEATH OF

THE SOUTHERN

MALE GAZE?

WHITE LADIES'

CULTURED

REVISIONINGS

*[S]exual difference in photography must be addressed—
insofar as it operates—in three different sites: on the level
of the biological gender of the photographer and his or her
intentions, in the construction of masculine and feminine
subject positions within photographic representation, and
in the unstable and subjective nature of photographic
representation as it is received by the sexed spectator—the
site where photographic meanings are equally produced.*
—Abigail Solomon-Godeau, Photography at the Dock

*Seated with Stuart and Brent Tarlton in the cool shade of
the porch of Tara . . . [Scarlett] made a pretty picture.*
—Margaret Mitchell, Gone with the Wind

The ostensible "Elizabeth" of Jane Rule Burdine's image, "Elizabeth Says Good-bye, Greenville, Mississippi," sits center frame, directing her peaceful gaze over unseen landscapes, unseen people (see figure 35). This, ideologically speaking, is as it should be in cultured visions of the "gyneolatry" W. J. Cash saw dominating southern histories and literatures since the antebellum period (85–89). The white male gaze at the center of these visions strategically elevated the southern white lady as the image of "the South," essentializing history and nation in her perfect, pure body, and masking less lovely realities of white patriarchal rule.[1] If chapter 1's sampling of photography in the South suggests some ways photography has worked to solidify a historically white male vision of southern ladyhood as "natural," it also evokes some of the images, and possible audiences, just outside of "Elizabeth's" frame. Just as Burdine's biological gender destabilizes essential notions of a "male gaze," the South's complex visual legacy undermines simple notions of how recipients of that gaze understand and return it. As we glimpsed in the work of Katherine Anne Porter and Zora Neale Hurston, southern women writers have long noted, and critiqued, the power of cultured vision to naturalize political culture as "essence" and the ongoing role of photographs in this process. The contemporary southern women writers to whom I will now turn have built on this literary legacy, and the visual legacy behind it, to re-vision both.

Not surprisingly, two of the strongest pillars supporting essentialized notions of the male gaze are technologies that base their truth claims on a physics of "essence": the blood-based essence of family and the light-writing chemical essence of photography. The intersection of the two occurs most concretely, and most "naturally," in the family photograph. In modern patriarchal cultures, the relationship between camera and family works symbiotically: photography plays

a crucial role in promoting patriarchal family ideals and making them appear natural, while at the same time, photography's importance in family ritual forms the basis of its cultural power.[2] Seemingly innocuous, eminently quotidian, the family photograph is intensely personal—meaningful to family members as to no one else—and yet thoroughly public, reinforcing social conventions of the image, as well as cultural visions of community and "place," that underpin national and cultural identity. The naturalizing effects of photography and of family can serve both to cement and to mask ideology, to guarantee that familial and national hierarchies of gender, race, class, religion, region—everything—"really is so."

In southern visual history, as we have seen, family photographs play these roles, and more. In images of white Civil War soldiers and black post-Reconstruction patriarchs, the gaze of the male subject is particularly fierce, enhanced with a gleam if necessary, to bolster evidence of control. Coinciding with the rise of do-it-yourself snapshot cameras in the early twentieth century, the patriarch often becomes the family "picture takin' man," appearing less often in the resulting photographs.[3] Understood in the context of the South's legacy of representational politics, the resulting, thoroughly conventional images of women and children stand in for a consensual, natural paternal control—with an additional nationalist valence. In times of perceived threat to southern white hegemony, symbols of the South such as the southern lady stand in for a fetishistic acknowledgment and denial of the white South's past and potential defeats. Racially, sexually, and socially pure, the southern lady, in the eyes of southern white men, and even some women, was a visible symbol of cultural stability, order, and most important, white male supremacy. It is not surprising, then, that in southern photo albums and literature alike, when southerners are seeking to reinforce the "naturalness" of southern patriarchal ideology, the image they invoke most frequently is the southern woman. The three contemporary southern writers discussed in this chapter—Rosemary Daniell, Jill McCorkle, and Josephine Humphreys—invoke this image and its visual legacy of "placing" for an opposing reason: they use the naturalizing function of photography against itself, to denaturalize the links between political culture, family, and visible essence that generations of photographs of southern "ladies" have purported to show.

A VISION OF LOVELINESS

Like the family photograph, the self-image of white southern "ladies" exists in the space of contradiction between the (in)visible reality and the envisioned ideal. Taking the male southern gaze upon herself and conflating it with the

desire of southern culture, Caroline Merrick admonished in an 1857 letter to a friend, "We owe it to our husbands, children and friends to represent as nearly as possible the ideal which they hold so dear" (quoted in Scott 9).[4] One hundred and thirty years later, Robb Forman Dew writes that she "worked so hard at being appealing!" growing up as a white girl in racially torn Baton Rouge in the 1950s, but that, inevitably, the effort to embody a symbol of racial and gender purity broke down: "I could no longer manage all the secrets of my own life in the face of the image I tried to sustain in public" (121–22). It is this type of cultured vision—the complexities of its construction and effect on the southern men and women who participate in it and its images—that contemporary southern women writers such as Daniell, McCorkle, and especially Humphreys critique and re-vision in their fiction. Using fictional family photographs as their vehicles, these writers engage the historical, cultural, and literary manifestations of this vision in the "New New South" context of their work, to enter a strategic contest over representational and ideological control that has been at the heart of southern culture since its beginning.

Modern "southern ladies," real and literary, occupy the uneasy position of a fetish: they are a substitute for (and thus a type of acknowledgment of) a lost past of white southern racial, gender, and class hegemony and at the same time a "natural," living denial that such a past ever ended. As Kathryn Lee Seidel argues in her study of the belle in American literature, writers after World War II and from the first bloom of the Southern Renascence share a "double self-consciousness" in their relation to southern types such as the belle and the lady: "They are reacting still to the same myths as writers of the 1920s and 1930s, but they have also read Faulkner, Glasgow, Tate, and Mitchell" (165–66). Seidel, writing in 1985, points to Tennessee Williams, William Styron, Shirley Ann Grau, and Gail Godwin as the best of the "contemporary-belle authors"; one might easily now gesture to a more recent generation of southern writers who manifest a "triple self-consciousness" gained by reading the revisions and reuses of the myth by their predecessors. Any new layer of self-consciousness about gendered southern mythology, however, is equally if not more directly the result of an increased awareness in the South and the nation of cultural pluralism, and of the rhetoric of visibility and vision that has accompanied and furthered this awareness.[5] Just as newly freed slaves chose to effect their own representational politics in black photography studios across the South, feminist authors and scholars have responded to the image of the southern lady with strategies that not only debunk her mythical image, but also critique the cultural gaze that created it and make visible southern women's alternative visions. Fostered first by the civil rights movement and then by the feminist, these strategies are exercises in the type

of "self-imaginings" that Benedict Anderson argues are central to constructing nations. Though Anderson stops short of creating a model for competing self-imaginings within a nation (the very definition of cultural plurality), his observations on cultural imaginings, and specifically on the forms of visual imaging that enable a culture to believe in its own history, remain useful for understanding the type of literary self-consciousness at work in the novels of contemporary southern women writers such as Daniell, McCorkle, and Humphreys.

In *Imagined Communities* Anderson identifies the mechanisms of culture—maps, museums, and the technologies of navigation, surveying, and photography, among them—that enable nations to imagine themselves as natural and continuous entities. The dynamic he describes is that of fetishization: photography, for example, is "only the most peremptory of a huge modern accumulation of documentary evidence . . . which simultaneously records a certain apparent continuity and emphasizes its loss from memory" (204). The photograph offers evidence of that which may not be directly remembered (oneself as a baby, for example), and out of this photographic "estrangement," Anderson concludes, "comes a conception of personhood, *identity* . . . which, because it can not be 're-membered,' must be narrated" (204). Many contemporary narratives by southern women grapple with this sense of estrangement, especially from the cultural and personal images of southern white womanhood that have historically been so central in the conception of southernness. Too young to have personal memories of antebellum "ladies," these writers have generally come of age in the postmodern period, where the rigid gender and race roles prescribed to their mothers have been at least partially unmoored by modernist literary treatments of the belle and lady and by the civil rights and feminist movements. What remains, however, are images, photographs in magazines and family albums that simultaneously assert the continuous, "natural" existence of the white southern lady and bury the real and symbolic violences of gender, race, and class that this image was designed to mask. Narratives such as Rosemary Daniell's *Fatal Flowers* and Jill McCorkle's *Tending to Virginia* and *The Cheer Leader* engage in the generational recovery work of undoing the technologies of memory/forgetting whereby the specificities and oppressions of southern white women's lives are imaged and narrated into the homogenous, ostensibly revered form of the lady. The lacunae in these narratives—the images and characters often left just outside the frame—sometimes re-perform the gymnastics of lenticular vision that have separated the work of gender recovery from racial recognition in the South.[6] Photographs in this work serve as documentary evidence not of the "essence" of white southern ladyhood but of the workings of southern ideology: the construction of the southern lady

in the vision of a culture that, in its desire to forge a coherent, "natural" regional identity, wills to "forget" the unnaturalness of its social structures.

To paraphrase Jon Smith's characterization of the South, southern white ladies occupy a position at once center and margin, colonizing and colonized, essential and constructed, within southern culture. These dynamics are illustrated most pointedly in a nonfiction context in Daniell's 1980 memoir, *Fatal Flowers: On Sin, Sex, and Suicide in the Deep South*. Describing a series of photographs of her deceased mother, several of which are reproduced in the text, Daniell meditates on the performative, highly visualized constructions of the southern belle and lady, and the damage these unattainable images have caused to generations of women in her family. "Imprinted with the archetypes of media and literature," Daniell and her mother, Melissa Ruth Connell, struggle to embody these images (9). While Connell seeks to quell her own ambivalence in the role, and commits suicide over her "failure," Daniell eventually rejects the "rigid stipulations" of southern ladyhood, only to find herself at sea in the ambivalence of her fought-for freedom (25–26). Appropriating Alice Walker's metaphor of the "masks" worn by southern white women, Daniell reveals the ideological constructions of gender and region that the facade of southern ladyhood is meant to make natural, and the enormous psychological costs of these constructions for southern white women.[7] In the process, she outlines an economy of gazes, both external and internal, that entrap women within southern patriarchy, "netted in one mutual silken bondage . . . [in] the pressures of a patriarchy stronger than in any other part of the country" (18).

Rather than some essential core of strength, piety, and purity, Daniell posits an always tenuous performance of southern womanhood that is highly ritualized, rigidly maintained, and primarily visual. The southern white female body—the "altar" of southernness—is in constant danger of failing its representative function: the *appearance* of that body, and its coverings, must be continuously surveilled and disciplined. The rigid expectations of appearance are circulated in public culture (in the pages of *Good Housekeeping* and *Southern Living*, for example) but are policed primarily by and among women, passed from mother to daughter, and enforced in the most informal social gatherings and family photographs. Within these quasi-public spaces of display, Daniell writes, failure to meet the visual standards of southern femininity is linked directly to failure to fulfill one's feminine role in patriarchy: "An added pound, a less-flattering

hairdo, the state of one's wardrobe were all commented upon, becoming cause and effect of the failed husband, child, or marriage" (6–7). Thus linked, visuality and feminine gender roles move the image of the southern woman into precarious territory. Among fierce competition for spotless, asexual perfection, indicated in the "church clothes" that are "the most important part of a Southern girl's or woman's wardrobe" (77), there is also the need to be "appealing"—sexually attractive to the men whose role is to "protect" the southern woman. To the great extent that visual appearance indicates "appropriate" gender (and race) behavior in the South, this double image evokes the specter of potentially undisciplined, "inappropriate," *enacted* sexual desire. By stilling the image—preempting the possibility of unsanctioned action—photographs contain this danger.

The actual photographs in *Fatal Flowers* show just such posed, stilled femininity. In the text's figurative photographs of her mother, Daniell models a different reading of these photographs' "reality" by identifying the contradictions of visualized purity and sexuality that eventually drive Melissa Connell to suicide:

> In the photograph in which Mother wore these romantically seductive clothes, her complexion is a perfect, if papery, magnolia cream; her cheeks and lips an unnatural Tangee pink, echoing the pink roses she inevitably holds in her arms. Dressed for a dinner or tea dance, she sits still, suspended in time. But even dressed in her school clothes—chemises, middy blouses, pleated skirts—animated and laughing, she is as sexily juicy, a perfect peach, a vamp. "The prettiest girl at Fulton High School," we were told over and over. (38)

Despite, indeed because of, this vaunted prettiness, subservience and self-control are the ultimate values for southern womanhood. For Daniell and her mother, the perfect matriarch is embodied in Connell's mother, Lee, who "presented an image of self-restraint that neared self-immolation" (33). That this image is raced as well as gendered is a truth only obliquely acknowledged in the text. Eliding the class and race strictures that ensure the black southern woman's "inferiority," the young Daniell haughtily contrasts the "simplicity and warmth" of her housekeeper's "way of life" to the frozen image to which Daniell aspires: "To be a *real* Southern woman was to be as responsible, as impenetrable, as unsmiling as Grandmother Lee" (34). And, Daniell is uncompelled to add, as *white*.

Indeed, for women who have "literalized the symbol" of white southern womanhood, the image itself signifies self-control.[8] While "traditional" southern white women may experience role-induced anxiety, hysteria, and breakdown, an outward demeanor of feminine self-control and self-denial, "even—*especially*—under duress" (93), masks these internal violences, enabling cultural forget-

ting of the brutal power of racism and patriarchy and providing a seemingly solid base on which to erect a continuous, natural white southern identity. But no matter how successfully Daniell performs the outward visual role of belle and lady, her awareness first of her mother's and then her own "messy" sexual desire undermines her sense of southern femininity. Daniell depicts her family's failure to live up to the ideal image as evidence of "an unseen, yet spreading, decay" (57), a rot that signifies not only the corrosive effects of her family relationships but also the degree to which she has internalized southern patriarchal ideology. Beneath the entirely conventional surface of her family's photograph — underneath the "sterility and rigidity of the expectations of appearance" — lurks "something dark, fetid, unhealthy" (82, 58) that threatens to break out everywhere, "like mildew in August" (125). Tara McPherson has argued that Daniell's repeated juxtaposition of images of southern female purity and pervasive decay infers "a causal link between the two, limning the sickness inherent in white southern womanhood" (170) and revealing the stakes of a "deformed whiteness, broken and infected beyond repair" (171). To be sure, even in the "Southern-fried *Seventeen* magazine success story" of Daniell's early belle years, and later in her outwardly prosperous second marriage, Daniell reflects on her own "white, white skin" as a thin shell "covering putrescence, a rot that sickened everyone she touched" (125, 173). Daniell's language evokes Joe Christmas's "notseeing and the hardknowing" vision in William Faulkner's *Light in August* of the menstruating female body as a row of cracked "suavely shaped urns," each one issuing "something liquid, deathcolored, and foul" (189). As if she has internalized Christmas's male gaze upon her own sexualized body, Daniell is profoundly ambivalent about that body's representative function: she is unable to find security either in accepting the ideal image of southern womanhood or in rejecting it.[9]

This ambivalence does not, however, stop Daniell or her mother from attempting to master the image of southern womanhood to her own advantage. Again, figurative photographs provide the symbolic battleground for competing narratives of "reality." "The messier Mother's life became," Daniell writes, "the less control she had over her destiny, the more she clung to the idea of correct form, of herself as a Southern lady" (93). In the absence of actual control, the illusion of self-control can be effectively imaged in a photograph: in a snapshot posed with her youngest daughter, Melissa Connell "is pretty, round-faced, smiling, giving no hint of her self-destructing core" (63). After years of (ambivalently) rejecting this image for herself, Daniell still finds the family photographs of southern women on which she bases her narrative so compelling that they enable her to believe that she has actually shared experiences that occurred before she was born. But ultimately what is most powerful about photographs for

Daniell is the evidence they provide, not of the "reality" of southern women's lives, but of the carefully constructed, contradictory, madness-inspiring masks that southern women are expected to bear. In the end, Daniell's gaze upon her family photographs is a deconstructive one: she explodes both the "naturalness" of southern gender and sexual roles—if not their racial underpinnings—and unmasks the false dichotomy of her "good" and "bad" mother, recognizing that the "smiling young mother" of the photographs and the "contemptuous shrew" of her memory are one (288). In her memoir Daniell begins the difficult and ambivalent work of narrating that connection, re-narrating white southern female identity.

Contemporary fictional narratives that grapple with the question of a modern southern identity, such as McCorkle's *Tending to Virginia* and *The Cheer Leader* and Humphreys's *Dreams of Sleep*, evince a self-consciousness not only of past cultural fetishes—the southern lady, for instance, standing in for "The South" itself—but also of the visual dynamic of fetishization that creates the images and narratives of "southernness." Like Daniell's, these works explore the crippling results for white women of internalizing the southern white male gaze and constructing oneself as the symbol that gaze wishes to see. And like Daniell, these authors make extensive use of (fictional) family photographs to figure both the pressures to conform and perform to the ideal image of southern white womanhood and the gap between that external image and their characters' inner selves. In a fictive realm, absent any "real" images, these photographs take on additional metaphoric weight: combined with other symbols and narrative structures, they may invite reflection less on the reality of ideology than on the ideology of the real that anchors cultural notions of gender and race in the South. The degree to which the performed whiteness that grounds the image of southern ladies is itself interrogated varies in these texts, often cast into relief only by a blackness kept on or just outside the family frame of the novel. McCorkle's *The Cheer Leader* begins with a series of dated fictional photographs, collated and narrated by the first-person narrator-protagonist, Jo Spencer. Like the teenaged Rosemary Daniell, Jo Spencer is by all outward appearances a successful southern belle: she is one of the "popular girls," a top student, the chief cheerleader. But, almost from the beginning, this success comes at a great psychic cost, as Jo buries her creative, individual self under a strict regimen of conformity and self-silencing. At a young age, Jo becomes fixated on the box of family photographs in her mother's closet, searching for visible evidence of her history—"the parts that I could not remember"—and altering photographs that seem to her to threaten that history (2). In particular, Jo is made anxious by her mother's senior prom photo, the idyllic image of her mother's own pinnacle of belle-hood. Although she reveres her

mother's strapless gown with a "ballerina length" tulle skirt, Jo finds it "wrong" that she herself is not in the picture and that her mother's prom date is not the man who will become Jo's father. The photograph becomes something of a fetish for Jo: it represents both the reality of change—her mother's life before children, with a different man—and the denial of change, the eternal, ideal image of southern white womanhood. Jo is driven to look at the photograph again and again, and even after she defaces her mother's prom date with a black marker, the image of the archetypal dress haunts Jo's imagination (1–2).

McCorkle here combines the iconography of the strapless tulle gown as an exterior symbol of southern feminine gender roles with the metaphor of the photograph as a technology for enshrining surfaces and freezing time, Jo's preferred methods for asserting control over others' access to her interior self. The black marker stands in both for the activity Jo will eventually choose—writing—and also for the unspoken function of the family photographs within McCorkle's text (and the perhaps unintentional effect of her text itself): reinscribing the whiteness of southern families through an ultra-whitened female body. Blackening the photograph has the dual effect of rendering threatening visions less visible and of highlighting Jo's whiteness through an unmarked and un-remarked-upon "naturalness." From the first (when she identifies her nursery school class as her "debut into social circles"), Jo understands herself as defined in a southern social context that for girls predicates being "accepted and liked" on maintaining appropriate gendered appearance and behavior (9). The racial component of this appearance remains implicit, unmarked. Because she is unwilling to "expose" herself by revealing her own creativity and desire (as her alter ego "mis-fit" classmate Beatrice does), Jo develops two disguises: first, the "good Jo Jo" smile and noncommittal speech that advances her popularity, and second, the "old lady suit" of an old bathrobe and scarf on her head, behind which she can "think wonderful poetic thoughts" (6, 11). Each disguise functions within the southern patriarchal visual economy as a type of preventative exposure—an acceptable mask—that wards off the threat of being seen as unfemininely creative, assertive, or sexual, or in Jo's terminology, as "an exposed ghost" (19). The "ghost" image suggests that Jo views her innermost core as ethereal, unsubstantial, and possibly deadened. To the extent that "ghost" has been used in African American culture as slang for white people, the repeated "exposed ghost" imagery also calls to mind the staggering absence of black southerners from the North Carolina landscape of The Cheer Leader. In the novel's one direct reference to African American southerners, Jo identifies the one positive function of her hospital birth photograph as its proof of a desired whiteness, disproving her older brother's contention "that he was the real child and that I had been left in the

trashpile by some black people who did not want me" (4). As Barbara Bennett argues, this moment is further evidence of "Jo's dependence on external proof of her worth" (16). Richly evocative of the obsession with throwaway bodies and trashed people that Patricia Yaeger finds so prevalent in southern women's writing (20–32, 67–87), this scene also intimates that the "horror" of Jo's whiteness lies beneath the horror of her femininity.

Each disguise is eminently photographable. Photographs, in this novel's schema, are not technologies of "exposure" or truth-telling but of masking and self-control: "It was easier to fool everyone," Jo says, rather than to expose her own fear or desire, "especially Daddy who always got a real kick out of the 'dress-up' pictures" (19). Willing herself to keep still, quiet, small, and "good," Jo attempts, in the classic mode of southern womanhood, to remain worthy of men's love and protection. In this attempt, Jo joins the conservative impulse of her southern culture: indeed, McCorkle positions her, albeit ambivalently, as its chief cheerleader. The box of family photographs McCorkle presents in The Cheer Leader is unusual in that among the conventional images of holidays and birthdays, there are also images of family disarray. Typically, the photos are taken by men—Jo's father, her older brother Bobby, the next-door neighbor, Mr. Monroe—but they include (at least in Jo's telling of them) the images most family albums omit: children crying, a mother looking "upset" at her children's behavior. These are not stereotypical images of southern white ladyhood, but they exert a similar type of pressure. Jo narrates these photographs and the ambivalent memories they evoke for her from an undisclosed point in the future, but the stories she tells reveal that from childhood she has cultivated the skill of reading photographic images and especially of reading herself as a photographic image. It is a skill, McCorkle seems to suggest, that develops from the southern obsession with external appearance, and one that not only lends Jo a poet's power to control the stories beside the pictures, but also frustrates that power in the face of an even more authoritative gaze: the male gaze that would freeze and define her inner self within a strictly visual frame. Jo's own desire to "freeze" moments, to deny or prevent change, is only partially mitigated at the novel's end. Her plan to show her imagined future son television reruns of Alfalfa and Buckwheat to prove "how they have not changed one bit" for generations, and to "grow" her landscape to look "just like it used to look, the way I remember it all," reflects an ongoing fetishization of a visualized southernness, with a particular, if backhanded, embodiment in a fantasy of racial harmony (265, 267). Nevertheless, Jo does claim a new awareness and embrace of movement and change, a consciousness that, "at least," she is "moving, sliding, changing" past the realm of static

image and toward the dynamic and unpredictable realm of her own "Could Be's" (266).

McCorkle's later novel, *Tending to Virginia*, moves away from the embodied frozen moments of Jo's photographic obsession to focus more broadly on the generational effects, for southern women, of "picturing" themselves and each other. Photographs are invested with a anthropomorphic power in the novel: one character shields herself as she dresses from the photographic "eyes" that gaze from the family photographs on her dresser; another declares that there are no photographs of his family, "They're all dead," as if these statements are equivalent. But far more powerful are the ideological effects of the southern cultured vision that photographs appear to reinforce in the novel. So thoroughly has the title character, Virginia Ballard, internalized the images of traditional southern womanhood that she cannot remember which are based on "actual" photographs and which she has simply made up. Literally pregnant with the next generation, Virginia resists "letting go" and allowing for her own creative and personal change, preferring instead to retreat to the safe haven of her maternal ancestors, who she feels have protected and "tended" her. Through Virginia's bout with mental and physical illness (much less severe though hardly less debilitating than Daniell's or Jo Spencer's), McCorkle suggests that southern women's internalization of the male gaze—and its desire to still, silence, and enshrine white female bodies as fetishes—places an intrinsic "madness" at the center of southern female identity. This is the madness, what Patricia Yaeger would call "the horror" (30), of literalizing southern gender and race ideology upon one's own body; and while McCorkle largely shuns the blatantly grotesque figures that Yaeger analyzes, *Tending to Virginia* offers a strong indictment of the willful, everyday blindness and deafness that enable southern patriarchal ideology to endure. The family photographs that Virginia treasures combine with a cultural tradition of female silence in the novel to effect a southern gendered memory (and identity) based on careful and deliberate forgetting of female lived experience.

Despite the "reality" Virginia ascribes to photography—once burning her aborted first wedding portrait as if that alone would erase the past—the opening image of the novel reveals the contingent relation of image and truth. Dreaming of her then-young grandmother and aunt, Virginia's subconscious conjures a scene "so clear in her mind" that it may be based on a photograph or may be "a picture that she has made up herself, outlined by words and memories, and then colored" (3). She then "hears" each female relative giving her own contradictory account of the picture's "true" meaning. Awake, Virginia forgets this ambiguity, instead desperately defending the pure and proper versions of the stories

she has been told about her maternal ancestors against her cousin Cindy's irreverent true confession–style narratives. Exhibiting the southern tradition of "loyalty . . . in the face of evidence contrary to [the] ideal" that Porter's Miranda learns in *Old Mortality* (11), Virginia repeatedly pictures her hometown of Saxapaw, North Carolina, as "just the same, always the same" (96). She leaves her law-student husband, their rented house, and "temporary life" to return to this imagined permanence.

Like Jo Spencer's fetish of her mother's prom photograph, "home"—the physical houses and beloved bodies of her female ancestors—functions as a type of fetish for Virginia, an object at once concrete and imaginary, designed to allay fear and cement identity. The source of fear for both characters, however, is rooted in a deeper, cultural dynamic: the southern male fetishization of racial and sexual purity in the bodies of southern white women. The power of white southern patriarchs is utterly contingent on an imaged southern white ladyhood, just as both roles depend on a subordinated notion of black manhood and womanhood. Though McCorkle's exploration of the interdependence of white and black southern roles is tentative at best, the intrinsic relation of masculine and feminine gender roles within a middle-class field of whiteness is made horrifically clear.[10] McCorkle presents this dynamic with grotesque literality in the character of Virginia's uncle Raymond Sinclair, whose growing self-delusion that he is a patriarch in the style of King Tut is directly predicated on a sadistic voyeurism, centered on viewing women's deadened, whitened bodies. Raymond experiences an almost sexual pleasure after watching his mother-in-law be embalmed, "slant and all drained of her life liquids." "Tessy's skin was so very very white," he tells his wife, Madge, and like the white sheets that evoke the Klan elsewhere in the novel, this female whiteness appears to reinforce Raymond's own sense of racial, sexual, and class power (75). Raymond's obsessive vision "scared" Virginia as a young girl: "He told me that I'd look nice in a tomb. . . . He said he could just see me wrapped up in a pure white sheet, my body oiled and perfumed, and he made me tell him that he was the king, that he was beautiful and that I worshipped him" (237). He has played the same "game" with the prepubescent Cindy, along with showing her sexually explicit photographs that Cindy internalizes such that she feels as if her father were "always watching her" (242).

Raymond embodies the southern white male gaze taken to its logical conclusion, a grotesque parody of the "gyneolatry" of W. J. Cash's cavalier patriarchs. But the ideological workings of this gaze, McCorkle's novel asserts, occur in much more subtle and pervasive ways in the "unseen everyday" of southern culture. Virginia has responded to Raymond's "viewing" her with pictures of her own: nostalgic, static images of her Grandmother Emily's "perfect" home, mar-

riage, and life. It is "easy to picture" her female relatives—easiest to picture the ones furthest in the past—for Virginia has rendered them as fixed in her nostalgic gaze as the photographs on her dresser (33). For her part, "Gram" Emily has reinforced these static images, telling Virginia that she was "always" happy and close to her husband, even as she silently remembers their arguments and betrayals, which, like sex, marital affairs, and menstruation, are "not the kind of thing to discuss" (141, 102). Echoing Daniell's memories of the pressures of feminine standards, passed on even in the most informal gatherings of southern white women, McCorkle reveals a vast, historic network of female silence and stoicism, where generations of mothers and daughters assume that the mythic image of southern ladyhood was true for their ancestors and drive themselves mad in their own failed attempts to live up to, or to challenge, this legacy. Static images of unspeaking southern women—like the old family photographs that haunt Virginia—perform the work of cultural memory, naturalizing the apparent continuity of southern ladyhood that is essential to southern identity. At the same time, such images perform the equally crucial work of enabling selective forgetting, erasing from memory the lived experiences of southern women that might challenge southern patriarchal ideology. *Tending to Virginia*'s somewhat contrived ending, where secrets are revealed, relationships are mended, and the specter of racial violence is (uneasily) buried along with other disruptive ghosts, imparts a lesson in honoring the past, but also "letting go" to tend the living. It also offers a critique of the visual legacy of southern white womanhood, the cultured vision that would picture women within an assigned social "place." While both Daniell and McCorkle champion the cause of female creativity and artistic expression in their characters, the defining male gaze that works to limit such expression remains fundamentally unrevised in their narratives. This revisioning is the project that Josephine Humphreys takes on in her 1984 novel, *Dreams of Sleep*.

STARING DOWN THE SOUTHERN MALE GAZE

Daniell's memoir and McCorkle's *The Cheer Leader* follow a loose bildungsroman structure, where their young protagonists come of age in and through images of southern white womanhood, ending up in an ambivalent half-space of rejection and nostalgia for those images. Josephine Humphreys's *Dreams of Sleep*, like McCorkle's *Tending to Virginia*, focuses on a mature southern white female protagonist as she struggles (ambivalently) to reconcile personal, professional desire with gendered cultured vision in the non-epic everyday of a traditional southern marriage. But whereas *Tending to Virginia* leaves the politics of marital-looking relatively unexplored, banishing Virginia's husband to the periphery of

the narrative, Humphreys's novel takes this particular "familial gaze" as emblematic of southern cultured vision and posits revising its patriarchal dynamics as crucial for both southern women and men. *Dreams of Sleep* engages the politics of cultured vision on at least three levels. First, at the level of images: what her characters will to see and desire to keep still and under control. The consistency and dailiness of this desire, a fetishist's solution of memorialization and denial, form the chief metaphor in the novel, a second level where characters' and narrative gazes are revealed as political, constitutive, and ultimately limited. Third, the novel responds to a specifically southern literary legacy of staring, white male protagonists. On all three levels, fictional photographs—family photographs in particular—stand in both for the ways southern cultured vision has sought to position and control women and for the avenues of resistance to that positioning.

Humphreys finds the roots of the South's gendered "ways of seeing" not only in southern cultural history but also in the literary history that has provided the narratives behind, or for, southern images. Southern literature from the Renascence forward has a rich tradition of characters whom Fred Hobson has described as "reflective and somewhat paralyzed well-bred, well-mannered, and well-educated young southern white males" (55), who are also great watchers, especially of southern women; Faulkner's Quentin Compson and Horace Benbow, Robert Penn Warren's Jack Burden, Allen Tate's Lacy Buchan, and Richard Ford's Frank Bascombe spring immediately to mind. As several critics have noted, Josephine Humphreys grapples with this literary legacy in her own fiction, most specifically as it is manifested in the novels of Walker Percy, the first southern writer by whom Humphreys claims to have been inspired.[11] In Percy's changing treatment of the cerebral male watcher, and the southern women he watches, we find the literary paradigm for the cultured vision Humphreys revisits and re-visions in her own work.

Walker Percy is perhaps best categorized in the generation of southern writers whom Seidel identifies as possessing a "double self-consciousness" about the South and its literary-cultural traditions. In Percy's novels, particularly in *The Moviegoer* (1960), *The Last Gentleman* (1966), and *The Second Coming* (1980), Quentin Compson's obsessive gaze has been transformed and reduced to a general cultural condition, wherein introspective southern males still gaze, but merely at the surfaces of a surface, (post?)modern South. *The Moviegoer*'s Binx Bolling, for instance, feels more comfortable in suburban movie theaters than in his native, upper-class New Orleans, even though he has moved to the suburb of Gentilly to escape the rage and depression he feels when living in the old section of town. The hero of both *The Last Gentleman* and *The Second Coming*, Will Barrett,

plays the introspective voyeur, gazing through his expensive telescope, yet he drifts through his time in New York and his return South by attaching himself to an equally wealthy and adrift family of southerners. Later, in *The Second Coming*, having married a crippled northerner, been widowed, and returned south, Will finds himself gazing at things that "ordinarily he would not have given . . . a second glance" (3) and falling alternately into spells of acute amnesia and remembrance.

Unsurprisingly, given the southern literary legacy, the most frequent object of these characters' misplaced gaze (misplaced, in Percy's view, because it does not rest on the true essence that is God) is the southern white woman. In Percy's work, modern belles lack the direct purposefulness and corruption of a Belle Benbow or Caddy Compson, though the seeds of their involition can also be found in the impossibility and irrelevancy of living up to the belle's idealized image in a modern world. They are either almost completely incapacitated, as is Kate in *The Moviegoer* (who ultimately hinges her very ability to act on Binx Bolling's directive gaze), or aimlessly wistful and spiritually corrupt about sex and life, as is Kitty Vaught in *The Last Gentleman* (who rests ambivalently in Will Barrett's viewfinder and watchful embrace). Only in *The Second Coming* does a potential belle figure, Kitty's twenty-year-old daughter, Allison, represent a regenerative force and hope within the New South. Allison, however, has only recently escaped from an asylum and literally cannot remember the past; perhaps it is not coincidental that she also lacks coherent speech.

While the figure of the belle has from its origin been a volatile one in southern literature, southern ladies traditionally represent a more mature, stable version of the white female role. In Percy's novels, few traditional southern ladies remain. Binx's aunt Emily Cutrer in *The Moviegoer* is an indomitable former "bird" (a particularly rebellious belle) whom Binx alternately serves, resists, and disappoints. In Binx's eyes she is the image of the southern lady, a function and agent of southern identity itself: "All the stray bits and pieces of the past, all that is feckless and gray about people, she pulls together into an unmistakable visage of the heroic or the craven, the noble or the ignoble. So strong is she that sometimes the person and the past are in fact transfigured by her" (49). Aunt Emily commands awe but is "absurd of course." Even Emily Cutrer must concede to New South decay when, at the end of the novel, she acknowledges that Binx does in fact represent "the last and sorriest scion of a noble stock" and allows her own disappointment in him to dissipate. Similarly, the one true southern lady in *The Last Gentleman*, Kitty's mother, Mrs. Vaught, comforts Will Barrett with the skill with which she understands and plays her role. By contrast, Kitty, whose lustfulness and financial greed reveal her as a symbol of a corrupt south-

ern lady in *The Second Coming*, discomforts the older Will Barrett as much as she did the younger with the ease with which she adapts to the crass exigencies of the New South. Only with Kitty's twenty-year-old daughter, Allie, who is the only of Percy's female characters to have a narrative point of view in these novels, does Will find an image of regeneration in and for the South. In Will and Allie's relationship, as Susan Irons has argued, Percy again depicts power and gender relationships through the metaphor of the gaze; theirs differs from Will's previous relationships because Allie is capable of returning and at times overpowering Will's gaze. Allie sees Will first, although he purposefully positions himself so he "could see without being seen" (68), and later, arguing with Kitty, he thinks "of Allie's eyes, the quick lively look she gave him" (258). Percy's attempt to reconfigure male-female relationships through a more mutual dynamic of the gaze is undermined by his characterization of Allie as a recovering mental patient; her childlike understanding and receptiveness to Will's own mental confusion, and indeed her comfort with her own body and abilities, are less the result of a mature subjectivity than the electroshock treatments she has received in the asylum. These treatments are especially significant within the southern context of the novel: Allie has rejected Kitty's attempts to mold her into a New South ballerina/belle by retreating to mental illness, but it is the amnesia about her past and culture brought on by the shock treatments that enables her to forget her position as southern symbol enough to return Will's gaze.[12] Though Allie occasionally uses her mother's southern colloquialisms in her broken speech, she is otherwise such a blank slate that she may, as the best potential New Lady and Will's new wife, perfectly mirror his own image of the future. Will's vision, not surprisingly, is a distinctly nostalgic one: a return to cultivating the land, small-town lawyering, and raising two children. More symbol than agent, women in Percy's novels are the object of male protagonists' longing gaze; wealthy white women, who should be ladies, most often function in his fiction as the visible symbol of the modern absence of a stable "ground" or essence of southern identity. Whether or not actual women can live up to the standard, however, the image of the southern lady and the gaze that wills to see it remain intact in Percy's novels.

Looking at Humphreys's and Percy's work in conjunction is productive for analyzing parallels and contrasts in their explicit treatments of male representations of southern white women in a realm somewhere in between southern lady and New South woman. Like Percy, Humphreys writes of an urban (though hardly "big city") South ringed by homogenizing suburbs and besieged by developers and settlers from Ohio who want to live in houses with columns. Humphreys's *Dreams of Sleep*, like her later novels, is set in Charleston, South Caro-

lina, a town that Humphreys in an interview describes as a place where "the past is everywhere, and you can't get away from it" (Magee 792). *Dreams of Sleep* is organized around the troubled marriage of two intense watchers, Will and Alice Reese. As the narrative progresses, each reflects on a series of snapshot-like memory-images, sometimes actually embodied in photographs, as they grapple with the past and its lingering cultural expectations of gender in their lives in New South Charleston. As both Kathryn McKee and Susan Irons have argued, Will and, to some extent, Alice descend from the line of southern cerebral, self-conscious, analytical characters experiencing dislocation in the modern world that produced Will Barrett and Binx Bolling. Irons argues further that Will and Alice's marriage functions as a parodic revision of the relationship between Percy's Will and Allie, subverting Will Barrett's dominating gaze and rewriting Percy's "literary patriarchy" (287). But the "literary patriarchy" that Percy continues and Humphreys critiques is a specifically southern one, and at the center of its tradition, and at the center of Will and Alice Reese's difficulty, is the fetishized image of the southern lady.

Southern ladies of the classic model are virtually nonexistent in *Dreams of Sleep*. Alice's mother, Elizabeth, knows all the traditions and requirements of upper-class Charleston ladies, though she herself maintains a distance: she sews their wedding gowns (not for money, but because she has a talent for it) and advises them on their trousseaux, but she never makes a dress for herself or passes on her knowledge to her daughter. Will's mother, Marcella, is an uneducated country girl, who, in marrying Edmund Reese, joins the rarefied circle of ladies in Charleston, becomes a prematurely "old" Charleston widow, and in her mid-fifties, marries again—this time to a fat real estate developer just relocated from Ohio. Strong-willed and wealthy as she is, Marcella does not measure up to the ideal image of the lady, especially in the eyes of her son, Will. Reacting to his own childhood fear of abandonment, he transforms that fear into "disappointment": his mother is "too flimsy to support a major love" (32) such as the one Will assumes his distant, philosophic southern father would have offered and deserved. As Will looks at a wedding photograph of Marcella surrounded by dark-suited men, the narrative switches briefly to free indirect discourse, and Will muses that Edmund may have been "charmed" by Marcella, but (perhaps because Marcella is "a country girl, uneducated"—not true lady material) he could not have moved beyond the stage of a "young man's ardor" (32). Marcella's pragmatism after his father's sudden death (and, fifteen years later, her remarriage to Duncan Smith) confirms Will's perception of her and, in his mind, releases him from the southern son's filial duties of respect and service. Will then turns to another woman, Alice, to embody his idealized image of southern ladyhood.

Despite being raised in what Michael Griffith calls a "nineteenth-century [southern] family" (102), Alice, who has followed her father's example into the world of philosophy and abstraction, is even less southern belle or lady material than Marcella. Though she is doing well on a math scholarship at a Virginia college, one night, Will recalls, "he looked at her in the light from a yellow porch bulb" and had "the distinct feeling that she was threatened," in need of rescue (39). Will thus recreates Alice under his gaze into an image that he can then use to fulfill his own gendered fantasy as a southern gentleman and patriarch. As he remembers the early days of their marriage, Will focuses on images of himself noticing Alice's physical fragility—her small breasts, her soft hair, the "bony plate of her breastbone"—and of moments when he felt compelled to protect her: fastening her coat, stomping open a bottle of codeine as she miscarries the first time, and watching her "in fascination," secretly, as she stays up late working on mathematics (40, 41).

Will's protective, pseudochivalric gaze upon Alice is as obsessive as Will Barrett's through his telescope, and is reminiscent of W. J. Cash's "downright gyneolatry" (86). Cash himself exposes this idolization as strategic (to compensate for white male copulation with black slave women), and feminist critics of Percy's texts, such as Irons, have pointed out that the idolizing watching of Will Barrett, Binx Bolling, and company amounts to an attempt to reinforce a nostalgic world order based on southern male dominance. Humphreys parodies this strategic "gyneolatry" by creating her obsessive watcher, Will Reese, as a gynecologist with an exaggerated sense of paternal control, even ownership, over his patients: "Every goddamned one of them was mine. I could see that girl, a girl my age, lying there panting, and in the days before they started letting husbands in she was all mine. . . . I'd hand over the baby. And she'd know it came from me" (102).

Will envisions himself as a patriarch in the old southern style, he and Alice becoming "progenitors of a whole new clan, the North Carolina Reeses" (44), but Alice's repeated miscarriages (she eventually does produce two "thin" girls) and the disintegration of "true" southern culture (the New South, in Will's viewing of Charleston, "is Ohio warmed over" [47]), thwart his plans. This disintegration, though hastened by Ohioans like Duncan Smith, is tied most explicitly to the women whom Will watches, who have, in his eyes, started "acting sad": women, he tells his best friend Danny Cardozo, "haven't lived up to my expectations" (30, 102). Humphreys uses Will's affair with Claire Thibault to reiterate and reveal the pathological, chronic nature of Will's voyeuristic approach. In a pattern that parallels his attraction to Alice, Will is drawn to Claire because, even though she is in many senses the quintessential New South woman (an operat-

ing room nurse, "Fast, sharp." [34]), she appears to Will as "very young, vulnerable" (97) and in need of rescue. As Claire moves to end their affair, Will reflects on a compressed image he considers its "zenith":

Once, a year ago, he watched her do her toenails in bed on a Saturday morning. She clipped them, her knees pulled up under her chin. He saw the white band of underpants between her thighs. . . . Then she held out the bottle and her foot for him to paint. The nail on her little toe was so small it was only a spot of pink. He knew as he touched it, touched the soft instep, the heel, the tendon like a tight string, that he would not in his lifetime see this happiness again; it was the still zenith of his time on earth. In the room all objects— the radio, the dresser and its tilted mirror, the thin white towel hung over a chair—were as they should be, instantly complete. Nothing could have been added or removed. Rooms, mornings, women to come would be less than this.
And so it proved. Now Claire paints her fingernails at the reception desk. (108–9)

Claire, like Alice, is for Will a symbol of a longed-for stability, a hedge against the decline, or "rot," so evident in the modern South (as embodied in his mother). Unlike the women in Daniell's memoir and McCorkle's fiction, Will externalizes the "decay" he sees eating away the core of southern culture—right onto the bodies of "sad" southern women. Beginning with an episode when his mother forgot to be home for him after his first day in first grade, Will has associated women, his fear of disaster, and deterioration: brooding on his mother, Will concludes, "disaster no longer comes as a fire or flood . . . but is instead a creeping, insidious thing—a decay. Things go bad, but slowly; things degenerate, rot" (100). Looking at Claire's apartment and his own house, Will reflects on the "slow fragmentation" of the South, embodied in "constant process of disintegration" of its patriarchal estates and "dynasties" (112). And where Will once felt a paternal relation to his patients, he now sees himself as "there to look for signs of disaster" (102), just as he does with his old Charleston house, "patching, gluing, temporizing, begging for time": "Is this," he asks, "noble activity for a man?" (112). As in Percy's novels, women here are the symbolic vehicles of ruin and denial; Humphreys brilliantly reiterates and exaggerates Percy's entwining of sexual and regional imagery:

It isn't that nothing is left. It is that what remains is such a old sad ghost of the thing that used to be, and he can't bear lying down with the vestiges. Hasn't he been looking for the thing that used to be, looking for it in Claire, looking for it in every woman giving birth on that stainless-steel table, look-

ing for it desperately and pathetically even in the unfinished faces of his own daughters? And now he knows it is not to be found whole again; it is scattered and dispersed, past reassembling; blown ashes. (174)

Although Will acknowledges that "his heart is a shambles of its own making" (109), his desire is to perpetuate the still, silent "zenith" of his moment with Claire; he wants to sneak up on Claire as she comes out of the bath, a moment he identifies as ideal for the voyeur: "Her face is clean and childlike and sure of privacy . . .—and all the while the voyeur lurks with his palette in the shadows, peeping. In the quiet instant just before violence he savors a pure guilt, all his own, none hers" (118). As they do for many of Percy's male characters, childlike, "fragile" women become a sort of fetish object for Will's simultaneous denial and acknowledgment of the changing southern world. But, unlike in Percy's novels, the female fetish objects in *Dreams of Sleep* ultimately refuse their intended representative function.

Indeed, as Will attempts to "sneak up" on Claire, "he meets her eyes, locking onto his as if they had been trained to the exact spot where he would emerge, waiting for him" (118). "Trained" here takes on its dual meaning of "aimed" and "instructed"; just as Will's character is shaped by its literary ancestors, Claire's also takes its place in a line of southern female characters culturally conditioned to recognize themselves as the potential object of a male predatory gaze, and to accede or resist appropriately. Claire admits that she has loved Will, or more precisely, Will's *type* (the alienated romantic, pseudo-cavalier): "I loved you before I loved you" (119).[13] She has played her role as silent, tragic mistress, but now she insists on talking, bringing to Will a "sadness" that he finds "oppressive, a general gloom raining down over the world" (34).

By preempting Will's voyeuristic gaze, Claire effectively disrupts the visual dynamic that undergirds his fetishistic imaging of her, but as a character, Claire functions to highlight rather than affect: Will's pathological vision is (again) diagnosed but not revised. In classical Freudian theory, women cannot be fetishists, but interestingly, it is through Alice that Humphreys depicts the full complexity of fetishistic viewing, exposing its regional, gendered basis and its political limitations. In the first chapter of *Dreams of Sleep*, Alice's character and point of view set the terms for Humphreys's examination and revisioning of the cultural politics of vision in the southern context. Alice, like Will, is a lonely watcher, but as a woman and an object of Will's gaze, she experiences the dual pressures of the fetishized object and a subject who also sees and fetishizes. The first moment in the novel reveals that she, like Will, desperately wishes to see, or form, symbols and to keep them still and under control: like Will, and so many of his

modern southern literary ancestors, she shares a sense that "everything was precarious," and that if she could "keep it still," "rot" might be averted (6). But as she reads her "signs," Alice receives a second, powerful message—she herself should remain still: "The message to Alice is, Don't move" (1). Like Percy's Allie, Alice engages in a sort of visual combat with a character named Will; gazes are returned, preempted, and sometimes overpowered. But unlike Allie, Alice retains both her mature power of speech and an acute consciousness of herself as symbol. While (perhaps because her mother deliberately neglects to "train" her) Alice evidences little direct consciousness of the specifically southern ideal,[14] Alice nevertheless understands that as a woman she represents a certain image in Will's eyes, and that this understanding and the tension it causes come to girls early in life. As Alice bathes, loathing the sight of her own body, her youngest daughter views her own face in the bathroom mirror, "study[ing] her face as if it were a picture of another person. At six she is starting to look at herself critically, starting to split the visible self off from the thinking self. A little girl at the mirror, just beginning that lifelong interrogation" (127). Clearly a nod to Lacan's psychoanalytic theory of the "mirror stage," this passage also evokes his notion of the "screen" through which the self must see itself and others. An extension of the original "mirror" moment of self-(mis)recognition, the screen, as Marianne Hirsch explains, is culturally specific: "the image/screen is the space where the visual field is localized and historicized" through cultural parameters of class, race, sexuality, nationality, and presumably, region (*Family Frames* 102–3).[15] As the chapter progresses, Humphreys embeds this notion of the "split" female self firmly within a specifically southern notion of separate spheres, where race, class, and gender prescriptions make up the "screen" of cultured vision through which southern "ladies" like Alice see themselves and others.

Though she does not conceive of herself as a southern lady, Alice has, consciously or not, "literalized the symbol" of the lady in the role she feels compelled, even desperate, to play. Humphreys uses metaphors of vision, particularly of photographs and the photographic, to reveal the complexities of and ultimately to revision the dynamic of fetishism that undergirds identity in the modern southern context of her novel. At the beginning of *Dreams of Sleep*, as Alice virtually (and visually) stalks Claire, it at first appears that she fits a dynamic outlined by feminist film critics like Laura Mulvey and Ann Kaplan, wherein the female viewer has two options: to identify with the represented, fetishized woman or to identify with the masculine gazer, engaging in desire and dominance of the fetishized Other. Prefiguring Will's own behavior (not revealed until chapter 3), Alice is "hungry for new looks" at Claire, dressing herself up in "lady's clothes" to go to Will's office and "steal long glances at her, at her nose,

the back of her neck, the perfect turn of ankle above white shoes" (3). Alice carries images of Claire as "snapshots in her mind" (3), and Humphreys makes explicit the parallel between Alice's and Will's position vis-à-vis Claire: "[Alice] was at jealousy's highest pitch, when a woman's obsession with her rival tends to resemble love" (4). Chronologically, Alice's behavior might be said to mirror Will's, yet in the structure of Humphreys's novel, Will's obsessive gaze mirrors Alice's; this suggests that it is the screen of cultured vision, rather than any gendered essence, that determines the common pathology of their views. Nevertheless, by following and obsessively imaging Claire, Alice (within a southern context) acts a traditionally masculine role, seeking control over Claire through the power of the voyeur.

Yet, unlike Will, Alice also experiences herself as controlled by vision, herself the object of a photograph. Nowhere is this dynamic clearer than in Alice's rumination on a photograph of herself and her daughters that Will insisted be taken on their family vacation. If, as Marianne Hirsch has argued, the familial gaze is culturally and historically specific, this episode of fictional family photography reveals the 1980s southern familial gaze to be solidly patriarchal and culturally conservative. Will refuses to go to any of the new South Carolina resorts (built by "Interlopers. Turning our real places into artificial places" [75]), preferring instead Bloody Marsh and Fort Fredrica, sites of Old South triumph. He consents to visit Sea Island, "where Southerners have been going for generations" and where the garden is "dense with red and pink and orange flowers, things like hibiscus and bougainvillea that don't grow even one state farther north" (75, 77). Exempting himself from the photograph, Will commissions an image that again conflates southern women and the southern landscape as possessions of his gaze. Alice recalls being bodily positioned by the photographer ("Let's have the Mommy here"), her own self-consciousness of her looks (like "someone already flinching from a blow that had not yet been delivered"), and the insistence of place ("a wide-open red flower brush[ing] her ear" amid the "whines" and "chucks" of grackles), as well as the "objective" reality of the resulting photograph, which shows "a handsome, healthy woman and beautiful children, blooming" (77–78). As Hirsch has asserted of family photographs in general, this image locates itself "precisely in the space of contradiction between the myth of the ideal family and the lived reality of family life" (Family Frames 8). Radically split from her own subjectivity in the photograph, Alice internalizes the damage: the photograph becomes "the kernel for a dream that started then, in which her children were not her own, but wraiths of children she had lost, the real children" (78).

Humphreys's use of this family photograph encapsulates the gendered dynamics of photographic seeing outlined by Abigail Solomon-Godeau in the quotation that opens this chapter. Taken and directed by men to cement the ideological relation of white women and southernness, this photograph serves (at least in Will's gaze) as a fetish object to ward off Will's own "sadness" and sense of decay. Photo theorists such as Diana Fuss and William Pietz have explored how, in their fixity, materiality, and dailiness, photographs mirror the visual aspects of fetishism.[16] By "freezing" a moment, the photograph removes an event from history and time, yet by the same process it preserves that moment as a static object. Humphreys's text both reflects this theory and revises it, and fictional photographs function in the novel as key figures for the revision. The key site of this revisioning is the photograph's expanded audience. For the family photographs in Dreams of Sleep, like their counterparts in Daniell's and McCorkle's work, do not remain solely in the patriarch's determining gaze. They circulate, most often in the hands and gazes of women. Claire's pointed public display of Will's family photographs in his office—a compulsive reminder of the stable intimacy she is denied—both reinforces the patriarchal fetish of family and highlights its hypocrisy: the very existence of her mistress gaze undermines the "natural" family structure the photograph is meant to validate. The Reese family photographs further mutate under the diverse gazes of the other female characters in Dreams of Sleep, highlighting above all the "unstable and subjective nature of photographic representation as it is received by the sexed spectator" (Solomon-Godeau 258). Ironically, in a novel filled with the type of anxiety about vision, fixity, and objectification outlined by recent critics, photographs—those ultimate still, fetishized objects of the gaze—come to work against this fixation.[17]

In Alice's mind, at least at the beginning of the novel, the Sea Island photograph stands for entrapment, an envisioning that enables Will (and the other husbands she sees watching their wives at the resort) to fix her and their children according to his own pleasure and need. Even as she (silently) critiques it, Alice has internalized this cultured vision. Like so many of Percy's male characters, Alice "stares," looking for "mysteries," omens, and signs in the surfaces of daily life, especially in the daily, visible lives of women. Unlike Will, however, Alice watches other women not to confirm her own mastery or subjectivity but to compare them with herself as an object that will represent properly in Will's world: "Washing the cereal bowls she hopes she is not very different from other women. Don't they all stand this way, belly against the lip of the counter, hands going slowly in and out of the suds, eyes focused past the window?" (2). As the wife of a doctor and a descendant of an old Charleston family, Alice makes "a deal

for the real world" (150) and tries to fulfill the role of wife, mother, and lady that Will envisions for her. In the most extended, and pointed, of the novel's "watching" scenes, Will conceals himself on the front porch to observe Alice entering their house. Although Will believes he is not visible, the next chapter, told from Alice's point of view, reveals that "she sees him, of course" (57). Alice calculates how to present herself to Will's vision such that he and she will reconnect as husband and wife: she is wearing her "doctor's wife" clothes and hopes that he "will see her in a new way" (57). But Alice's attempt to represent herself within Will's gaze—to see herself through his eyes—fails precisely because as a female who is also a viewing, speaking subject, she can never live up to the fetishized ideal (the silent, still "marble statue") Will still holds dear. Alice's humming a modern tune as she stands within his view on the porch makes Will "furious" (56).

Alice's transformation in *Dreams of Sleep* comes through her recognition that such self-envisioning hampers her ability to act in the modern world. She moves from believing, "If you don't see yourself as being able to do it [act in the world], then you can't, no matter how easy it is," to recognizing, "Maybe that was the trouble. You didn't need to imagine it; you needed to *do* it" (203, 204). Significantly, it is primarily through the "different point of view" (67) of another woman, her babysitter Iris Moon, that Alice comes to her realization. Like Percy's Allie Huger in *The Second Coming*, Iris is young (eighteen) and has spent time in a mental hospital. Shortly after Alice hires Iris as a babysitter, she speculates that Iris may even be "slightly retarded," but she identifies this as an asset: like Allie Huger, Iris "seems strong" and "unburdened by a sense of history or home or kin" (129). But unlike Allie, Iris retains her memory and her ability to speak, and thus her ability to "start her life" independent of a male protector. Also unlike Allie, Iris comes from a lower-class white family: it is Iris who feels she must "protect" and care for her mother, who lives on welfare, an incapacitated victim of a codependent relationship with Iris's father. While Iris's history, home, and kin remain invisible to Alice, Iris, as her name implies, provides the lens that makes visible the class and race assumptions that help construct Alice's view of the world.

Iris becomes acquainted with the Reese family by viewing the same family photograph that sends Alice into despair; in fact, Humphreys presents Iris's vision and interpretation of the photograph before Alice's. Iris has grown up a member of the only white family living in an otherwise black housing project; the photograph of the Reese family is on the dresser of her next-door neighbor, Queen, who is Alice's mother-in-law's maid. Every year, Queen receives and displays a new family photograph of the Reese girls, though her feelings about her employer and these children are ambivalent. When one day the photographs

"glowed suddenly in their frame" and Iris determines to babysit for the Reeses, Queen cautions her about the dangers of "tending a white girl's babies" (17, 25). In addition to being cheated of fair pay and social security as an unofficial "family" member, there is the problem of love: "You got to love the babies, and they love you too awhile, at least till they get to school. Then they forget. They don't have no more need of you, they are gone" (26). Humphreys's portrayal of Queen is problematic: neither she nor her son Emory (whose name means "home strength") are fully rendered characters, mostly serving as the constant, stable support for Iris that her parents do not provide. But by including Queen's and Emory's consistent, intimate presence throughout the book, Humphreys does avoid the near-total "lenticular" separation of black and white southerners that haunts *Fatal Flowers* and *The Cheer Leader*. Queen's narration of the Reese photograph suggests that she frames the image not out of love or possessiveness but to contain the southern whiteness that is otherwise continually overstepping its bounds.

Queen and Emory help Iris see whiteness, both the children's ("the whitest children in the world," Iris thinks) and her own (24). When Iris responds to Emory's warning not to bury her true self taking care of the Reese children, saying, "They're not white children to *me*. They're children," Emory retorts, "I done forgot, Miss Iris. 'Scuse me, *ma'am*," shaming her into recognizing her assumed racial privilege (153). But though Iris loves both Queen and Emory, she willfully ignores their insights. To Iris, the Reese family photograph signifies possibility —the potential fulfillment of her own plan to "rescue" someone else's children (by kidnapping them) and love them properly, thus revising and reordering her own neglected childhood. This vision, significantly, parallels Will's desire to create his future life in the "proper" image that he felt lacking in his childhood. Each vision has a complex, and perhaps subconscious, relation to the fetish of the southern lady and to Alice: while Will would enshrine Alice as an "authentic" lady to counteract his mother's "failure" and to confirm his own identity, Iris would ensconce herself as a revised, though in a sense even purer, form of the lady she sees Alice failing to be—she would lead a life of complete devotion to children and the feeble, completely devoid of sex (but also free of male dominance). Ironically, it is Iris's desire to fulfill this image (with its intrinsic racism) that makes her unable to picture herself starting a new life with Emory. Though the effort is doomed to failure, Iris remains willfully blind to the discrepancy between her real and imagined life.

Alice perceives herself as a failure, even before she believes she overhears Iris proclaim her a "flop" (208), but it is because of Iris's motivating presence that the reader (if not Alice) gains a clearer understanding of the specific cultural

forces that shape Alice's vision and how she is viewed in the world. Iris's fearlessness inspires Alice to walk to the store "Iris's way" through a black neighborhood that from Alice's lenticular point of view is "like a world coexistent with the rest but not visible from it" (133). As Will seeks out "vanishing" and "doomed" traces of the South, Alice here nostalgically enjoys acting as "a pair of eyes, a mind, moving through this black neighborhood, this hidden world almost certainly doomed" (135). In a rare event, Alice reflects on the specifically southern aspect of her upbringing, with its complex racial and class tensions, but still, like Will, she considers herself a passive victim: "One day something will blow up, but Alice doesn't know whether it will be the world or the South or the Reese family" (134). At the store Alice's complacency is shattered by two events: she reads the words "FUCK YOU," carved, we may assume, by some meatpacker on the back of a chicken (and the two store workers to whom she reports the offense laugh), and she sees Claire kissing Will's friend Danny Cardozo, indicating that Will's affair (and by extension her own) has come to an end. Her response is, even in her own eyes, absurd and symptomatic: a fake, compressed scream from a canister called "the Shrieker" (139). Alice sees herself once again in the eyes of the terrified clerk staring at her—"*Crazy white woman*, she must think" (139). The reader, because Humphreys has juxtaposed Alice's consciousness of her southern context with Iris's, is encouraged to make a connection (at this midpoint in the novel) beyond the abilities of either character, to understand these regional forces of class, race, and gender as helping to construct the cultured vision that perpetuates the images by which these characters are defined and, consciously or not, by and against which they define themselves.

Iris's own progress in the novel is her recognition that she must in fact work within her own family and history to accomplish her goal of revisioning her future. But as she reinterprets the Reese photo at various points in the novel, Iris demonstrates the possibility of a cultured vision that changes through time, that is contingent on, as well as constitutive of, the human relationships in its view. Iris's final moments in the novel are a crisis of abandonment and exposure, wherein she almost allows herself to be taken in, literally and figuratively, by her father (who, true to form, disappears at the last second), and she finally acts out her own hostility and longing for her mother (she kicks a chair out from under Fay's feet, and Fay responds, finally, with attention). Although Iris here reenters the hazardous terrain of gendered power relations, her final episode nonetheless recuperates vision as a metaphor for self-awareness: now that "the outer coverings are gone" in her torturous relationship with her mother, mother and daughter can start again, knowing, "The danger is the same. The difference is that you can see it" (226–27).

Iris's most significant contribution to the novel is precisely her vision, or point of view, which Humphreys presents as counterstrategic to Will's and Alice's. To a photograph taken by a male photographer, directed by and for Will's vision, Iris brings the perspective of class-differentiated viewing, just as Queen introduces racial differentiation and Claire re-places the paternalistic gaze within the context of its own hypocrisy. From one version of southern identity—symbolized by the idealized image of the southern lady that fits none of the women— an expanded notion of southernness that accounts for alternative visions, and a revised view of vision itself, is revealed in the course of the novel. Will Reese may intend the Sea Island photograph to naturalize and stabilize his own patriarchal status. Instead, the image is revisioned by the gazes, and narratives, of the woman it would objectify (Alice) and of those it would render invisible (Claire, Iris, and Queen). In the public arena and within his own family, Will's photograph is subject to the indeterminate and potentially subversive field of interpretation. As Patricia Holland asserts (invoking Homi Bhabha), "Family photography may both conceal and reveal, but its investigation can never end with the closed circle it appears to represent. We are always returned to an interpretive community and faced with the recognition of difference and dissent" (Spence and Holland 14).

Thus the photograph that may initially be read as a metaphor for Will's fetishistic fixation instead suggests that representation, even photographic representation, is a process. The family photograph, like all representations, is "part of a set of relations" that, as Gillian Swanson has explained, is "structured according to a hierarchy" but is nevertheless "always open to a recasting, seeing meanings according to a range of differences rather than as unequivocal, as established through a series of norms against which difference is measured" (26). This is the specifically feminist thrust of Humphreys's cultured re-visioning: to take the South's fixing of masculine subject/feminine object positions as a problem, rather than as a given.[18] Through the novel's photographic metaphors, the mystery of meaning—and of identity—is transformed from an essence or truth to be discovered and owned to a negotiation of complex and shifting relationships.

The photographs that pervade *Dreams of Sleep* (always of women) stand for the larger project of Humphreys's revision of southern texts such as Percy's. The female characters in Percy's books are perceived by their male watchers as the central image of whatever construction of the southern world those watchers are trying to uphold. In Percy's work, the camera figures explicitly as the tool of Will Barrett's voyeuristic, and desperate, gaze.[19] But in Humphreys's novel, as in Daniell's memoir and McCorkle's fiction, it is women who own, manipulate, and interpret the photographs themselves, revealing the supposedly fixed images to

CHAPTER 3

CAMERAS AND

THE RACIAL REAL

PHOTOGRAPHS

AS EVIDENCE AND

ASSERTION IN

AFRICAN AMERICAN

SOUTHERN FICTION

Since then I've sometimes been overcome with a passion to return into that "heart of darkness" across the Mason-Dixon line, but then I remind myself that the true darkness lies within my own mind, and the idea loses itself in the gloom. Still the passion persists. Sometimes I feel the need to reaffirm all of it, the whole unhappy territory and all the things loved and unlovable in it, for all of it is part of me. Till now, however, this is as far as I've ever gotten, for all life seen from the hole of invisibility is absurd.
—Ralph Ellison, Invisible Man

Again and again, when the negative space of the woman of color meets the Age of Mechanical Reproduction or, worse yet, Baudrillard's "simulations," the resulting effect is . . . a form larger than life, and yet a deformation powerless to speak.
—Michelle Wallace, Invisibility Blues

As we have seen in Daniell's memoir and McCorkle's and Humphreys's fiction, the obsessive visualization of southern white womanhood leads to a myopic and willful blindness toward black southerners, "like a world coexistent with the rest but not visible from it" (Humphreys 133). Aunt Jemima, Jezebel, Prissy, Brown Sugar—these images may be so customary as to be "practically invisible, part of America's racial background noise" (Roberts 1). Or, more like a photographic negative, images of southern black women—counterimages that represent a black female story of racial exploitation or pride or resistance—may be so unfamiliar, may be such an opposing mirror, as to be purposely, necessarily rendered invisible in the development of a positive southern white female identity. Jane Rule Burdine's "Elizabeth Says Goodbye, Greenville, Mississippi" bids farewell to unseen others that, thanks to photographers like fellow Greenvillian Henry Clay Anderson, we know included proudly *self*-representing African American women. Racist daguerreotypes like J. T. Zealy's "portrait" of "Drana, Country Born" explode their original boundaries in antebellum culture, as contemporary photographers like Carrie Mae Weems and Clarissa Sligh reappropriate these "anthropological" images within their own revisionist critiques. In each case, what Michelle Wallace characterizes as the "negative space of the woman of color" (Invisibility Blues 252) foregrounds the complex, ambivalent role of visibility in establishing the race and gender boundaries that mark individual, communal, and regional identity in the South.[1]

Negative space as illustrated by juxtaposed numbers 2 and 3. From Donis A. Dondis, A Primer of Visual Literacy (1973). (Courtesy of MIT Press)

Of course, negative space is only "negative" in relation to what dominates the eye, and this, as "trick" Gestalt images like the juxtaposed 2 and 3 teach us, is crucially activated by the eye of the beholder. Issues of visibility and invisibility, of visualized subjection and resistance, figure centrally in contemporary African American southern culture and discourse, particularly in the work of activist writers such as Julie Dash and Alice Walker. Yet, as the critical response to Dash's film and novel, *Daughters of the Dust*, and Walker's fiction—especially the earlier, southern-based novels—indicates, attempts to re-vision the "negative space" of the southern black woman into a dominant position are challenged not only by the formidable legacy of the white southern lady but also by long-standing debates within African American culture over "positive" and "negative" images of African Americans.[2] At the root of these debates are an anxiety about technologies of "realism" that have worked to naturalize and reinforce derogatory stereotypes of African American men and women, a wariness born of the historic power of visual representations to evidence the "real" of race, and a fear of potential audience misinterpretation or misuse of these representations.

In this chapter I want to reopen the discussion of images in Alice Walker's fiction, but to focus on how images themselves are represented in her work within larger discussions of visual power, ambivalence, and representational politics in the African American South. Zora Neale Hurston's career in anthropological photography and Julie Dash's evocation of Hurston's work in the film and novel versions of *Daughters of the Dust* provide a context for understanding the complex imbrications of familial and public self-presentation that Walker develops in her fiction. In Walker's short story "Everyday Use" and her novels *Meridian* and *The Temple of My Familiar*, fictional photographs serve as potent figures, not only of the power of visual representations to real-ize identity, but of the crucial determining role of audiences in activating that power. In the hands of Walker's southern black female protagonists—hands that often hold fictional cameras and photographs—the "negative space" of the black southern woman becomes a central, complex field. Reflecting photography's double legacy for African Americans in the South, the fictional photographs in Walker's works serve as a barometer, registering the internal pressures of representation within African American communities and between their southern and world contexts.

The representational pressures figured in Walker's fictional photographs speak both to photography's long-standing association with visible "evidence" and to the visible's "long, contested, and highly contradictory role as the primary vehicle for making race 'real' in the United States" (Wiegman 21). In the antebellum and Reconstruction South, whites justified the subjugation of Africans, African Americans, and Native Americans with a variety of "evidence," including biblical, philosophical, anecdotal, and linguistic.[3] When "scientific" evidence was called for, however, the primary approach was anthropological, and the mode of inquiry and transmission, visual.[4] Robyn Wiegman has skillfully applied Foucault's genealogy of vision, knowledge, and power to European and American racial histories, to argue that "economies of visibility" (understood as both the economic system undergirding race slavery and "the epistemologies attending vision and their logics of corporeal inscription") were the foundation of scientific racism and the racial oppression it justified (4). By most historical and critical accounts, photography has functioned as a leading technology in such visual economies.

Because it has been read as such an effective tool of the state—providing evidence par excellence whether to support government-backed scientific or social programs (anthropology, criminology, public health) or to inspire emotional adherence for policies such as the New Deal—photography has justifiably been associated with both literal and figurative objectification, colonization, and exploitation. Since the 1930s, however, Western photography criticism has unjustifiably theorized photography in terms of mastery and domination that make it difficult, if not impossible, to imagine an oppressed people using the camera to assert subjectivity. For African American women, the theoretical problems seem especially acute. As explored in the previous chapter, feminist photography theory beginning in the 1970s followed feminist film theory in embracing the psychoanalytic paradigm. Thus, following the "science" of Freudian and Lacanian psychoanalysis, both the acts and products of photography are figured in terms of a masculine gaze acting upon a passive feminine object; as a visual recorder, the camera by definition becomes the masculine predatory agent, reducing all in its view to the position of static, feminized fetish-objects. Later, so-called postcolonial formulations of photography build on this model, asserting that photography is an inherently aggressive medium, a tool invented by the West at the cusp of the imperialist expansion and designed to assure Westerners of their own mastery. Stemming from Edward Said's characterization of the Western will to power as a "unitary web of vision" (240), studies like Malek Alloula's The Colo-

nial *Harem* and Catherine Lutz and Jane Collins's *Reading National Geographic* echo theorists such as Kobena Mercer that photography "lubricates the ideological reproduction of 'colonial fantasy' based on the desire for mastery and power over the racialized Other" (352). The camera, in much of this theory, is inherently a "master's tool": the structurally inherent framing action of photography, to use Abigail Solomon-Godeau's words, "offers a static, uniform field in which orthogonals converge at a single vanishing point," conferring a position of visual mastery on the spectator and relegating the viewed to the status of an object that exists solely to confirm the subjectivity of the master-viewer (180–81).[5]

Central to maintaining this ideological fantasy is a fetishistic, photographic fixity (of the type discussed in chapter 2) and a strict alignment of photography with realism. What is often effaced within discussions of photography's "reality effect," however, is the historically constructed, rather than technically inherent, nature of the effect itself.[6] As Robert Ray has illustrated, the photograph's status as evidence had to be asserted and policed by *language*, precisely because of photography's radical indeterminacy as a technology of self-evidential explanation. The fascinatingly irrelevant detail, the "mute ambiguity" of a photograph, would not conform to the real of racial ideology (for instance), evoking instead "precisely what eluded classification" (Ray 155), so language was employed to recuperate photography as a mode of "instrumental" realism, within an evidential frame. This is perhaps what Benjamin noted when, citing Brecht, he dismissed photography's transparency: "Less than ever does a simple *reproduction of reality* express something about reality" ("Short History" 213, emphasis in original). Nevertheless, because "documentary" practice "embraced—and indeed elevated to an ethical principle—the notion of photography as evidentiary truth" (Solomon-Godeau 188), and because that practice has historically been employed in the ideological reproduction of domination, realist photographs are discounted as potential tools of resistance. For instance, a collection of lesbian photographs does not include documentary work because "the realism of documentary has often been used ideologically to reinforce notions of naturalness" (Boffin and Fraser 9–10). And Henry Louis Gates Jr.'s passionate defense of Kara Walker's and Michael Ray Charles's controversial visual reenactments of racial stereotypes as having "evolve[d] beyond realism to the meta-level of self-conscious, political and formalistic commentary" implies that realist images contain the ideological hurts of racism, and that an artistic practice "beyond realism" is the true sign of self-awareness and control ("Extreme Times" 5).

Confined first to tightly controlled studio "portraits" (such as the slave anatomy studies provided a Harvard anthropologist by southern photographer J. T. Zealy) and developing into a wider documentary field that would be known as

"visual anthropology," photography emerged as one of the most trusted forms of visual evidence to support anthropological theories of race. Not surprisingly, white southern anthropologists formed some of the most enthusiastic adherents to the "American School" of anthropology, which used visual cues and comparative anatomy to argue that Negroes and Caucasians were the products of two separate creations.[7] Despite the abrupt decline of the American School (squelched by Darwin's reunification of human origin), the association of comparative anatomy with racial hierarchy, and photography's role in providing "evidence" to support it, lasted well into the twentieth century and provided a legitimizing basis for the continued subjugation of African Americans, especially in the South.[8] The new anthropology, legitimated by the new visual evidence, amounted to a biological renaturalization of the old visible "evidence" of race. As such, anthropology took its place within a new visual epistemology, in which an ethic of observation became more closely intertwined with the construction of state identity and power.

In order for photographs to perform their real-izing function in anthropology, however, their status as evidence must first be accepted as natural, as somehow inherent in the very technology of cameras and film. If, given the many un-realistic qualities of early photographs, it was a "curious phenomenon" that virtually all nineteenth-century Americans accepted photography as objective truth, it is even more curious that—despite years of modernist and postmodernist debunking of photography's indexical attachment to the real, and despite what would seem enormous political and ideological stakes in refuting this attachment—many twentieth-century Americans, including the critical theorists cited above, still tacitly accept (and in some cases insist on) this association. In the case of African American southerners, as I have argued in the introduction, this tacit acceptance may be strategic. Partly in response to repressive white southern visualizations of black identity and to the practical strictures placed on black visual expression, and also as part of a larger strategic effort to construct a black southern, nationalist identity, early black southerners and their more recent critical interpreters have tended to focus on powerful traditions of African American oral and aural expression. Here I want to suggest that despite some real political benefits of this strategy, bracketing the visual, or worse, using the exploitative visual as a foil against which African American orality can assert itself, ensures that images of the black southerner, especially of the black southern woman, will remain, in several senses of the term, "negative space." Historical, material strictures become theoretical strictures as well, resulting in a critical un-acknowledgment of rich historical and literary traditions of African American strategies of visual resistance. The work of southern black women

writers such as Zora Neale Hurston, Julie Dash, and Alice Walker leads us beyond dichotomies of powerful orality and exploitative visibility, of "positive" and "negative" images, to show that the complex legacy of African American visibility is not an either/or proposition but an ambivalent dynamic that admits mutual influences, fluid boundaries, and multiple possibilities. Encouraging the move beyond positive/negative images, bell hooks has called on black intellectuals and their allies to make "the effort to critically intervene and transform the world of image making authority" central to "political movements of liberation and self-determination" (4). With its continuing concern to explore and address this "world of image making authority" in the South, the work of Alice Walker lends itself to just such a project.

ZORA NEALE HURSTON'S ANTHROPOLOGICAL GAZE

In the twin lights of the critical emphasis on aurality and the racist tradition of visualized anthropology in the South, it is both fortuitous and appropriate that the southern black woman whom Alice Walker found as her great literary influence also happens to have been a trained anthropologist.[9] Zora Neale Hurston has been praised for her attention to oral narrative techniques and the "speakerly" quality of her texts, and Walker's work has been profitably analyzed as a direct continuation and revision of that aspect of Hurston's project.[10] But Walker's work, like Dash's that follows it, evidences a keen awareness of and response to a less-discussed yet no less salient facet of Hurston's legacy: Hurston's role as a southern black female anthropologist in the context of a white southern anthropological tradition and the complex interventions in a *visual* tradition that she thus effected. It is in each author's treatment of the visual—particularly the visual in context of its historical, evidential force—that we may see how Dash's and Walker's work expands on Hurston's model to address issues of cultural vision and representation crucial to each writer. In the trajectory of this work, we can begin to trace a southern, "womanist" history of African American reappropriation of photography to transgress boundaries and reorder representational politics within the anthropological and literary fields.

With photography historically and critically linked to racism, imperialism, and patriarchy, the possibility that African American women and/or other historically dominated groups might reappropriate this technology for their own political and expressive ends seems dim indeed. Yet, even as James Agee was writing the painful meditation on photographic and representational exploitation that would become *Let Us Now Praise Famous Men*, Hurston was demonstrating just such a reappropriation. The spirit of Hurston's collecting varied widely from the

social realism of Agee and Evans, or of her more direct rival Richard Wright: she was working to transform representations of her subjects from "tongueless, earless, eyeless conveniences" (Hurston, *Their Eyes* 1) to powerful creative, complex beings. Hurston did not eschew photography's realism; rather, she sought to reclaim its power, from supporting racist "science" to confirming African American experience. Often, this involved recasting or reframing images that many African Americans (such as Wright) considered iconically "negative." Beginning in the later 1920s Hurston traveled to Florida and throughout the South collecting images and folk speech, often carrying a camera with her as part of what she called "the spy-glass of Anthropology" (*Mules and Men* 1).[11] The last decade has seen increasing acknowledgment of Hurston's foundational role in filmic anthropology and the ways her particular technique—which ranges from static wide shots to handheld angles from within dance groups to mock anthropological head shots—anticipates postmodernist anthropological practice, visual and otherwise. As many critics have noted, Hurston in her visual and written anthropology searched for techniques that would embody African American expressive culture on its own terms, while also avoiding, as she told Langston Hughes in 1929, "loop-holes for the scientific crowd to rend and tear us" (quoted in Hemenway 126).[12] Sieglinde Lemke has argued that although Hurston blurred generic boundaries in her anthropological work, her "faith in 'pure objectivity' remained unshattered" (173). Hurston takes up the camera for revisionary purposes, but very much with a faith in the precepts of anthropology and (at least implicitly) in photographic anthropology.

Hurston's 1938 work, *Tell My Horse*, provides a first-person anthropological account of Afro-Caribbean culture in Jamaica and Haiti that includes several brief accounts of photography, along with actual photographs, by the author. Hurston's camera functions within this text as a rhetorical sign that places Hurston in both an outside (anthropological) and inside (African-descended) relation to her Haitian and Jamaican subjects. When the camera highlights her status as an outsider, it is as a symbol of the naiveté and potential danger of the anthropological project, both for the anthropologist and the observed culture. Employing a strategic self-deprecating humor, Hurston describes how she pressures her Jamaican hosts into going on a very dangerous wild hog hunt, so that she can sample authentic jerked pig. The serious preparations for the trip include fashioning spears, loading days' worth of food, and ritual blessings befitting of the possibility of bodily harm or death. As the party begins its trek, the hunters carry spears and guns; Hurston mockingly contrasts her own gear: "I stumbled along with my camera and note book and a few little womanish things like comb and tooth brush and a towel" (32). Unlike her companions, Hurston is soon over-

whelmed by the rough terrain, and on the second day she loses her Kodak or, as she writes ambiguously, "Maybe I threw it away" (33). We may read this episode as a comment on the utter uselessness of modern technologies in the rugged backcountry of Jamaica, or even of the shallowness of overvaluing vision: the "hog-sign" that the hunting party is searching for turns out to be a scent, not a sight. At the same time, Hurston's casual, or perhaps active, loss of the camera signals her immersion in the hunt experience and cements her authority to speak about it. Losing, or rejecting, Western *technologies* of vision, this view suggests, may be key to understanding Afro-Caribbean culture. Yet if the claimed and disclaimed camera signals Hurston's critique of American ideological notions of "evidence," Hurston does not renounce her outside status: rather, she claims it as a value in what Bakhtin would call her dialogic, "creative understanding" of Jamaican culture (7).[13] Hurston maintains her particular outside/inside status within the hunting party; her unacculturated feet continue to ache the entire way back, but as the group enters the village, she too is singing the Karamante' songs.

Another episode in *Tell My Horse* points to a more radical purpose behind Hurston's use of actual and textual photographs and reveals Hurston's complex understanding of photography's relation to the "real"—an understanding that both acknowledges the legacy of photographic mastery and reappropriates this mastery to assert a specifically Afro-Caribbean reality. In what she calls the "greatest thrill" of her research in Haiti, Hurston came "face to face with a Zombie" and photographed her (*Dust Tracks* 168).[14] Throughout *Tell My Horse*, Hurston narrates voodoo practices and lore, implicitly demanding that her readers accept them as no "more invalid than any other religion" (*Dust Tracks* 169). Yet in the case of Zombies, Hurston admits that she might have left Haiti "interested but doubtful," but for the fact that "I had the rare opportunity to see and touch an authentic case. I listened to the broken noises in its throat, and then, I did what no one else had ever done, I photographed it. . . . So I know that there are Zombies in Haiti. People have been called back from the dead" (*Tell My Horse* 182). In this case, far from losing or throwing away her camera, Hurston obtains permission from doctors to photograph the hospitalized Zombie and makes several images. She includes one of these photographs in *Tell My Horse* and provides her subject's name: Felicia Felix-Mentor. Moving from her own subjugated position within U.S. racist culture, Hurston seizes a technology that is in theory inherently exploitative. By inscribing her own gaze upon the further subjugated Haitians (including the ultimate "colonized" body of a Zombie), Hurston both invokes the colonizing power of the camera and revises it through a trickster strategy. Rather than disclaiming photography's evidential relation to the real, here Hurston *uses* photography's "realism" to appeal to her Western readers' cultural belief (that

"photographs reflect reality") in order to assert and provide evidence for what they might otherwise deny as unreal—the power of African traditions embodied.

This assertion is an instance of what Homi Bhabha theorized as the ambivalence of "transparent" discourses of colonial authority such as photography: an inherent ambivalence, born of the simultaneous assertion of colonial coherence and difference, that enables resistance as "a form of subversion, founded on the undecidability that turns the discursive conditions of dominance into the grounds of intervention" (112). Adding to this undecidability is the fact that Hurston's are not the only photographs that illustrate Tell My Horse: roughly half of the photos, and almost all that seem to be of active, ongoing voodoo ceremonies, are identified as having been taken by Rex Hardy Jr. In November 1937 Hardy was a twenty-two-year-old photographer traveling with writer Alexander King to cover a border war between Haiti and the Dominican Republic for Life magazine. According to Hardy, King had "an additional private agenda. He was interested in Voodoo and had communicated with his friend Nora [sic] Hurston, who put us in touch with a Houngan (voodoo priest) in Port au Prince. . . . He arranged for us to attend a voodoo ceremony in the jungle outside the city. . . . This was all very secret. These were the pictures which later turned up in Ms. Hurston's book."[15] Hurston had returned to the United States from her Guggenheim-financed research in Haiti in late September: she, King, and Hardy never met.[16] Hardy's photographs appeared in photo-essay form in two consecutive issues of Life in December 1937, and clearly King and Hurston were in contact: Hurston ("a Negro author with a Guggenheim fellowship") is credited with one of the photographs in the spread, the photo of Felix-Mentor, labeled "the first photograph of a zombie ever taken" ("Black Haiti" 27). There is no known correspondence documenting the decision to include Hardy's photographs in Tell My Horse: Hardy himself recalls that he did not find out his photographs were included until well after the book's publication.[17] It is possible that Hurston's publisher Lippincott bought Hardy's photographs without consulting Hurston, to better illustrate Hurston's text; it is also possible that Hurston, near the peak of her career, had some voice in the selection and deliberately chose to include the Hardy images, perhaps to add another layer of "ambivalence" to the photographic project of the text.

At an iconic level, it is difficult to tell the difference between Hurston's and Hardy's "Voodooism" photographs, although generally Hurston's are more intimate images of people she knows and writes of in the text, such as the Mambo Etienne or the bathers at the sacred spring, Saut d'Eau. The "reality effect" functions similarly for each. But while the Life photo-essays trade on a tradition of colonial exoticism, with its twin traces of fear and desire, Hurston's language

and personal photographic authority re-anchor the visual iconography of *Tell My Horse* within her own Afrocentric narrative. Hurston's text and its accompanying photographs encourage a rethinking of postcolonial theories of the photographic gaze, away from iconographic readings of how subjects are constructed by colonial visions and toward what might be called more broadly iconologic readings of images in a relation or exchange. What we are left with is an economy of gazes and their representative images that, though never a free trade zone, is in the business of crossing borders as much as building them.

ANTHROPOLOGICAL DAUGHTERS

Julie Dash's 1992 film, *Daughters of the Dust*, and its sequel, the 1997 novel of the same name, evoke Hurston's anthropology career and the complex theoretical and ethical issues raised by her photographic practice. While Hurston was concerned to represent black folk as a "people," Dash in her carefully researched fictions highlights the slippery relation between representing a "people" and representing family in African American southern culture. Marianne Hirsch's general observation that family photography is always "doubly exposed"—embedded at once in the family frame and in the broader cultural context wherein that family exists (*Familial Gaze* xii)—rings especially true in the history of African American southern family photographs, where, as the work by Clarissa Sligh, bell hooks, and Deborah Willis discussed in chapter 1 attests, the racial subtext of southern visual colonization and exploitation lurks behind every album and wall of family images. If the southern legacy of anthropological and stereotypical imagery has rendered photography an inherently self-conscious medium for African American southerners, Dash's work makes these dynamics explicit, raising the implicit issues in Hurston's anthropology to the level of organizing theme and principle. Placing cameras in the hands of her black "anthropologist" characters, and placing those characters squarely in the fault lines between family and public cultures, Dash explores a southern representational politics of modernity, identity, resistance, and the African American "real" that signifies her "people's" ongoing history of survival and self-determination.

The filmic *Daughters* chronicles one day in 1902, as members of the Peazant family prepare to leave their South Carolina Gullah (or Geechee) island home to migrate to New York. Contemporary critical reception centered on the film's visual lushness and lyrical beauty, though several critics voiced concern that this beauty detracted from the realism of Dash's vision: Jeff Shannon of the *Seattle Times* complained, "Most of the time the characters are strolling or lounging about; we never see the farming skills which provide their lavish feast, barely

feel the resented presence of white landlords across the water"; and Todd Carr of *Daily Variety* concurred, "Regardless of the extent of the research, [the film] refuses to satisfy on a documentary level."[18] These responses reflect a cultured vision trained to see southern black bodies either in grotesque stereotype or as vehicles for social realism: as Dash herself remarked, there is no critical context for a film so thoroughly researched and loaded with unfamiliar ethnicity, outside of the documentary genre (*Making* 28). It is as if the familial images in Dash's film are insufficiently "negative" to convey her African American characters' place either within recognizably (racist) "southern" ideology or within an American narrative of the pathological or tragic black family. They thus fail to signify, particularly in the eyes of the Hollywood critics and executives who repeatedly told Dash, "they just couldn't see it" (Mills 30). Again, the issue centers on an ambivalent photographic concept of the "real," as it butts against the "real" of African American experience and history. In interviews Dash emphasizes that she has taken liberties with historical fact (using, for example, indigo-stained hands as a lingering symbol of slavery, when such stains would not actually have remained on skin) in order to support her larger re-visioning of the legacy of African and slave culture. Bell hooks finds that the film's strength is "its insistence on a movement away from dependence on 'reality,' 'accuracy,' 'authenticity,' into a realm of the imaginative," ultimately asserting that the question of the real "isn't the point" (Dash, *Making* 31). But the vexed issue of the "real" of African American experience everywhere haunts *Daughters of the Dust.* The struggle to define what that "real" will be—the "real" of the ancestral culture of Dawtah Island, or the "real" of the modern, mainland world—is the central conflict for the characters, and Dash's effort to represent both "reals" in concert is the source of the film's lyricism and of its discomfort for some critics.

Dash embodies the contact point of these "reals" in the character of a photographer. Returning from her Christian missionary activities on the mainland to guide her family in its transition, Viola Peazant brings with her to the island Mr. Snead, a "Philadelphia-looking Negro" photographer, to document the family's departure.[19] With his camera and kaleidoscope, Mr. Snead is the personification of modern technological progress and the "culture, education and wealth of the mainland" that Viola has promised her family (*Making* 79). Snead's commission is primarily an anthropological one: he has been hired to "document" a cultural migration. It becomes increasingly meaningful to Snead, however, that this migration is not only of a "people" but of a family. Acting as an amateur anthropologist, Snead begins conducting interviews with the family members he photographs, and later he seeks out other "extended family" members such as the Muslim Bilal Muhammed, who lives on a remote part of the island. Unlike

Viola, a Peazant daughter who has removed herself from her heritage by donning a cloak of Christianity and who attempts to maintain her ethnographic detachment until the very end, Mr. Snead comes to recognize the common thread of history that connects him to the African traditions preserved on the island, and he readily participates in the family and religious rituals. Snead's conversion from anthropologist to "family" photographer is effected not only by the oral history he collects but also courtesy of his own camera. For the first half of the film, Snead reacts to the family tales of "Salt Water Negroes" and "magic" folk remedies with amused skepticism. But, as he prepares to take a group portrait of the Peazant men, Snead is startled to see the image of a young girl (the Unborn Child who has been narrating the film) in the camera's viewfinder. The scene is clearly coded comic as he jumps from beneath his camera cloth only to find no trace of the little girl. Film critic Jacquie Jones asserts that Snead is not the only one surprised by the camera's vision: "When she startles Mr. Snead, the Unborn Child unnerves American cinematic protocol, which demands that history be uncomplicated and purged, that Africa be foreign and romantic, that Black women be negligible and simple, and that African American culture be conscripted by oppression and ethical poverty" (21). This unnerving does not call into question the value or validity of visual technologies: rather, as Julia Erhart has argued, the scene affirms the power and promise of these technologies for effecting a more inclusive cultured vision.[20] Like Hurston, Dash here strategically uses photography's cultural associations with reality to convey the "real" of African American spiritual and cultural beliefs. If, as Dash has suggested, Mr. Snead stands in for the film's viewing public, catching a glimpse of the Unborn Child in the viewfinder encourages that audience (who has been seeing and hearing the Unborn Child throughout the film) not to dismiss her as filmic fantasy, but to really believe what they are seeing. The "reality effect" of Snead's camera mirrors the function of Dash's cinematic camera for her audience: the oral, interpersonal legacy of the ancestors is supplemented, and may ultimately be supplanted, by the power of modern visual representations.

Mr. Snead's reaction to his camera's vision also models the hoped-for result of Dash's film: a move toward greater understanding, accommodation, and embrace of a living African heritage. Snead alters his anthropological mode from distanced observer to participant. He does not stop taking (or believing in) photographs, but rather he becomes "inspired . . . going for angles and camera positions unlike the traditional compositions of his day" (Making 146). Snead's transformation is also the primary trajectory of Dash's novel Daughters of the Dust, which brings questions of anthropological appreciation and appropriation to bear in a more explicit—and more explicitly feminist—relation to the southern

African American family. Set in 1924, this sequel chronicles the return to the islands by Amelia Varnes, the granddaughter of Haagar, the Peazant daughter who most vehemently rejected the ancestral ways of the Gullahs. Raised in a loveless marriage in New York, Amelia becomes curious about her island heritage when she completes a college anthropology assignment. In a situation strongly reminiscent of the beginnings of Hurston's career, Amelia's esteemed professor is intrigued by Amelia's family history and excited by the access she as a relative may have to the Gullah people: he secures funding from a mysterious benefactor (who may wish to develop some property there) for an extended period of fieldwork on Dawtah Island. He supplements Amelia's own Brownie camera with a benefactor-financed 16-millimeter motion picture camera. Snead's outsider status and male gaze is in the later *Daughters* replaced with an even more pointedly "doubly exposed" figure: a female familial "insider" whose education, relative wealth, and representational power (all symbolized in the cameras she totes) place her in a tenuous, "outside" relation to the relatives she comes to study.

When Virginia photographer Clarissa Sligh discusses her role as keeper of her family's photo albums in the 1950s, she emphasizes the intertwining strands of racism and representational politics that motivated her own photographic gaze: "I wanted to create a positive image of the black American family—but it was based on the stereotype of the white American family. I rarely saw anything positive about blacks in the newspaper. Making a family album was, for me, a reaction to all the negative imagery that was in the daily newspapers, one way of resisting those stereotypes."[21] In the island environment that Dash constructs in her novel, the daily bombardment of this white gaze and its effects on African American self-representation seem far away, firmly at bay. The walls of family photographs and letters in Nana Peazant's old house, now inhabited by her greatgranddaughter Elizabeth (the Unborn Child of the film), are like the walls of photographs in bell hooks's southern grandmother's house: "a private, blackowned and -operated gallery" (in Willis, *Picturing Us* 47), a representational safe space. As Elizabeth Abel has pointed out in relation to hooks's work, these "galleries" are also a generationally distinct, gendered space of female expression (in Hirsch, *Familial Gaze* 131). Indeed, the patriarchal and colonizing male gaze seems in the *Daughters* sequel to be functionally marginal. The "cameramen" who have visited the island over the years, including the amateur-anthropologist-cum-family-photographer Mr. Snead, are significant only for their products: family photographs that the women of the novel employ as the modern-day equivalents of the tin can of relics that Nana Peazant used as an incentive and aid to storytelling.[22] When Eula Peazant complains to Amelia, "I been trying to talk Eli into going to the mainland to get some good pictures of the family," Eli

just shrugs (76). In contrast to Humphreys's Will Reese, who attempts to embody his patriarchal vision in a family photograph, or to the African American patriarchs who sat surrounded by their families for portrait photographers like Richard Samuel Roberts or Prentice Polk, Eli Peazant seems to have little investment in such "modern" material representations of his familial power. And although the sponsors of Amelia's anthropology fieldwork are white men interested in the academic and physical colonization of the island, Dash keeps them on the periphery of the novel, ostensibly focusing her narrative on the internal ethics of representation within a female-centered, African American frame. In Dash's novel, even more so than in her film, it is black women who control the means, contexts, and display of familial photographic representations.

Yet, as the reaction to Amelia's arrival with her cameras attests, the residents of Dawtah Island are extremely conscious of the anthropological gaze and its exploitative legacy. Receiving Amelia as a family member, her relatives are shocked to discover her anthropological purpose. One even questions Amelia's familial status: "We dont know she. She come down here to make fun of us like de other mainlanders. Ackin like we de fools!" (77). Amelia's embarrassment in this scene marks the beginning of her own double consciousness of her status as family and "scientist." Predictably, like Mr. Snead before her, Amelia comes to identify much more strongly with her extended family than with the anthropological project that sent her to study them. Warned by Elizabeth that the walls of photographs and letters in Nana's house are "not all of us by a long way," Amelia gradually learns to listen to people tell their stories "their own way" (86). Her participation in the daily activities of the community, from farming to drinking to praying, results in a self-reflexivity and cultural awareness that inspire Amelia to reject the "distant perspective and cold language" of her anthropological training and the ideological and physical technologies of anthropological "evidence" (283). As the embodiment of the objectifying and freezing properties of colonizing vision, the camera would be the logical symbol of the exploitative anthropological gaze, ripe for rejection. Indeed, the camera does not stay in Amelia's hands for long. Amelia finds it cumbersome and increasingly lets her young cousin Ben, who seems to have a natural talent for composition and timing, handle the photographic part of her collecting. Although Amelia's anthropology professor early on praises Amelia and her "research assistant" for their "strong pictorial sense" (205), Amelia herself does not see the processed film until well after her return to New York, where it is clear that she had not only lost track of the amount of footage Ben has shot but "had actually forgotten about it" altogether (281). Like Hurston on the hog hunt, Amelia seems to have "thrown

turing" practices for its own ends. If, as Martin Heidegger asserted in the 1930s, turning the world into a picture is the distinguishing obsession of the modern age (134), then Amelia's refusal to have her thesis and film shown publicly—to avoid being herself an agent of change—may be read as a refusal of modernity. But when that refusal is read in light of Amelia's determination to return to the island with her family images *for her family*, we are encouraged to find not a rejection of modernity but an attempt to control the contexts of that modernity, to render it integral to the community's self-representational practice.[23]

Amelia's revisionary anthropological project is a more complexly layered instance of the postcolonial photographic reclamation documented by Michael Aird, where descendants of Aboriginal victims of European anthropological photography "look past" stereotypical depictions to find evidence and memory of their ancestors and culture (in Pinney and Peterson 25). In Dash's novel the anthropologist is herself part of the family she studies, and the photographs that were initially intended as anthropological documents transform almost in the making into family photographs. But as these family photographs are of African American southerners, they will be seen culturally not only by Amelia's professors but also by a wider American audience (including whites and "mainlander" blacks) as transparent "evidence," understood within the southern visual legacy of racist and classist anthropology, documentary photography, and regional stereotypes. Preparing her thesis film, Amelia must "look through" the dominant cultured vision and edit accordingly. Excluded—held back for her family's viewing—is footage that might be misconstrued or used as "negative" evidence: the humorous "trick" shots, Amelia herself working in the fields, Rebecca looking frozen and hypnotized by the camera. Included are images of islanders at work, church, and play, creating a "pictorial story that ran through the lives of the people, never intruding, but showing their everyday realities and capturing their grace" (291). Such images literally silence the skeptical committee members. And while even these images might be read as "negative" by "mainlanders" such as Amelia's grandmother Haagar, the novel leaves no doubt that the film will be cherished by the formerly skeptic islanders as an important component of family memory, much like the walls of photographs in Nana's old house. While the "conventions of the traditional anthropological view" are soundly rejected in the novel, the camera and its "realism" are not. Rather, the fictional photographs in Dash's narrative function precisely as evidence: evidence of that which cannot be seen in racist American culture. Amelia's solution to her anthropological dilemma implies that some images should not be shown in the wider culture, for their own protection. But the "doubly exposed" status of film and photographs

at the novel's end suggests a productive ambivalence about the "transparent" technologies of anthropological authority—an ambivalence that enables Dash's feminist characters to reclaim these media's power to represent the "real" of their own heritage and modernity. The *Daughters of the Dust* novel "shows" the full range of Amelia's images; in conjunction with the film, it offers a positive assertion of the possibilities, alongside the risks, of African American visual representation.

ALICE WALKER'S REALPOLITICS

Working in a southern milieu, Alice Walker explores similar themes of intracultural, domestic "anthropology" in her story "Everyday Use" and her novel *Meridian*. As in the novel *Daughters of the Dust* and in the bulk of Hurston's work, the "anthropology" taking place in "Everyday Use" is done by an African American southern woman who has had an "outside" education and returned to visit her native community. But Walker's story is loaded with the historical ironies of the 1960s Black Power and Africanist movements that in some cases prevented understanding *within* African American cultures: Walker's amateur anthropologist experiences no conversion to a cultural empathy with her familial subjects. Immersed in a symbolic Africanist movement, the ever-stylish Dee, now called Wangero, returns to her mother's house (presumably from the North) to "rescue" her heritage from her backward southern relatives. Even before kissing her mother, Dee snaps a series of Polaroid photos designed to highlight the rural, "authentic" setting she once loathed. In her mother's account, Dee "stoops down quickly and lines up picture after picture of me sitting there in front of the house with Maggie cowering behind me. She never takes a shot without making sure the house is included. When a cow comes nibbling around the edge of the yard she snaps it and me and Maggie *and* the house" (29). The camera in Dee's hands becomes a symbol and symptom of her shallow understanding of the culture she seeks to capture and claim. It is one of our first and most concrete clues that Dee's new interest in her culture is fixated on objects (these include her family members' bodies) and their visual impact. "Imagine!" Dee/Wangero exclaims as she clutches quilts handmade by her grandmother—a typically ironic invoking of imagery in the story, for clearly Dee would need neither to imagine nor image her heritage had she put that heritage to everyday use. Dee's Polaroid photographs function as the symbolic antithesis of her sister Maggie's cherished quilts: they represent an alien technology that effects a fragmented, alienated point of view, as opposed to the quilts' "sampling" that implies a native, integrated hermeneu-

tic of wholeness. As Dee and her boyfriend send "eye signals" to one another over her mother's head (30), it is clear that Dee is too immersed in an objectifying vision to throw away her camera (which is safely on the backseat of the car she drives away in) and actually to understand her family's culture. The Polaroids will be joined by parts of the hand-carved family butter churn, all props for Dee's vision that would construct the South and southern black life as commodified Art.

The title character of Walker's *Meridian* is on the receiving end of such objectifying vision. Truman Held, a black photographer and painter, rejects Meridian (after impregnating her) because she is not a virgin, and because she is not as worldly as the white civil rights worker, Lynne Rabinowitz, whom he eventually marries. Later, when the Black Power movement proclaims "Black is Beautiful," Truman (oblivious to Meridian's abortion) exhorts her to "*Have* my beautiful black babies" (116, emphasis in original). Another of the northern white female civil rights workers takes photographs of her southern black female coworkers as they come out of the shower or straighten their hair. The act is understood by her black subjects as anthropological and is met on its own terms with the rebuke: "This here ain't New Guinea" (103). Lynne, to her own shame, considers the South and black southerners "Art" (130). In the lens of Truman's camera, Lynne herself, along with their daughter, Camara, is art, and when she no longer appears to Truman in this way, when she instead looks to him like politics, he moves to photograph decrepit, artistic buildings instead. *Meridian* is saturated with photography as a metaphor for objectification, commodification, and use, within and between the races—and the sexes.

Yet photography's evidential power also provides a frame for communication about changing African American southern identities. Meridian becomes "aware of the past and present of the larger world" when she sees images of the civil rights struggle on television (73). *Meridian* is framed by Meridian's contemplation of two different photographs, each of which appears as symbolic within her evolving notion of an essential southernness consisting of religion, music, and black communal identity. When near the beginning of the novel Meridian is confronted by her militant activist friends over her unwillingness to kill for the movement, she thinks of her southern past:

> What none of them seemed to understand was that she felt herself to be, not holding on to something from the past, but *held* by something in the past: by the memory of old black men in the South who, caught by surprise in the eye of a camera, never shifted their position but looked directly back; by the sight of young girls singing in a country choir . . . the purity that lifted their songs

like a flight of doves above her music-drunken head. If they committed mur-
der—and to her even revolutionary murder was murder—*what would the music
be like?* (27–28, emphasis in original)

Years later, Meridian begins to attend various churches but feels herself "an
outsider, as a single eye behind a camera. . . . If she were not there watching, the
scene would be exactly the same, the 'picture' itself never noticing that the cam-
era was missing" (193–94). When one Sunday she enters a Baptist church remi-
niscent of her childhood, however, she witnesses a changed ritual. In a service
that revolves around a photograph of a slain young black civil rights worker, the
prayers are for community involvement, the sermon is purposefully performed
in Martin Luther King Jr.'s style, and, most shocking to Meridian, the music has
changed, from dirge-like to martial. Meridian's "picture" of southernness shifts
as the church incorporates the photographic evidence of its fallen son along-
side its traditional "ways to transformation" of music and prayer (200), and Me-
ridian's own resolve is transformed, such that she acknowledges her own will-
ingness to kill to prevent further decimation of her people. For Meridian, this
photograph functions less as a fetish object than as what psychoanalytic critic
Christopher Bollas has termed a "transformational object": an object that stimu-
lates an "aesthetic moment" or "intense affective experience," through which
an adult subject remembers "a relationship which was identified with cumula-
tive transformational experiences of the self" (17). The transformation effected
through such an object is of the "unthought known" (in this case, Meridian's
capacity to kill) into conscious thought (Bollas 3–4).[24] Next to photography's
power to objectify, Walker posits the affective power of the photographic object
to communicate personal and cultural change.

Even within "Everyday Use" there is space to deconstruct vision's, and the
camera's, objectifying potential. Both the Polaroids and the quilts constitute
visual representations of cultural life; the difference is that one representational
technology comes from outside the culture, while the other has been made inte-
gral to the culture's self-expression over time.[25] Dee's fault is not that she em-
braces the new technology, but that she does it uncritically, without transform-
ing it to serve her native culture's expressive traditions or needs. Like Dash's
Amelia, Walker's character approaches her family with "appreciation," but Dee's
is an appreciation of "things," and her use of the camera serves to reinforce
rather than lessen the objectifying distance between Dee and her mother and
sister. Unlike Amelia, Dee does not have to meet the expectations and approval
of white anthropologists. Her behavior with the camera, however, highlights a
representational politics grounded in alienation and misunderstanding within

the "family" of African American southerners. This is a subject Walker explores more thoroughly in her fourth novel, *The Temple of My Familiar*.

In *The Temple of My Familiar* Walker builds on Hurston's use of the camera to assert and provide "real" evidence of the "unreal" of African history and its living presence in African American culture. In the character of Lissie Lyles, Walker depicts an African American southern female who truly remembers all of African and diaspora history, having lived perhaps hundreds of lives. Lissie's seemingly fantastic stories are verified—first for her own private vindication and amusement, then as evidence to be passed on—in a series of photographs in each of which she actually appears as a different woman. If this seems on first glance like magic realism, I suggest that in the context of Hurston's photo-work, these fictional photographs' realism is finally less magical than instrumental. Like Hurston and Dash, Walker presents her readers with photographs that, even in fictional form, strain conventional notions of realism. In so doing, she attempts to establish a strategic win/win position for her fictional images within the field of African American representational politics: If her audience accepts photography's inherent realism, then they must acknowledge the culturally "unreal" and disremembered legacy of the African diaspora. If they reject the photographs' "reality effect," then they must acknowledge the constructed nature of all photographic realities, including those that have historically been invoked to oppress African Americans. Of course, actual readers are never constrained to do what they "must," but the active strain placed on conventions of photo-realism by Lissie's series of portraits does cast conventional forms of photographic epistemology into relief and heightens the tension inherent in avowing or disavowing photography as evidence. Within the grand scope of *The Temple of My Familiar*, the story of Lissie, her husband Hal, and their conversations with Suwelo (who is the grandnephew of Lissie's recently deceased lover, Rafe) constitutes an extended meditation on the power of vision—of what a community wills and wills not to see, of the responsibility and struggle to cross those lines and make visible the self, and finally of the crucial role of the audience in activating and acknowledging the "truth" of visual representations.

Like Toni Morrison's *Beloved*, Lissie represents the trauma of the African diaspora embodied as a southern black woman. Her presence and story are to be discovered by Suwelo, a black former professor of American history, who, though he does not realize it (and like so many of the characters in the novel), is in search of his own roots. In Suwelo's version of American history, African Americans are a sidelight, virtually invisible, and Suwelo eventually finds himself feeling the same. As in many of Morrison's novels, historical identity is to be recovered through a physical and/or emotional voyage south. The first refer-

ences to Lissie in The Temple of My Familiar signal an absent yet very present character. The middle-aged Suwelo has just arrived in Baltimore to sell the house he has inherited from newly deceased great-uncle Rafe. Suwelo finds Lissie's name in odd little notes written on miscellaneous objects in Rafe's handwriting. Then the "ancient" Hal arrives to mow the lawn and suggests that Lissie is the subject of most of the photographs that cover the walls of Rafe's house, adding, mysteriously, "Lissie was our wife" (39). As Suwelo begins "almost unconsciously, to scrutinize the pictures" (34), he sees none that could be of Lissie, and then he notices that there are "light oval and square spots where pictures had once hung on the walls. Someone had taken them down" (40).

At first it appears that, embodied in these missing photographs, Lissie will fit the theoretical mold of the woman of color, unseen because she is unrepresented, or represented only as the negative spaces on the wall. But then Lissie presents herself as an "ancient," but living, breathing character, in possession of the missing images—thirteen photographs of what appear to be completely different women. We find that in her young married life she ran away with and became pregnant by a traveling black photographer from Charleston named Henry Laytrum. She leaves Laytrum when he reveals he is married, and she returns to her own husband, Hal, to give birth. Henry Laytrum's character serves two purposes: he illustrates the little-emphasized historical fact that photography was a popular and flourishing practice among black southerners in the early twentieth century, and he plays the role of "photographer as seducer/exploiter" that forms one of the familiar lines of cultural meaning attached to photography. But in a radical reversal of the "photography as exploitation" model, Lissie turns trickster, reappropriating the photographer's labor and products for her own, self-assertive agenda. The portraits she employs Laytrum to make over thirty years serve as evidence of what she knows to be true: that she remembers history because the people she has been in past lives still live within her. Lissie comes to understand herself through these portraits, realizing that "my memory and the photographs corroborated each other exactly" (91). With language that echoes Hurston's excitement about making her photographs, Lissie revels in the empowerment that the self-portraits represent to her: "It was such a kick. The selves I had thought gone forever, existing only in my memory, were still there! Photographable. Sometimes it nearly thrilled me to death" (92).

As a "colored woman" in the South, Lissie is beneath notice in the larger, white culture. She and Hal and their families lived on an unidentified island, probably, like Dash's Dawtah Island, off the coast of South Carolina, where they were exploited by the mainland whites and left to live in poverty and malnutrition. Narrating to Suwelo, Lissie places her experience in the broader context

of world events—World War I, the Depression, the frequent lynching of African Americans—but, she asserts, "this is what was happening to me" (92), and the photographs are her evidence.

At the end of her life, Lissie realizes that her photos must be passed on to "someone who'd understand" (89) the significance of the history represented in the images and would carry the narrative into the future. Decontextualized, or un-narrated, the photographs may be misread as representing separate women and discrete legacies. Initially, Lissie tells Suwelo that she has been lucky enough to be a black woman in all her lives, lucky because she may continue to act in the "ancient logic of her existence as who she is" (53). But at the end of the novel, in a letter sent after her death, Lissie reveals that she has in fact had lives as men, white women, and even as a lion, but that she has kept these existences hidden from everyone but Rafe. These lives, too, appeared in photographs taken by Laytrum, but Lissie tears them up, for she fears that these are parts of herself that cross too many lines. Even her most intimate community, including Hal, cannot see across the lines of gender and, especially, of race that artificially divide the whole of Lissie's experience. Though she has destroyed the photographic evidence, Lissie paints new self-representations of these lives before she dies and narrates her experience to Suwelo, who later plays back her words for Hal. To Hal, Lissie's images are a mark of trauma: a historical, racial trauma that he has embodied in an extreme fear of white people and cats. It is a trauma at least as strong as the trauma of being forbidden by his father to draw or paint, and the response to both traumas is the same: he loses his sight. Hal, who has gone blind rather than understand these last paintings of Lissie's, is grieved by his own failure, but after listening to Lissie's tape-recorded story, miraculously seems to be able to see part of Lissie's paintings. This seeing is the ultimate act in the novel, and the ultimate form of acknowledgment. The trauma of the African diaspora and the story Lissie tells of it become the site of a dialogic, *creative* understanding of African American southern and national cultures.

Lissie's photographs in *The Temple of My Familiar* stand for the project of the novel and Walker's southern-based work as a whole—to draw attention to the cultural lines that govern what can and cannot be seen, and to transgress those boundaries. Against a legacy of racist deployment of visual evidence in anthropology, and Zora Neale Hurston's singular redeployment of that science in the South, Walker uses fictional photographs as the basis for a meditation on the parallel cultural constructions (and reconstructions) of evidence and identity. Photography, the purveyor of so much psychocultural damage, is also, strangely, the instrument of cultural healing, and the ambivalent legacy of photography for African American southerners becomes a story of fluid boundaries, mutual

influences, and multiple possibilities. As Ann Cvetkovich has suggested in another context (a context that will be explored more fully in the following chapter), "Perhaps we can live with the queer interdependence of that which harms and that which heals in order to embrace the unpredictable potential of traumatic experience" (373).

The theoretical framing of photography in the dualistic terms of subject/object, masculine/feminine, and colonizer/colonized has developed from a distinctly Western, imperialist tradition. Yet these supposedly inherent attributes of the camera are in fact signifiers whose cultural meanings are determined by the culture in which they are read and from which they derive and, as such, are open to reactivation and rereading by other cultural groups. Inspired by the walls of photographs in her childhood southern home (like the wall of photographs in Rafe's house and Nana's island home), bell hooks has emphasized the need for African American critics to recognize and continue this process of rereading the visual, through photography:

> The word *remember* (re-member) evokes the coming together of severed parts, fragments becoming a whole. Photography has been, and is, central to that aspect of decolonization that calls us back to the past and offers a way to reclaim and renew life-affirming bonds. Using these images, we connect ourselves to a recuperative, redemptive memory that enables us to construct radical identities, images of ourselves that transcend the limits of the colonizing eye. (In Willis, *Picturing Us* 53)

Lissie's photo collection, in the hands of an informed viewer like Suwelo, will ensure that Lissie's radical identity will continue in time. African American self-representation through photography, according to hooks, creates "ruptures" in a historically traumatic African American southern experience of the visual. Walker's work celebrates these ruptures, both within African American southern cultures and within the larger arena of American representational politics. In so doing, she insists for the visual a place of trust and respect, and she claims its value as a positive strategic force for asserting cultural identity.

The very conception "poor white" is an oxymoron. It insists on the irreconcilable nature of its two parts; the unnaturalness of their yoking assumes a world view in which to be white is to be assured of a satisfactory share of personal resources. When whites are discovered deprived of these—as was most dramatically the case in the South— they take on the status of freaks, to be reviled, cured, pitied, accepted, or mocked.

—Sylvia Jenkins Cook, From Tobacco Road to Route 66

Any fiction that comes out of the South is going to be called grotesque by northern readers—unless it is really grotesque. Then—it is going to be called photographic realism.

—Flannery O'Connor, quoted in C. Hugh Holman,
 "The View from the Regency-Hyatt"

Brutally raped and beaten by her stepfather, twelve-year-old Bone Boatwright, heroine of Dorothy Allison's *Bastard out of Carolina*, emerges bruised and bandaged from an Appalachian county hospital. A photographer is waiting. Much as "Daddy Glen" has violently asserted his paternal right of access to his stepdaughter, the photographer, in taking a picture, asserts a public, symbolic access to Bone's "white trash" body. When the photograph appears on the front page of the local newspaper, Bone is thrice brutalized: her young, defiant female body is physically broken; her classed body is symbolically exposed; and, as she internalizes the community's stigmatization of her family, her personal body image is ravaged by self-loathing. In this self-loathing, Bone is less upset by the public display of her image than by the knowledge that the photograph will be included in her Aunt Alma's family scrapbook, which then appears to her as a catalog confirming her ugly, grotesque lineage:

> As soon as I saw the picture of me on the front page of the *News*, I knew it would wind up in her scrapbook, and I hated it. In it, I was leaning against [Aunt] Raylene's shoulder, my face all pale and long, my chin sticking out too far, my eyes sunk into shadows. I was a Boatwright there for sure, as ugly as anything. I was a freshly gutted fish, my mouth gaping open above my bandaged shoulder and arm, my neck still streaked dark with blood. Like a Boatwright all right—it wasn't all my blood. (293)

Like a gutted fish, Bone has been caught and rent open, exposed and available for consumption. As her own vision conflates with that of the news photograph,

Bone sees herself as she imagines herself and her family envisioned, as representative of all that is ugly, violent, and excessive. In this charged episode Bone becomes, literally, a cultural picture, a *something* accessible to and accessed by a hegemonic vision that, thanks to a long legacy of southern, particularly Appalachian, "white trash" images, knows just where to "place" this little girl's battered body.

The photograph that places Bone, in the public eye and in her own mind, is a familiar one in southern Appalachia's visual history. If the Farm Security Administration photographers and their journalist brethren descended (or ascended) upon the poorest Appalachian folk in the name of documentary activism, for many, such as Margaret Bourke-White and Walker Evans, who followed Doris Ulmann's steps if not her aesthetic, this work became part of their own artistic projects. Occasionally, these projects met with overt resistance, and the image of mad mountaineers shooting photographers has entered the U.S. visual lexicon almost as firmly as those of the poor, broken bodies and landscapes that those photographers found so compelling. The 1967 murder of Canadian photographer Hugh O'Connor by Kentuckian Hobart Ison discussed in chapter 1 is echoed, for example, in Lee Smith's 1983 novel *Oral History*, when crusading schoolteacher turned art photographer Richard Burlage returns to the mountain community he abandoned ten years before to make photographs. The man who confronts Burlage assumes that he is yet another documentarian with the Works Progress Administration—a delusion Burlage is happy to foster—and begins to tell the hard conditions of his life. But the visible contrast between that life and Burlage's shiny new car riles the mountaineer, and he suddenly grins and shoots out its rearview mirror. Burlage's first-person account, "Discourses Upon the Circumstances Concerning His Collection of Appalachian Photographs, c. 1934," narrates his near-simultaneous horror at being shot and his determination to keep shooting (a camera) himself. Moments after the episode with the mountaineer, Burlage is in "shooting range" of his former lover's house, "clicking away" in a desperate bid to re-place Appalachian bodies within his own framework (227–28). If the experience makes Burlage anxious to return to his urban family, his written "Discourses" reveal his ever-lingering desire to visualize Appalachian bodies and landscapes back into a contained and containable "place."

Like McCorkle, Humphreys, Dash, Walker, and (as I will argue in chapter 5) Smith, Allison demonstrates through her work that the boundaries of this "place" are cultural and contested, not natural or fixed. The power of *Bastard out of Carolina* is that Bone does not remain the "trash" thing her culture would have her represent. Nor does she shoot the photographer. Instead, through the course of the novel Bone begins to learn, incompletely, her own powers of represen-

tation. Bone's growing self-consciousness of the gendered and class dynamics of representational power in the South is developed, in part, around two sets of fictional photographs: the family photographs Bone "reads" for visible connections between her self and family, and the newspaper photographs collected in Aunt Alma's scrapbook that depict her "white trash" family in various states of drunken, incestuous excess. Contradicting Bone's vision, Aunt Alma insists that the Boatwrights aren't "bad-looking," they "just make bad pictures" (293). As the narrative of *Bastard* makes abundantly clear, within their hometown of Greenville, South Carolina, the Boatwrights participate in a southern economy of representation that sets intracultural boundaries along lines of class, gender, and race. Within the design of this economy, the Boatwrights—and especially the Boatwright women—will always look "bad," and they will be given to know it. But, as its title suggests, *Bastard out of Carolina* also participates in a larger representational context, a complex context that yokes together "official" discourses of patriarchal and state power, with more amorphous cultural dynamics of insider or outsider-ness, negotiated within a local and a national frame. And as this novel, along with Allison's short stories in *Trash* and her memoir, *Two or Three Things I Know for Sure*, makes clear, within this national representational economy the Boatwrights and their "trashy" type have, literally and figuratively, made "good pictures" indeed. For if "white trash" is a freakish oxymoron, it is a culturally productive one. Here, as Barbara Babcock has formulated, "what is socially peripheral is often symbolically central" (32): like the dose of black paint essential to making "Optic White" in *Invisible Man*, the poorest of Americans, and especially southerners, have been essential to defining American national identity. Bone's progress in *Bastard* is to recognize this dynamic as an *ongoing* representational battle—not a hopeless struggle to overcome "trash blood" or femaleness, but an active, continuing contest over who can claim the power to "picture" poor white bodies in what way and for what end.

This chapter aims to use a smaller question—how and why does photography figure so prominently in Dorothy Allison's work?—to get to some much larger ones: How have poor white bodies, particularly female bodies, been represented in the southern and national imaginaries? What issues of access and power are figured in these representations? How have these representations been used in an ongoing politics of identity and status? Paralleling the southern African American visual experience, a vast legacy of literary and visual images has established a "freak," "queer," "grotesque"—and, especially, southern—tradition of poor white representations in the United States that crucially supports and threatens to rupture dominant cultural hegemonies. Born out of this physical, symbolic, *cultural* violence, Dorothy Allison's work accesses the discourse of "white trash"

and re-visions it, reordering the narrative of access and representational power to reclaim for Appalachian white female "trash" a legitimate place in southern, and national, identities.

"WHITE TRASH": APPALACHIA'S VISUAL LEGACY

White trash as we know it is both an economic identity and something imaginary or iconic. When we talk about white trash, we're discussing a discourse which often confuses cultural icons and material realities, and in effect helps to establish and maintain a complex set of moral, cultural, social, economic, and political boundaries.
—*Annalee Newitz and Matthew Wray, "What Is 'White Trash'?"*

There are and have been "white" people living in poverty in every region and time of America's history. But in the national imagination, the prototypical poor white lives in a trailer or a shack, likely in the South, and most likely in the south-ern part of the Appalachian mountain chain that stretches from northern Mis-sissippi through Alabama, Georgia, South Carolina, North Carolina, Tennessee, Kentucky, Virginia, Maryland, and West Virginia.[1] As a subset of the South, this region is relatively homogeneous: while African, Native, Asian, and, in increas-ing numbers, Hispanic Americans are represented, the Appalachian South is much whiter, poorer, and less educated than the rest of the South and the nation. Its image is as the land of drunken, feuding, incestuous, illegitimate, ignorant mountain folk and "trailer trash," where pregnant preteens and snake-handling preachers are the norm. Grotesque sexuality, physical (likely genetic) deformity, and intractable poverty are its icons. By and large (though usually without the re-gional frame), these are the images that the recent field of "white trash" studies seeks to engage.[2]

The beginnings of "white trash" cultural criticism in the 1990s offered so-cial critique and identity politics embedded in a rhetoric of visibility. Examin-ing "white trash" serves as a corrective, argues John Hartigan Jr., to "a distorted image of urban poverty" in America that has been "established and maintained, in part, through a willingness of social scientists to ignore 'poor whites,' while obsessively (over)representing the conditions of blacks living in poverty" (in Newitz and Wray, *White Trash* 43). The term simultaneously presents whiteness as a racially marked category and calls attention to underclass poverty, de-naturaliz-ing the type of race/class associations that make an epithet like "nigger trash" unnecessary, because redundant. It also, according to Annalee Newitz and Mat-thew Wray, opens space for whites to interact with multiculturalist discourse not only as reverse-victims of multiculturalism but also as victims who have suffered

at the hands of the dominant culture ("What Is 'White Trash'?" 61–63). Under this rubric, work such as Dorothy Allison's strategically claims the mantle of "white trash" as a "potent symbolic gesture of defiance, a refusal of the shame and invisibility that come with being poor," and "a way to call attention to a form of injustice which is often ignored" ("What Is 'White Trash'?" 58).

Although this reading helpfully places Allison's work within a frame of representational politics, the particular politics it evokes echo too closely a tradition of visual documentary representation of poor whites from which Allison's work surely derives, but which it just as surely resists. The classic documentary project, as William Stott has described it, "makes vivid the unimagined existence of a group of people by picturing in detail the activities of one or a few of its number; documentary makes them visible, gives the inarticulate a voice. . . . [providing] 'a picture of society given by its victims'" (56). Such a mission, typical of the 1930s photo-textual tradition that produced both Erskine Caldwell and Margaret Bourke-White's *You Have Seen Their Faces* and James Agee and Walker Evans's *Let Us Now Praise Famous Men*, seeks to "shed light" on invisible white poverty to inspire change, yet it also tends to romanticize the poor, circumscribing their complexity as effectively as the caricaturizations offered in another classic of 1930s realism, Caldwell's *Tobacco Road*. Though their approaches varied widely, Caldwell, Bourke-White, Agee, and Evans together contributed to a powerful set of representational boundaries—a particularly American, predominantly Appalachian, myth of the poor that would force what Dorothy Allison describes as a "choice" between the "good poor" and the "bad poor" (Skin 15–18). The good poor were the noble, honest, hardworking victims of circumstance or the system, romanticized in different ways by *Let Us Now Praise Famous Men*, *You Have Seen Their Faces*, Depression-era movies, and proletariat novels. The bad poor might be victims as well, but they were ungrateful, ignoble, unregenerate trash, caricatured in *Tobacco Road* and other popular fiction. Allison's work has been described as lying in the "middle ground" between Agee and Caldwell (Reynolds 365), but Allison has declared that, though she understood herself to be one of the bad poor, the reality of her family's lives was invisible—"not on television, not in books, not even comic books" (Skin 17). Allison claims the labels imposed on her family— "the lower orders, the great unwashed, the working class, the poor, proletariat, trash, lowlife and scum" (Two or Three 1)—yet she aggressively re-narrates the cultural stories behind them. Central to this re-narration is her determination to address and incorporate the visualized, gendered legacy of Appalachian white trash, especially as it has been embodied in photographs. A brief review of this legacy is thus in order.

characteristics. . . . Bodies become coded as trashy when associated with unregulated reproduction, unrestrained or perverse sexuality, and lax work ethic" (169). "Trash" thus becomes more than a class designation: it represents an essential state. This essence, like other putative essences in the South, is highly visualized, and it is reinforced through a long tradition of visual and literary images.

From its earliest representations, evidence of the degeneracy that would come to be known as "trash" has been primarily visual. Visible difference here stands for essential difference, the type of difference that can justify family, community, or national boundaries. Reporting on a 1728 surveying expedition to establish the "dividing line" between his state and North Carolina, Virginia colonist William Byrd described on the other side of that "line" an array of "indolent wretches" with "custard complexions," whose noses had collapsed from a syphilis-like disease that Byrd attributed to a fresh pork diet, and who lived nearly naked in bark-covered pens, like "mere Adamites, innocence only excepted" (180, 184–85). Byrd's account provides not only "the first comic portrait of the southern poor white" (Cook 3), but it also explicitly links such descriptions to projects of nation-building, as Byrd carefully delineates shiftless North Carolinians from his native Virginian compatriots.[5] Drawing on the legacy of Byrd's account, and borrowing the visual epistemologies of the eugenics movement (see chapter 1), W. J. Cash in 1941 drew a similar picture of the "distinctive physical character" of southern white "crackers": "a striking lankness of frame and slackness of muscle in association with a shambling gait, a boniness and misshapeliness of head and feature, a peculiar sallow swartness, or alternatively a not less peculiar and a not less sallow faded-out colorlessness of skin and hair" (25).[6] In the three examples I will briefly consider here—Caldwell's *Tobacco Road* and *You Have Seen Their Faces* (coauthored with Bourke-White) and Agee and Evans's *Let Us Now Praise Famous Men*—reformist ideals clash head-on with the powerful representational legacy of white trash in constituting the middle-class culture these authors aim to revise. In each case, the authors used a realist or documentary technique to portray their white trash subjects as potent symbols of a southern (and by extension national) class system rotten at its core. In each case, the very accessibility of the poor white subject to the eyes of these authors and their middle-class audiences—an accessibility seemingly unproblematic to Caldwell and Bourke-White but deeply problematic to Agee, if not Evans—is figured in terms of a "queer" sexuality that effectively reinscribes the white trash body within a frame of middle-class anxiety and reassurance. Sex—excessive, perverse, sometimes comic, and always highly visible—becomes a primary marker of "white trash" representation. In these representations of society's victims, with their victimized sexuality, Caldwell and Bourke-White, Agee and Evans, veer from caricature

to romanticization, creating the now-classic visualizations of white poverty with which Dorothy Allison's work contends.

When Allison discusses her early searches for representations of her family or self in literature, the name mentioned most frequently is Erskine Caldwell.[7] In his fiction and essays, especially in his most famous work, *Tobacco Road* (1932), Caldwell portrays poor whites, with women as special victims, in a state of irremediable dissolution and degradation caused by the unrelentingly exploitative nature of the southern tenant-farming system. The fictional mode in *Tobacco Road* and both its Broadway and film adaptations is tragicomedy, although so familiar and reassuring was the scapegoating comic representation of the poor white— descended from Byrd's reportage, Augustus Baldwin Longstreet's 1835 *Georgia Scenes*, George Washington Harris's Sut Lovingood stories, and countless representations of the "rube"—that some critics chastised Caldwell for disrupting the genre with social commentary (Cook 66–67). All the stereotypical visualizations of white trash are available for inspection in the novel: collapsing house, junkyard car, and grotesque, barely clothed bodies. Perhaps reflecting a presumably shared male gaze of author, readers, and male characters that transcends even gaping class difference, only the female characters in *Tobacco Road* are visualized with precision, and their bodies serve as the most shockingly visible, and comic, site of sexual spectacle in the novel. Daughter Ellie May drags her bare bottom across the sand toward seducing brother-in-law Lov Bensey out of a few of his turnips and is left lying in the sandy yard, dress behind her head, while her brother Dude watches "the red wood-ants crawl over the stomach and breasts of his sister" (39). As the thirty-nine-year-old preacher Bessie consummates her marriage to sixteen-year-old Dude, the rest of the family crowds in the doorway to watch, while the "patriarch," Jeeter Lester, approaches the couple, pulls back the quilt to get a better look at Bessie, and ponders whether God wants him to castrate himself to end his lascivious thoughts. In an interview Caldwell explicitly linked the sexual practices of his characters to their economic deprivation,[8] yet he generally skirted questions about its comic presentation with an appeal to exposing society's weaknesses through realism (Reynolds 361). It seems clear in *Tobacco Road* that the committed leftist Caldwell felt free to access his white trash subjects' victimized sexuality as comedy, in the service of shocking his middle-class audiences into reform.

This presumed freedom of access is even more evident in his straightforwardly documentary project, *You Have Seen Their Faces* (1937), initially conceived as a document of the truthful basis of Caldwell's fiction and message. Collaborating with his future wife, photographer Margaret Bourke-White, Caldwell delivers in his nonfiction text a stinging indictment of the southern sharecropping

system and the racism and brutal exploitation that supported it. Yet this text, in conjunction with Bourke-White's photographs and the fictional captions that accompany them, "brutalized" its poor subjects by making them seem as abject as possible, thus catering to the expectations of the book's middle-class audience (Stott 219). The book's disclaimer-epigraph proclaims the liberties taken with these subjects: the legends accompanying the photographs "are intended to express the authors' own conceptions of the sentiments of the individuals portrayed; they do not pretend to reproduce the actual sentiments of these persons." Thus, a photograph of three presumed sharecroppers—a thin, overalled man, a barefoot woman with an enormous goiter, and a pantless little boy—framed within a doorframe bears the legend, "Poor people get passed by" (159), and a close-up shot of a grizzled, near-toothless, but smiling man is captioned, "I get paid very well. A dollar a day when I'm working" (153). Bourke-White's self-described photographic technique highlights the full extent of the access she and Caldwell presumed to their subjects. Remote control and flash in hand, Bourke-White would wait: "It might be an hour before their faces or gestures gave us what we were trying to express, but the instant it occurred the scene was imprisoned on a sheet of film before they knew what had happened" (187). As William Stott has paraphrased it, "The subjects say either 'Look at me, how wretched my life is,' or 'Look at me, my life is so wretched I don't even know it" (221). *You Have Seen Their Faces* sold extraordinarily well.

At the precise time Bourke-White and Caldwell were traveling the South, the summer of 1936, Walker Evans and James Agee were living with and chronicling the lives of three tenant families in Hale County, Alabama (still one of the most impoverished counties in Appalachia). They reacted to Bourke-White's comments, published the following year, with fury, feeling that they had been "outsmarted by an inferior motive" (Evans quoted in Stott 222). Agee and Evans's book *Let Us Now Praise Famous Men* (finally published in 1941) may be read as a response to *You Have Seen Their Faces* and documentary projects like it. In contrast to Bourke-White, Evans photographed his subjects only with their full awareness and consent. His photographs assert the aesthetic beauty and dignity of the tenant family's simple dwellings and possessions. Yet like Bourke-White, Evans was chiefly interested in the *visibility* of his poor subjects' lives: "The poor, the primitive, and the young are the natural heroes of photography; all others have learned too much disguise" (Stott 275). His access to these lives seems not forced, yet complete. The boundaries of the visible world Evans aimed to construct in the final text include photographs of tired, ragged, yet dignified tenants but exclude self-commissioned photographs (the taking of which are described in Agee's narrative) of the same tenant family posing in their best clothes.[9] Working within

these bounds, Evans through his photographs encourages his audience to acknowledge "low" forms (the tenants and their possessions) as not just fully but extraordinarily beautiful and human.

Agee's obsessive, self-critiquing text, by contrast, is an assault on his audience. Agee aims to disrupt what he sees as his middle-class audience's habitual absorption of white trash as scapegoat, and to prevent the potential complicity of his and Evans's effort in this absorption. His strategy is one of "mutual wounding"(370): for example, Agee includes explicit statements of his own sexual desire, the better to justify his comments on the sexuality of his subjects. Again these comments focus most directly on sexualized female bodies: Agee identifies with tenant George Gudger's fumbling, "unconcealable" attraction to his wife's sister, Emma, and suggests that it is in all of the involved adults' minds that Emma should spend her remaining few days in the Gudger household "having a gigantic good time in bed, with George, a kind of man she is best used to, and with Walker and with me" (61, 62).[10] Yet, fully intertwined with Agee's own middle-class desire, this sexuality is presented as natural, if victimized by inarticulateness, economic hardship, frustration, and cultural unacknowledgment. In Agee's text the tenant families are better specimens of humanity than Agee and his own ilk. Agee's ironically titled "famous men" are righteously so; as victims of an infamous system, they are "innocent" even of their faults.

Agee and Evans thus present a portrait of the "good poor," hardworking, honest victims of a heartless system, forever doomed to relentless fate. In his effort to construct this vision of America, Agee omits the type of petty cruelty, lust, greed, and sloth that fills *Tobacco Road*, and he avoids most of the maudlin, ultimately brutalizing sentimentality that infects *You Have Seen Their Faces*.[11] Ultimately, however, Agee and Evans's vision of white poverty is as objectifying as Caldwell and Bourke-White's. Painfully aware of the presumptiveness of their project, Agee and Evans nevertheless claim and invite access to poor white bodies in the name of social reform, in order to reveal "invisible" white poverty and inspire change. The public visual legacy of poor white representation in the United States is thus one of double-erasure: a middle-class subjectivity asserts a right of access to poor white bodies and renders them visible only to the extent that they support a middle-class national imaginary as (1) the demonized or comically corrupt "other" against which the purer nation is formed or (2) the purer, tragic "other" against which any true notion of Americanness can be measured. Within this dynamic, female bodies function as the site of a national, and in some ways particularly southern, "male gaze." Dorothy Allison is heir to this visual legacy, and her work makes the full extent of its damage clear: under control of these "trash" images, in the absence of self-representation, poor whites, especially

women, can be denied access to the complexity of their own experience. Allison confronts this tragedy head-on in her fictional and autobiographical explorations of southern poor white experience by directly engaging, critiquing, and revising the representations, especially the photographs, that have constructed her own and her characters' identities. In the process, she reveals a facet of the southern, poor white visual legacy that is almost never acknowledged: the power of the private self-representations, especially as embodied in family photographs and albums. Doing so, Allison reorders the dynamic of access and the notion of nation, on which the oppression of her people has depended.

REPRESENTING TRUST: WHAT
DOROTHY ALLISON KNOWS FOR SURE

I am my mama's daughter, one with my tribe, taught to believe myself of not much value, to take damage and ignore it, to take damage and be proud of it. We were taught to be proud we were not Black, and ashamed that we were poor, taught to reject everything people believed about us—drunken, no-count, lazy, whorish, stupid—and still some of it was just the way we were. The lies went to the bone, and digging them out has been the work of a lifetime.—*Dorothy Allison,* Skin

Allison is above all concerned with excavating the politics of oppression—what she calls the "politics of *they*"—to understand "why human beings fear and stigmatize the different while secretly dreading that they might be one of the different themselves" (*Skin* 35). Delineating and representing a "*they*" has been crucial to forming both the American and southern nations, and in both cases, "white trash" has served as a "good picture" of the "they." As the "their" in *You Have Seen Their Faces* and the "us" in *Let Us Now Praise Famous Men* demonstrate, the construction of an us/them boundary has been essential even in progressive works meant to trouble that border. But Allison refuses the customary narrative of victimhood that attends the stigma of "they." Her work amply demonstrates that white trash southerners have been on both the receiving *and* the giving end of stigmatization. In an economy of oppression there are necessarily hierarchies—relational scapegoating. Within the larger nation, the South has historically functioned as a representational repository of national racism, class exploitation, religious fanaticism, and gender/sex oppression. Within the South, "white trash" has served as a container for regional legacies of violence, incest, racial brutality, illiteracy, and indolence.[12] Within the patriarchy of white trash culture, Allison's work makes clear, women, girls, sexual transgressives, and blacks of all ages and genders represent the low Other, the source of disorder.[13]

But, as Foucault has taught us, power circulates, even in the most hierarchical and repressive regimes. As a "reverse-discourse" to the rhetoric of "they," Allison strategically offers the resistant designation "queer," a term that she applies to those who have been "taught how to destroy themselves": southerners, the poor, women, lesbians, and especially, sexually transgressive lesbians (Rowe 7). Ann Cvetkovich has compellingly suggested that white trash is a "queer category" and that the sexual violence associated with this category, in Allison's work, produces "a particular, and proudly queer, national and regional identity" (372). With Cvetkovich, and Allison, I want to insist on the dual valence of "queer" as a specifically homosexual term and as more generally designating a "deviant" subject position—a term signifying "an unresolved tension rather than a solution" (Cvetkovich 374).[14] It is precisely this tension which provides the risk and power of "queer-ness" in the South. The "odd," the "grotesque," and even the "Other" of categories such as the feminine, the "colored," or the poor can be accommodated within the southern paternalist discourse of benign, protective subjugation, but an openly defiant sexual "deviance," especially lesbian sexuality, which by definition would exclude the patriarch, is radically not accommodated.[15] Claiming a "queer" position in the South and, moreover, insisting on the rightful place of queer narratives of southern and national identity deny the privileged access asserted by dominant narratives to poor white, southern female, lesbian life. Re-placing the stories of final victimization, re-visioning the "evidence" they rely on, enables a different type of access: access to the power of self-representation by the queered of southern culture, establishment of the representational trust that is the first step in constructing a truly accommodating "home" and nation.

"Home," writes Allison in "Public Silence, Private Terror," "is what I have always wanted—the trust that my life, my love, does not betray those I need most, that they will not betray me" (Skin 111). Allison's autobiographical work and her novel Bastard out of Carolina make clear that this "trust" that is "home" will derive not from some essential notion of place or blood but from the powerful interaction of stories told and stories acknowledged. Home-building, like resistance, happens in the realm of representation and narrative, and this is a realm that demands a continual re-linking between the private and the public, the individual and the communal. As a memoir, Allison's Two or Three Things I Know for Sure (1995), by definition of its genre performs this re-linking. It becomes clear on page one that storytelling will be the hero, the primary strategy for resistance, survival, and hope: "The story becomes the thing needed" (3). But this memoir is also a feminist photo-text, and it is the inclusion of photographs from Allison's family collection, particularly of women, that makes the text's meditations on

evidence, roots, and accessibility especially urgent. Photographs in *Two or Three Things* stand on the border of public and private, and they function as potent symbols of the paradoxical power of facades (representations, stories) simultaneously to permit and to deny access to the "truth." Photographic re-visioning becomes a supporting trope for the master trope of storytelling.

Conceived in something like the relation of *Tobacco Road* and *You Have Seen Their Faces*, *Two or Three Things* is a complementary document to Allison's fiction.[16] As in *Bastard out of Carolina*, Allison represents the intimate connections between class, race, and gender oppression and sexuality, and refuses to unyoke them in the service of an easier, more comfortable narrative. What Allison writes about photographs in her memoir speaks directly to the gendered, classed nature of southern cultured vision, in a narrative of access taken, and denied:

> Let me tell you about what I have never been allowed to be. Beautiful and female. Sexed and sexual. I was born trash in a land where the people all believe themselves natural aristocrats. Ask any white Southerner. They'll take you back two generations, say, "Yeah, we had a plantation." The hell we did. (32)

Allison refutes the imaged myth of white southern commonality, insisting on the importance of claiming her family's brutal history "of death and murder, grief and denial, rage and ugliness" (32). At the same time, she shows the mechanisms by which her family internalizes the myths of white southern culture — romantic narratives of white supremacy (what Cash calls the "proto-Dorian bond"), southern womanhood, beauty, the noble poor — even while they resist them through their very lives, with fierce pride. The power of cultural images, the "documents" of cultural narrative, to call their subjects to recognize themselves represented in the image itself, or in their exclusion from the image, is especially insidious for the women of Allison's family. Referring directly to the representational legacy of the poor white body descending from *You Have Seen Their Faces* to modern-day journalism, Allison narrates the imbrications of gender, class, and sexuality in a visual field:

> The women of my family were measured, manlike, sexless, bearers of babies, burdens, and contempt. My family? The women of my family? We are the ones in all those photos taken at mining disasters, floods, fires. We are the ones in the background with our mouths open, in print dresses or drawstring pants and collarless smocks, ugly and old and exhausted. Solid, stolid, wide-hipped baby machines. We were all wide-hipped and predestined. Wide-faced meant stupid. Wide hands marked workhorses with dull hair and tired eyes, thumb-

ing through magazines full of women so different from us they could have been another species. (32–33)

As the magazine images illustrate, the Gibson family women are denied access to "beauty." The visualization of the poor white female is "ugly" and translates into a legacy of self-hatred, as generations of poor white men in Allison's family call their wives "ugly old woman," and mothers, sisters, and cousins call each other "ugly bitch" (36). Behind the young Allison's prayer to be saved from the women in her family, to not become one of them, is the rage, fear, and shame-filled pride that make up the stories her mother and aunts told each other: "the stories that sustained and broke them" (69).

It is only after Allison confronts this rage by breaking her public silence about her sexual abuse by her father and its relation to her "queer" sexual desire, and insists on the interconnection between this abuse, desire, and her class background, that Allison's focus shifts to claiming her family as a queer source of her own power. Structurally, the memoir performs this transition repetitively, though a series of presentations, denials, and acknowledgments. Tropologically, the transition is figured through a textual act of looking at actual and referenced photographs, and the relation of that act to storytelling. After a bewildering session where Allison's mother refuses to talk about the dead members of her family, even to help her daughter complete a grade-school assignment to make a family tree, Allison's mature voice, italicized, warns: *"Two or three things I know for sure, and one of them is just this—if we cannot name our own we are cut off at the root, our hold on our lives as fragile as seed in a wind"* (12). The scene is repeated pages later when Allison's mother resists talking about family photographs, photographs that Allison knows are "full of stories—ongoing tragedies, great novels, secrets and mysteries and longings no one would ever know" (17). When her mother dies, her untold stories of the photographs die with her. This is the power of rage and silence, a way of preventing access, which Allison describes elsewhere as a family policy, "to keep my mouth shut and give no one a weapon to use against us" (*Skin* 240). In similar terms, Allison describes the "tragedy" of her uncles' lives as silence, embodied in photographs where "they stare out directly, uncompromising, arms crossed or braced on their knees" (*Two or Three* 28).

But in a direct violation of "family policy," Allison includes actual photographs of her family, especially of her female relatives, and tells her own stories about them. Above the narrative description of the women in her family as "work-horses with dull hair and tired eyes," Allison places an apparently unposed photograph of several women, including her mother and aunt, on a porch, looking exhausted and worried (33). Preceding and following this photograph, however,

are posed portraits of these same women and others from youth to middle age, some carefully made up in the style of Barbara Stanwyck or Grace Kelly, all looking composed and in control. Allison makes the parallel between the strategic visible "masks" her uncles wore and the strategic power of storytelling: "The story of what happened, or what did not happen but should have—that story can become a curtain drawn shut, a piece of insulation, a disguise, a razor, a tool that changes every time it is used and sometimes becomes something other than we intended" (3). But as much as stories and photographs can be used to deny access, they can serve as a way of asserting a rightful self-control over that access. By presenting private photographs of her female relatives as they represented themselves—both as young, hopeful girls made up like movie stars and as hard, tough survivors—in the public form of a memoir, Allison allows access to her family, refuting the "stories other people would tell about my life":

> I tell my stories louder all the time: mean and ugly stories; funny, almost bitter stories; passionate, desperate stories—all of them have to be told in order not to tell the one the world wants, the story of us broken, the story of us never laughing out loud, never learning to enjoy sex, never being able to love or trust love again, the story in which all that survives is the flesh. That is not my story. I tell all the others so as not to have to tell that one. (71–72)

The memoir becomes a space of representational trust, where Allison can acknowledge the stories of her family through her retellings, and where Allison can hope to have her own story acknowledged by a reader. She ends her memoir with a combination assertion and plea to that reader: "*I can tell you anything. All you have to believe is the truth*" (94).

This sense that power resides in the control of representations, literary or photographic, forms the thematic backbone of Allison's first novel, *Bastard out of Carolina*. The fictional photographs that appear throughout the novel reflect the double-edged legacy of photographs as important conveyors of identity and family roots, and as tools of symbolic manipulation and violation, that runs through *Two or Three Things I Know for Sure*. *Bastard*'s heroine Bone Boatwright's earliest attempt to understand the relationship between her mother, Anney, her new stepfather, Glen, and the rest of her family is represented as a process of reading a photograph. Bone's Aunt Alma has purchased a new Brownie camera, "determined to document every family occasion she could"; it is the camera that coaxes Granny Boatwright, who dislikes Glen, out onto the porch, and that figuratively recreates the family to include its newest member (37). Later, looking at the photograph, Bone contrasts the transparency of her mother's image,

Daddy Glen's progression is, in a sense, the opposite movement from Bone's. Allison clearly draws the connections between Glen's own oppression by southern class and gender conventions and his physical and sexual abuse of Bone. As the least-favored son of a middle-class family, who has married into "trash," Glen is consumed by the desire to live up to, and the need to live down, the ways his family and his regional culture would represent him. He wishes to be a southern father in the old patriarchal mode, as his disapproving father is to him. Glen labors to resist the same white trash designation that "illegitimizes" Bone, but as a white man, he is entitled the "release" of race and gender dominance. Glen starts from a position of presumed access: as a white southern husband and stepfather, he will order his new family of women according to the patriarchal image that is his birthright. When, encountering Bone's resistance, this symbolic access is denied, Glen reasserts his power through sexual and physical violence, attempting to coerce Bone into accepting the gendered self-image that would confirm his own power: she as his daughter, property, infinitely accessible to him. Daddy Glen's attempts to translate physical control back into symbolic dominance are almost successful: when Bone sees herself through her stepfather's eyes, as if at the bottom of endless hole, "dirty, ragged, poor, stupid," she wants to die (209). But Bone's anger and the powerful stories she tells herself to support it refuse victimhood, denying Glen the crucial power to represent her identity.

In telling the story of a "bastard out of Carolina," Allison draws parallels between the personal story of Glen's attempt to control Bone's identity and the public access claimed by dominant culture to represent "white trash" lives. The violating, exploitative nature of this representation is embodied in the novel in a series of newspaper photographs published of the Boatwright family in various states of drunken, violent, incestuous excess. In the washed-out newsprint, Bone believes, "nobody looked quite like my family. Worse than crazy; we looked moon-eyed, rigid, openmouthed, and stupid" (293). When Bone is carried from the hospital after Glen has raped her, the photographer is waiting to take her picture—as yet another battered piece of Boatwright trash. In an ironic reappropriation of these images, however, Bone's Aunt Alma collects the photographs within her own scrapbook, and she explicitly names the chief factor in "looking good" within their culture: "The difference is money. It takes a lot of money to make someone look alive on newsprint," she tells Bone, "to keep some piece of the soul behind the eyes" (293). Bone's initial resistance to being included in Alma's scrapbook is transformed by her recognition of the "soul" not represented in the newspaper images but in her aunt's seemingly lighthearted manipulation of them—the soul-trying difficulty and determined strength behind her family's love. When Anney gives Bone a new copy of her birth certificate, un-

marked with the blemish "illegitimate," Bone acknowledges that her mother's life story has "folded into" her own, and that she will be, like her mama, a Boatwright woman (309).

Although she does not realize it at age twelve, Bone's determination to accept her female, Boatwright identity is part and parcel of a recognition of her own power to engage in imaginative retellings of her individual and communal life—to picture her own self, her South, and her "home." "Southerners," Minrose Gwin has written, "have always maintained that place makes us who we are and that the stories we tell ourselves about 'home'—the places we come from—are the means through which we negotiate identity" (437). The traditional southern notion of home, a felicitous space where the father reigns supreme, is, Gwin suggests, interrogated by narratives of father-daughter incest such as *Bastard out of Carolina*; for southern daughters like Bone, "'home' may not be grounded in place but in the replacement of the self elsewhere" (437). I have argued that "home" in Allison's work is understood not as an essence of blood or geographical place but as a space of representational trust, a space that can be created, or reclaimed, through the power of stories told and acknowledged. That Bone chooses finally to remain in Greenville with her lesbian Aunt Raylene, "trusting her arm and her love," suggests that the "home" Bone will create will be a queer one, but that it will not be radically "elsewhere" (309). Rather, Allison's novel and her memoir assert the privilege of this queer position to define the meaning of the place—the nation, the region, the class, the race, the sexuality—in other words, the "home" she comes from.

RE-ENVISIONING HOME

I've these pictures my mama gave me—stained sepia prints of bare dirt yards, plank porches, and step after step of children—cousins, uncles, aunts; mysteries. The mystery is how many no one remembers. I show them to Jesse, not saying who they are, and when she laughs at the broken teeth, torn overalls, the dirt, I set my teeth at what I do not want to remember and cannot forget.—Dorothy Allison, "River of Names," in Trash

That the contest to define meaning is so often figured through fictional photographs in Allison's work indicates the continuing power of the legacy of visual representations of southern poor whites in America. Allison's story "A River of Names" joins *Bastard out of Carolina* and *Two or Three Things* in suggesting that pictures deprived of narrative tend to take on the dominant cultural narrative: in the case of pictured poor white bodies, family photographs may become social realist documentary or perhaps even comic relief. These dominant narratives assert

a right to access the bodies of poor whites, to "picture" them, and to control the stories around those pictures. It is this narrative that Allison repeatedly refutes in her stories and nonfiction, asserting her own claim to allow or control access to images of her family and, in the process, exposing the psychological damage the battle itself entails.

And the battle, Allison's work makes clear, is ongoing. In Allison's "real life," her other autobiographical writings tell us, her family took "the geographic solution": when she was thirteen, they moved from the South Carolina Piedmont to Central Florida (Skin 19). This change did lend Allison a "protective anonymity," displacing her hereditary "trash" status and ironically letting the "myth of the poor" "settle" over Allison and her sisters, and "glamorize" them (Skin 21). But the adult Allison asserts that the move "did not fix our lives," and she critiques the impulse behind it as "the conviction that the life you have lived, the person you are, is valueless, better off abandoned, that running away is easier than trying to change things, that change itself is not possible" (Skin 19–20). Stories such as "River of Names," "Mama," and "I'm Working on My Charm" feature adult protagonists experiencing the pain of trying to elude or repress the past by leaving home, changing context. By having Bone stay in Carolina, Allison in Bastard refigures her own healing anger, which she developed in her twenties, into a much younger, but wiser character. Bone, Allison says, "begins to hold people responsible" (quoted in Megan 73), and this gives her the power to make her own personal space of change, and to re-vision the "place" of her family, her region, her class, and her sexuality—including their respective violences— in forming the life she has lived and will live. The actual photographs and the stories told around them in Two or Three Things I Know for Sure mirror the ways the fictional photographs in Bastard out of Carolina mean to Bone. Through these photographs, Bone recognizes, critiques, and resists the claim that dominant narratives of "white trash" have made on her people and her self, and she reclaims access to the power to represent her own body and history.

Theorizing photography in a gendered, familial frame, Marianne Hirsch has formulated the power of such re-vision:

If the camera gaze of the family snapshot can be said to construct the girl as a social and familial category, then resisting the image—either at the time or later in the process of rereading—becomes a way of contesting that construction, of rewriting the present by way of revising the past. Reading, rereading, and misreading thus become forms of active intervention: they enable a re-vision of the screens through which the familial gaze is filtered and refracted and thus a contestation of the gaze itself. (Family Frames 193)

In *Bastard* family photographs appear in conjunction with journalistic photographs so that the gazes Bone contests — the "people" she begins to hold responsible — belong not only to her family but also to the culture that has constructed, represented, and de-legitimized that family. By claiming the legitimate place of her queer, "white trash" character *within* the South, Allison reorders and reclaims the South itself.

CHAPTER 5

RE-IMAGING

SOUTHERN

COMMUNITIES, OR,

PICTURING THE

POST-SOUTH

What it comes down to is the continued existence, despite (or more properly, because of) time and change, of a social and cultural community in which membership offers a form of self-definition. . . . Even allowing for the utmost diversity and extremes of individual experience, and encompassing attributes both good and bad, worthy and unworthy, there is a shared identity involved, and whatever the complexity of ingredients that go to make it up, it works in direct and palpable ways to cause its members to identify their concerns with those of a particular social and cultural allegiance. Nobody has precisely defined what the entity is or what goes into the mix. Yet it is.
—Louis D. Rubin, The American South

I've learned to keep my face behind the camera, my lens aimed at a dream of my own making.
—Natasha Trethewey, *"Disclosure," in* Bellocq's Ophelia

If southern vision is transformed, if the "master narrative" of the South is exploded to include its historically silenced others, what specifically southern remains? Anxiety about the "death of the South," a feature of southern cultural criticism ever since "the South" was invented, seems only to have intensified in the postmodern era. John C. Calhoun's deathbed cry, "The South! The poor South! God knows what will become of her," echoes in the Agrarian manifestoes of I'll Take My Stand, in Walter Sullivan's laments over southern artists' "Death by Melancholy," and in Jack Butler's concern that, should the South turn out not to exist, he will have to end a speaking career of answering the question of its continued existence, and pay back all the travel expenses he has written off in the process.[1] Since Lewis Simpson introduced the term in 1980, there has been great speculation—alternately grieving or celebratory—that since the last quarter of the twentieth century we have been living in a "postsouthern" America. In place of "divine authorization" or autochthonous ideality, the postsouthern is manifested through self-consciousness of its "utter dependence on itself" (Simpson 268, 229), its sense of place characterized by "an awareness of capitalism's material and experiential reproduction of traditional or supposedly 'natural' southern loci."[2] Simulacra not only replace essence, but there is a "new" (melancholic? liberating?) awareness that "the South" has always been a performative, political play of signifiers. Under this rubric, questions of the "specifically southern"

have been reframed within debates over postmodernism, postmodernity, and the (im)possibility of a post(modern)South, especially as embodied in southern writing. In short, they have again been framed within familiar but now ironized issues of identity and canon, position and "place."

Contemporary southern women's writing stands in uneasy critical relation to these newly problematized (but not newly problematic) notions. Sometimes incidentally and sometimes pointedly, women's writing has been invoked in criticism that knells the "death of the South," both in terms of a postmodern loss of regional identity and specificity and of an overall decline in the "power" of southern writing. Conservative critics have deemed the work of Bobbie Ann Mason and Anne Tyler, for example, too postsouthern, for its Kmart contexts and "throwaway culture" obliviousness to history, while champions of postmodernism have found it not postsouthern enough, for its realist "fidelity to minute details and accurate description" and dearth of "forceful," self-conscious experimentalism (Raper 5).[3] This chapter counters the classed and gendered implications of this brand of criticism by analyzing the complex role of visual culture in contemporary southern women's literary depictions of postsouthernness. The post-South that emerges in the works I focus on here—by Tyler, Lee Smith, Natasha Trethewey, and Ann Beattie—proves less a matter of the postmodern capitalist disintegration of traditional southern "place" or the demythologizing imposition of history upon an autochthonous essence, than of an openly visible, visual contest to determine who and what will represent "the South," what and who can be included (acknowledged, accommodated) within the canon of southernness.

If on the surface the anxieties of postsouthernness appear ontological (whither the southern essence?) or epistemological (whither our way of knowing "the South"?), the thrust behind them is ethical. I have argued that contemporary southern women writers like Josephine Humphreys, Jill McCorkle, Julie Dash, Alice Walker, and Dorothy Allison use photography—the "pencil of nature"— as a metaphor to expose the ethical, cultural bases of the essentialized visions that define social "place" in the South.[4] In previous chapters I have foregrounded what might be called a representational politics of evidence: a complex visual legacy of images meant to prove the naturalness of southern ideology, such as the southern lady, the patriarchal family, the anthropological subjects of "blackness," and the "white trash" body, as they are evoked and re-visioned within these writers' fictions. With few exceptions (Dee/Wangero's Polaroid snapping in Walker's "Everyday Use," for example) female characters in these works have been objects of a southern patriarchal photographic gaze, and their strategies of resistance have centered on reappropriating or re-narrating the meaning of

the photographs that result. Responding to visual legacies of pictured south-ern women, these writers picture the picturing, critiquing and revising the cul-tural visions that would "place" them. The current chapter extends this analysis by shifting focus to writers who picture women who are themselves picturers. Smith's *Oral History* and Trethewey's *Domestic Work* depict early twentieth-century male characters self-consciously visualizing "the South," intent on naturalizing their visions through the photographed bodies of southern women. Trethewey's *Bellocq's Ophelia*, Tyler's *Earthly Possessions*, and Beattie's *Picturing Will* present "the other side" of this story.[5] These works each feature women characters who are photographers, each of whom takes up a camera to represent what's missing from the southern picture—not the "natural" details of their female reality, but their particular experience and vision of "southernness." Taken together, these five works exemplify and enact a (post)southern representational politics of *cre-ation*. Placing cameras in the hands of their female protagonists, these authors draw pointed analogs to their own work as writers, recontextualizing southern formal ethics in an explicitly gendered (as well as raced and classed) frame.

"PLACE": CANON, CULTURE, AND CAMERA

The troubling place of contemporary southern women writers in the canon of southern literature, and in "the South" itself, is brilliantly encapsulated in Natasha Trethewey's 2002 sonnet, "Southern Pastoral." The poem recalls an unidentified persona's recurring dream of being photographed with the Fugi-tive Poets in front of their least favorite southern city, Atlanta. In context of this notoriously forward-looking "international city"—the very emblem of post-southernness—Trethewey depicts the pressures (and pleasures) of competing visions of southernness in a postmodern frame. As in a dream, the imagery of "Southern Pastoral" is slippery, with startling juxtapositions and flashes of allu-sion. The photographer in the poem, assisted by Robert Penn Warren, arranges the shot with all the trappings of Agrarian life. The always-under-construction skyline of Atlanta is "hidden by the photographer's backdrop— / a lush pas-ture, green, full of soft-eyed cows." A glass of bourbon is offered. But though the persona accepts the drink (her *"Yes"* echoing Molly Bloom's fraught sexual acquiescence) and seems to embrace the camaraderie of the Fugitives, these ap-pear to come with the price of fulfilling a specific representational function. "*Say* '*Race*,' the photographer croons," and the persona is "in / blackface again when the flash freezes us." Blackface, like the photographer's backdrop, is a facade, an artificial structure meant to reinforce a desired "reality" (the "certainty" of

race) or to mask an undesired one (its ambivalence). The seductive sounds of the poem—the consonance of sibilant "esses" and lingering "enns," the assonance of lowing cows and droning bulldozers—lead up to the freezing moment of visual order, where the persona is made "again" to take on the role of blackness, the Agrarian function of "*Race*." That function is one of an assigned "place," a highly constrained or frozen one, within "the South" and, since the Fugitives are so associated with the New Criticism, within the southern literary canon.

But ambivalence and irony abound in the poet's masterful manipulation of received image and structure, and the "place" assigned to the persona—while it may seem like the "tight spot" evoked by Ralph Ellison and (notoriously, for feminists) by Houston Baker Jr.—proves to be no more determinative than black-face makeup.[6] Trethewey's challenge is formidable. The images, like the sounds, of southernness are powerful, beloved even by the persona. Robert Penn Warren's voice is "just audible above the drone / of bulldozers," yet he is still quite capable of directing the photo shoot. The persona's loaded "*Yes*" occurs at the end of a line where the cows on the photographer's backdrop (this is after all a dream) are "lowing, a chant that sounds like *no, no*" (in prohibition? rebuke? warning?). The seductiveness of the Fugitives' images is their danger, for they work to disguise the oppression of African Americans within the "traditional southern way of life" and in the glory days of southern literary criticism. When the persona of "Southern Pastoral" asserts her voice in the final couplet, "*My father's white, I tell them, and rural*," attempting to break the visual lock of race, the Fugitives counter with the ultimate canonical assertion of literary mastery: "*You don't hate the south they ask. You don't hate it?*" Quentin Compson's denial is reissued as a question that at once invokes (as an aggressive act) the shadow of Faulkner and, ironically, suggests pleading: *you won't take your place?* It is a question that, as a mixed-race poet who self-identifies as southern, Trethewey has herself repeatedly encountered.[7]

Her answer appears twofold. "Southern Pastoral"'s masterful juxtaposition of sound and vision, its "Old" and "New" South imagery, and its perfect ten-syllable lines (an eleventh syllable emphasizes the significance of the responses ending lines seven and fourteen) create a sense of poetic control and unity that might be envied by the New Critics. But within this mastery of form are clear signs of a "deformation of mastery," where Trethewey redefines the terms of poetic success.[8] The lines may have ten syllables, but they eschew the strictures of pentameter or rhyme, instead enacting an internal rhythm of verbal and visualized speech. And if the pastoral has historically represented an urban poet's idealization of some Golden Age of rustic innocence and idleness, Trethewey's

re-presentation reveals the Fugitive shepherds busily attempting to shore up the "natural" bases of southernness. The "place" of the contemporary African American poet ("black" and urban, a northern migrant) is no more "real" in the poem: the interdependence of (significant) cultural signifiers is revealed in (playful) play. Trethewey's is a post-South where the signs of southernness are posted, self-reflexively, and the mechanisms of representational power are exposed and reappropriated. It is a place that Trethewey claims, and commands.

"Command" is a word too rarely used in criticism of contemporary southern women's writing, particularly in discussions of postmodern literature. In an anxious debate about the general relationship of the South and postmodernity, southern literature, and postmodernism, women's writing is made most often to stand for conservative opposition to postmodern innovation. Domesticity, "sense of place," family, "women's voice," storytelling, realism—these are southern women writers' critically acknowledged domain, whether acclaimed as a preserve of strength or bemoaned as a limitation. Although he credits Eudora Welty with an appreciation for risk taking and an ambivalent relation to realism, Julius Rowan Raper finds her "chiefly in the camp of memory" and mimesis (12), as opposed to John Barth's postmodernist metafictions, which "work to liberate the imagination from the passivity and fatality associated with realism, naturalism, and derivative movements" (13). Contemporary southern literature by both men and women generally remains mired in the conventions of local color and modernism, according to Raper, and "consider[ing] the popular success of contemporary *realistic* Southern writers like Anne Tyler and Bobbie Ann Mason," he finds the likelihood of a Barthian postmodernism's taking hold in southern literature "slim indeed" (4). Fred Hobson concurs in his assertion that "the southern writer in a postmodern world is not necessarily, is not usually, a postmodern *writer*" (9). Rather, the contemporary southern writer "essentially *accepts*, rather than invents, his world, is not given to fantasy, does not *in his fiction* question the whole assumed relationship between narrator and narrative, does not question the nature of fiction itself" (9, emphasis in original). Declaring the main line of contemporary writers (including some men) influenced by Welty rather than Faulkner, Hobson notes that few "attempt to write the 'big novel,'" concluding:

> If one has any concern at all about the very healthy condition of contemporary southern fiction, it might be that one sometimes finds—despite an abundance of literary skill, verisimilitude, charm, picturesque-ness, and humor—a relative want of *power*, a power that often had its origins in or at least was related to—at least in Warren, Styron, and part of Faulkner—a certain southern self-consciousness; a power that, in Warren and Styron, stemmed in part

from a philosophical, even mildly didactic intent, the kind of writing asso-
ciated with the novel of ideas, the novel of historical meditation, or the novel
concerned with sweeping social change. (10)

Southern fiction, unmoored from its masculine foundations, appears less
commanding than before. Hobson immediately acknowledges that he may be
searching for a "particular kind of power" (10), though he stops short of acknowl-
edging its gendered basis.[9] Roughly contemporaneous with the highly publi-
cized "resurgence" of southern literature dominated by women writers in the
1980s, the canon of southern literature is itself devalued, damned with praise
that itself reinscribes southern gender roles, at least as they pertain to upper- and
middle-class white southerners. Confronted with this critical chorus (not un-
like Trethewey's cows chanting "*no, no*"), feminist critics have responded along
two main fronts. Some, like Linda Tate, have sought to deconstruct the opposi-
tion of progressive, experimental postmodernism and conservative, traditional
realism. Tate aims to recuperate a "long-standing tradition" of southern women
writers depicting "family, race, history, sense of place, and women's voice" in
realist narrative as "a subversive move, perhaps even more radical in its intent
and effect than the more overtly political fiction of recent postmodernism" (6,
176). Others, such as Patricia Yaeger, attack the critical lenses through which
southern women's writing has been identified with such traditional categories,
which Yaeger brands "mystifications designed to overlook the complexities of
southern fiction" (34). She proposes to "dynamite the rails" of southern liter-
ary criticism that have kept white women's fiction "hemmed in" and "palliated
by even the best of critics," and black women's fiction "marginalized, minori-
tized — not quite counted as southern" (64, 62). Only by changing the categories
of southern literary criticism, "undomesticating" southern women's fiction, and
examining its "fierceness" and "in-your-face" engagement with the grotesque
can this work be understood "in all of its power" (2). Freed from constraining
modes of interpretation, southern women's literature for Yaeger not only com-
mands, it "astonishes."

With radically different approaches, Yaeger and Tate each attack a common
patriarchal vision: a critical branding that works to assign women's writing a
diminished place in the southern literary canon. As with the other southern
visual legacies I have discussed, these literary critical visions extend beyond a
regional frame. This is the hazard of accepting the proverbial glass of bourbon
and taking on (in both senses) the label of "southern": southern women writers
like Trethewey must contest a "freezing" both in terms of canonical status and
image, both within the South and in national and international contexts. The

representational field within which this contest takes place reveals the intimate, gendered connections between southern critical legacies and the visual legacies I have addressed in previous chapters—those dynamics of cultured vision in (and of) the South and the images they produce. In these contexts, it is not surprising, though it is sad, that contemporary southern women's writing that renders the visions behind southern culture and criticism *visible*—that creates what Scott Romine calls "reflexive moments" (19) to denaturalize the essential, ideological images of southernness—is so often identified with the "decline" of southern literature. In my reading of this literature, I propose, like Tate, to trouble the narrow understandings of postmodernism that have excluded much of southern women's writing, but unlike Tate I am uninterested in recuperating the traditional categories through which this literature has been read. With Yaeger, I am committed to broadening these categories and exploring the powerful ways contemporary southern women's writing interrogates critical and cultural visions in the field of the "non-epic everyday." If the frame-breaking re-visions enacted by Trethewey, Smith, Tyler, and Beattie rely less on the grotesque imagery that interests Yaeger (these authors rate barely a mention in *Dirt and Desire*), their dramatic reconfigurations of southern formal ethics are perhaps no less "astonishing."

"THE OTHER SIDE OF THE PASTORAL COIN"

Lee Smith's 1983 novel, *Oral History*, treats the ethics of representational form as an explicit theme. The southern cultural divide between oral and visual representation is presented in the novel through a series of episodes occurring over a ninety-year period told by multiple narrators, some "orally," some in "writing," and some in "photographs." As in "Southern Pastoral," cameras and photography in the novel represent the purposeful construction of the South and its inhabitants as a "freezing" image, meant to cement a particular (white, male, middle-class) critical vision. Like the persona in Trethewey's poem, most of Smith's multiple narrators "talk back" to that vision though a defiant orality that nevertheless shows an acute self-consciousness of self as image. Indeed, the connection of orality with "authentic" vernacular speech, communal storytelling, folk songs, and religious practice, and of visuality with writing, superficial scholarly discourse, exploitative photographs, and class pretension, has led one critic to summarize the novel's thesis as "oral good, written bad" (Robbins 135). But Smith sets up these familiar binaries in *Oral History* to break them down, along with the divisions between center and margin, "truth" and legend, city and country, "authentic" and "post-South," with which they are associated. In the process, *Oral History* becomes a self-reflexive meditation not only on the politics

and ethical responsibilities of storytelling but also on the place of the southern writer in the ongoing construction of southern "place."

Like "Southern Pastoral," *Oral History* juxtaposes imagery of the rapidly modernizing post-South with images of an older, "pastoral" time. The frame tale of a 1980s oral history project bookends a family saga beginning with the 1876 birth of Almarine Cantrell and tracing, in highly fragmented form, the lives of his descendants in the Virginian Appalachian community of Hoot Owl Holler. Like Dee/Wangero in "Everyday Use" and Amelia Varnes in *Daughters of the Dust*, college student Jennifer Bingham comes from the "big city" (in this case the nearby, marginally bigger valley town of Abington) in search of preconceived, romantic pictures of a vanishing past, which she expects to find embodied in the Cantrell family (her mother's people) and their haunted homestead. The novel opens with images of the "true treasure" Jennifer seeks: her grandfather, Little Luther Wade, sways on a porch swing, strumming his dulcimer, while his wife, Old Ora Mae, crochets an afghan in a star pattern, and children play with june bugs tied to strings "they are swinging around and around through the hot evening air" (13). These bucolic images are immediately undercut, however, by clear indications that even this remote region is connected economically and culturally to modern America. Little Suzy, Jennifer's toddler cousin, wears silver nail polish and plays with a *Charlie's Angels* doll, and *Magnum P.I.* competes with Little Luther's traditional folk singing as the soundtrack of Appalachian trailer house life. The living room is furnished Mediterranean-style, the van custom painted and upholstered in orange shag, and Jennifer's Uncle Al has recently quit his concrete business to sell AmWay full-time with his wife. These small signs point ahead to the "capitulat[ion] to a money economy, finance-capitalist land-speculation, and large-scale real-estate development" that Martyn Bone argues inspired Allen Tate's critical sense that "both 'the South' and 'southern literature' were doomed" (viii). If Smith is writing southern literature in 1983, it is of a South that appears on the brink of dissolving entirely into simulacra. Soon, declares an omniscient narrator at the end of the novel, Jennifer's uncle will "make a killing in AmWay" and invest the money in a ski run, the success of which will inspire him to turn his family homestead into Ghostland, "the prettiest theme park east of Opryland itself," where tourists can pay an extra $4.50 at sunset to observe a wildly rocking chair and hear the ghostly laughter in the Cantrell family's abandoned house (285).

At the beginning of the novel, writing itself appears to be a sign and symptom of postmodern, postsouthern alienation. Proclaiming that she "was nothing" and "didn't know a thing" before taking a college oral history course, Jennifer searches for signs of an authenticity she feels herself to lack (16). Armed with

a tape recorder (for "proof") and a notebook, she records her "Impressions" in writing: "One feels that the true benefits of this trip may derive not from what is recorded or not recorded by the tape now spinning in the empty room above me, but from my new knowledge of my heritage and a new appreciation of these colorful, interesting folk. My roots" (19). All indications of her family's modernity are buried under picturesque expectations, literally written out of the picture in service of a deeper cultural need for a coherent, nostalgic Appalachian image. Jenny's stilted written voice and postsouthern placelessness are directly contrasted by the obviously "placed," vernacular speaking voice of Granny Younger, whose "oral" storytelling comprises the first of the chapters which Jennifer's story frames. Invoking an image of young Almarine Cantrell surveying his land, Granny Younger simultaneously asserts her own speakerly authority and the relative ignorance of her "listening" audience: "I know moren most folks and that's a fact, you can ask anybody. I know moren I want to tell you, and moren you want to know. And if I never knowed exactly where Almarine was when he was little, I could have give you a good idea" (27). Granny Younger's omniscience as she goes on to tell the story of Almarine's marriages is certified by her intimate knowledge of "place": the "place" of Hoot Owl Holler, of Almarine and his family within the mountain community, and of her listening audience relative to each. Her frequent asides to the audience ("I smoke a pipe too and you know it"; "by then he knowed moren you do" [31, 49]) may encourage readers' intimate participation in her oral exchange, or it may position readers as those who likely "know" what they know from images. Here, the authenticity of a past southern "place" and voice is contrasted to an "outside" reader, the vapid drone of 1980s television, and the naive picturings of a mis-placed coed's folklore writing, adrift in the placeless, self-less post-South.

This temporal-formal contrast is linked to other dichotomies presented in the novel, particularly in the divisions between urban and rural, rich and poor, insider and outsider, "truth" and simulation. The embodiment of upper-class, urban, outsider falsity is Richard Burlage, a young Richmonder who has turned to teaching in the "hinterlands" in a search for authenticity of religion and self, as a way to ease post–World War I modernist anxiety. Richard's journal entries, which comprise the longest chapter in Oral History, echo Jennifer's in the frame tale, both in attitude and style.[10] Like Jennifer, Richard seeks the "simplicity" and "something real" that he expects to find in the mountain folk, and he locates the most "natural" embodiment of this authenticity in the bodies of mountain women. Comparing two women he meets on the train to Appalachia, Richard expounds on the "object lesson" he sees before him as "two ways to face the world. One way as embodied by this old woman—simple, unassuming, a kind of peas-

ant dignity, a naturalness inherent in her every move. The other, exemplified by the girl—smartness, sophistication, veneer without substance. . . . I have now opted for the old woman's way. . . . My present trip to the mountains is indeed a trip to that wellspring of naturalness she symbolized. And I admired my choice: the correct choice, the only choice for a sensitive and moral man in my dilemma" (103). Unsurprisingly, Richard's favorite poem is Christopher Marlowe's famous pastoral, "The Passionate Shepherd to His Love," which reflects the romanticization of the "profound simplicity" and "oneness with the natural things of the earth" that he sees in his "most vivid mental image" of the beautiful Dory Cantrell (130, 124). This pastoral vision is the key distinction between Richard's reading of female "poor white" bodies and one such as Daddy Glen's in *Bastard out of Carolina*: though the access Richard assumes to have or reject Dory's body is eventually as complete and almost as brutal as Glen's, his attitude is never one of ridicule or violence, but always of sentimentality and even nostalgia for the image he knows "cannot last" (157).[11]

The repeated linking of cultural ignorance, superficial "scholarliness," and the written word in Smith's novel suggests a "thesis": the attempt to freeze or capture the essence behind this nostalgic image in writing is an ethically dubious project, doomed to failure. Richard's prose degenerates into a series of exclamation points as he butts up against his own representational limits, and language fails him in the depiction of his and Dory's sexual desire, just as he, clinging to class privilege and the visual realm of writing, will fail Dory. The interworkings of class and visual exploitation in his pastoral gaze become even clearer as Richard moves to reclaim an authoritative access to Appalachia while further establishing his own "natural" distance from it. Returning to Hoot Owl Holler after a ten-year absence (having abandoned Dory unknowingly pregnant with twins), Richard turns to a more directly "essential" technology, the camera, to attempt to record the essence of his mountain experience. Having given up his literary pretensions (perhaps recognizing the failure of language, or memorializing his loss of control in the linguistic realm), Richard has taken up photography, which like the mirror on his new automobile, pleases him for its ability to frame his images (his own self-image and his romantic image of the mountain folk) "so nicely" (217). Unlike the photographers combing Appalachia in the 1930s as part of the Works Progress Administration or Tennessee Valley Authority projects, Richard is there not to document or bring change but to make art.[12]

The subject of this art is, as before, the mountain South. But art's cultural frame has changed. Richard accordingly reframes his pastoral nostalgia for the past in a modernist sense of irony, which emerges in his photographic framings of Appalachia and his written "discourse" about them. When young boys in

the town greet him by begging for money, he distracts them by taking their picture, emphasizing the visual evidence of poverty (cardboard-patched shoes, the muddy street) in contrast to his shiny new automobile: "an incongruous, ironic juxtaposition!" (218). When those images threaten to exceed their frame—when for example, a long view of the Smith Hotel, "rising flat and white up from its tiny wrecked yard" (a "joke" in Richard's eyes)—reveals under magnification the human presence of two girls in a window, the "object lesson" he takes this time is another self-legitimizing platitude about the power of "a frame, a photograph [to] illumine and enlarge one's vision rather than limit it" (222–23). Thus reclaiming the power of bourgeois framing that he sought to reject in his original sojourn, Richard uses words to re-tie the image to stereotype. He names the photograph, "Whorehouse, c. Hard Times" (223).

Similarly, Jennifer moves to recontain the image of her Uncle Al's assaultive kiss by "chang[ing] it all around in her head." Simultaneously invoking and repudiating the signs of modernity denied previously, she reclaims a classed power to "freeze" the mountain folk: "Some things may seem modern, like the van, but they're not, not really. They are really very primitive people, resembling nothing so much as some sort of early tribe. Crude jokes and animal instincts—it's the other side of the pastoral coin" (284). Both Richard's and Jennifer's searches for the "authentic" pastoral fail; they respond by attributing a different type of "nature" to the objects of their gaze. Estranged from the orality that "talks back" to their preconceived images (Jennifer substitutes a tape recorder for her own ears; Richard finds orally transmitted stories "so first-hand as to make [him] . . . distinctly uneasy" [220]), these seekers fall back on essentializing, stereotyping vision and its technologies, the pen and the photograph.

To read the implications of this formal choice as Smith's own endorsement of orality over vision, however, would be to miss the primary thrust of Oral History. Behind such dichotomous notions of form, Smith shows us, is a modernist quest for the "real": the authentic truth of a story, whether that story be a family mystery or the cultural mysteries of social "place." Although Smith renders each of her characters' narratives in conventionally realist prose, "the real," in terms of a singular truth or master narrative, is precisely what Oral History calls into question. Richard Burlage's camera and Jennifer Bingham's notebook highlight the self-conscious (if not self-aware) effort to represent the "natural" truth of a South that was always already under construction. But so does Granny Younger's "authentic" speech, especially in conjunction with the other "voices" in the novel. Granny talks back, not only to hostile images imposed upon Appalachia, but also to the imposition of "real" singular truth upon the complex realities of her charges' lives: "Don't you forget it is Almarine's story . . . iffen twas my story,

why I'd be all hemmed in by the facts of it like Hoot Owl Holler is hemmed in by them three mountains. . . . I'll tell you a story that's truer than true, and nothing so true is so pretty. It's blood on the moon, as I said. The way I tell a story is the way I want to, and iffen you mislike it, you don't have to hear" (37). Echoing Faulkner's *Absalom, Absalom!* narrator's determination that Quentin and Shreve's version of the truth is "probably true enough," Granny Younger's "truer than true" tale suggests that representing "the South" is more a matter of ethical than epistemological truth.

Several critics have noted the irony of the title *Oral History* adorning a written book, and some have suggested that Smith valorizes orality in the novel to the extent of condemning her own writerly project.[13] Smith herself describes the "oxymoron" of "oral history" not in terms of the formal tension between oral and written, but of the cultural divide between story and history: "If it is spoken it is not history, if it is spoken it is automatically the storyteller's tale" (Herion-Sarafidis 11). Smith uses multiple narrators and hybrid forms (written orality and photographs) not to devalue the "reality" of the past but to show that the past is always already a construct of the present. The "other side of the pastoral coin" is not opposite content: Jennifer's counternarrative of violent, sexually aggressive primitivism was there all along, strategically "naturalized" out of the picture. Rather, "the other side of the pastoral coin" is an opposite formal ethic: a realm where formal choices and their implications are visible, and the *process* of representation is de-"naturalized." Notions of southern place and canon shift function here from an autochthonous grounding to a postmodern interplay of voices and visions. Richard Burlage's assertion that a frame can enlarge one's vision is only true if the frame itself is acknowledged. This is the postmodern gesture of Smith's novel. The postsouthern "place" she creates in *Oral History* is not a trashland of popular culture or a degraded capitalist "Ghostland" of its former self, but a place where the multiple frames that have always supported, contained, and surrounded "the South" are now visible, and their interplay and contest acknowledged, even celebrated.

THE POLITICS OF CREATION

For all of its cultural and literary frame-breaking, *Oral History* leaves cameras in a familiar place: in the hands of a "picture-takin' man." Generally speaking, southern women's writing, as the novels discussed thus far indicate, follows southern history in representing the preponderance of photographers as male.[14] Photographic *practice*, in which I include the commissioning, possession, distribution, display, and interpretation of photographs, may be a female domain,[15]

but where women take up the camera in southern women's writing, there are often signs of ambivalence: witness Amelia Varnes's awkwardness with the camera in Daughters of the Dust, Zora Neale Hurston's ambiguous camera loss in Tell My Horse, and Tory Durrance's flinging her inherited Leica into the lake in Cynthia Shearer's Wonder Book of the Air. For these protagonists, ambivalence springs, in part, from southern patriarchal and racist visual legacies of photographic evidence and from a certain type of anxiety over their own re-visionary roles in the ongoing southern representational politics of evidence. For the female fictional photographers in Trethewey's Bellocq's Ophelia, Tyler's Earthly Possessions, and Beattie's Picturing Will, ambivalence about taking up the camera comes from a similar source, but for different reasons. Their cameras are sometimes literally patriarchal heirlooms, but the revisions these characters enact through the lens are less about providing evidence of the real than about creating a new reality. Mirroring the projects of their authors, these characters are explicitly engaged in a representational politics of creation: an open contest to assert personal agency and regional definition in complex relation to the southern frame of their lives.

It is in the dual context of the historical legacy of southern visual representations and the ongoing critical debates about how best to understand it that Natasha Trethewey published her first two books of poetry, Domestic Work (2000) and Bellocq's Ophelia (2002). Trethewey's first engagement with photography seems primarily formal. Here, the formal issue is less the division between visual and oral than the formal limitation of words to represent temporal life. Invoking the formal ambivalence of the photograph, fictional photography in Trethewey's early poems stands at once as a metaphor for text and for what always remains outside that text, a metaphor for the textual representation of time and for the textual unrepresentability of time. The first poem in Domestic Work, "Gesture of a Woman-in-Process"—subtitled "from a photograph, 1902"—offers an image of two women surrounded by, as Trethewey describes it,

> their dailiness:
> clotheslines sagged with linens,
> a patch of greens and yams,
>
> buckets of peas for shelling. (3)

Evoking one hazard of the necessarily long exposures of early photography, Trethewey ends the poem by calling attention to the special qualities of photographic and, by extension, poetic form:

> One woman pauses for the picture.
> The other won't be still.

Even now, her hands circling,
the white blur of her apron
still in motion. (3)

The focus on the stillness and motion embodied in art of course recalls Keats, and also Faulkner's famous injunction that "the aim of every artist is to arrest motion, which is life, by artificial means and hold it fixed so that 100 years later when a stranger looks at it, it moves again since it is life" (Meriwether and Millgate 253).

But while Faulkner's statement posits form as an existential abstraction, Trethewey's *Domestic Work* immediately links this abstraction to gender, class, race, and regional dynamics. In the poem "Three Photographs," based on photographs of African Americans taken by the white documentarian Clifton Johnson in 1902, Trethewey extends Faulkner's formal meditation to encompass the point of view not only of the "artist" but also of his subject and a third, much later viewer. Section one of the poem focuses on the racism of a white photographer praising "Negro" men for being

such good subjects.
Always easy to pose,

their childlike curiosity.

Section two employs the perspective of a subject asked to pose for a different photo, and it explodes the ideology embedded in the photographer's quest for "naturalness": "*Natural*, he say. / What he want from me?" Contrasting the desire to hold something still forever to the natural processes of change, death, and decay, the section's cabbage vendor persona claims that still photographs are "unnatural like hoodoo love" and offers the possibility of a reverse gaze, to

turn that thing around
and make him see himself
like he be seeing me—
distant and small—forever. (7)

The poem's final section features a contemporary viewer of photographs in a white-walled gallery and shifts the primary meaning of the photograph from its exploitative origins to its potentially subversive, transcendent effects. Drawing on her own memories of southern washerwomen, like her own grandmother, the persona of this section imagines the life and laughter of eight women in the gallery photograph, but notes:

in his photograph,
women do not smile,
their lips a steady line
connecting each quiet face.

Their pose is a form of resistance, both a denial of the artist's presumed access to their lives and a self-assertion of survival and future identity:

Shaded
by their loads, they do not squint,
their ready gaze through him,
to me, straight ahead. (9)

Extending the feminist chestnut, not only the personal/domestic but also form itself become political, and the historical context of Trethewey's poems suggests it always has been. As in Richard Powers's postmodern novel *Three Farmers on Their Way to a Dance*, the power of the photographic gaze here shifts from the artist-as-preserver to a type of imagined collusion between the photographed subjects and, most important, the imagining viewer, the true artist.

Trethewey's second book, *Bellocq's Ophelia*, compresses these speculations into a single case study. In what has been described as a "novella-in-verse" (Campo 183), *Bellocq's Ophelia* imagines the interior life of one of the mixed-race prostitutes photographed by E. J. Bellocq in New Orleans's notorious red-light district, Storyville, in the 1910s. Grounded in the specificities of its New Orleans place and time, *Bellocq's Ophelia* taps into a particular southern milieu that in its particularity manages to heighten and magnify the most vexing aspects of the overall southern dynamics of race, gender, and sexuality. Using photographs and photography as their organizing metaphor, Trethewey's poems offer a highly contemporary, sophisticated model for how we might reread the "evidence" of southern history for the unheard and unseen, and how once acknowledged, this evidence leads to new mappings of the past and future South.

Despite the title, Bellocq functions as minor character in *Bellocq's Ophelia*. Besides Ophelia, the main protagonist of the poems is the camera, and the interchange of photographic gazes it occasions. Herself the product of a then-illegal "mixed marriage" in 1966 Mississippi, Trethewey uses photography's notoriously selective vision and its simultaneous, obsessive association with visual truth as a powerful metaphor for the selective, obsessive nature of race and gender "truth" in the South. Trethewey's Ophelia has learned to stand perfectly still, present her white skin and teeth for inspection, and recite lessons when her

white father comes to visit. She is given arsenic pills to make her skin whiter, and she develops strategies to ignore and evade the sexual abuse by men that eventually forces her to flee her rural Mississippi home for New Orleans. These are all skills that come in handy when poverty forces her to take up residence as a prostitute in a "fancy house," where she is renamed "the *African Violet*" and made to perform tableaux vivants. Sitting for "Papá" Bellocq's camera, "a reversed silhouette / against the black backdrop," Ophelia reflects on the training in pliant objecthood that makes her ideally suited as "spectacle and fetish" (20). Initially considering herself "as mute / as my own namesake," Ophelia cedes her agency to Bellocq's vision: "Now I face the camera, wait / for the photograph to show me who I am" (23, 21).

Here photography figures what Susan Sontag once characterized as the "cruelty" of photographic objectification, in the particular context of New Orleanian visual traditions of race and gender proscriptions. In a poem titled, "Photograph of a Bawd Drinking Raleigh Rye," based on Bellocq's photo of a woman in striped stockings (see figure 28), Trethewey reminds contemporary readers of their own participation in the voyeuristic tradition of representing women. On the surface of an image of woman as image, there is the viewer's thumbprint, confirming, as the persona states:

> this is all about desire,
>
> how it recurs—each time you look, it's the same moment,
> the hands of the clock still locked at high noon. (34)

This symbolic violence is never absent in *Bellocq's Ophelia*, but Trethewey also uses photography to figure the possibility of resistance and transformation, which Trethewey images as "the glittering hope of alchemy" (27). A key transition point occurs when Ophelia buys herself a camera and learns that she, too, holds the power, and responsibility, of representation. In a letter-poem to her former schoolteacher, Ophelia writes she has

> learned the camera well—the danger
> of it, the half-truths it can tell, but also
> the way it fastens us to our pasts, makes grand
> the unadorned moment. (30)

Owning the past necessitates confronting all parts of history, signified in the poem "October 1911" as a series of photographs, "good" and "bad" images. Amplifying this theme is a sequence of poems that make visible what Bellocq's camera cannot see:

silverfish behind

the walls, the yellow tint of a faded bruise—

other things here, what the camera misses. (43)

The limitations of Bellocq's photographic gaze become the power of Ophelia's, and Trethewey's, own. By reframing the visual "evidence" pictured in Bellocq's photographs through the lens of a traditionally muted woman, and by re-placing the power of the camera's gaze into that same woman's hands, Trethewey asserts the historical and ongoing southern visual tradition of resistant re-imaging, in which her poetry takes part.

The real source of power in the act of re-imaging is here less a re-presentation of better, more "real" photographic evidence, however, than the creative agency of picturing the "real." Ophelia dedicates her photographic efforts not toward capturing "what the camera misses"—there are realities in her New Orleans world that "*you cannot see*"—but to ordering her environment according to her own creative vision (28). "What power / I find in transforming what is real—" exclaims Ophelia in "Disclosure," as she, like Bellocq, like Trethewey, like generations of writers and literary critics, orders the facade of her southern reality. In the face of southern gender, race, and class conventions that "mask" and "obscure" her, Ophelia learns to seize creative initiative:

to keep

my face behind the camera, my lens aimed

at a dream of my own making. (44)

Though we as readers cannot literally see Ophelia's images, we witness the dream of making through Ophelia's written "voice," which in Trethewey's contemporary poems both evokes a southern past and presents a new "reality."

That new reality is a postsouthern one, not in setting but in consciousness. *Bellocq's Ophelia* takes place on classic terrain of southern race and gender ideology, "reality" that cameras classically have been employed to prove or disprove. Trethewey uses a fictional female photographer, however, to focus not on the "truth" that cameras can or cannot see, but on the self-conscious creation of a visualized southernness, both Ophelia's and her own. By contrast, the female photographer at the center of Anne Tyler's *Earthly Possessions* evinces neither self-awareness nor any concern for the South as such. Amply concerned with both, Tyler in this novel develops themes of personal and creative agency in reverse, as from a photographic negative. Using intertwined metaphors of photography and the journey South, Tyler charts a postmodern relation of self and community in an explicitly postsouthern context.

Thomas Haddox has argued that "postsouthernness" preserves traditional notions of southern literature and culture even as it works to supplant them (567–68), and like Trethewey, Tyler in *Earthly Possessions* evokes classic tropes of southern gender and class by way of highlighting their tropological status. Like Ophelia, Charlotte Ames Emory has learned to pose and to perform her daughterly duties, though as a lower-middle-class white girl coming of age in the post–World War II South, those duties include competing in county fair beauty contests and dropping out of college to care for her parents, rather than picking cotton. Unlike Ophelia, Charlotte appears to internalize the passivity prescribed for her: she prides herself in offering no resistance whatsoever, almost drowning as a child because she refuses to scream or cause a disturbance. Tyler casts her narrative in the first person, but there is some question, not least in her narrator's eyes, of whether there is a person—an active agent—behind the narration. Whether acquiescing to marry, accepting the care of an abandoned infant, or being taken hostage by a bank robber, Charlotte considers herself "gifted with the ability of giving up . . . all I had to do was pretend we were on some great, smooth, slow conveyor belt" (78). At first, Charlotte appears as an extreme version of the objectified southern lady, a woman who has "literalized the symbol" of passive southern womanhood and now experiences a world ordered by husband or kidnapper with similar pleasure, "like a cat in sunshine" (83). But the southern "sense of place" that supported the southern lady role has undergone deep changes since Charlotte's "Dick and Jane" childhood. By the time Charlotte reaches full adulthood—thirty-five years old with two kids of her own—her small town of Clarion, Maryland, has transitioned from a pastoral land of county fairs and civic pride, where Charlotte "knew everybody," to a postsouthern anonymity, where the family home is sandwiched between a Texaco and an Exxon, surrounded by thrift shops and liquor stores. In a perverse recasting of the autochthonous ideal, indifferent and estranged Charlotte appears to have sprung, unself-consciously, from her increasingly alienated southern environment. Like a Walker Percy hero, "in order not to mind too much," Charlotte has "loosened [her] roots, floated a few feet off, and [grown] to look at things with a faint, pleasant humorousness"—a classic postmodernist ironic stance (120).

As the novel progresses, however, Tyler reveals Charlotte's postmodern alienation to be a strategic choice, to evade responsibility for her own agency. Charlotte's recognition of this choice is charted through two parallel and juxtaposed journeys, one physical, as she is transported south as a hostage of Jake Simms, and one photographic, as she inherits and eventually transforms her father's portrait photography business. To Charlotte, home is, like her father's consistently posed photographs, a frozen place from which there is no escape. Murray Ames's

"set ideas" about "honest" portraiture evoke southern conventions of honorable class and gender behavior: just as he forces his wife to quit her teaching job ("he didn't want a wife who worked"), Ames forces generations of schoolchildren to pose before an unchanging painted backdrop of "blue, blue sky and one broken-off Ionic column" and all of his customers to assume an identical "sideways look" such that a display of his portraits resembles "a field full of flowers, all being blown by the same strong breeze" (9, 58). Reminiscing about a career of photographing important men and forcing other people with "no judgment" into proper poses, Ames chides Charlotte, "I never have held with these fancied-up photographs. No use pretending someone is what he isn't" (60). Realizing that she is expected to quit college and tend her father and his business, Charlotte equates photographs, which "froze a person, pinned him to cardboard like a butterfly," with her own situation, "home, trapped, no escape" (57).[16]

Using similar language, Charlotte describes seeing news footage projected on an array of televisions in an appliance store of herself and Jake Simms fleeing the robbery scene: "We were locked together forever. There was no escape" (26). Nevertheless, in what has led several critics to characterize this as a "runaway housewife" novel, Charlotte initially responds to her kidnapping as a fantasy fulfillment of "moving on at last" (52).[17] Traveling south through Virginia and Georgia, Charlotte notes that she and Jake "truly had traveled; we'd left that cold false Maryland spring behind and found a real one" (101). But Charlotte's realization of self, like Tyler's re-vision of the South, is not a journey toward finding a lost authenticity but toward acknowledging creative agency. Tyler presents the postmodern problem of what is "real" most directly in Charlotte's photography work. Unlike her father with his "set ideas," Charlotte takes portraits "any way people asked" because she has "no feelings about it" (59). Disclaiming her own agency, Charlotte allows her clients to drift among "stray props," adorning themselves in sequined shawls, fake swords, peacock feathers, and ping-pong paddles, which she often does not notice until the developed prints "astonish" her (150). In an ironic reappropriation of the classic southern photograph—the Civil War general's portrait—Charlotte photographs her aged boarder, Miss Feather, in a cape and pistol, thus setting off a demand for similar portraits from her other customers. Dismissing a regular client's question of whether the pistol is real—"Certainly it's real. . . . You see it, you feel it: it's real"—Charlotte is nevertheless vexed by the connection between reality and culture, fretting that her father "would never approve" of her portraits because, he would say, they are not "really real" (198). The question extends to the very core of her self-conception: when a photograph that Charlotte believes is a portrait of her mother's "true daughter" (who was switched at birth) is identi-

fied by her dying mother as a picture of herself (Charlotte's mother) as a child, Charlotte must question the foundational narratives upon which she has built her life. The photographic reality that Charlotte has assumed shifts; the oppositions she has drawn between herself and the "true daughter" become entirely new connections between past and present.

Ties to traditional narratives are not easily severed, however. Charlotte's brother-in-law, Amos, confronts her hiding behind her "father's camera" and his definitions of reality: "What's your father got to do with it? . . . This studio's been yours for, what? Sixteen, seventeen years now. It's been yours nearly as long as it was his. . . . And still you act surprised when somebody wants you to take his picture. You have to decide if you'll do it, every time. A seventeen-year temporary position! Lord God" (198). Amos's condemnation of Charlotte's "passivity" hits the mark, but his identification of its roots falls short. Rather than refusing her property rights—"never mind whose toes they step on, even your own"— Charlotte has refused her own creative agency, her responsibility for her own fate (199). Pairing Charlotte with Jake, a doppelganger of denial, and sending them both hurtling through the post-South, Tyler sets the conditions for Charlotte's recognition of her own role in defining self and community. The farther south Charlotte travels—the more Tastee Freeze, Texaco, pecan stand, and thrift shop facades she sees strung together—the more she connects these facades with her own creative work. Defying the threat of gunfire, Charlotte leaves Jake in Florida, willingly becoming dependent on the community Traveler's Aid to return her to Maryland, her husband, and her photo studio. Concluding that her subjects' "borrowed medals may tell more truths than they hide," Charlotte acknowledges her own responsibility in the re-visioning of her community and, equally important, acknowledges the competing visions of others.[18] This is not the circular return to a passive life that many critics have decried; it is an active embrace of agency within, rather than against, a postsouthern community.[19]

If Tyler examines the reluctance of a southern woman to picture her own agency, Ann Beattie in Picturing Will explodes the gendered basis of this picturing. As the multivalent title implies, Beattie in Picturing Will explores the will to picture —especially one southern woman's will to photograph—and what that "will" looks like when pictured by other characters and by Beattie herself. At the most literal level the title refers to a boy named Will, the son of Jody the photographer. The novel addresses the ways Jody and other adults literally and figuratively picture the child for their own ends, and ultimately it raises the possibility of Will as a picturer and the question of what exactly it is that picturing will do. Drawing clear analogies to her own writerly project, Beattie uses photography both as a structuring device and as a metaphor for the gendered dynamics of seeing,

artistic creation, and professional ambition that haunt her adult characters.[20] A writer often maligned as a post-postmodern minimalist and a "Kmart realist," Beattie in *Picturing Will* highlights the process of artistic creation and the gender and class politics that affect the making, selling, and, by extension, the critical reception of art in contemporary America. Grounding her novel in the post-South—both the neo-genteel liberal post-South of Charlottesville and the strip mall and swimming pool post-South of Florida—renders these politics particularly (and peculiarly) visible, enabling Beattie more vividly to evoke the visual and literary legacies her work challenges.

The opening pages of *Picturing Will* present a southern woman "mesmerized" by what she has created: a thriving photography studio and business. Beattie reveals the source of this wonder with the compression of a short-story writer: Jody has been snagged by a conventional narrative of femininity—symbolized by a high heel snapped by a sidewalk crack—into marrying Wayne, a blustering embodiment of the neo-gentleman (frequent roses, a move to the Virginia countryside, constant bravado), whose bullying plans "to create a life for himself, and for her" cause Jody to "view her own ambition with skepticism" (5). Beattie presents Jody's ambition a priori and the power of gender conventions to stifle it as a source of astonishment. As for Trethewey's Ophelia, photography functions as a way out of this entrapping narrative. Unlike Ophelia and Charlotte Emory, who learn photography from father figures, Jody appears to teach herself. Traditional family photos appear only rarely in the novel; Beattie, like Trethewey and Tyler, is focused on her female protagonist's extrafamilial creative vision. Jody studies books of photography and, inexplicably to Wayne, hangs photos of people they don't know (purchased from the Library of Congress) on the walls of their home. After Wayne abandons her and their six-month-old son, Will, without a word and without money, Jody makes her way farther south "almost randomly" to a girlfriend's empty house in Charlottesville. There, years later, she prefers to tell herself that "photography and good luck had saved her, [because] it was still too painful to think that her father's small savings account" or her girlfriend's generosity were determining factors (6). Working her way from clerk in a camera shop to in-demand wedding photographer, Jody regards her "self-made" success with wary astonishment—she prowls her studio at night to make sure Wayne's "roses hadn't taken root to bloom again at the bottom of the trash" (5)—and with the aggressive ambition of an artist. Any ambivalence this southern woman shows toward the camera arises in direct proportion to the hours she must use it to earn a living rather than to pursue her own artistic vision.

Though in early drafts Beattie organized *Picturing Will* geographically, with sections divided between Virginia, Florida, and New York, the novel as published

is structured in three parts: "Mother," "Father," and "Child." Much criticism of the novel centers on who is the truer parent to Will, Jody or her domestic second husband, Mel Anthis.[21] The root of this criticism is, of course, the traditional gender roles that are invoked and flouted over the course of the narrative. Beginning the book with Jody's section, Beattie encourages readers to perceive its structure photographically, both in terms of perspective, like the wide-angle and close-up views of Will's life that Jody sends in envelopes of miscellaneous detritus to Wayne, and in terms of framing, particularly in what is left out or not said. Beattie's portrayal of Jody's art-making in Virginia constitutes one of the most extended meditations on the artistic photographic process in American fiction, and it is a close analogy to Beattie's fictional technique: "Until you looked through the lens, you could never be sure. That was when things took on a prominence they didn't have in life, or when details disappeared. You could find that the picture you thought to take with a wide-angle lens was really better seen in close-up. You could know the routine, use the right exposure, compose perfectly, but still—the photographs that really worked transcended what you expected, however certain the results may have seemed at the time" (17).

As Jody works her way into a photograph, shooting through the "obvious" until observation and felicity combine into "the right picture," her ambition for personal expression—for making "photographs that revealed what she knew about the world in 1989"—becomes clear (18). The rest of the novel places this desire in its multiple contexts. The three sections of Beattie's novel coexist as in a collage of wide-angle and close-up views, radically different visions of the same events and of the Will that binds them together. These sections are interspersed with four italicized chapters of ruminations on child-raising, with a quality so intimate (and similar to the brief passages of second-person narration that occur in Jody's sections) that readers may assume they represent Jody's interior voice. When in the last of these chapters, the voice is revealed to be Mel's—these are the pages that Mel has written about raising Will in lieu of pursuing his own ambitions as a novelist—Jody's devotion to her artistic career and subsequent detachment from Will and Mel are pictured from a wider though no less individualized view: "*She pursued fame, and left it to you to pursue baby-sitters. And the closer you and the child became, the more she withdrew, as if that was what she had wanted all along: a clear road, space, time, the people around her happily involved. You would expect a little jealousy. More guilt. But that isn't the way it was*" (216). Even for the devoted stepfather, the subject of this story is not Will, but Jody's will.

The southern settings of Beattie's novel help ensure that the story of Jody's will will be understood in terms not only of the ethics of child-rearing but also of the ethics of creation. Perceptions of Jody's artistic drive are dually framed in

the novel by gendered points of view and geography. To Jody's New York agent, D. B. Haverford, whom Jody (and the narrator, for the rest of the book) christens Lord Haveabud, Jody's ambition, like his own, goes without mention, other than that she must move to New York to nurture it. Haveabud is concerned with Jody's image not for ideological but for marketing reasons, though he notes that "anyone who had melded into Chelsea well enough to wear her lover's shirt over white painter's pants with neon-green socks and moccasins would need no coaching" (82). Indeed, Jody's "type" fits almost too seamlessly within a northern urban context; her voice (though not her ambition) disappears almost entirely upon her move north. The tensions in Beattie's story of the ethics of creation arise from Jody's dual status as both image and imager of southern culture. Placing the origins of Jody's ambition and art in the post-South enables Beattie both to evoke southern visual and literary legacies of domesticity and the grotesque (for her own and Jody's greater profit) and to challenge these legacies, highlighting the revisionary work of her own narrative.

If Jody views her move to Charlottesville as "almost random," Beattie purposefully seizes on what Jon Smith has called the "dangerous" qualities of this small southern city to ground Jody's "dangerous" ambitions. To Smith, Charlottesville, "with its world-class university, its old and new money driving up real-estate prices . . . its liberal politics and active gay community," represents "the sort of prosperous, progressive South (never a 'new South') that must be repressed to continue narrating the region in terms of colonized global-southern decline" (Smith and Cohn 12). Similarly, Jody's will to picture, her creative agency, must be repressed in order to continue to picture the South as a "white man's country" with southern white women as its domesticated, pedestaled icons. Setting Jody in Charlottesville allows Beattie (like Jody) to exploit her audience's expectations of southernness and to revise them. Jody's flourishing photography business, her gay neighbor, and her nurturing husband-to-be reflect Charlottesville's "progressive" environs, while the weddings Jody photographs represent the uneasy relation between southern tradition and modernity, as well as Jody's own conflicted relation to (post)southern culture. Because pilfering has become such a problem, for example, even the wealthy hosts have turned to the simulacra of plastic champagne glasses. Jody avoids photographing their plastic shards as "too obvious," but she often sympathizes with the anxious brides performing the rituals of personal and community identity because "it was desperation rather than vanity that made them look soulfully into the camera, because the camera had the power to stop time and to verify that they were part of a tradition" (65). In her work, Jody's camera functions as a pre-

server of tradition; in her art, Jody seeks to render these traditions startling or ironic in the "right picture."

The ethics of what constitutes the "right picture" are explored most directly in the Halloween party Jody is hired to photograph and its aftermath. The costume party in an abandoned country church epitomizes the nexus of old and new, as well as the typically postmodern sense of (gently/genteelly) parodic iconoclasm with which many of Charlottesville's citizens approach it. In the tradition of photographers like Walker Evans and William Christenberry, Jody finds "character" in the old church and plans to return to photograph it in the morning. But the photographs she ends up making will more evoke the "grotesque" images of Ralph Eugene Meatyard or Diane Arbus. Driving home from the party, Jody's best friend, Mary Vickers, hits a deer. Arriving on the scene, other costumed revelers stop to assist. As Mel tends to Mary Vickers's cut face, she thinks to look to her friend Jody. But Jody is not there to help:

> Jody had been moving fast. She had a roll of 1000 ASA in her camera and was in the process of taking photographs of Casper the Ghost as he crouched with Peter Pan by the car headlights. As she moved the camera and Mary Vickers's startled look suddenly became the central image of the frame, she clicked quickly. Thank you, God, she was thinking, for the invention of the autowinder. The next shot she took was the photograph that would later be blown up and hung on the large wall to the right-hand side of Haveabud's gallery in New York—the primary display wall, the place people always looked as they began to find their way into the depths of the gallery: Mary Vickers's eyes, bright enough to bore a hole through the camera lens, full moon shining to one side, people clotted together on the road, and in the background the large form of a ghost, white body billowing in the wind, looking down at who knew what. (49)

Jody's sacrifice of her friend for art recalls Faulkner's famous declaration, "If a writer has to rob his mother, he will not hesitate; the 'Ode on a Grecian Urn' is worth any number of old ladies" (Meriwether and Millgate 239). Faulkner's statement, especially in its southern context, is shocking enough for its filial disrespect; Beattie's version, also in its southern context, is more so because the artist (Jody and Beattie) is herself female. Here, Beattie revises a southern literary legacy by reappropriating a declaredly "masculine" representational (as opposed to reproductive) power of creation for her female artist-figure. She, at least partially, revises a related southern visual legacy of photographic gaze dynamics by placing a camera in the hands of a southern woman who is unambivalent

about her own will to picture. And Beattie marks a seemingly definitive break for Jody from the gendered expectations of nurturance, self-sacrifice, and motherhood: after this episode Mel and Wayne's third wife, Corky, in Florida are the only characters who are seen caring for Will's daily needs.[22] Jody anxiously recalls Will from a Florida visit with his biological father to have a "family" photograph taken of herself and Will—as a publicity spread for *Vogue* magazine.

Although in interviews Beattie demurs as to whether Jody's artistic aggression is feminist (Mary Vickers, after all, is a fellow woman), it is certainly radical.[23] Having this aggression illuminated on a southern country road highlights this radicality. In an important sense, Beattie's use of southern settings mirrors Jody's: to invoke audience expectations of "character," peculiarity, and perhaps a certain grotesque portentousness—to get on the gallery wall in New York. In this fundamentally conservative strategy, there is a danger that Jody's gesture, and Beattie's narrative, will themselves be seen as extensions of a southern grotesque tradition and thus labeled, contained, and ignored. Setting the novel in the "post-South" of Charlottesville, however, helps mitigate this danger, placing Jody's actions and Beattie's novel in context of an ongoing southern politics of revision and (re)creation. The photographic collage structure of the novel helps "realize" this context, with the gaps and clear contradictions between vantage points schooling readers not to confuse realism with a singular reality, but rather to recognize that ordering "facades" is the crucial work of claiming representational power. *Picturing Will* partakes of the post-South to participate in creating it.

In picturing this postsouthernness, a condition that appears to transcend regional boundaries, that evokes southern traditions only to "disappoint" or revise them, that threatens to spin out into an ever-homogenizing string of materialism, capitalism, and cultural "decay"—can anything specifically southern be said to remain? Contemporary southern women's writing of the kind I have examined in *Ordering the Facade* shifts the basis of this question from an ontological search for the "real" of southernness—for a southernness that "just is"—to an openly political, representational contest over what is "specified" as southern and by whom. If the "real" South appears to dissolve into mere simulacra, this writing asserts, it is because it always was. The simulacra, the facades of southernness, are not "mere": they constitute the "norms, codes, and manners" that comprise southern community, providing, as Romine has argued, the simulation of a shared reality in place of the impossibility of an actually shared one (3). If all the resources of southern ideology and technology, including photography, have been marshaled to deny this—to insist on a naturalness that would reinforce a hegemonic "reality"—so have the southern fictions considered here

marshaled their own resources, including photography, to create the "reflexive moments" that make these battles visible.

Fictional photography in works by Smith, Trethewey, Tyler, and Beattie functions not as a figure of anxiety over the South as simulacrum but as a metaphor for the raced, classed, and gendered dynamics of visual power that determine which "facade" will represent "the South." Each of these authors engages in a de-centering of southern literary "master narratives" that is consistent both with canonical postmodernism and with feminist deconstruction of patriarchal power structures. In their works, however, the postsouthern gesture is less a matter of challenging or re-visioning the "evidence" offered to support traditional southern "reality," than it is of aggressively and transparently creating "realities." The specifically postmodern power of these authors' works resides not in the deconstruction of regional identity but in the open contest to define the representations that comprise "the South." [24] This political postmodernism takes place within a continuing southern project of resistance and renewal: a project that exposes the vision of a culture as just that—cultured—and, as such, open to challenge and re-vision.

Does the artist encounter disaster? He will "make capital"
of it. If one is a victim . . . one can by the solace and
vengeance of art convert this very "liability" into an "asset."
One tries to fight on his own terms, developing a strategy
for imposing the proper "time, place, and conditions."
—Kenneth Burke, "Literature as Equipment for Living"

The question to ask of pictures from the standpoint of a
poetics is not just what they mean or do but what they
want—what claim they make upon us, and how we are to
respond. Obviously, this question also requires us to ask
what it is that we want from pictures.
—W. J. T. Mitchell, What Do Pictures Want?

The closing pages of this book were written as the aftermath of Hurricane Ka-
trina continues to ravage New Orleans and countless Gulf Coast communities
only some seventy miles from my home in Baton Rouge. It is a disaster unparal-
leled in U.S. history, a disaster seemingly designed to re-cement the image of the
South as a peculiar "problem" of unstoppable natural forces and massive human
failings. In it we can see so clearly the disasters of southern—American—his-
tory repeating themselves: the tragedies of poverty and class privilege, racism,
and violence, even the tendency of the federal government to ignore, then over-
ride, southern spaces and peoples. In the context of such disaster and of the
monumental efforts to rescue, aid, and recover human beings, writing and even
thinking about literature seems fruitless, maybe even unethical.

It helps to remember that what we call southern literature sprang, and will
continue to spring, from all this. That, following Kenneth Burke's formula-
tion, all literature is a strategy for dealing with situations, a way of marshaling
thoughts and images to fight on our own terms. If literature is indeed "equip-
ment for living," maybe it is appropriate for imagining ongoing life, even in the
midst of ongoing catastrophe.

There is some evidence for this in a book published roughly concurrent with
the hurricane, Ronlyn Domingue's *The Mercy of Thin Air*, a novel that imagines an
afterlife in New Orleans and Baton Rouge. In the summer of 1929 Domingue's
young protagonist, Raziela "Razi" Nolan, drowns in a freak accident, in the
midst of a passionate love affair. Rather than crossing into whatever is beyond,
Razi remains "between," sharing New Orleans with others in her "situation" for
the next seventy-five years. Razi's peculiar form, a density "knit of energy" rather
than matter, gives her a sort of half-presence: rid of the constraints of human

flesh, her senses are super-heightened, and she can travel any distance (30). Through a "trick" of electromagnetism, those "between" can interact with the physical world, moving objects, playing cello, even writing letters. Their bodily manifestations are real, but disconcertingly unbodied, detached, untouching, and untouchable. Indeed, there is a cardinal rule: "Do not touch. Any and all attempts will result in a desire for the tangible you cannot fulfill, and it will make you very vulnerable to your memories. Contact with the breathing—the living— can be disruptive, even dangerous. Some of you will be able to shape your energy into a shell of what you were, inside and out, but don't let that fool you. You simply no longer have the inherent structures needed to experience touch in a way that is either familiar or satisfying" (59). In short, the "between" relate to the living world as if they were photographs.

Like the deluge of very real images coming out of New Orleans post-Katrina, fictional photographs saturate Domingue's text, drawing on, even as they (re)-create, collective memories and visual legacies of southern people and places. Two aspects of these fictional photographs especially lend themselves to some concluding speculations on how contemporary southern women's writing has positioned us to think about photography, particularly in a post-Katrina moment. Like so many of the fictional photos included in Ordering the Facade, the dozens of photographs that haunt The Mercy of Thin Air are what David Madden calls the "charged images" of Domingue's text. In the aftermath of Katrina, however, we are perhaps charged to "look" at them in a new way: to ask new questions about what it is we want from pictures and what they might want from us. If, as George Lipsitz has suggested, the collective memories formed through this charge and countercharge "open up wounds" that underlie our culture, they also "keep alive cherished possibilities" for acknowledgment and change (271).

A first aspect of Domingue's fictional photography will by this point in my account of southern visual legacies be familiar: the powerful role of photographs in creating (not just reflecting) personal and cultural histories, in forging desired (and, to some, undesired) links between past and present, and in engaging in an ongoing contest to determine who and what is visible in and as the South, and how the South should be seen. Photographs are themselves figures of between-ness in the novel, acting as both objects and subjects of memory, forming connective bridges of personal and cultural understanding between the generations of southern women who handle them.[1] But like any force in the ongoing formation of cultural memory, these bridges span contested waters, and photographs also serve as figures of disconnection and frustration. The Mercy of Thin Air opens its first-person narrative with Razi tracing the outline of her own body in a photograph, much as she recalls tracing a path down her beloved Andrew

O'Connell's arm in New Orleans before she died in 1929. Although she is able to "hold" the photograph, Razi aches with the frustrated desire to experience real touch as she remembers it. Similarly, in 2004 Baton Rouge, Andrew's granddaughter Amy (from his marriage long after Razi's death) is jolted back into an experience of traumatic loss after seeing DVD images of her deceased lover, images that increase her own pain and desire to an extent that she is estranged from her very much living husband. Subjugating this pain within anger at her grandfather's destruction of family photographs before his own death, Amy obsessively scans and retouches old family photographs to create a digital archive, in Razi's words, "of images so clear, so bright, that the people almost seemed to move" (272). Like Miranda in Porter's *Old Mortality* and Jo in McCorkle's *The Cheer Leader*, Amy wants from these photographs evidence of a personal and cultural ideal. Thanks to new technology, her loyalty to this ideal can extend beyond simply ignoring photographic "flaws" or blacking them out with a magic marker, to digitizing them and perfecting every pixel. If this desire to confirm and control the "truth" of memory is pursued through a photo-technology itself perched uneasily between concrete and abstract realms, it is firmly grounded in southern visual culture.

Like these photographs and their (dis)embodiments of desire, Razi haunts Amy's house, first empathizing with and then learning a lesson from Amy's and her own photographic obsessions. Amy's retouching is paralleled by her gradual willingness to look at the photographs and other buried memories of her lost love, to open up the wounds of mourning and begin the process of re-memory. Despite Razi's initial praise of Amy's scanning project, Domingue's novel ultimately pushes away from mimetic efforts at image preservation as the key to re-memory and toward ethical understandings of the claims such images make upon memory, acknowledgment, and cultural "place." At the precise moment readers might expect finally to "see" Amy's digitized collection, the power goes out, the fuses blasted by Razi's realization that Amy's grandfather "Poppa Fin" and Razi's Andrew are one and the same. This revelation comes not from Razi's over-seeing photographic "truth" but from her witnessing Amy's own acknowledgment of love and connection to her grandfather. The novel closes with (now also dead) Andrew's eyes watching Razi from a photograph as she prepares to go "beyond" by holding the hand of their dying friend, Twolly. This time, Razi traces the "effluvial contours" either of a photograph or of her own ethereal body—the imagery folds together—only to discover that Andrew's presence within her lies not in the "complicated sweep of sensation and substance [she] was," but in the speech and "map" of memory (308).

This narrative of desire beyond human limitations, figured in the dead look-
ing at the dead in and as photographs, gives a new twist to W. J. T. Mitchell's
question, "What do pictures want?," linking the answer to an ethics of memory
anchored in "place." When Domingue wrote these photographs, she was doubt-
less (if unconsciously)[2] influenced by what I have called the visual legacies of
southern culture, among them the rich history of visual representations evok-
ing the famous sense of "place" in the South—both as a noun (physical loca-
tion) and a verb (social positioning)—and the use of photographs to evince, or
to contest, various "truths" of southern familial, gender, race, and class iden-
tities. Like the other southern women writers featured in this study, Domingue
engages the ghosts, as it were, of photographs past. Readers "see" the photo-
graphs of Razi and the other southern characters and places in the novel not only
because Domingue describes them ekphrastically, but because, as I have argued
throughout this study, they have seen them before, as part of the cultured visions
and collective memories they form of New Orleans, south Louisiana, and its
people. But the South's visual legacies, like the notion of "the South" itself, are
always contested, always subject to re-vision. The images coming out after Hur-
ricane Katrina now haunt southern, U.S., and even global visual culture, altering
collective memories and creating new, or at least newly visible, open wounds.
If Domingue's text drew on cultured visions of New Orleans when it was writ-
ten, now, when we read it, it seems impossible not to search for the "new" New
Orleans in its imagery. What do we want from pictures of the city, its people and
places? What do these pictures "want" from us?

I have argued that contemporary southern women's fiction provides an answer
grounded in southern visual legacies. In a southern frame, the crucial work of
photographs is not to cement epistemological truths but to effect the ethical
work of cultural representation, empowerment, acknowledgment, and trust. If
the photographs of Katrina's aftermath represent very real bodies in a very real,
very damaged place, they represent even more how quickly one facade built of
cultured visions can give way to another. There is danger in this, but also power.
What possibilities for change and re-vision do the now openly visible wounds of
New Orleans contain? Whose stories will frame the new "real" of this most cher-
ished, and feared, southern city? Will the order that comes from the disordering
of "New Orleans" acknowledge the heritage of racial and class "placing" that
brought us to this pass, or the old—and the new—connections between this
heritage and the transnational forces that built (and are rebuilding) the city? The
history and ongoing legacies of visual culture in the South suggest that what-
ever realities emerge from Katrina's floodwaters will be created in the interplay

NOTES

INTRODUCTION

1. These cultural images are indeed what have delimited the category of "southern women" into two major strains, black and white, rendering all other sorts of women living in the South—Native American, Chinese, Jewish, Indian, Cuban, Central American, and Vietnamese, to name only a few major groups—virtually invisible.

2. I use the term "fictional photographs"—following Judith Sensibar's lead in "Faulkner's Fictional Photographs: Playing with Difference"—rather than the more general "figurative photograph" because "fictional photograph" better evokes a textual, literary context. Figurative photographs might also refer to paintings of photos or drawings of photographs included in comix, for example. These figurations are fascinating in themselves, but they are outside the parameters of my study here. The term "fictional photograph" has also been used to describe constructed or manipulated photographs "in which the meaning of the photographic image is determined by the photographer's intention, rather than by the actual qualities of the subject matter before the camera" (Arkins). I prefer Miles Orvell's term for this type of work—"photographing fictions" (163).

3. Susan Williams's *Confounding Images*, for instance, analyzes fictional photographs in antebellum northern literature, though she never characterizes her work as such. See also Armstrong, North, Rugg, and Megan Williams. Born of the same cultural studies movement that informs this project, most of these studies share with my own a concern for borders: for revealing and critiquing the boundary between photography and literature as it is made to represent various formal, political, and ideological divisions within specific cultures. Beyond this, they share with each other (and with predecessor works by Carol Shloss, Ralph Bogardus, Françoise Meltzer, Jefferson Hunter, Timothy Sweet, and Mary Price) a focus on the nineteenth century, with occasional attention to the first half of the twentieth century, a point to which I shall return at the end of this introduction.

4. McPherson's metaphor of the lenticular was inspired by a "3-D postcard" that, when viewed from one angle, shows a large plantation and hoop-skirted young lady and, when shifted slightly, reveals a "stereotypical image of a grinning, portly mammy" (26). The two images cannot be viewed at the same time. McPherson is particularly concerned with the "lenticular logic of racial visibility" (7) in American representations of southern culture, which "often serves to secure our understandings of race in precise ways, fixating on sameness or difference without allowing productive overlap or connection, forestalling doubled vision and precluding alliance" (27). *Ordering the Facade* explores this "monocular logic" as it relates to race and to gender, class, and sexuality, attempting to provide, as McPherson recommends, "a framework that allows us to understand the images or narratives in relation" (7, 27).

5. To borrow Scott Romine's terms, the southern white woman functions as an icon, an image that "permits a mimetic orientation in which the positive attributes of commu-

nity (cohesiveness, order, stability, interdependence, and so on) are lent a kind of iconic integrity or, to put the matter another way, are displaced onto things" (7–8). The texts included in *Ordering the Facade* take these bodies-made-icons, and the strategies that make them, as their major subject.

6. For critical histories of American photography see Orvell, Garner, Goldberg et al., Bunnell, Sandweiss, Willis, McEuen, Stott, and Trachtenberg. The relationship of photography and American literature has seen a flowering of new studies in the past ten years, including North, Susan Williams, Megan Rowley Williams, Hansom, Hirsch, and Adams.

7. This dynamic is complicated by fictional photographs based on actual photographs, such as Richard Powers's *Three Farmers on Their Way to a Dance*, an extended meditation on August Sander's photograph of the same name, which appears on the book's cover. Powers takes the notion of photographic reference as a central theme.

8. Early feminist theorists of the visual such as John Berger and Laura Mulvey critiqued the ways that vision and visual representation position women as passive objects for the consuming gaze of the predatory male spectator, in terms that virtually precluded female agency or self-representation within a visual field. Later French psychoanalytic feminists, led by Luce Irigaray, linked visual culture with phallocentrism and critiqued the totalizing, gendered basis of vision—what Martin Jay has christened "phallogocular-centrism" (493). Recent feminist work on gender politics and "the visual," with its central concern built on the constructedness of gender and identity and the role of vision in this construction, has wrestled with and enriched these early theories in order to consider the possibilities for feminist empowerment through visual expression and effective feminist visual-political practice. Most apt for this study are the ways certain feminist theorists (particularly those such as Abigail Solomon-Godeau and Jan Zita Grover, who focus on photography) have seized on "phallocentric" theories of vision—the visual basis of fetishism, for example—to critique power dynamics within photographic representation and to reveal the limitations of the theories themselves.

9. My use of "becomes" here is meant to reflect trends in criticism. As Houston Baker evokes Malcolm X's declaration that "'Mississippi' was anywhere in the United States south of the Canadian border" to illustrate, the South has always already been America, just as "America" has only ever existed in transnational contexts (Baker, *Turning South* 10).

10. Martin Jay is explicating Mieke Bal's theory of the closeted gaze in the introduction to Brennan and Jay, *Vision in Context*.

11. After an unsuccessful attempt to publish her stories and photographs together (which she later derided as "an amateurish idea"), Welty seems deliberately to have distanced her writing from photography. In story after story framed around the act of framing, envisioning, and telling, only rarely does a camera or photographer appear, and fictional photographs are equally scarce. Well-known exceptions include the photographer who marries Stella Rondo in "Why I Live at the P.O.," the magazine photograph that earns Mrs. Pike her reward in "The Petrified Man," the family reunion photo made in *Losing Battles*, and, most strange, the photographs of the dead girl killed on the train track in *Delta Wedding*. Several critics, including Harriet Pollack, Suzanne Marrs, Mae Miller

Claxton, Francis V. O'Connor, and Paul Binding have examined the influence of Welty's photography on her fiction. Much of this criticism focuses on what David Madden calls "the charged image" in Welty's fiction: Binding asserts that "each story concentrates on a moment . . . irreversible, yet also multilayered, containing other truths with other outcomes than the dominant one" (13), and Marrs offers that at primary issue for Welty is time's progress, what happens in "the world outside the picture's frame" (28). Thus, while Welty's angle of vision remains photographic, she uses photography in her works as a cautionary tale, "a warning to the photographer-writer's 'eye,'" that static vision necessarily precludes living understanding (Binding 59).

12. Barthes pointedly refused to include the photograph of his mother that inspired his meditation on photography in *Camera Lucida*.

13. Mitchell is, of course, epiphenomenal. His work in *Iconology*, *Picture Theory*, and *What Do Pictures Want?* surveys and builds on theories regarding the word/image split from antiquity to digital reproduction.

14. See also Braden 22–43; Owsley 95–132; Cash 53–58; and entries on "Illiteracy," "Conversation," "Folk Speech," and "Religion" in Wilson and Ferris. Significantly, Wyatt-Brown draws his conclusion by parallel to scholarship on African American orality: "If scholars have been able to trace American black folkways to African traditions, it stands to reason that similarly oral-based transmissions had an impact upon white Americans, especially in the deeply conservative ranks of poor and middling folk" (32).

15. Later in *Judgment and Grace*, Wilson expands on southern suspicion of book culture but then also explores the "less recognized" influence of the written word over oral culture for both black and white southerners (122–25).

16. Genovese, *Roll, Jordan, Roll*, 561–66 and notes; Jordan 384, 399–401; Oates 129–33.

17. For more on the origins of white southern nationalism, see Craven, Eaton, Sydnor, McCoy, McCardell, and Freehling.

18. Important sources on African American nationalism include Bracey, Meier, and Rudwick; Bethel; and H. Baker, *Journey Back*. For a specifically southern context, see Stuckey; Sidbury; and Genovese, *Roll, Jordan, Roll*.

19. In contrast to music, which, according to Barthes, can in no way be construed as a "tableau," the literary "work" becomes in postmodernist writing a grounded object in space, subject to much the same constraints as the image and other plastic or *dioptric* arts. The spatialized work here takes on characteristics of the spatialized word (language in print), in the spirit of Lessing, as a (necessary) "encroachment" or container of the temporal "text."

20. These graphic marks can directly transmit meaning: speed-readers learn to bypass the learned "vocalization" process of reading in order to take advantage of the brain's ability to process vast amounts of visual information, at much greater rates than the fastest speaking voice.

21. This argument is developed more thoroughly in relation to William Faulkner's work in my essay, "Faulkner, Photography, and a Regional Ethics of Form."

22. *Ordering the Facade* is virtually unique in this contemporary focus. See note 3 above.

1. See, in particular, Morrison's *Playing in the Dark* chap. 1; and Said 55. For expansions on these arguments, see the introductory essays in Kaplan and Pease.

2. Note that contemporary politics indicate a shift here. The conservative white South seems to be positing itself (as, ironically enough, the Republican Party posits it) as the cradle of American values, ahead of the curve in recognizing and decrying liberal humanist attempts to "eradicate the American family" through abortion rights, feminism, welfare, gay marriage, and the separation of church and state.

3. Versions of these points have been put forward by many southerners, in more or less scholarly contexts. Two of the most considered formulations are provided by C. Vann Woodward in *The Burden of Southern History* and Jack Temple Kirby in *Media Made Dixie*.

4. An earlier version of Madden's essay was published as part of the exhibition catalog *Southern Eye, Southern Mind: A Photographic Inquiry*, in 1981. "The Cruel Radiance of What Is" is by no means Madden's only or last word on the subject of photography and the South, and photography in literature. See, for example, his treatment of fictional photographs in his novels *Bijou* and *Sharpshooter*.

5. Civil War photo-historian William C. Davis estimates that these photographers produced more than 1 million images (3).

6. On January 1, 1862, *Humphrey's Journal, Devoted to the Daguerreian and Photogenic Arts* summed up the situation: "The Photographic art down South has completely died out in consequence of the war. The miserable rebels are shut up like a rat in a hole" (qtd. in Smith and Tucker 104). Some exceptions include J. D. Edwards of New Orleans, who photographed Confederate battle posts in Pensacola, Florida, in 1861 and may have gone on to become a Confederate spy (Smith and Tucker 101–2; Jenny Davis 344–47), Allen Christopher Oxford of Pickensville, Alabama, who photographed Union soldiers, apparently for Confederate military intelligence (Robb, " 'Engraved' " 254), and George S. Cook of Charleston, South Carolina, who used blockade-runners to obtain supplies and demanded customers pay in gold in order to successfully maintain his photography studio (Kocher and Dearstyne 9–10). As Margaret Denton Smith and Mary Louise Tucker note in *Photography in New Orleans: The Early Years, 1840–1865*, New Orleans was itself an exception to the supply squeeze. In contrast to other southern cities, which were necessarily preoccupied with fighting the war, once New Orleans fell to Union troops and the blockade was lifted in May 1862, the city's photographers were able to "carry on a relatively lively practice in both portraiture and view photography," though subject to the constraints of Union occupation, which included the seizure of portraits of Confederate generals (120–21, 107).

7. The Civil War photography project eventually bankrupted Brady. The U.S. Congress purchased his collection in 1875 for a fraction of its value (Orvell 64). Interestingly, Barnard's *Photographic Views of Sherman's Campaign* was reissued in 1977 (with a new preface by Beaumont Newhall) and remains in print. Dunn offers the intriguing suggestion that Barnard's photographs, despite their origin, now "hold a special appeal" for (presumably white) southerners because Barnard's disciplined, romantic pictorialism "resonates

strongly with what became the 'official' postwar southern view of the conflict": "Barnard, himself a gentleman, photographed a gentleman's war . . . [and] romantic memories, like beautiful photographs, develop a life of their own and eventually become a part of reality" (*Southern Eye* 5). Madden's interpretation of southerners' relation to Civil War photography stands in distinct contrast. When the definition of "southerner" is expanded beyond white Confederates and their descendants, the range of possible readings increases exponentially ("Cruel Radiance").

8. Ulmann's approach derived from a tradition of depicting "vanishing" Native Americans led by photographers such as Edward Curtis and other pictorialists such as Ulmann's mentor, Clarence White. On Ulmann's attitudes toward and artistic project about these "types," see P. Jacobs; and the remembrance by Niles in Ulmann 1971.

9. Nixon used multi-image insert pages, a strategy of quantitative rather than qualitative evidence (and doubtlessly a bid to save on production costs). A caption beneath three photographs by Dorothea Lange of African Americans in Mississippi and Georgia pointedly asks, "HAVE YOU REALLY SEEN THEIR FACES?" (60). Ironically, the sheer accretion of images may have lessened their power to evoke visceral support for Nixon's social reform admonishment that "pending the arrival of an economy of abundance and accompanying renaissance, it behooves the South and Southerners to be concerned with an immediate improvement of the region's low production and income status" (95). James Agee and Erskine Caldwell this was not.

10. A more extensive discussion of *Let Us Now Praise Famous Men* and its response to Caldwell and Bourke-White's *You Have Seen Their Faces* occurs in chapter 4.

11. For more on the reception of *Let Us Now Praise Famous Men* by those who were photographed, see Maharidge and Williamson; and Raines.

12. See Stott for more on this photograph, which he claims "explodes" the premise of Agee and Evans's book (284–87). Evans is quoted by Stott as saying in the early 1970s that if there were another revision of *Let Us Now Praise Famous Men*, he would include the photograph. I discuss the representational-political ramifications of Agee and Evans's nation-building project in greater detail in chapter 4.

13. For an excellent overview of the formation and operations of civil rights organization publicity offices within the context of the overall importance of photography for the civil rights movement, see Kasher 8–18. Many of Randall's movement photographs were unprinted and unseen until *Faces of Freedom Summer: The Photographs of Herbert Randall* was published in 2001.

14. Previous lynchings (between 1882 and the early 1950s there were an estimated six thousand lynching deaths) were often reported in the white press (Wilson and Ferris 174–76), but the coverage of Till's murder in black and white papers was of a different quality. Of the Till photographs, Mississippi activist Amzie Moore has asserted, "They had newspapers from all over the continent of North America, some from India, and it was the best advertised lynching that I had ever heard. Personally, I think this was the beginning of the Civil Rights Movement in Mississippi in the twentieth century. From that point on, Mississippi began to move" (qtd. in Bailey and Furst 25). Detroit congressman Charles

Diggs, who attended the Till trial at which the defendants were acquitted, later commented, "The picture in Jet magazine showing Emmet [sic] Till's mutilation was probably the greatest media product in the last forty or fifty years, because that picture stimulated a lot of interest and anger on the part of blacks all over the country" (qtd. in Kasher 11).

15. Russell Baker, agreeing with Taylor Branch, argues that television's need for "brief moments dramatic enough to produce public emotions" shaped the strategy of movement organizers (7). Indeed, the period of the civil rights movement roughly corresponds to the period of transition from newspapers to television newscasts as the primary creators and disseminators of "national news." As Jack Temple Kirby amply demonstrates in Media Made Dixie, television has played a powerful role in manufacturing, perpetuating, and disseminating images of the South. Unlike still cameras and photo-processors, however, the means of television production are not easily accessible to most people, and thus television has not provided the multiple avenues of self-representation and resistance to dominant images that I argue photography has enabled in the South.

16. For examples of this type of photography, see Dugan esp. 29–32. Significantly, the images appear in a chapter entitled "Possessions," which gives in its entirety a wide, though not proportionately representative, sampling of photographic activity in the South during antebellum and war times.

17. As representations, however, the photographs exemplify a different type of power. The commissioned photographs depict beings so subject that they may be stripped of the right to clothing, yet, as Alan Trachtenberg has argued, "the pictures shatter that mold by allowing the eyes [of the pictured slaves] to speak directly to ours, in an appeal to a shared humanity" (Reading 56). Trachtenberg's reading highlights the photograph's power to subvert intention: if, as objects, the photographs represent literal force, as representations they are radically separate from that force and can be read within a field of representational politics that shifts across time and space, to create meanings that serve different "masters."

18. An unusual correspondence between a separated mother and daughter, both slaves, reveals that these women, with the aid of their masters, exchanged several photographs, and that these photographs served a double purpose, functioning both as mementos and propaganda. Writing for the daughter (circa 1860), the Reverend Mr. Mattison of the African Methodist Episcopal Church described one daguerreotype as "both taken on one plate, mother and son, and are set forth in their best possible gear, to impress us in the North with the superior condition of the slave over the free colored people" (qtd. in Moutoussamy-Ashe 6–7). For details on this episode, see Loewenberg and Bogin 63–69.

19. From the Eutaw, Alabama, Alabama Whig, May 5, 1859.

20. From the Mobile Daily Advertiser, April 18, 1843.

21. The framed collection in the Texas State Capitol of African American Texas legislators from 1868 to 1900 is a wonderful exception. The next photographs of black Texans in this context are of Barbara Jordan, Curtis Graves, and Joseph Lockridge, who joined the legislature in 1966.

22. Allen, a self-described antiques "picker," found and purchased these photographs from

estates and from families and dealers who had found them in old family albums, or tucked behind grandpa's old shaving mirror, or stashed in a trunk in the attic with or without Klan memorabilia. Certainly, and probably rightly, the motivations of James Allen—a white southern male—in collecting and publishing these images have been the subject of much of the anxious public reception of *Without Sanctuary* and the exhibitions of the photographs in New York, Pittsburgh, Atlanta, and Jackson, Mississippi. Of course, lynching has never been far from the thoughts of many African American and Euro-American writers, particularly African American activists such as Ida B. Wells and W. E. B. Du Bois and southern fiction writers such as Richard Wright, Margaret Walker, Lillian Smith, Harper Lee, Ralph Ellison, and William Faulkner. But it is only since the end of the civil rights movement that lynching has received book-length attention from academic historians, and it was only with the 1984 publication of Trudier Harris's *Exorcising Blackness* that literary lynchings underwent similar examination. In the past five years no fewer than twenty books have been published examining various aspects of lynching, including Allen's book of photographs.

23. For more on the links between science and photography in the service of racist ideology, see David Green's related articles, "Classified Subjects" and "Veins of Resemblance." Trachtenberg's *Reading American Photographs* (53–60) and Wiegman's *American Anatomies* (esp. chaps. 1–2) place this history in a specifically American context. I will return to this subject in chapter 3.

24. Vivian Buck died of "enteric colitis" at eight years old, in the middle of an apparently normal elementary school career. Carrie Buck was released from the Virginia Colony after her sterilization; she married twice and died in 1983. In 1938 the head of Western State Hospital in Virginia, Joseph S. DeJarnette, lamented the low rate of involuntary sterilization in the United States, relative to Nazi Germany: "Germany in six years has sterilized about 80,000 of her unfit while the United States with approximately twice the population has only sterilized about 27,869 to January 1, 1938 in the past 20 years. . . . The fact that there are 12,000,000 defectives in the US should arouse our best endeavors to push this procedure to the maximum" (*Eugenics*, "Influence" section). See also Gould, "Carrie Buck's Daughter."

25. The story and implications of O'Connor's death are sensitively explored in Elizabeth Barret's 2000 documentary film, *Stranger with a Camera*. Adams is not technically an "outsider" to the Kentuckians he photographs: he grew up in Hazard, Kentucky, but was separated from the people who later became his subjects by class and education. Adams's photographs are alternately characterized as exploitative and insightful. Writing in the *Lexington Herald-Leader* in 1998, Julie Ardery, for example, asserts that Adams's second book, *Appalachian Legacy*, might better have been titled, "Let Us Now Praise Heinous Men," and that "Adams' photographs come close to portraying Appalachia as one big horror show" (F4), whereas Felicia Feaster in *Art in America* reviews the photographs as a "haunting redemption of these cultural pariahs and their environs" (117). The controversy over Adams's intentions, methods, and reception is examined in Jennifer Baichwal's 2002 documentary film, *The True Meaning of Pictures: Shelby Lee Adams' Appalachia*.

26. The text beneath the photo included here (as figure 23) reads, "This aging couple grew up under the much-disputed institution of slavery and, even if they failed to get the promised 'forty acres and a mule,' achieved contentment with a half-acre and a home-made dwelling" (Kocher and Dearstyne 219). In 2003 the Cook Collection photographs were set to work for a completely different cause: the reclamation of southern black history and visual presence. See *Through the Lens of Time*.

27. Brooke Baldwin notes a similar phenomenon in messages inscribed on the back of racist postcards. By "humorously identif[ying] either himself or the card's white recipient as one of the Blacks pictured on the card," postcard writers "demonstrated the confidence joke sharers had in their white identity and the racial superiority which they believed that identify bestowed upon them" (22).

28. As the Cook Collection attests, access to photography was not always rigidly divided by the color line in the South. Early photography was first and foremost a business, and photographers were concerned to attract customers. Whether that meant inviting all colors and classes to their studios or discriminating against some citizens depended largely on the mores of the particular community and photographer. In smaller communities that could not support two separate photography businesses, one photographer (most often white) served all segments of society.

29. See *One Time, One Place* (1971); *Photographs* (1989); *Country Churchyards* (2000); and *Some Notes on River Country* (2003).

30. Ewald's earlier book, *Appalachia: A Self Portrait*, collected the work of seven working photographers from Appalachia, again to achieve an insider view.

31. Of course, southern artists are not alone in incorporating and critiquing the southern visual legacy in their work. To cite only two of the most famous examples: Californian Betye Saar's mixed-media projects, "The Liberation of Aunt Jemima" and "Women and Warriors: The Return of Aunt Jemima," reappropriate Jemima and other imagery of laboring black women and lay such stereotypes bare. The daughter of Mississippi sharecroppers, Oregon-born Carrie Mae Weems in her *Sea Island Series* incorporates the J. T. Zealy slave daguerreotypes, shading them red and overlaying them with text that repositions them within a narrative of witness and condemnation of their "scientific" exploitation.

32. Interior quotation is from Hall, "After Life" 18.

CHAPTER TWO

1. Jones in *Tomorrow Is Another Day* provides a useful synthesis of twentieth-century theories regarding the function of the southern lady as symbol in the South. More recently, the topic has been engaged and expanded by Fox-Genovese (chap. 4), Wolfe (esp. chap. 3), Seidel (esp. chap. 10), and Wyatt-Brown.

2. These arguments are developed more fully in Spence 136; and Hirsch, *Family Frames* 5.

3. The colloquialism "picture takin' man" was also the adopted moniker of Harlem photographer, James Van Der Zee. See Haskins.

4. There is some evidence that African American women, despite massive physical and

ideological prohibitions, also desired and attempted to live up to the ideal image of southern ladyhood, both in life and fiction. See Fox-Genovese 216–22. Novels such as Charles Chesnutt's *The House behind the Cedars* draw portraits of the false white southern lady in order to contrast the truer qualifications of her wrongly reviled black counterpart, while Zora Neale Hurston's Janie in *Their Eyes Were Watching God* is the victim of her grandmother's and second husband's desire to have her sit on the porch in the manner of a languid southern lady.

5. Richard Gray reflects on the problems and possibilities of cultural pluralism from a different angle in *Southern Aberrations*, esp. chap. 6.

6. "Lenticular" refers to Tara McPherson's argument that contemporary white southern culture represents itself as completely separate from black southern culture. See McPherson 7, 25–27; and my introduction.

7. Walker grounds the "mask" of southern white womanhood firmly in the terrain of white racism and black labor: "Those women would act 'nice' to blacks . . . but eventually their faces became their masks." When Walker's mother works all day for one such woman, "The woman gave Mama seventy-five cents, and she threw it back in her face" (qtd. in Daniell 194–95). Daniell largely drops Walker's race/class analysis to focus on the gender/class nexus that oppresses her white female subjects. See Tara McPherson's critique of this focus in *Reconstructing Dixie* (168–74).

8. On the dynamic of "literalizing the symbol" of southern ladyhood, see Jones, "Belles and Ladies."

9. In drawing this parallel, I do not wish to imply that Daniell also internalizes Joe Christmas's misogyny and fear of menstruation. To the contrary, Daniell embraces this aspect of her sexuality wholeheartedly: "In the South, a woman's sexuality—and the Southern man's fear of and dependency on it—is the source of her power; I loved the red that swirled in the toilet bowl, or lay close to my body, warmly trapped in cotton" (105).

10. Unlike in *The Cheer Leader*, named black characters do appear in *Tending to Virginia*, in roles of service, friendship, and violence. The stories of the lynched Curie and his daughter Mag Sykes are subsumed in the larger narratives of the southern white women, although repeated images of Brer Rabbit, Tar Baby, and African violets as a background for white skins, pink robes, and blue eyes suggest an unarticulated relationship that grounds the overt struggles of the novel.

11. Humphreys identifies Percy's *The Last Gentleman* as "the first southern novel I had ever read that seemed real, that seemed about my [urban] South" (Vinh 138). Critics who have drawn parallels between Percy's and Humphreys's work include McKee, Hobson, and Irons. Irons analyzes *Dreams of Sleep* as a response to Percy's novels, in which Humphreys uses Freudian and feminist paradigms of the gaze to explore issues of gender and power, rewriting Percy's "literary patriarchy" (and obsessive male watchers such as Will Barrett) through parody and revision (287). Though Irons and I agree on several fundamental points, her argument ignores the regional context of Percy's and Humphreys's work, thus missing several key levels of Humphreys's re-visioning.

12. One wonders if, as Allie continues to recover from these treatments and to regain the

power of coherent speech, Will will be able to handle Allie's mature speaking subjectivity, or if she will rebel against Will's Old South tendencies.

13. Claire's statement and the persistence of her cultured desire echo Rosa Coldfield in Faulkner's *Absalom, Absalom!*, who admits that she loved Charles Bon before she saw him, loved the imaged idea of him such that it was hardly necessary for his actual body to exist: "Because even before I saw the photograph I could have recognised [sic], nay, described, the very face. . . . so who will dispute me when I say, Why did I not invent, create it?" (118).

14. Speaking from Alice's point of view, the narrator later asserts, "She could leave home in an instant, as most women could, and make a new one somewhere else. It is men to whom home means a certain place, a territory marked and held" (185).

15. Here Hirsch is explicating Kaja Silverman's readings of Lacan in *The Acoustic Mirror*.

16. In his two-part essay "The Problem of the Fetish," William Pietz provides a thorough linguistic and historical account of the fetish, establishing a foundational link between the fetish and the ideology of material commodity that is especially interesting in the context of the concurrent rise of photography and industrial capitalism in the nineteenth century. Diana Fuss, in her work on the "homospectatorial" position conditioned by fashion photography, makes explicit the connection between the fixative fetish and the still photograph: "Photography, which similarly seeks to fix an image in an eternal moment of suspense, comes to function not merely as a technological analog for the psychical workings of fetishism but as one of its internal properties—that is, the fetish itself has 'the frozen, arrested quality of a photograph'" (720; internal quotation from Adams, "Of Female Bondage" 252). That photographs have often functioned as fetish objects in Western culture and literature by no means dictates that they *must*, as I hope to show below.

17. For an extended analysis of this "anxiety" manifested in photography and literature, see Shloss, *In Visible Light*. Jay's *Downcast Eyes* provides a more general and extensive overview of the development of such an anxiety.

18. I am re-visioning Solomon-Godeau's formulation here: "It is a specifically feminist approach to take the camera's fixing of subject/object positions as a problem, rather than as a given" (276).

19. In *The Second Coming* it is Allison's psychiatrist who attaches a camera to a telescope, replicating Will Barrett's displaced obsession with bird-watching in *The Last Gentleman*. The phallic characteristics of the camera, oft-noted by feminist theorists, are extended, so to speak, and overdetermined by the addition of the telescope. The dynamic is ironically reversed in *Dreams of Sleep*: at the moment preceding Will Reese's greatest revelations, that his images and consequent judgments of the women in his life have been wrong, Will perceives that "the future is so small! A round, tiny place at the wrong end of a telescope" (188).

CHAPTER THREE

1. The black woman in culture, Deborah Willis and Carla Williams have asserted, is as in a photographic negative, "opposite of the white woman, a visual transformation from

presence to absence" (1). My use of "ambivalent" here is meant to evoke Homi Bhabha's postcolonial theory of "ambivalence," which itself trades on the poststructuralist and deconstructive impulses prevalent in the most useful race and gender analyses of photography. As he explicates this theory in *The Location of Culture*, Bhabha employs a photographic metaphor: "Despite appearances, the text of transparency inscribes a double vision: the field of the 'true' emerges as a visible sign of authority only after the regulatory and displacing division of the true and the false. From this point of view, discursive 'transparency' is best read in the photographic sense in which a transparency is also always a negative, processed into visibility through the technologies of reversal, enlargement, lighting, editing, projection, not a source but a re-source of light. Such a bringing to light is a question of the provision of visibility as a capacity, a strategy, an agency" (110).

2. Most famously, Walker's Pulitzer Prize–winning novel, *The Color Purple*, was castigated by certain African American critics for its "negative" depictions of black men. According to these accounts, Walker's involvement with "white" feminism had alienated her from the black community/family and broken an "unspoken but almost universally accepted covenant among black writers" "to present positive images of blacks" (Watkins 1). See also Bradley. The question of "socially responsible" representation by African Americans of African Americans remains a heated one. *The International Review of African American Art* 14.3 (1997) dedicates a full issue to a useful overview of these debates. For an introduction to this issue see "Extreme Times."

3. A good cross-section of documents justifying slavery from these perspectives is provided by McKitrick in *Slavery Defended*.

4. In this white southerners followed their northern counterparts, as well as virtually every other colonizing power at the time. Edward Said identifies vision—a "static system of 'synchronic essentialism'"—as one the chief mechanisms of Orientalist domination (240). See also essays in Asad, *Anthropology and the Colonial Encounter*. The argument continues, but with increased acknowledgement of the counterhegemonic uses of anthropological photographs, in Pinney and Peterson, *Photography's Other Histories*.

5. A second strain of investigation, practiced by theorists as divergent as Trinh T. Minh-ha, Laura Mulvey, Judith Butler, and bell hooks, builds on theorizations by Frantz Fanon, Homi Bhabha, Lacan, Foucault, and others to offer a response to Gayatri Spivak's, "Can the Subaltern Speak?" (This is most often a version of "how the subaltern speak.") Here, it is Western theorizations of the camera that constrain postcolonial subjective expression. Deborah Poole (in *Vision, Race, and Modernity*) among others has criticized theoretical genealogies that elide the complex colonial contributions to creating the photographic "terrain of the *other*" (to use Alan Sekula's terms, qtd. in Poole 140). The supposedly transparent, rigorous attention to the formal attributes of the camera actually masks a second colonizing gesture, the elimination of even the theoretical possibility of non- or anticolonial expression by those historically "othered" in colonial anthropological practice. The theoretical framing of photography in the dualistic terms of subject/object, masculine/feminine, colonizer/colonized developed from a distinctly

Western, imperialist tradition: these supposedly inherent attributes of the camera are in fact signifiers whose cultural meanings are determined by the culture in which they are read and from which they derive and, as such, are open to reactivation or rereading by other cultural groups. Evidence of these rereadings remains critically undertheorized, although Poole's study of photographic practice in colonial and postcolonial Peru, Rey Chow's analysis of Chinese cinema, Judith Gutman's *Through Indian Eyes*, and Pinney and Peterson's *Photography's Other Histories* demonstrate varied productive approaches.

6. Roland Barthes's original description of the "reality effect" pertains primarily to literary realism, which he finds "logically" arose in conjunction with techniques of "the real" such as photography ("Reality Effect" 146).

7. The preeminent American School anthropologist Louis Agassiz first concluded that Negroes were a separate species based on his initial viewing of an African American waiter in Philadelphia (Stanton 103). To bolster his anthropometric evidence of polygenism, Agassiz commissioned J. T. Zealy to make a series of daguerreotypes of slaves in South Carolina, discussed in chapter 1. Southern anthropologist Josiah Nott pronounced Agassiz's work "a clincher" and welcomed his contributions to the new science (Stanton 109). For more on Zealy's photographs, see chapter 1 and Trachtenberg, *Reading American Photographs* 52–60, 70. The degree to which southerners embraced the American School anthropology is a matter of some historical debate. William Stanton argues that while white southerners agreed with its premise (Negro inferiority), they rejected its counter-Scriptural conclusion (separate origins). George Fredrickson disputes this account, demonstrating that several prominent southern journals and statesmen endorsed the new science (82–90). Even as Darwin was publishing his ground-shifting *The Origin of Species*, southern anthropologists such as Samuel Cartwright sidestepped the genus-unity issue and used a visual-anthropometric catalog of Negro features to justify slavery as a positive good. See Cartwright's "The Prognathous Species of Mankind" (1857), reprinted in McKitrick (139–47).

8. While the power of slave masters resided as much in individualized, specular acts (public auctions, floggings, rape) as in white surveillance, postbellum southern culture, as Wiegman rightly argues, depended increasingly on a panoptic regime of white supremacy (39–42). Post-Reconstruction images of the jezebel, the tragic mulatto, Mammy, Sambo, and the watermelon pickaninny, along with "No Colored" and "Whites Only" signs, were the evidential apparatuses of a panoptic economy of oppression, which the specular acts of Klan lynchings and anti–civil rights riots served to reinforce. The "truth of the body" that anthropology rendered visible legitimized cultural images, and indeed a cultured vision, ultimately more lasting than the racist science itself.

9. Hurston's influence on Walker is well known, perhaps best explained in Walker's own essays "Saving the Life That Is Your Own," "Zora Neale Hurston: A Cautionary Tale and a Partisan View," and "Looking for Zora," all reprinted in *In Search of Our Mothers' Gardens*.

10. Most notably by Henry Louis Gates in *The Signifying Monkey*.

11. Hurston's 1927–29 contract with her New York patron, Charlotte Osgood Mason, pro-

vided her with a car and a moving picture camera (Hemenway 109; Boyd 160). Several of Hurston's films, including images from her interview with one of the oldest surviving African ex-slaves, Cudjo Lewis, are in the archives of the Library of Congress.

12. Critics exploring Hurston's anthropological representational strategies include Carby, Karen Jacobs, Lemke, Charnov, and Mikell.

13. Bakhtin maintains, "In the realm of culture, outsideness is a most powerful factor in understanding." He continues, "A meaning only reveals its depths once it has encountered and come into contact with another, foreign meaning: they engage in a kind of dialogue, which surmounts the closedness and one-sidedness of these particular meanings, these cultures" (7). Hurston asserts the value of her outsider's perspective most forcefully as she describes the status of women in the Caribbean (Tell My Horse 57–62).

14. Boyd claims that Hurston found eight "authentic cases" in Haiti (293).

15. Personal correspondence, Rex Hardy Jr. to author, June 26, 2003. I am indebted to Terri Ruckel for her research assistance in locating Rex Hardy Jr., whose photographic career ended after World War II when he entered the aviation field. Austrian-born author, illustrator, and professional raconteur Alexander King (1900–1965) was associate editor of Life from 1937 to 1938. King claimed to have "4,000 intimate friends," whose ranks evidently included Hurston. Hardy's photographic essays "Massacre in Haiti" and "Black Haiti: Where Old Africa and the New World Meet" appeared in Life's December 6 and December 13, 1937, issues, respectively.

16. Boyd 300; Personal correspondence, Rex Hardy Jr. to author, June 26, 2003.

17. Personal correspondence, June 26, 2003. Hardy's photographs, sometimes in cropped form, also appear in the British edition of Tell My Horse, published as Voodoo Gods: An Inquiry into Native Myths and Magic in Jamaica and Haiti by J. M. Dent and Sons in 1939. This edition sold much better than the American version (Boyd 322).

18. Carr as quoted by Dash in an interview with bell hooks in Dash, Daughters of the Dust: The Making of an African American Woman's Film 39. Further references will be cited in the text as Making. This volume includes a photostat copy of the screenplay for Daughters.

19. Screenplay direction from Making 77.

20. In her compelling essay, "Picturing What If: Julie Dash's Speculative Fiction," Erhart argues that this scene, in conjunction with a scene in which the Unborn Child looks through a stereopticon and sees moving images, "reveals the enormous potential in the hegemonic imaging system to capture a figure that even some of the film's characters cannot see": "Overall, this moment, like the above scene with Mr. Snead, suggests both the overwhelming potential of traditional apparatuses of vision and their shortcomings. As Snead's camera could only fleetingly capture the Child's image in its lens but not hold it, the stereopticon historically only suggested movement in the depicted image without being able to show it. What the Child does in both cases is improve on the devices, suggesting at once their usefulness and limitations in envisioning African-American histories" (128).

21. Interview quoted in Willis, "A Search for Self" (Hirsch, Familial Gaze 109).

22. Snead has in fact married into the family: in the novel he and Viola are mentioned as having become missionaries on the mainland.

23. It is clear from this resolution that Amelia controls the fate of her thesis and film. The issue of ownership, however, is never addressed in the novel. Technically, Amelia has been lent the cameras and provided with film as part of an "experiment" for her wealthy benefactor, a white man who wants to develop some island property. Hurston's contract with Charlotte Osgood Mason stipulated that all materials Hurston collected in her travels were Mason's property and that Hurston could not use them without Mason's permission. It would be perfectly believable if Amelia's benefactor insisted on similar control, but Dash chooses not to tackle this issue, having instead (after some argument) Professor Colby nod "with respect and understanding" and return to Amelia her thesis (295).

24. For further discussion of photography's role as a transformational object, see Kember 32–35.

25. This is of course not to say that the representational technology of photography is foreign to the African American South (a notion I hope chapter 1 has dispelled entirely), but that it is apparently outside the culture of the southern home in "Everyday Use." In a personal account of her own southern upbringing, bell hooks draws an explicit parallel between quilt making and photographic expression when she says that her grandmother positioned the photos on the wall of her home "with the same care that she laid out her quilts" (in Willis, *Picturing Us* 52).

CHAPTER FOUR

1. The Appalachian range also extends north through Ohio, Pennsylvania, and New York. As David Reynolds documents, "white trash is not fiction nor even an exclusively Southern reality" (359). Nearly all of the eugenic family studies done between 1877 and 1919, recently collected and reissued by Nicole Hahn Rafter under the title *White Trash*, were performed in the Northeast and Midwest, although the "most racist" and latest study (not included in Rafter's book) was *Mongrel Virginians* by Arthur H. Estabrook and Ivan E. McDougle (1926). Taken as a genre, the rural white trash eugenic studies, wherever they were based, reveal their authors' concern for consolidating and nationalizing the urban professional middle class to which they themselves belonged (Rafter 12–17).

2. The past decade has seen a virtual explosion in "whiteness studies," as scholars have heeded calls by African American theorists such as bell hooks and Toni Morrison to interrogate the unmarked, universalized status of whiteness in Western civilization. The result has been a raging controversy. If studies such as Noel Ignatiev's *How the Irish Became White* and David Roediger's *Wages of Whiteness* perform the crucial work of making whiteness a visible category, there is serious disagreement over the consequences of such visibility. Does the study of "whiteness" risk creating a monolithic white culture or ethnicity that does not exist, that may further enforce a dichotomy of white/nonwhite and, worse, may play into the hands of white supremacists and hate groups? Will academic devel-

opment of a white ethnic identity crowd out emergent minority ethnic discourse? What are the stakes of focusing—as does much of Theodore Allen's book, and the essays collected in Babb, Hill, and Newitz and Wray, *White Trash*—on lower-class whites, or "white trash"? As Newitz and Wray point out, postmodern multicultural theorists have often used figures of race and class as "a means for talking about class difference without actually using a language of class analysis" ("What Is 'White Trash'?" 67); studies such as those collected in *White Trash* are more conscientious about theorizing and making explicit the interconnectedness of race, class, and sexuality. But in resisting the "'vulgar multiculturalist' assumption that whiteness must always equal terror and racism" (*White Trash* 5), do Newitz and Wray reify white trash? Why focus on the poorest of whites, rather than the middle class or the richest? I suggest that it is because the fictions that comprise "white trash" are more tangibly visible, less protected, and thus more easily accessed than those that create the unmarked middle class. This accessibility needs to be acknowledged, theorized, and reclaimed, as Allison's work encourages us to do. Recent studies such as David Roediger's *Black on White* and Jane Davis's *The White Image in the Black Mind* suggest further avenues for such study.

3. The dynamic I am suggesting here mirrors one found by Davis, Gardner, and Gardner in their 1941 sociological study, *Deep South*: when questioned, wealthier white southerners tended to consider all poorer southerners "poor whites" or "white trash," whereas poorer southerners took pains to delineate between "plain folk" and "trash" (63–73).

4. The twinned notions of a "white race" and of male privilege were thus deployed to prevent a class alliance between economically oppressed whites and blacks against wealthy white landlords. For different versions of this "deployment," see Cash, Theodore Allen, Morgan, and Genovese, *World the Slaveholders Made*.

5. For example: "One of the representatives of North Carolina made a midnight visit to our camp, and his curiosity was so very clamorous that it waked me, for which I wished his nose as flat as any of his porciverous countrymen" (Byrd 61).

6. But Cash then takes pains to refute the "classical" notion that these southerners descended from a different stock than better-off whites, blaming progressive impoverishment and ill health on the exploitative economic system of the South: "There is no more mystery about even the peculiar appearance of the cracker. A little exaggerating here, a little blurring there, a little sagging in one place and a little upthrusting in another— and *voilà!* . . . Catch Calhoun or Jeff Davis or Abe Lincoln (whose blood stemmed from the Carolina foothill country, remember) young enough, nurse him on "bust-head" [jug liquor], feed him hog and pone, give him twenty years of lolling—expose him to all the conditions to which the cracker was exposed—and you have it exactly" (26–27, ellipses in original). In one rhetorical flourish, Cash simultaneously critiques upper-class southerners' attempts to distance themselves from the results of their own legacy of class exploitation and ties all white southerners, rich and poor, into the national realm. The American nation Cash would construct is one of frustrated opportunities for class awareness and alliance, where the "mind of the South" serves as an synecdoche for a

national history of exploitation, destructive individualism, and diversionary representations of racial, gendered, and religious "essence" that prevent class solidarity.

7. See, for example, Allison's essay "A Question of Class," in Skin (15); and her interview with Pratt (30).

8. See Morris Renek's 1964 interview, "'Sex Was Their Way of Life': A Frank Interview with Erskine Caldwell," cited in Reynolds 366.

9. See Stott's discussion of the ways this photograph "explodes" the premise of Let Us Now Praise Famous Men (284–87).

10. This suggestion is strenuously avowed false by Evans (Stott 303).

11. The second section of the chapter titled "A Country Letter," which juxtaposes the derogatory statements of the townspeople regarding the tenants with a litany, presumably spoken by the tenants, of "How did we get caught? Why is it things always seem to go against us? Why is it there can't ever be any pleasure in living? . . ." is an especially egregious exception (78–81). In conversation with Stott, Evans says this section made him squirm (Stott 304).

12. Joel Williamson has represented this dynamic as the "grits thesis," wherein ruling white southerners placed the blame for the South's reputation for racial violence and sexual licentiousness solely on the backs of poor "white trash," obscuring the fact that "upper- and lower-class whites have actually worked in tandem on the racial front. They have functioned, not against each other, but both against the Negro, the intermittent, sporadic, open violence of one complementing the steady, pervasive, quiet violence of the other" (294–95).

13. There are, of course, many other positions and overlapping boundaries within these hierarchies. I have not here addressed the distinctions—crucial in the South—of religion, ethnicity, geography, or genealogy, to name just a few. Since Allison's work is primarily concerned with the imbrications of class, sexuality, gender, and race, I have focused on these.

14. See also Judith Butler's discussion of the necessarily conflicted status of the interpellation "queer," which she asserts must be "never fully owned, but always and only redeployed, twisted, queered from a prior usage and in the direction of urgent and expanding political purposes" (228).

15. This is not to say that southern culture has been completely intolerant of lesbianism. Southern literary characters such as Aunt Raylene in Bastard out of Carolina, Aunts Faith and Merleen in Shay Youngblood's Soul Kiss, and Mab Segrest's eighty-three-year-old neighbor Lisabeth in "My Mama's Dead Squirrel" suggest that as long as it remains unnamed, lesbian life can proceed relatively unharassed in the South. Southern lesbian writers in particular have created these memorable "Aunt" characters, perhaps to stake a claim of ancestry and organicism for southern lesbianism. For the degree to which the "southern grotesque" performs an accommodationist or subversive function, see the positions outlined by Segrest in "Southern Women Writing: Toward a Literature of Wholeness"; and Yaeger chap. 1, esp. 24–25.

16. *Two or Three Things* was originally written for performance beginning in 1991, shortly after the publication of *Bastard out of Carolina*. Revised substantially for publication, the final written form, Allison has said, was meant "to distinguish between her real family and the fictional family" in her novel (Champagne 14). See the "Author's Note" at the end of *Two or Three Things* (97).

17. For a nuanced reading of Anney Boatwright's role in the "bastard plot" of the novel, see Schor and Stolzenberg.

18. Ann Cvetkovich's insightful discussion of this fantasy, and of its role in constructing a queer sexuality and nation, has significantly informed my own. See esp. 367–73.

CHAPTER FIVE

1. Calhoun quoted in Nevins 280; Butler, "Still Southern after All These Years" (Humphries and Lowe 33).

2. Martyn Bone's helpful formulation (74). I regret that Bone's *Postsouthern Sense of Place in Contemporary Fiction* arrived too late in the process of preparing this manuscript to more significantly enrich my argument.

3. Hobson alludes to this "too postsouthern" criticism, to argue against it (esp. chap. 2); Raper critiques popular realist southern writing like Mason's and Tyler's as part of a modern (as opposed to postmodern) preoccupation with "bolstering the old self with the comforts of a fixed place" (11).

4. The "pencil of nature" is a term coined, and the title of a book, by William Henry Fox Talbot to describe his invention, the calotype photograph, also known as the talbotype.

5. I intentionally echo Molly Hite's seminal analysis of feminist postmodernism, *The Other Side of the Story*, in which she asserts that "the other side of the story is also, if implicitly, another story" (4).

6. See Baker's theorization of the Trueblood episode in Ellison's *Invisible Man* in "To Move without Moving." Anne Goodwyn Jones provides a synopsis and extension of feminist responses to this article in "Houston Baker and the South: More Tight Spots."

7. See, for example, interviews by Petty and Rowell.

8. See Houston Baker Jr.'s theorization of "mastery of form" and "deformation of mastery" in *Modernism and the Harlem Renaissance*.

9. Returning to the topic near the end of *The Southern Writer in the Postmodern World*, Hobson does offer some speculations about why "novels of ideas" historically have been written by men, by way of distinguishing this older tradition from modern southern literature written (indistinguishably) by women and men, an implicitly feminized literature descended from Welty rather than Faulkner (78).

10. Jennifer "shall descend now, to be with [the family] as they go about their evening chores" (20); Richard "shall descend for the evening meal" (114). Jennifer experiments with imagery: " 'Please pass the salt of the earth,' she writes, . . . know[ing] she'll make an A for the course" (16). So does Richard—"We are all enclosed here, as in God's womb (intriguing image!)"—as he contemplates turning his notes into a novel (156).

11. In dramatic contrast to Daddy Glen's representation of Bone's sexuality, Richard interprets Dory's sexual "desire to be a kind of purity: everything is transparent with her" (147).

12. Burlage's encounter with the mountain man overlooking the coal camp on Hurricane Mountain, who believes Burlage's claim that he is with the WPA, is discussed in chapter 4.

13. See especially Jones, "World of Lee Smith"; and Robbins.

14. In addition to the works I will discuss here, exceptions include Catherine Ennis's *The Naked Eye*, Roxanne Pulitzer's *The Palm Beach Story* and Rosellen Brown's "Good Housekeeping." Curiously, contemporary literature by southern men seems more frequently to reverse this dynamic, particularly in mystery stories. See, for example, James Lee Burke's *Sunset Limited*, G. D. Gearino's *Blue Hole*, James W. Hall's *Body Language*, and Ron Rash's *Saints at the River*.

15. As argued, from different angles, by bell hooks and Rosy Martin. Hooks contrasts the patriarchal thrust of her father's picture-taking to her grandmother's keeping of walls of family photographs ("In Our Glory," in Willis, *Picturing Us* 49–50); and Martin asserts with regards to her photo-therapy project, "It seems that in most families mothers are the archivists and guardians of family history" ("Unwind the Ties that Bind" in Spence and Holland 211).

16. Charlotte's initial view of photography echoes several of Tyler's earlier characters', including Aunt Hattie in *Tin Can Tree*, who refuses to have her photograph reproduced for people she likes: "Press everything flat on little squares of paper—well, that's all right. But not for people that you'd like to stay *interested* in you" (64).

17. See, for example, Shelton and Bouton.

18. Her husband Saul's parishioners, for example, are "suspended in a lens of his own, equally truthful, equally flawed" (215).

19. Critics who have complained of the novel's circularity and Charlotte's passivity include Sullivan, "Insane and Indifferent" 155–57; and Broyard.

20. As if to emphasize these analogies, the U.K. paperback edition of *Picturing Will* features an author photograph (presumably) of Beattie with her face obscured by the camera she holds to her eye.

21. Examples include Daly and Wyatt.

22. The novel's structure encourages us not to take what we "see" too literally. Though we do not see Jody and Will together in the same room again for twenty years (until the final "Child" section), Jody attributes her career success to Will's daily need, and she defines "intensity" in relation to her experience with him. So even though we do not "hear" it, it is difficult to imagine that Jody entirely ceases this type of thinking when she cedes the primary caregiver role to Mel.

23. See Seshchari.

24. I am indebted to Shelley Jackson's early formulation of this idea in relation to Josephine Humphreys's work (275).

EPILOGUE

1. Again enacting a familiar aspect of southern photo-history, cameras remain in male hands in the novel (Razi's Andrew O'Connell is an avid amateur photographer), but photographs and the narratives that surround them are the province of women.

2. In an interview Domingue claims to have been a "reluctant Southerner before Katrina hit," but that in the aftermath of the hurricane she became more conscious of a collective bond: "I share history, traditions, and memories with people I've never met. I'm connected to them" (Harrison).

WORKS CITED

Adams, Parveen. "Of Female Bondage." *Between Feminism and Psychoanalysis*. Ed. Teresa Brennan. London and New York: Routledge, 1989. 247–66.

Adams, Timothy Dow. *Light Writing and Life Writing*. Chapel Hill: University of North Carolina Press, 1999.

Agee, James, and Walker Evans. *Let Us Now Praise Famous Men*. 1941; Boston: Houghton Mifflin, 1988.

Allen, James. Personal interview. August 13, 1997.

Allen, James, Hilton Als, John Lewis, and Leon F. Litwack. *Without Sanctuary: Lynching Photography in America*. Santa Fe, NM: Twin Palms, 2000.

Allen, Theodore W. *The Invention of the White Race*. 2 vols. London: Verso, 1994.

Allison, Dorothy. *Bastard out of Carolina*. New York: Dutton, 1992.

———. *Skin: Talking about Sex, Class, and Literature*. Ithaca, NY: Firebrand Books, 1994.

———. *Trash*. 1988; New York: Plume, 2002.

———. *Two or Three Things I Know for Sure*. New York: Plume, 1995.

Alloula, Malek. *The Colonial Harem*. Minneapolis: University of Minnesota University Press, 1986.

Anderson, Benedict. *Imagined Communities*. Rev. ed. London: Verso, 1991.

Anderson, Henry Clay. *Separate, But Equal: The Mississippi Photographs of Henry Clay Anderson*. New York: PublicAffairs, 2002.

Andrews, William, et al., eds. *The Literature of the American South: A Norton Anthology*. New York: W. W. Norton and Company, 1997.

Ansa, Tina McElroy. *Baby of the Family*. New York: Harcourt Brace and Company, 1989.

Ardery, Julie. "Appalachian Gothic: Kentucky Native's Images Glare with Tender Harshness." *Lexington Herald-Leader* August 9, 1998: F4.

Arkins, Joseph. "Fictional Photographs 1850–1950." Exhibition introduction, George Eastman House, August 10–October 5, 1980. <http://www.geh.org/link/geh-exhibs/arkins.html>. April 7, 2006.

Armstrong, Nancy. *Fiction in the Age of Photography: The Legacy of British Realism*. Cambridge, MA: Harvard University Press, 1999.

Asad, Talal, ed. *Anthropology and the Colonial Encounter*. London: Ithaca Press, 1973.

Babb, Valerie Melissa. *Whiteness Visible: The Meaning of Whiteness in American Literature and Culture*. New York: New York University Press, 1998.

Babcock, Barbara. *The Reversible World: Symbolic Inversion in Art and Society*. Ithaca, NY: Cornell University Press, 1978.

Baichwal, Jennifer, dir. *The True Meaning of Pictures: Shelby Lee Adams' Appalachia*. Mercury Films, 2002.

Bailey, Ronald W., and Michele Furst. *Let Us March On! Selected Civil Rights Photographs of Ernest C. Withers, 1955–1968*. Boston: Massachusetts College of Art, 1992.

Baker, Houston A., Jr. *The Journey Back: Issues in Black Literature and Criticism*. Chicago: University of Chicago Press, 1980.

———. *Modernism and the Harlem Renaissance*. Chicago: University of Chicago Press, 1987.

———. "To Move without Moving: An Analysis of Creativity and Commerce in Ralph Ellison's Trueblood Episode." *PMLA* 98 (October 1983): 828–45.

———. *Turning South Again*. Durham, NC: Duke University Press, 2001.

Baker, Ray Stannard. *Following the Color Line*. 1908; New York: Harper and Row, 1964.

Baker, Russell. "Bravest and Best." *New York Review of Books* April 9, 1998: 4–7.

Bakhtin, M. M. *Speech Genres and Other Late Essays*. Ed. Caryl Emerson and Michael Holquist. Austin: University of Texas Press, 1986.

Baldwin, Brooke. "On the Verso: Postcard Messages as a Key to Popular Prejudices." *Journal of Popular Culture* 22 (Winter 1988): 15–28.

Barilleaux, René Paul, ed. *Passionate Observer: Eudora Welty among Artists of the Thirties*. Jackson: Mississippi Museum of Art, 2002.

Barnard, George. *Photographic Views of Sherman's Campaign*. New York: Dover, 1977.

Barret, Elizabeth, dir. *Stranger with a Camera*. Produced by Elizabeth Barret. 2000.

Barthes, Roland. *Camera Lucida*. Trans. Richard Howard. New York: Farrar, Straus and Giroux, 1981.

———. *Image, Music, Text*. Trans. Stephen Heath. New York: Farrar, Straus and Giroux, 1977.

———. "The Reality Effect." *The Rustle of Language*. Trans. Richard Howard. Oxford, UK: Basil Blackwell, 1986. 141–48.

Beattie, Ann. *Picturing Will*. New York: Random House, 1989.

Benjamin, Walter. "A Short History of Photography." *Classic Essays on Photography*. Ed. Alan Trachtenberg. New Haven, CT: Leete's Island Books, 1980. 199–216.

———. "The Work of Art in the Age of Mechanical Reproduction." *Illuminations*. New York: Schocken Books, 1968. 217–51.

Bennett, Barbara. *Understanding Jill McCorkle*. Columbia: University of South Carolina Press, 2000.

Bergan, Brooke. "A Wedge in Time: The Poetics of Photography." *Antioch Review* 48 (Fall 1990): 509–24.

Berger, John. *Another Way of Telling*. New York: Pantheon Books, 1982.

———. *Ways of Seeing*. New York: Penguin Books, 1977.

Bernhard, Virginia, et al., eds. *Hidden Histories of Women in the New South*. Columbia: University of Missouri Press, 1994.

Bethel, Elizabeth Rauh. *The Roots of African-American Identity*. New York: St. Martin's Press, 1997.

Bhabha, Homi K. *The Location of Culture*. New York: Routledge, 1994.

Binding, Paul. *The Still Moment: Eudora Welty, Portrait of a Writer*. London: Virago Press, 1994.

"Black Haiti: Where Old Africa and the New World Meet." Photographs by Rex Hardy Jr. *Life* December 13, 1937: 26–31.

Boffin, Tessa, and Jean Fraser, eds. *Stolen Glances: Lesbians Take Photographs*. London: Pandora-HarperCollins, 1991.

Bogardus, Ralph. *Pictures and Texts: Henry James, A. L. Coburn, and New Ways of Seeing in Literary Culture*. Ann Arbor, MI: UMI Research Press, 1984.

Bollas, Christopher. *The Shadow of the Object: Psychoanalysis of the Unthought Known*. New York: Columbia University Press, 1987.

Bone, Martyn. *The Postsouthern Sense of Place in Contemporary Fiction*. Baton Rouge: Louisiana State University Press, 2005.

Bouton, Katherine. Review of *Earthly Possessions*. *Ms.* 6 (August 1977): 35.

Boyd, Valerie. *Wrapped in Rainbows: The Life of Zora Neale Hurston*. New York: Scribner, 2003.

Bracey, John H., August Meier, and Elliott Rudwick, eds. *Black Nationalism in America*. Indianapolis: Bobbs-Merrill, 1970.

Braden, Waldo W. *The Oral Tradition in the South*. Baton Rouge: Louisiana State University Press, 1983.

Bradley, David. "Telling the Black Woman's Story." *New York Times Magazine* January 8, 1984: 24–37.

Branch, Taylor. *Pillar of Fire: America in the King Years, 1963–1965*. New York: Simon and Schuster, 1998.

Brennan, Teresa, and Martin Jay, eds. *Vision in Context: Historical and Contemporary Perspectives on Sight*. New York: Routledge, 1996.

Brown, Rosellen. "Good Housekeeping." *The Longman's Anthology of Women's Literature*. Ed. Mary K. DeShazer. New York: Longman, 2001. 837–38.

Broyard, Anatole. "Tyler, Tracy and Wakefield." *New York Times Book Review* May 8, 1977: 12.

Bryant, Marsha, ed. *Photo-Textualities: Reading Photographs and Literature*. Newark: University of Delaware Press, 1996.

Bunnell, Peter C. *Degrees of Guidance: Essays on Twentieth-Century Photography*. Cambridge, UK: Cambridge University Press, 1993.

Burke, James Lee. *Sunset Limited*. New York: Doubleday, 1998.

Burke, Kenneth. "Literature as Equipment for Living." *The Philosophy of Literary Form: Studies in Symbolic Action*. 2d ed. 1941; Baton Rouge: Louisiana State University Press, 1967. 293–304.

Butler, Judith. *Bodies That Matter*. New York: Routledge, 1993.

Byrd, William. *The Prose Works of William Byrd of Westover*. Ed. Louis B. Wright. Cambridge, MA: Belknap Press of Harvard University Press, 1966.

Caldwell, Erskine. *Tobacco Road*. 1932; Athens: University of Georgia Press, 1995.

Caldwell, Erskine, and Margaret Bourke-White. *You Have Seen Their Faces*. 1937; New York: Arno Press, 1975.

Campo, Rafael. "Domestic Work, and: Bellocq's Ophelia, and: The Paintings of Our Lives, and: Days of Wonder (review)." *Prairie Schooner* 77 (Winter 2003): 181–85.

Carby, Hazel V. "The Politics of Fiction, Anthropology, and the Folk: Zora Neale Hurston." *New Essays on Their Eyes Were Watching God*. Ed. Michael Awkward. Cambridge, UK: Cambridge University Press, 1990. 71–93.

Carmer, Carl. *Stars Fell on Alabama*. 1934; Tuscaloosa: University of Alabama Press, 1985.

Cash, Wilbur J. *The Mind of the South*. New York: A. A. Knopf, 1941.

Champagne, Rosaria. "Passionate Experience." *Women's Review of Books* 13 (December 1995): 14–15.

Charnov, Elaine S. "The Performative Visual Anthropology Films of Zora Neale Hurston." *Film Criticism* 23 (Fall 1998): 38–47.

Chesnutt, Charles W. *The House behind the Cedars*. 1900; New York: Penguin, 1993.

Chow, Rey. *Primitive Passions: Visuality, Sexuality, Ethnography, and Contemporary Chinese Cinema*. New York: Columbia University Press, 1995.

Christenberry, William. *Southern Photographs*. Millerton, NY: Aperture, 1983.

Claxton, Mae Miller. "'Untamable Texts': The Art of Georgia O'Keefe and Eudora Welty." *Mississippi Quarterly: The Journal of Southern Cultures* 56 (Spring 2003): 315–30.

Cook, Sylvia Jenkins. *From Tobacco Road to Route 66: The Southern Poor White in Fiction*. Chapel Hill: University of North Carolina Press, 1976.

Crary, Jonathan. *Techniques of the Observer*. Cambridge, MA: MIT Press, 1990.

Craven, Avery O. *The Growth of Southern Nationalism, 1848–1861*. Baton Rouge: Louisiana State University Press, 1953.

Culver, Stuart. "How Photographs Mean: Literature and the Camera in American Studies." *American Literary History* 1 (Spring 1989): 190–205.

Cvetkovich, Ann. "Sexual Trauma/Queer Memory: Incest, Lesbianism, and Therapeutic Culture." *GLQ* 2.4 (1995): 351–77.

Daly, Brenda O. "Ann Beattie's *Picturing Will*: Changing Our Images of 'Good' Mothers and Fathers." *The Critical Response to Ann Beattie*. Ed. Jaye Berman Montresor. Westport, CT: Greenwood Press, 1993. 158–76.

Daniell, Rosemary. *Fatal Flowers: On Sin, Sex, and Suicide in the Deep South*. 1980; Athens, GA: Hill Street Press, 1999.

Dash, Julie, dir. *Daughters of the Dust*. American Playhouse, 1992.

———. *Daughters of the Dust: A Novel*. 1997; New York: Plume, 1999.

———. *Daughters of the Dust: The Making of an African American Woman's Film*. New York: New Press, 1992.

Davis, Allison, Burleigh B. Gardner, and Mary R. Gardner. *Deep South: A Social Anthropological Study of Caste and Class*. Chicago: University of Chicago Press, 1941.

Davis, Jane. *The White Image in the Black Mind*. Westport, CT: Greenwood Press, 2000.

Davis, Jenny. *Shadows of the Storm*. Garden City, NY: Doubleday, 1981.

Davis, William C. *Touched by Fire: A Photographic Portrait of the Civil War*. Boston: Little, Brown, 1985.

Day, Caroline Bond. *A Study of Some Negro-White Families in the United States*. Harvard African Studies, vol. 10, Varia Africana V. Cambridge, MA: President and Fellows of Harvard College, 1932.

De Lauretis, Teresa. *Technologies of Gender: Essays on Theory, Film, and Fiction*. Bloomington: Indiana University Press, 1987.

Deleuze, Gilles. *Foucault*. Minneapolis: University of Minnesota Press, 1988.

Dew, Robb Forman. "The Power and the Glory." *A World Unsuspected: Portraits of Southern Childhood*. Ed. Alex Harris. New York: Penguin Books, 1987. 108–26.

Domingue, Ronlyn. *The Mercy of Thin Air*. New York: Atria, 2005.

Dondis, Donis A. *A Primer of Visual Literacy*. Cambridge, MA: MIT Press, 1973.

Douglass, Frederick. "Narrative of the Life of Frederick Douglass, an American Slave, Written By Himself (1845)." *The Oxford Frederick Douglass Reader*. Ed. William L. Andrews. New York: Oxford University Press, 1996. 21–97.

Dugan, Ellen, ed. *Picturing the South: 1860 to the Present*. San Francisco: Chronicle Books/ High Museum of Art, 1996.

Eaton, Clement. *The Growth of Southern Civilization, 1790–1860*. New York: Harper, 1961.

Eco, Umberto. "Critique of the Image." *Thinking Photography*. Ed. Victor Burgin. London: Macmillan, 1982. 32–38.

Eggleston, William. *The Democratic Forest*. Introduction by Eudora Welty. New York: Doubleday, 1989.

Ellison, Ralph. *Invisible Man*. 1947; New York: Vintage/Random House, 1990.

Ennis, Catherine. *The Naked Eye*. Tallahassee, FL: Naiad Press, 1998.

Erhart, Julia. "Picturing What If: Julie Dash's Speculative Fiction." *Camera Obscura* 38 (May 1996): 117–31.

Estabrook, Arthur, and Ivan E. McDougle. *Mongrel Virginians*. Baltimore, MD: Williams and Wilkins, 1926.

Eugenics: Three Generations, No Imbeciles: Virginia, Eugenics, and Buck v. Bell. February 13, 2004. Claude Moore Health Sciences Library Historical Collections, University of Virginia. <http://www.healthsystem.virginia.edu/internet/library/historical/eugenics/>. July 11, 2006.

Ewald, Wendy. *Portraits and Dreams: Photographs and Stories by Children of the Appalachians*. New York: Writers and Readers Publishing, 1985.

———, ed. *Appalachia: A Self-Portrait*. Frankfort, KY: Gnomon Press for Appalshop, Inc., 1979.

"Extreme Times Call for Extreme Heroes." *International Review of African American Art* 14.3 (1997): 3–15.

Faulkner, William. *Absalom, Absalom!*. 1936; New York: Vintage International, 1990.

———. *Light in August*. 1932; New York: Vintage International, 1990.

Faust, Drew Gilpin. "Altars of Sacrifice: Confederate Women and the Narratives of War." *Journal of American History* 76 (March 1990): 1200–1228.

———. *Mothers of Invention: Women of the Slaveholding South*. Chapel Hill: University of North Carolina Press, 1996.

Feaster, Felicia. "New York: Shelby Lee Adams at Yancey Richardson." *Art in America* 87 (March 1999): 117.

Fox, Robert Elliot. *Masters of the Drum: Black Lit/oratures across the Continuum*. Westport, CT: Greenwood Press, 1995.

Fox-Genovese, Elizabeth. *Within the Plantation Household: Black and White Women of the Old South*. Chapel Hill: University of North Carolina Press, 1988.

Frank, Joseph. *The Widening Gyre*. New Brunswick, NJ: Rutgers University Press, 1963.

Fredrickson, George M. *The Black Image in the White Mind*. New York: Harper and Row, 1971.

Freehling, William W. *Prelude to Civil War: The Nullification Controversy in South Carolina, 1816–1836*. New York: Harper, 1965.

Fuss, Diana. "Fashion and the Homospectatorial Look." *Critical Inquiry* 18 (Summer 1992): 713–37.

Garner, Gretchen. *Disappearing Witness: Changing Twentieth-Century American Photography*. Baltimore, MD: Johns Hopkins University Press, 2003.

Gates, Henry Louis, Jr. *The Signifying Monkey*. New York: Oxford University Press, 1988.

———. "The Trope of a New Negro and the Reconstruction of the Image of the Black." *Representations* 24 (Fall 1988): 129–55.

Gearino, G. D. *Blue Hole*. New York: Simon & Schuster, 1999.

Genovese, Eugene. *Roll, Jordan, Roll: The World the Slaves Made*. 1972; New York: Vintage/Random House, 1976.

———. *The World the Slaveholders Made*. 1969; Middletown, CT: Wesleyan University Press, 1988.

Goldberg, Vicki, Robert Silberman, and Garrett White. *American Photography: A Century of Images*. San Francisco: Chronicle Books, 1999.

Gould, Stephen Jay. "Carrie Buck's Daughter." *The Flamingo's Smile*. New York: W. W. Norton and Company, 1985. 307–13.

———. *The Mismeasure of Man*. New York: W. W. Norton, 1981.

Gray, Richard. *Southern Aberrations: Writers of the American South and the Problem of Regionalism*. Baton Rouge: Louisiana State University Press, 2000.

Green, David. "Classified Subjects: Photography and Anthropology: The Technology of Power." *Ten-8* 14 (1984): 30–37.

———. "Veins of Resemblance: Photography and Eugenics." *Photography/Politics: Two*. Ed. Patricia Holland et al. London: Comedia, 1986. 9–21.

Griffith, Michael A. "'A Deal for the Real World': Josephine Humphreys's *Dreams of Sleep* and the New Domestic Novel." *Southern Literary Journal* 26 (Fall 1993): 94–108.

Grover, Jan Zita. "Dykes in Context: Some Problems in Minority Representation." *The Contest of Meaning: Critical Histories of Photography*. Ed. Richard Bolton. Cambridge, MA: MIT Press, 1989. 163–203.

Gutman, Judith Mara. *Through Indian Eyes*. New York: Oxford University Press for the International Center of Photography, 1982.

Gwin, Minrose. "Nonfelicitous Space and Survivor Discourse: Reading the Incest Story in Southern Women's Fiction." *Haunted Bodies: Gender and Southern Texts*. Ed. Anne Goodwyn Jones and Susan V. Donaldson. Charlottesville: University Press of Virginia, 1997. 416–40.

Haddox, Thomas F. "Elizabeth Spencer, the White Civil Rights Novel, and the Postsouthern." *Modern Language Quarterly* 65 (December 2004): 561–81.

Hale, Grace Elizabeth. *Making Whiteness: The Culture of Segregation in the South, 1890–1940*. New York: Vintage, 1998.

Hall, James W. *Body Language*. Thorndike, ME: Thorndike Press, 1999.

Hall, Stuart. "The After-Life of Frantz Fanon: Why Fanon? Why Now? Why *Black Skin, White Masks?*" *The Fact of Blackness: Frantz Fanon and Visual Representation*. Ed. Alan Read. Seattle: Bay Press, 1996. 12–37.

———. "Reconstruction Work: Images of Post-War Settlement." *Family Snaps*. Ed. Jo Spence and Patricia Holland. London: Virago, 1991. 152–64.

Hansom, Paul, ed. *Literary Modernism and Photography*. Westport, CT: Praeger, 2002.

Harris, Michael. *Colored Pictures: Race and Visual Representation*. Chapel Hill: University of North Carolina Press, 2003.

Harris, Trudier. *Exorcising Blackness: Historical and Literary Lynching and Burning Rituals*. Bloomington: Indiana University Press, 1984.

Harrison, Cynthia. "The Mercy of Thin Air." *Garage Band*, February 12, 2006. <http://www.cynthiaharrison.com/garageband/archives/2006/02/the.mercy.of.th.html>. April 8, 2006.

Haskins, James. *James Van DerZee: The Picture-Takin' Man*. New York: Dodd, Mead, 1979.

Heidegger, Martin. "The Age of the World Picture." *The Question Concerning Technology and Other Essays*. New York: Harper and Row, 1977. 115–54.

Hemenway, Robert E. *Zora Neale Hurston: A Literary Biography*. Urbana: University of Illinois Press, 1977.

Henninger, Katherine. "Claiming Access: Controlling Images in Dorothy Allison." *Arizona Quarterly* 60 (Autumn 2004): 83–108.

———. "The Death of the Southern Male Gaze: Josephine Humphreys's Revisionings." *Southern Quarterly* 39 (Summer 2001): 17–34.

———. "Faulkner, Photography, and a Regional Ethics of Form." *Faulkner and Material Culture*. Ed. Joseph Urgo. Jackson: University Press of Mississippi, 2006. 121–38.

———. "Zora Neale Hurston, Richard Wright, and the Postcolonial Gaze." *Mississippi Quarterly* 56 (Fall 2003): 579–93.

Herion-Sarafidis, Elisabeth. "Interview with Lee Smith." *Southern Quarterly* 32 (Winter 1994): 7–18.

Hightower, Sheree, and Cathie Stanga. *Mississippi Observed*. Jackson: University Press of Mississippi, 1994.

Hill, Michael, ed. *Whiteness: A Critical Reader*. New York: New York University Press, 1997.

Hirsch, Marianne, ed. *The Familial Gaze*. Hanover, NH: University Press of New England, 1999.

———. *Family Frames: Photography, Narrative, and Postmemory*. Cambridge, MA: Harvard University Press, 1997.

Hite, Molly. *The Other Side of the Story: Structures and Strategies of Contemporary Feminist Narrative*. Ithaca, NY: Cornell University Press, 1989.

Hobson, Fred. *The Southern Writer in the Postmodern World*. Athens: University of Georgia Press, 1991.

Holman, C. Hugh. "The View from the Regency-Hyatt: Southern Social Issues and the

Outer World." *Southern Fiction Today: Renascence and Beyond*. Ed. George Core. Athens: University of Georgia Press, 1969. 16–32.

"Holmes on Lynching." *Crisis* 3 (January 1912): 109–11.

hooks, bell. *Black Looks: Race and Representation*. Boston: South End Press, 1992.

Howorth, Lisa. "Fear God and Give Glory to Him: Sacred Art in the South." *Reckon* 1 (1995): 40–51.

Humphreys, Josephine. *Dreams of Sleep*. New York: Penguin, 1984.

Humphries, Jefferson, and John Lowe, eds. *The Future of Southern Letters*. New York: Oxford University Press, 1996.

Hunter, Jefferson. *Image and Word: The Interaction of Twentieth-Century Photographs and Texts*. Cambridge, MA: Harvard University Press, 1987.

Hurston, Zora Neale. *Dust Tracks on a Road*. 1942; New York: HarperCollins, 1996.

———. *Mules and Men*. 1935; New York: Harper and Row, 1990.

———. *Tell My Horse.*1938; New York: Harper and Row, 1990.

———. *Their Eyes Were Watching God*. 1937; New York: Harper and Row, 1990.

Hutcheon, Linda. *The Politics of Postmodernism*. London: Routledge, 1989.

Ignatiev, Noel. *How the Irish Became White*. New York: Routledge, 1995.

Irigaray, Luce. *Speculum of the Other Woman*. Ithaca, NY: Cornell University Press, 1985.

Irons, Susan. "Josephine Humphreys's *Dreams of Sleep*: Revising Walker Percy's Male Gaze." *Mississippi Quarterly* 47 (Spring 1994): 287–300.

Jackson, Shelley M. "Josephine Humphreys and the Politics of Postmodern Desire." *Mississippi Quarterly* 47 (Spring 1994): 275–85.

Jacobs, Karen. "From 'Spy-Glass' to 'Horizon': Tracking the Anthropological Gaze in Zora Neale Hurston." *Novel: A Forum on Fiction* 30 (Spring 1997): 329–60.

Jacobs, Philip Walker. *The Life and Photography of Doris Ulmann*. Lexington: University Press of Kentucky, 2001.

Jay, Martin. *Downcast Eyes: The Denigration of Vision in Twentieth-Century French Thought*. Berkeley: University of California Press, 1993.

Jones, Anne Goodwyn. "Belles and Ladies." *Encyclopedia of Southern Culture*. Ed. Charles Reagan Wilson and William Ferris. Chapel Hill: University of North Carolina Press, 1989. 1527–30.

———. "Houston Baker and the South: More Tight Spots." *Southern Literary Journal* 36.2 (Spring 2004): 145–70.

———. *Tomorrow Is Another Day: The Woman Writer in the South, 1859–1936*. Baton Rouge: Louisiana State University Press, 1981.

———. "The World of Lee Smith." *Southern Quarterly* 22 (Fall 1983): 115–39.

Jones, Jacquie. "The Black South in Contemporary Film." *African American Review* 27 (Spring 1993): 19–24.

Jones, Suzanne W., and Sharon Monteith, eds. *South to a New Place: Region, Literature, Culture*. Foreword by Richard Gray. Baton Rouge: Louisiana State University Press, 2002.

Jordan, Winthrop D. *White over Black: American Attitudes toward the Negro, 1550–1812*. Chapel Hill: University of North Carolina Press, 1968.

Kaplan, Amy, and Donald E. Pease, eds. *Cultures of United States Imperialism*. Durham, NC: Duke University Press, 1993.

Kaplan, E. Ann. "Is the Gaze Male?" In *Powers of Desire: The Politics of Sexuality*. Ed. Ann Snitow, Christine Stansell, and Sharon Thompson. New York: Monthly Review Press, 1983. 309–27.

Kasher, Steven. *The Civil Rights Movement: A Photographic History*. New York: Abbeville Press, 1996.

Kember, Sarah. *Virtual Anxiety: Photography, New Technologies, and Subjectivity*. Manchester, UK: Manchester University Press, 1998.

King, Mary. *Freedom Song: A Personal Story of the 1960s Civil Rights Movement*. New York: William Morrow, 1987.

Kirby, Jack Temple. *Media Made Dixie*. Rev. ed. Athens: University of Georgia Press, 1986.

Kocher, A. Lawrence, and Howard Dearstyne. *Shadows in Silver: A Record of Virginia, 1850–1900, in Contemporary Photographs taken by George and Huestis Cook with Additions from the Cook Collection*. New York: Charles Scribner's Sons, 1954.

Kracauer, Siegfried. *History: The Last Things before the Last*. New York: Oxford University Press, 1969.

Krauss, Rosalind E. *The Optical Unconscious*. Cambridge, MA: MIT Press, 1993.

Lemke, Sieglinde. "Blurring Generic Boundaries: Zora Neale Hurston: A Writer of Fiction and Anthropologist." *REAL: The Yearbook of Research in English and American Literature* 12 (1996): 163–77.

Lessing, Gotthold. *Laocoon: An Essay upon the Limits of Painting and Poetry*. 1766. Trans. Ellen Frothingham. New York: Noonday, 1961.

Linker, Kate. "Representation and Sexuality." *Art after Modernism*. Ed. Brian Wallis. New York: New Museum of Contemporary Art, 1984. 391–415.

Lipsitz, George. *Time Passages: Collective Memory and American Popular Culture*. Minneapolis: University of Minnesota Press, 1990.

Loewenberg, Bert James, and Ruth Bogin, eds. *Black Women in Nineteenth-Century American Life*. University Park: Pennsylvania State University Press, 1978.

Lowe, John, ed. *Bridging Southern Cultures*. Baton Rouge: Louisiana State University Press, 2005.

Lutz, Catherine A., and Jane L. Collins. *Reading National Geographic*. Chicago: University of Chicago Press, 1993.

Madden, David. *Bijou*. New York: Crown Publishers, 1974.

———. "The Charged Image in Katherine Anne Porter's 'Flowering Judas.'" SSF 7 (Spring 1970): 277–89.

———. "The Cruel Radiance of What Is." *Southern Quarterly* 22 (Winter 1984): 5–43.

———. *Sharpshooter*. Knoxville: University of Tennessee Press, 1996.

———. "The South and Photography." Paper presented at the International Symposium on Photography and the South, Arles, France, April 2, 1998.

Magee, Rosemary M. "Continuity and Separation: An Interview with Josephine Humphreys." *Southern Review* 27 (Autumn 1991): 792–802.

Maharidge, Dale, and Michael Williamson. *And Their Children after Them: The Legacy of Let Us Now Praise Famous Men, James Agee, Walker Evans, and the Rise and Fall of Cotton in the South.* New York: Pantheon Books, 1989.

Marks, Laura. "Reinscribing the Self." Interview with Clarissa Sligh, June 1989. <http://www.ric.edu/fas/fas16oct/Reinscribing.html>. October 4, 2004.

Marrs, Suzanne. "Eudora Welty's Enduring Images: Photography and Fiction." *Passionate Observer: Eudora Welty among Artists of the Thirties.* Ed. René Paul Barilleaux. Jackson: Mississippi Museum of Art, 2002. 9–31.

Mason, Bobbie Ann. *In Country: A Novel.* New York: Harper & Row, 1985.

———. *Shiloh and Other Stories.* 1982; New York: Modern Library, 2001.

McCardell, John. *The Idea of a Southern Nation: Southern Nationalists and Southern Nationalism, 1830–1860.* New York: W. W. Norton, 1979.

McCorkle, Jill. *Carolina Moon.* New York: Ballantine, 1996.

———. *The Cheer Leader.* Chapel Hill, NC: Algonquin, 1984.

———. *Tending to Virginia.* New York: Ballantine, 1987.

McCoy, Drew R. *The Last of the Fathers: James Madison and the Republican Legacy.* Cambridge, UK: Cambridge University Press, 1989.

McDaris, Wendy, ed. *Visualizing the Blues: Images of the American South.* Memphis, TN: Dixon Gallery and Gardens, 2000.

McDowell, Deborah E. "Reading Family Matters." *Haunted Bodies: Gender and Southern Texts.* Ed. Anne Goodwyn Jones and Susan V. Donaldson. Charlottesville: University Press of Virginia, 1997. 389–415.

McEuen, Melissa A. *Seeing America: Women Photographers between the Wars.* Lexington: University Press of Kentucky, 2000.

McFadden, Bernice. *Sugar.* New York: Dutton, 2000.

McKay, Nellie. "An Interview with Toni Morrison." *Contemporary Literature* 24 (Winter 1983): 413–29.

McKee, Kathryn. "Rewriting Southern Male Introspection in Josephine Humphreys's *Dreams of Sleep.*" *Mississippi Quarterly* 46 (Spring 1993): 241–54.

McKitrick, Eric L., ed. *Slavery Defended: The Views of the Old South.* Englewood Cliffs, NJ: Prentice-Hall, 1963.

McPherson, Tara. *Reconstructing Dixie: Race, Gender, and Nostalgia in the Imagined South.* Durham, NC: Duke University Press, 2003.

Mebane, Mary E. "Black Folk of the American South: Two Portraits." *The American South: Portrait of a Culture.* Ed. Louis D. Rubin Jr. Baton Rouge: Louisiana State University Press, 1980. 86–100.

Megan, Carolyn E. "Moving toward Truth: An Interview with Dorothy Allison." *Kenyon Review* 16 (Fall 1994): 71–83.

Meltzer, Françoise. *Salome and the Dance of Writing: Portraits of Mimesis in Literature.* Chicago: University of Chicago Press, 1987.

Mercer, Kobena. "Looking for Trouble." *The Lesbian and Gay Studies Reader.* Ed. Henry Abelove, Michèle Aina Barale, and David Halperin. New York: Routledge, 1993. 350–59.

Meriwether, James B., and Michael Millgate, eds. *The Lion in the Garden: Interviews with William Faulkner, 1926–1962*. New York: Random House, 1968.

Metz, Christian. "Photography and Fetish." *October* 34 (Fall 1985): 81–90.

Mikell, Gwendolyn. "When Horses Talk: Reflections on Zora Neale Hurston's Haitian Anthropology." *Phylon* 43 (September 1982): 218–30.

Miller, Francis T. *Photographic History of the Civil War*. 10 vols. New York: Review of Reviews Company, 1911.

Mills, David. "Despite Hollywood's Fears, 'Dust' Sees the Light, at Last." *Chicago Sun-Times* March 3, 1992: 30.

Mitchell, Margaret. *Gone with the Wind*. 1936; New York: Avon Books, 1973.

Mitchell, W. J. T. *Iconology: Image, Text, Ideology*. Chicago: University of Chicago Press, 1986.

———. *Picture Theory*. Chicago: University of Chicago Press, 1994.

———. "Space, Ideology, and Literary Representation." *Poetics Today* 10 (Spring 1989): 91–102.

———. *What Do Pictures Want? The Lives and Loves of Images*. Chicago: University of Chicago Press, 2005.

Moore, Charles, and Michael S. Durham. *Powerful Days: The Civil Rights Photography of Charles Moore*. New York: Stewart, Tabori and Chang, 1991.

Morgan, Edmund S. *American Slavery, American Freedom: The Ordeal of Colonial Virginia*. New York: W. W. Norton, 1975.

Morrison, Toni. *Beloved*. New York: Alfred A. Knopf, 1987.

———. *Playing in the Dark*. New York: Vintage/Random House, 1992.

Moutoussamy-Ashe, Jeanne. *Viewfinders: Black Women Photographers*. New York: Writers and Readers Publishing, 1993.

Mulvey, Laura. "Visual Pleasure and Narrative Cinema." *Screen* 16 (Autumn 1975): 6–18.

Neumaier, Diane, ed. *Reframings: New American Feminist Photographies*. Philadelphia: Temple University Press, 1995.

Nevins, Allan. *Ordeal of the Union*. Vol. 1. New York: Scribner, 1947.

Newitz, Annalee, and Matthew Wray. "What Is 'White Trash'? Stereotypes and Economic Conditions of Poor Whites in the U.S." *Minnesota Review* 47 (May 1997): 57–72.

———, eds. *White Trash: Race and Class in America*. New York: Routledge, 1997.

Niles, John Jacob. *The Appalachian Photographs of Doris Ulmann*. Penland, NC: Jargon Society, 1971.

Nixon, Herman Clarence. *Forty Acres and Steel Mules*. Chapel Hill: University of North Carolina Press, 1938.

North, Michael. *Camera Works: Photography and the Twentieth-Century Word*. New York: Oxford University Press, 2005.

Oates, Stephen B. *The Fires of Jubilee: Nat Turner's Fierce Rebellion*. New York: HarperCollins, 1975.

O'Connor, Francis V. "Framing Time in Expressive Spaces: Eudora Welty's Stories, Photographs, and the Art of Mississippi in the 1930s." *Passionate Observer: Eudora Welty*

among Artists of the Thirties. Ed. René Paul Barilleaux. Jackson: Mississippi Museum of Art, 2002. 56–84.

Ong, Walter J. *Orality and Literacy*. New York: Routledge, 1982.

Orvell, Miles. *American Photography*. New York: Oxford University Press, 2003.

Owsley, Frank Lawrence. *Plain Folk of the Old South*. Baton Rouge: Louisiana State University Press, 1949.

Page, Thomas Nelson. *Social Life in Old Virginia*. New York: Charles Scribner's Sons, 1897.

Percy, Walker. *The Last Gentleman*. New York: Avon Books, 1966.

———. *The Moviegoer*. New York: Noonday Press, 1960.

———. *The Second Coming*. New York: Ivy Books, 1980.

Peterkin, Julia, and Doris Ulmann. *Roll, Jordan, Roll*. New York: Bobbs-Merrill, 1933.

Petty, Jill. "An Interview with Natasha Trethewey." *Callaloo* 19.2 (1996): 364–75.

Pietz, William. "The Problem of the Fetish." Part 1, *Res* 9 (Spring 1985): 5–17; Part 2, *Res* 13 (Spring 1987): 23–45.

Pinney, Christopher, and Nicholas Peterson, eds. *Photography's Other Histories*. Durham, NC: Duke University Press, 2003.

Pollack, Harriet. "Photographic Convention and Story Composition: Eudora Welty's Uses of Detail, Plot, Genre, and Expectation from 'A Worn Path' through *The Bride of the Innisfallen*." *South Central Review* 14 (Summer 1997): 15–34.

Pollock, Griselda. "Missing Women: Rethinking Early Thoughts on Images of Women." *The Critical Image*. Ed. Carol Squiers. Seattle, WA: Bay Press, 1990. 202–19.

Poole, Deborah. *Vision, Race, and Modernity*. Princeton, NJ: Princeton University Press, 1997.

Porter, Katherine Anne. *Pale Horse, Pale Rider: Three Short Novels* [Old Mortality; Noon Wine; Pale Horse, Pale Rider]. New York: New American Library, 1962.

Powers, Richard. *Three Farmers on Their Way to a Dance*. New York: Beech Tree Books, 1985.

Pratt, Minnie Bruce. "Dorothy Allison." *The Progressive* 59 (July 1995): 30–34.

Prenshaw, Peggy Whitman, ed. *More Conversations with Eudora Welty*. Jackson: University Press of Mississippi, 1996.

Price, Mary. *The Photograph: A Strange, Confined Space*. Stanford, CA: Stanford University Press, 1994.

Pulitzer, Roxanne. *The Palm Beach Story*. New York: Simon & Schuster, 1995.

Rabb, Jane M., ed. *Literature and Photography: Interactions, 1840–1990*. Albuquerque: University of New Mexico Press, 1995.

Rafter, Nicole Hahn, ed. *White Trash: The Eugenic Family Studies, 1877–1919*. Boston: Northeastern University Press, 1988.

Raines, Howell. "Let Us Now Revisit Famous Folk." *New York Times Magazine* May 25, 1980: 31–46.

Randall, Herbert. *Faces of Freedom Summer: The Photographs of Herbert Randall*. Tuscaloosa: University of Alabama Press, 2001.

Rankin, Thomas. "The Ephemeral Instant: William Faulkner and the Photographic Image." *Faulkner and the Artist: Faulkner and Yoknapatawpha, 1993*. Ed. Donald M. Kartiganer and Ann J. Abadie. Jackson: University Press of Mississippi, 1996. 294–317.

Raper, Julius Rowan. "Inventing Modern Southern Fiction: A Postmodern View." *Southern Literary Journal* 22 (Spring 1990): 3–18.

Rash, Ron. *Saints at the River*. New York: H. Holt, 2004.

Ray, Robert B. "Snapshots: The Beginnings of Photography." *Photo-Textualities: Reading Photography and Literature*. Ed. Marsha Bryant. Newark: University of Delaware Press, 1996. 152–59.

Reynolds, David. "White Trash in Your Face: The Literary Descent of Dorothy Allison." *Appalachian Journal* 20 (Summer 1993): 356–66.

Robb, Frances Osborn. "'Engraved by the Sunbeams:' Alabama Photographs, 1840–1920." *Made in Alabama: A State Legacy*. Ed. E. Bryding Adams. Birmingham, AL: Birmingham Museum of Art, 1995. 238–79.

———. "Mary Morgan Keipp (1875–1961)." *Encyclopedia of Alabama*, sample article. <http://www.encyclopediaofalabama.org/samples/sample04.html>. April 6, 2006.

———. *Shot in Alabama*. Forthcoming.

Robbins, Dorothy Dodge. "Personal and Cultural Transformation: Letter Writing in Lee Smith's *Fair and Tender Ladies*." *Critique* 38 (Winter 1987): 135–45.

Roberts, Diane. *The Myth of Aunt Jemima: Representations of Race and Region*. New York: Routledge, 1994.

Roediger, David R. *Black on White: Black Writers on What It Means to Be White*. New York: Schocken Books, 1998.

———. *The Wages of Whiteness: Race and the Making of the American Working Class*. New York: Verso, 1991.

Romine, Scott. *The Narrative Forms of Southern Community*. Baton Rouge: Louisiana State University Press, 1999.

Rowe, Michael. "We're as American as You Can Get." *Harvard Gay and Lesbian Review* 2 (Winter 1995): 5–10.

Rowell, Charles Henry. "Inscriptive Restorations: An Interview with Natasha Trethewey." *Callaloo* 27.4 (2004): 1022–34.

Rubin, Louis B., ed. *The American South: Portrait of a Culture*. Baton Rouge: Louisiana State University Press, 1980.

Rugg, Linda Haverty. *Picturing Ourselves: Photography and Autobiography*. Chicago: University of Chicago Press, 1997.

Said, Edward W. *Orientalism*. 1978; New York: Vintage, 1979.

Sandweiss, Martha A. *Print the Legend: Photography and the American West*. New Haven, CT: Yale University Press, 2002.

Sante, Luc. *Evidence*. New York: Farrar, Straus and Giroux, 1992.

Sayre, Maggie Lee. *"Deaf Maggie Lee Sayre": Photographs of a River Life*. Ed. Tom Rankin. Jackson: University Press of Mississippi, 1995.

Schor, Hillary M., and Nomi Stolzenberg. "Bastard Daughters and Illegitimate Mothers: Burning Down the Courthouse in *Bastard out of Carolina* and *Bleak House*." *REAL: Yearbook of Research in English and American Literature* 18 (2002): 109–29.

Scott, Anne Firor. *The Southern Lady: From Pedestal to Politics, 1830–1930*. Chicago: University of Chicago Press, 1970.

Segrest, Mab. *My Mama's Dead Squirrel: Lesbian Essays on Southern Culture*. Ithaca, NY: Firebrand, 1985.

Seidel, Kathryn Lee. *The Southern Belle in the American Novel*. Tampa: University of South Florida Press, 1985.

Sekula, Allan. "The Body and the Archive." *The Contest of Meaning: Critical Histories of Photography*. Ed. Richard Bolton. Cambridge, MA: MIT Press, 1989. 343–88.

Sensibar, Judith. "Faulkner's Fictional Photographs: Playing with Difference." *Out of Bounds: Male Writers and Gender(ed) Criticism*. Ed. Lucy Claridge and Elizabeth Langland. Amherst: University of Massachusetts Press, 1990. 290–315.

Seshchari, Neila C. "Picturing Ann Beattie: A Dialogue." *Weber Studies: An Interdisciplinary Humanities Journal* 7 (Spring 1990): 12–36.

Shannon, Jeff. "Daughters of the Dust Is Pleasing, But Doesn't Linger in Memory." *Seattle Times* June 19, 1992: 24.

Shearer, Cynthia. *The Wonder Book of the Air*. New York: Vintage Contemporaries, 1996.

Shelton, Frank W. "The Necessary Balance: Distance and Sympathy in the Novels of Anne Tyler." *Southern Review* 20 (Autumn 1984): 851–60.

Shloss, Carol. *In Visible Light: Photography and the American Writer, 1840–1940*. New York: Oxford University Press, 1987.

Shufeldt, Robert Wilson. *America's Greatest Problem: The Negro*. Philadelphia: F. A. Davis Company, 1915.

Sidbury, James. *Ploughshares into Swords: Race, Rebellion, and Identity in Gabriel's Virginia, 1730–1810*. New York: Cambridge University Press, 1997.

Silverman, Kaja. *The Acoustic Mirror: The Female Voice in Psychoanalysis and Cinema*. Bloomington: Indiana University Press, 1988.

Simpson, Lewis P. *The Brazen Face of History*. Baton Rouge: Louisiana State University Press, 1980.

Smith, Jon. "Postcolonial, Black, and Nobody's Margin: The US South and New World Studies" *American Literary History* 16 (Spring 2004): 144–61.

Smith, Jon, and Deborah Cohn, eds. *Look Away! The U.S. South in New World Studies*. Durham, NC: Duke University Press, 2004.

Smith, Lee. *Oral History*. New York: Ballantine, 1983.

Smith, Margaret Denton, and Mary Louise Tucker. *Photography in New Orleans: The Early Years, 1840–1865*. Baton Rouge: Louisiana State University Press, 1982.

Solomon-Godeau, Abigail. *Photography at the Dock*. Minneapolis: University of Minnesota Press, 1991.

Sontag, Susan. *On Photography*. New York: Farrar, Straus and Giroux, 1977.

The South by Its Photographers. Birmingham, AL: Birmingham Museum of Art, 1996.

Southern Eye, Southern Mind: A Photographic Inquiry. Memphis, TN: Memphis Academy of Arts, 1981.

Spence, Jo. *Putting Myself in the Picture: A Political, Personal, and Photographic Autobiography.* London: Camden Press, 1986.

Spence, Jo, and Patricia Holland, eds. *Family Snaps: The Meanings of Domestic Photography.* London: Virago, 1991.

Spivak, Gayatri Chakravorty. "Can the Subaltern Speak?" *Marxism and the Interpretation of Culture.* Ed. Cary Nelson and Larry Grossberg. Chicago: University of Illinois Press, 1988. 271–313.

Stanton, William. *The Leopard's Spots: Scientific Attitudes toward Race in America, 1815–59.* 1960; Chicago: University of Chicago Press, 1982.

Stott, William. *Documentary Expression and Thirties America.* New York: Oxford University Press, 1973.

Stuckey, Sterling. *Slave Culture: Nationalist Theory and the Foundations of Black America.* New York: Oxford University Press, 1987.

Sullivan, Walter. *Death by Melancholy: Essays on Modern Southern Fiction.* Baton Rouge: Louisiana State University Press, 1972.

———. "The Insane and the Indifferent: Walker Percy and Others." *Sewanee Review* 86 (Winter 1978): 155–57.

Swanson, Gillian. "Rethinking Representation." *Screen* 27 (September/October 1986): 16–28.

Sweet, Timothy. *Traces of War: Poetry, Photography, and the Crisis of the Union.* Baltimore, MD: Johns Hopkins University Press, 1990.

Sydnor, Charles S. *The Development of Southern Sectionalism, 1819–1848.* Baton Rouge: Louisiana State University Press, 1948.

Tagg, John. *The Burden of Representation: Essays on Photographies and Histories.* Minneapolis: University of Minnesota Press, 1988.

Talbot, William Henry Fox. *The Pencil of Nature.* 1844; New York: Da Capo Press, 1969.

Tate, Linda. *A Southern Weave of Women.* Athens: University of Georgia Press, 1994.

Thomas, Kelly L. "White Trash Lesbianism: Dorothy Allison's Queer Politics." *Gender Reconstructions.* Ed. Cindy L. Carlson, Robert L. Mazzola, and Susan M. Bernardo. Burlington, VT: Ashgate, 2002. 167–88.

Through the Lens of Time: Images of African Americans from the Cook Collection. Virginia Commonwealth University. <http://www.library.vcu.edu/jbc/speccoll/cook/cook11.html>. June 5, 2005.

Trachtenberg, Alan, ed. *Classic Essays on Photography.* New Haven, CT: Leete's Island Books, 1980.

———. *Reading American Photographs.* New York: Hill and Wang, 1989.

Trethewey, Natasha. *Bellocq's Ophelia.* St. Paul, MN: Greywolf Press, 2002.

———. *Domestic Work.* St. Paul, MN: Greywolf Press, 2000.

———. "Southern Pastoral." *Callaloo* 27.4 (2004): 1041.

Trinh, T. Minh-ha. *Woman, Native, Other: Writing Postcoloniality and Feminism.* Bloomington, IN: Indiana University Press, 1989.

Twelve Southerners. *I'll Take My Stand.* 1930; Baton Rouge: Louisiana State University Press, 1977.

Tyler, Anne. *Earthly Possessions.* New York: Ballantine, 1997.

———. *The Tin Can Tree.* New York: Random House, 1965.

Ulmann, Doris. *The Appalachian Photographs of Doris Ulmann.* Remembrance by John Jacob Niles. Penland, NC: Jargon Society, 1971.

Vinh, Alphonse. "Talking with Josephine Humphreys." *Southern Quarterly* 32 (Summer 1994): 131–40.

Wadlington, Warwick. *Reading Faulknerian Tragedy.* Ithaca, NY: Cornell University Press, 1987.

Walker, Alice. *The Color Purple.* 1982; New York: Pocket Books, 1985.

———. "Everyday Use." *Everyday Use.* Ed. Barbara Christian. New Brunswick, NJ: Rutgers University Press, 1994. 23–35.

———. *In Search of Our Mothers' Gardens.* San Diego, CA: Harvest-HBJ, 1983.

———. *Meridian.* New York: Washington Square Press/Pocket Books, 1977.

———. *The Temple of My Familiar.* New York: Pocket Books, 1989.

Wallace, Michelle. *Invisibility Blues.* New York: Verso, 1990.

———. "Modernism, Postmodernism, and the Problem of the Visual in Afro-American Culture." *Out There: Marginalizations and Contemporary Culture.* Ed. Russell Ferguson, Martha Gever, Trinh T. Minh-ha, and Cornel West. Cambridge, MA: MIT Press, 1990. 39–50.

Watkins, Mel. "Sexism, Racism, and Black Women Writers." *New York Times Book Review* June 15, 1986: 1, 35–37.

Watters, Pat. *Down to Now: Reflections on the Southern Civil Rights Movement.* New York: Pantheon, 1971.

Welty, Eudora. *Country Churchyards.* Jackson: University Press of Mississippi, 2000.

———. *One Time, One Place: Mississippi in the Depression; A Snapshot Album.* New York: Random House, 1971.

———. *Photographs.* Jackson: University Press of Mississippi, 1989.

———. *Some Notes on River Country.* Jackson: University Press of Mississippi, 2003.

Werner, Craig. *Playing the Changes: From Afro-Modernism to the Jazz Impulse.* Chicago: University of Illinois Press, 1994.

Wiegman, Robyn. *American Anatomies: Theorizing Race and Gender.* Durham, NC: Duke University Press, 1995.

Williams, Megan Rowley. *Through the Negative: The Photographic Image and the Written Word in Nineteenth-Century American Literature.* New York: Routledge, 2003.

Williams, Susan S. *Confounding Images: Photography and Portraiture in Antebellum American Fiction.* Philadelphia: University of Pennsylvania Press, 1997.

Williamson, Joel. *The Crucible of Race: Black/White Relations in the American South Since Emancipation.* New York: Oxford University Press, 1984.

Willis, Deborah, ed. *Picturing Us: African American Identity in Photography.* New York: New Press, 1994.

————. *Reflections in Black: A History of Black Photographers, 1840 to the Present*. New York: W. W. Norton, 2000.

Willis, Deborah, and Carla Williams. *The Black Female Body: A Photographic History*. Philadelphia: Temple University Press, 2002.

Wilson, Charles Reagan. *Judgment and Grace in Dixie*. Athens: University of Georgia Press, 1995.

Wilson, Charles Reagan, and William Ferris, eds. *Encyclopedia of Southern Culture*. Chapel Hill: University of North Carolina Press, 1989.

Wolfe, Margaret Ripley. *Daughters of Canaan: A Saga of Southern Women*. Lexington: University Press of Kentucky, 1995.

Woodward, C. Vann. *The Burden of Southern History*. Rev. ed. Baton Rouge: Louisiana State University Press, 1968.

Wyatt, David. "Ann Beattie." *Southern Review* 28 (Winter 1992): 145–59.

Wyatt-Brown, Bertram. *Southern Honor: Ethics and Behavior in the Old South*. New York: Oxford University Press, 1982.

Yaeger, Patricia. *Dirt and Desire: Reconstructing Southern Women's Writing, 1930–1990*. Chicago: University of Chicago Press, 2000.

Youngblood, Shay. *Soul Kiss*. New York: Riverhead Books, 1997.

INDEX

Note: Page numbers in italics refer to illustrations.

Access: cultural hierarchies of presumed, 43, 137, 138, 141; economic, 43, 141, 201 (n. 2); paternal right of, 136, 152; representational, 43, 125, 136–37, 139, 141–52, 154, 165, 170; resisting others', 93, 141, 146, 147–50, 154, 170; sexual, 136, 141, 143, 151, 152, 165

Accessibility: of poor white bodies, 138, 145, 154, 201 (n. 2); visual accessibility of poverty, 43, 141, 142, 143, 144, 145

Adams, Shelby Lee, 39, 193 (n. 25)

Agassiz, Louis, 34, 38, 198 (n. 7)

Agee, James, 1, 10–12, 13, 30, 118, 119, 140, 142, 144–45, 191 (nn. 9–12). See also Let Us Now Praise Famous Men

Aird, Michael, 128

Allen, James, 36, 37, 192–93 (n. 22); Without Sanctuary, 36, 37, 193 (n. 22)

Allen, Theodore, 201 (n. 2)

Allison, Dorothy, 6, 23, 136–57 passim, 201 (n. 2), 202 (nn. 7, 13, 15), 203 (nn. 16, 17); Bastard out of Carolina, 6, 136–38, 147, 148, 150–53, 154–55, 165, 202 (n. 15), 203 (nn. 16–18); Skin, 140, 146, 147, 149, 154, 202 (n. 7); Trash, 138, 153; Two or Three Things I Know for Sure, 6, 138, 140, 147–50, 153, 154, 203 (n. 16)

Ambivalence: and discursive "transparency," 121, 129, 197 (n. 1); southern ambivalence toward photography, 168, 176; toward southern gender roles, 89, 91; as strategic response, 6, 114, 121, 129

Anderson, Benedict, 16, 17, 88

Anderson, Henry Clay, 39–40, 41, 46, 68, 113

Ansa, Tina, 5

Anthropology, 39, 114–34 passim, 157, 193 (n. 23), 197 (nn. 4, 5); American School of, 117, 198 (n. 7); and race, 8, 39, 66, 115–18, 122, 198 (nn. 7, 8); visual, 39, 115, 117. See also Photography: and anthropology

Appalachia, 30, 33, 38, 39, 46, 136–44, 163–66, 193 (n. 25), 194 (n. 30), 200 (n. 1)

Armstrong, Nancy, 187 (n. 3)

Aunt Jemima, 1, 5, 113, 194 (n. 31). See also Gender stereotypes

Aurality, 14–15, 17–18, 19, 117–18. See also Formal ethics; Orality

Babcock, Barbara, 138

Bahktin, Mikhail, 120, 199 (n. 13)

Baker, Houston, Jr., 159, 188 (n. 9), 189 (n. 18), 203 (nn. 6, 8)

Baker, Russell, 192 (n. 15)

Bal, Mieke, 188 (n. 10)

Baldwin, Brooke, 36, 194 (n. 27)

Barnard, George, 29, 51, 190–91 (n. 7)

Barnard, Frederick A. P., 33

Barth, John, 160

Barthes, Roland, 4, 9, 13, 18, 20, 44, 189 (nn. 12, 19), 198 (n. 6)

Baudrillard, Jean, 113

Beattie, Ann, 6, 24, 157, 158, 162, 168, 175–80, 181, 204 (nn. 20, 22); Picturing Will, 6, 24, 158, 168, 175–80, 204 (nn. 20, 22)

Belle, southern, 1, 3, 4, 41, 87, 88, 89, 91, 92, 99–100, 102, 195 (n. 8). See also Gender stereotypes

Bellocq, E. J., 6, 24, 44–45, 76, 158, 168, 170–72

Benjamin, Walter, 20, 116

Bennett, Barbara, 94

Bennett, Ella Costello, 40

Berger, John, 20, 188 (n. 8)

Bhabha, Homi K., 111, 121, 197 (nn. 1, 5)

Bollas, Christopher, 131

Bone, Martyn, 163, 203 (n. 2)

Bourke-White, Margaret, 29, 30, 53, 137, 140, 142, 143–44, 145, 191 (n. 10). See also *You Have Seen Their Faces*

Braden, Waldo, 14, 189 (n. 14)

Brady, Mathew, 29, 190 (n. 7)

Buck, Carrie, 38, 67, 193 (n. 24)

Burdine, Jane Rule, 46, 83, 85, 113

Burke, Kenneth, 182

Butler, Jack, 156, 203 (n. 1)

Butler, Judith, 197 (n. 5), 202 (n. 14)

Byrd, William, 142, 143, 201 (n. 5)

Caldwell, Erskine, 30, 140, 142, 143–44, 145, 191 (nn. 9, 10), 202 (n. 8); *Tobacco Road*, 140, 142, 143, 145, 148. See also *You Have Seen Their Faces*

Canon, 10, 157, 158–62, 167, 181

Carr, Todd, 123, 199 (n. 18)

Cartwright, Samuel, 198 (n. 7)

Cash, Wilbur J., 7, 15, 85, 96, 102, 142, 148, 189 (n. 14), 201 (nn. 4, 6)

Charles, Michael Ray, 116

Chesnutt, Charles, 195 (n. 4)

Christenberry, William, 45, 179

Civil rights movement, 87, 88, 130–31, 193 (n. 22), 198 (n. 8). See also Photography: and civil rights movement

Civil War, 27, 28–29, 32, 35, 39, 45, 86, 174, 190–91 (nn. 5–7). See also Photography: and Civil War

Class: and form, 13, 18, 24, 162, 165, 166, 169; and literary criticism, 157, 161, 162, 176; and poor whites, 108, 136–54 passim, 201 (nn. 2–4, 6), 202 (n. 12); and southern identities, 28, 110, 164,

172, 173, 174, 181, 182, 185, 201–2 (nn. 3, 4, 6), 202 (n. 12); and southern lady, 87, 88, 90, 96, 101, 105, 110, 112, 195 (nn. 4, 7); southern visual legacies of, 1, 7, 8, 33, 34, 36, 41, 43, 111, 140–54 passim, 182, 185, 187 (n. 4), 194 (n. 28)

Clay, Maude Schuyler, 46, 81

Colonialism: and the gaze, 18, 22, 121–22, 125, 135, 197–98 (nn. 1, 4, 5); and the South, 22, 27, 89, 126, 178; visual, 22, 44, 120, 122, 126, 127. See also Gaze: colonizing; Gaze: postcolonial theories of

Community: African American, 15, 114, 129, 130, 197 (n. 2); bases of, 2, 13, 14–15, 16, 17, 27, 39, 40–42, 86, 113, 128, 131, 132, 134, 142, 153, 156, 163, 180; imagined, 8, 16, 27, 88, 156; and the post-South, 175, 178

Cook, George and Huestis, 40–41, 71, 190 (n. 6), 194 (nn. 26, 28)

Crary, Jonathan, 4

Creation: ethics of, 176–79; representational politics of, 158, 168, 172, 180, 181, 183

Cultured vision, 14, 22, 23–24, 85–87, 95, 97, 98, 105–7, 110, 123, 124, 127, 128, 148, 162, 185, 198 (n. 8)

Culver, Stuart, 20, 30

Cvetkovich, Ann, 135, 147, 151, 203 (n. 18)

Daguerreotypes, 33–35, 61, 113, 190 (n. 6), 192 (n. 18), 194 (n. 31), 198 (n. 7)

Daniell, Rosemary, 6, 23, 86–97 passim, 103, 107, 111, 113, 195 (nn. 7, 9); *Fatal Flowers*, 6, 88, 89–92, 109, 195 (nn. 7, 9)

Dash, Julie, 6, 23, 114, 118, 122–33 passim, 137, 157, 199 (nn. 18–20), 200 (nn. 22, 23); *Daughters of the Dust* (film/screenplay), 114, 122–24, 126, 129, 199 (nn. 18–20); *Daughters of the Dust*

(novel), 6, 114, 122, 124–29, 131, 163, 168, 200 (nn. 22, 23)

Davidson, Donald, 17

Depression, 29, 32, 39, 42, 134, 140

Desvergnes, Alain, 45, 78

Documentary. *See* Photography: documentary

Domingue, Ronlyn, 24, 182–85, 205 (nn. 1, 2)

Douglass, Frederick, 15, 17, 40

Dugan, Ellen, 28, 192 (n. 16)

Dunn, Elaine, 29, 190–91 (n. 7)

Eco, Umberto, 20

Ellison, Ralph, 113, 159, 193 (n. 22), 203 (n. 6); *Invisible Man*, 113, 138

Erhart, Julie, 124, 199 (n. 20)

Estabrook, Arthur, 38, 200 (n. 1)

Ethics: of creation, 177, 178; of memory, 184–85. *See also* Formal ethics; Representation: ethics of

Eugenics, 38, 66, 142, 193 (n. 24), 200 (n. 1)

Evans, Walker, 1, 10, 29, 30–31, 42, 45, 54, 55, 119, 137, 140, 142, 144–45, 179, 191 (n. 12), 202 (nn. 10, 11). *See also Let Us Now Praise Famous Men*

Ewald, Wendy, 46, 194 (n. 30)

Fairbrother, Fay, 46–47

Familial gaze. *See* Gaze: familial

Family albums, 6, 37, 47, 86, 88, 125, 136–37, 138, 193 (n. 22)

Family photography, 1, 4, 33, 34, 39, 41, 46, 85–101 passim, 106–9, 111, 114, 122–24, 125–28, 134–35, 138, 146–48, 149–55, 176, 180, 184, 204 (n. 15)

Farm Security Administration (FSA), 29, 30, 42, 43, 137

Faulkner, William, 45, 87, 91, 98, 159, 160, 167, 169, 179, 187 (n. 2), 189 (n. 21), 193 (n. 22), 196 (n. 13), 203 (n. 9)

Feminist visual theory, 4, 9, 11, 22, 23, 105,

115, 127, 129, 188 (n. 8), 195 (n. 11), 196 (n. 18)

Ferris, William, 41–42

Fetish: southern lady as, 8, 23, 86, 92–112 passim

Fetishism: photography as figure of, 8, 88, 92–94, 97, 98, 105, 107, 111–12, 115–16, 131, 171, 188 (n. 8)

Fictional photographs. *See* Photography: fictional

Ford, Richard, 98

Formal ethics, 11–21, 24, 158, 162, 167, 189 (n. 21)

Foucault, Michel, 115, 147, 197 (n. 5)

Fox, Robert Elliot, 15, 17

Fredrickson, George, 198 (n. 7)

Fuss, Diana, 107

Gardiner, Alexander, 29

Gates, Henry Louis, Jr., 15, 17, 19–20, 36, 116, 198 (n. 10)

Gaze: anthropological, 23, 116–17, 118, 122, 123–25, 126–29, 130, 134–35, 157; colonizing, 18, 22, 44, 115–16, 118, 125; familial, 23, 31, 98, 106, 127, 154; female, 87, 92, 104, 105–6, 107, 110, 125, 157–58, 162, 167–68, 172, 175–76, 177–79, 181; feminist theories of, 22, 125, 127, 188 (n. 8); male, 85–97 passim, 104, 106–10, 115, 118, 125–26, 127, 143, 145, 157–67 passim, 171–72, 188 (n. 8), 195 (n. 11); postcolonial theories of, 4, 11, 115–16, 121–22, 128, 135, 197–98 (nn. 1, 5)

Gender: and formal ethics, 13–14, 18, 24; and literary criticism, 157, 160–62, 176–77; and photography, 2, 85–86, 92–93, 107, 125, 127, 138, 154, 170–71, 174, 175–78, 185, 188 (n. 8), 197 (n. 5); and race, 34, 37, 46, 87–88, 90, 92, 93, 95–96, 113, 134, 141; and southern identities, 4, 6, 7, 8, 10, 13, 22, 28, 87–89,

95, 97, 98, 101, 102, 110, 113, 138, 140, 148, 151–52, 175, 180–81, 195 (nn. 7, 8, 11); and southern literary canon, 157–62

Gender stereotypes: southern female, 1, 3, 4, 5, 8, 23, 26, 34, 41, 85–114 passim, 157, 173, 179, 187 (n. 4), 194 (n. 31), 195 (n. 8), 198 (n. 8)

Glasgow, Ellen, 87

Godwin, Gail, 87

Gould, Stephen J., 38, 193 (n. 24)

Grau, Shirley Ann, 87

Gray, Richard, 27, 195 (n. 5)

Griffith, Michael, 102

Grotesque, the, 45, 95, 96, 136, 138, 139, 147, 161, 162, 178, 179, 180, 202 (n. 15)

Gwin, Minrose, 153

Haddox, Thomas, 173

Hale, Grace Elizabeth, 37

Hall, Stuart, 26, 194 (n. 32)

Hardy, Rex, Jr., 121, 199 (nn. 15–17)

Harris, George Washington, 143

Harris, Trudier, 193 (n. 22)

Hartigan, John, Jr., 139

Heidegger, Martin, 128

Hill, Samuel S., 14, 18

Hirsch, Marianne, 4, 105, 106, 122, 127, 154, 188 (n. 6), 194 (n. 2), 196 (n. 15)

Hite, Molly, 203 (n. 5)

Hobson, Fred, 98, 160–61, 195 (n. 11), 203 (n. 3)

hooks, bell, 43–44, 118, 122, 123, 125, 135, 197 (n. 5), 199 (n. 18), 200 (n. 25), 204 (n. 15)

Howorth, Lisa, 18

Hughes, Langston, 119

Humphreys, Josephine, 6, 23, 86, 87, 88, 92, 97–98, 100–12, 113, 126, 137, 157, 195 (n. 11); Dreams of Sleep, 6, 92, 97–98, 100–112, 126, 195 (nn. 11, 12), 196 (nn. 13, 14, 19)

Hurley, F. Jack, 39, 141

Hurston, Zora Neale, 2, 4, 5, 85, 124, 125, 126, 129, 132, 133, 168, 195 (n. 4), 198 (nn. 9, 11), 200 (n. 23); as anthropologist, 114, 118, 119, 120, 121, 122, 134, 199 (nn. 11–15); Mules and Men, 119; Tell My Horse, 119–22, 168, 199 (nn. 13, 17); Their Eyes Were Watching God, 2–3, 4, 5, 119, 195 (n. 4)

Hutcheon, Linda, 20

Identity: bases of, 2, 86, 88, 114, 135, 153; loss of, 11, 156–57, 180–81; identity politics, 139, 147, 201 (n. 2); southern, 2, 5, 8, 10, 14, 16–18, 21–23, 27–28, 39–41, 43–44, 47–48, 89, 91–92, 95–97, 99–100, 105, 109, 111, 113, 114, 117, 122, 130, 132, 134, 135, 138–39, 146–47, 153, 156–57, 158–60, 180–81, 185, 194 (n. 31)

I'll Take My Stand, 156

Irigaray, Luce, 22, 188 (n. 8)

Irons, Susan, 100, 101, 102, 195 (n. 11)

Jay, Martin, 11, 22, 188 (nn. 8, 10), 196 (n. 17)

Jezebel, 1, 8, 113, 198 (n. 8). See also Gender stereotypes

Jim Crow segregation, 38, 40

Jones, Anne Goodwyn, 194 (n. 1), 195 (n. 8), 203 (n. 6), 204 (n. 13)

Jones, Jacquie, 124

Kasher, Steven, 31, 32, 191 (n. 13)

Katrina, Hurricane, 24, 182, 183, 185, 205 (n. 2)

Keipp, Mary Morgan, 44–45, 77

King, Alexander, 121, 199 (n. 15)

King, Martin Luther, Jr., 40, 131

King, Mary, 31, 32

Kirby, Jack Temple, 190 (n. 3), 192 (n. 15)

Krauss, Rosalind, 20

Lacan, Jacques, 105, 115, 197 (n. 5)

Lady, southern, 1, 8, 23, 41, 85–114 passim, 157, 173, 179, 187 (n. 4), 194 (n. 1), 195 (nn. 4, 7, 8). *See also* Gender stereotypes

Laughlin, Clarence John, 45

Lemke, Sieglinde, 119, 199 (n. 12)

Lenticular vision, 6, 88, 109, 110, 187 (n. 4), 195 (n. 6)

Lesbianism, 116, 147, 153, 202 (n. 15). *See also* "Queer": "queer" sexuality

Lessing, Gotthold, 18, 19, 189 (n. 19)

Let Us Now Praise Famous Men, 10, 11, 30–31, 45, 54, 118, 140, 142, 144–45, 146, 191 (nn. 10–12), 202 (nn. 10, 11). *See also* Agee, James; Evans, Walker

Lion, Jules, 33–34

Lipsitz, George, 183

Longstreet, Augustus Baldwin, 143

Lynching, 8, 134, 191 (n. 14), 193 (n. 22), 198 (n. 8); photographs of, 36–38, 39, 41, 46, 63, 64

Lytle, Andrew D., 29

Madden, David, 7, 28, 29, 30, 31, 32–33, 183, 189 (n. 11), 190 (n. 4), 191 (n. 7)

Mammy, 1, 5, 34, 187 (n. 4), 198 (n. 8). *See also* Gender stereotypes

Mann, Sally, 45

Marshall-Linnemeier, Lynn, 46, 47, 84

Martin, Louise, 39–40, 41, 69

Mason, Bobbie Ann, 157, 160, 203 (n. 3)

McCorkle, Jill, 6, 23, 86, 87, 88, 92–97, 103, 107, 111, 113, 137, 157, 184; *Carolina Moon*, 6; *The Cheer Leader*, 6, 88, 92–95, 97, 109, 184, 195 (n. 10); *Tending to Virginia*, 88, 92, 95–97, 195 (n. 10)

McFadden, Bernice, 5

McKee, Kathryn, 101, 195 (n. 11)

McPherson, Tara, 6, 21, 91, 187 (n. 4), 195 (nn. 6, 7)

Meatyard, Eugene, 45, 79, 179

Memory: cultural, 1, 28, 36, 88, 128, 130, 135, 160, 183–85; fictional photographs as figure of, 21, 24, 133, 183, 184; personal, 1, 35, 40; of the South, 12, 28, 45, 95, 101, 160, 185; technologies of, 88, 184

Mitchell, Margaret, 85, 87

Mitchell, W. J. T., 13, 19, 20, 22, 182, 185, 189 (n. 13)

Moore, Charles, 31, 32, 45, 58

Moore, J. Mack, 41, 73

Morrison, Toni, 27, 132, 190 (n. 1), 200 (n. 2)

Mulvey, Laura, 105, 188 (n. 8), 197 (n. 5)

Najjab, David, 46, 82

National Association for the Advancement of Colored People (NAACP), 8, 37, 40, 64

"Negative images," 36, 113, 114, 118, 119, 123, 125, 127, 128, 197 (n. 2)

Negative space, 113, 114, 117, 133

Negatives, photographic, 172, 196–97 (n. 1); as metaphor, 27, 196–97 (n. 1)

Newitz, Annalee, 139–40, 201 (n. 2)

New Orleans, 24, 34, 44, 98, 170, 171, 172, 182–85, 190 (n. 6)

New South, 87, 99, 100, 102

Nixon, H. C., 30, 191 (n. 9)

North, Michael, 23

Nott, Josiah, 198 (n. 7)

O'Connor, Flannery, 136

O'Connor, Hugh, 39, 137, 193 (n. 25)

Ong, Walter J., 17

Oral culture: African American, 15–18, 19–20, 117–18, 124, 189 (nn. 14, 15); southern, 1, 14–20, 21, 117–18, 124, 162–63, 164, 166–67, 189 (nn. 14, 15)

Orality, 13–14; and writing, 19–21, 166–67

Orvell, Miles, 45, 187 (n. 2), 188 (n. 6)

Pastoral, 159, 162–63, 165–66, 167, 173

Percy, Walker, 98–111 passim, 173, 195 (nn. 11, 12)

Peterkin, Julia Mood, 29

Photography: and anthropology, 34, 38–39, 114–30 passim, 193 (n. 23), 197 (n. 4), 198 (nn. 5, 7, 8); art, 1, 20, 44–47, 125, 130, 176–80; and civil rights movement, 29, 31–32, 33, 40, 43–44, 45, 191 (nn. 13, 14), 192 (nn. 14, 15); and Civil War, 28–29, 35; community, 33–34, 35, 39–42, 173–75, 176; documentary, 29–31, 33, 42, 45, 88, 116, 123, 127, 128, 137, 140–41, 142, 143, 144, 153, 169, 193 (n. 25); fictional, 2–7, 9–14, 20–21, 22, 23–25, 87–97, 98, 111–12, 114, 115, 123–38 passim, 150–84 passim, 187 (nn. 2, 3), 188 (nn. 6, 7, 11), 190 (n. 4); formal qualities of, 9, 11–13, 20–21, 44, 88, 107, 115–16, 197–98 (n. 5); journalism, 1, 29, 31, 121, 136, 155, 199 (n. 15); and language, 1, 12–13, 20, 162, 165, 167; and literature, 2, 4, 6–7, 8, 13, 187 (n. 3), 188 (n. 6), 190 (n. 4), 196 (n. 17); naturalizing function of, 2, 23, 85–86, 88, 91–92, 111–24 passim, 132; popular, 1, 36–37, 88; postmodern, 20, 45–47; and racism, 34–35, 36–38, 114, 116–17, 118–19, 130, 169, 193 (n. 23), 198 (n. 7); "reality effect" of, 12, 116, 121, 124, 132, 198 (n. 6); slave-commissioned, 34–35, 87, 192 (n. 18); and "the South," 1, 4, 5, 8, 10–11, 21–22, 27–28, 41, 45–48, 88–98 passim, 106–9, 111, 157–60, 174–75, 179–81, 190 (n. 4)); in the South, 8–9, 10, 24, 26–48, 167–68, 190 (nn. 5–7), 191 (nn. 7–14), 192 (nn. 14–22), 193 (nn. 22, 24, 25), 194 (nn. 26, 28, 30), 200 (n. 25); southern attitudes toward, 5, 23, 28–33, 39, 42–44, 191 (n. 7). See also Daguerreotypes; Family photography; Fetishism: photography as figure of; Gender: and photography; Lynching: photographs of; Memory: fictional photographs as figure of; Negatives, photographic: as metaphor

Pietz, William, 107, 196 (n. 16)

Place: social, 2, 16, 18, 21–22, 32, 48, 86, 97, 137, 153, 157, 159, 160; southern sense of, 153–64 passim, 173, 185

Polk, Prentice, 40, 70, 126

Pollack, Griselda, 7

Poole, Deborah, 4, 197–98 (n. 5)

Poor whites. See White trash

Porter, Katherine Anne, 3, 4, 5, 85, 96, 184; Old Mortality, 3, 4, 5, 96, 184

Postcolonial visual theory. See Gaze: postcolonial theories of

Postmodernism, 11, 23, 88, 98, 119, 156–57, 158, 160–62, 167, 173, 179, 181, 203 (nn. 3, 5, 9)

Post-South, 156–57, 160, 164, 176, 178, 180

Postsouthernness, 156–67 passim, 172, 173, 175, 178, 180–81, 203 (nn. 2, 3)

Powers, Richard, 170, 188 (n. 7)

"Queer": as resistant designation, 147, 153, 202 (n. 14); "queer" sexuality, 142, 147, 149, 151, 203 (n. 18)

Race: visual economies of, 4, 115. See also Photography: and anthropology; Photography: and racism; White trash

Randall, Herbert, 31, 56, 191 (n. 13)

Rankin, Tom, 42

Ransom, John Crowe, 17

Raper, Julius Rowan, 160, 203 (n. 3)

Ray, Robert, 116

Realism, 114–32 passim, 142–43, 157, 160–61, 166–68, 172, 174, 176, 180–81, 198 (n. 6), 203 (n. 3)

Reconstruction, 35–36, 39, 115

Religion: as aspect of southern identity, 7, 28, 86, 130, 164, 189 (n. 14), 202 (n. 13); and oral tradition, 14–15

Representation: ethics of, 5, 6, 11–21, 24, 30, 116, 122, 126, 157, 167, 179, 184, 185; southern politics of, 8–11, 14, 24, 27–28, 42, 87, 114, 118–22, 127, 132, 135, 138–39, 145–46, 157–58, 160, 168, 192 (nn. 17, 18), 197 (n. 2)

Reynolds, David, 140, 200 (n. 1)

Robb, Frances Osborn, 33, 34, 35, 44

Robbins, Dorothy Dodge, 162, 204 (n. 13)

Roberts, Diane, 113

Roberts, Richard Samuel, 40, 126

Romine, Scott, 13, 162, 180, 187 (n. 5)

Rubin, Louis D., 156

Saar, Bettye, 194 (n. 31)

Said, Edward, 22, 27, 115, 190 (n. 1), 197 (n. 4)

Sayre, Maggie Lee, 42, 74

Scarlett O'Hara, 1, 5, 26, 34, 85

Seidel, Kathryn Lee, 87, 98, 194 (n. 1)

Sekula, Alan, 197 (n. 5)

Sensibar, Judith, 187 (n. 2)

Sexuality: and southern belle/lady, 90–93, 96, 103, 195 (n. 9); white trash, 141–54 passim, 165–67, 201 (n. 2), 202 (nn. 8, 12). See also "Queer": "queer" sexuality

Shannon, Jeff, 122–23

Shearer, Cynthia, 168

Shloss, Carol, 4, 187 (n. 3), 196 (n. 17)

Silverman, Kaja, 4, 196 (n. 15)

Simpson, Lewis, 156

Simulacra, 156, 163, 178, 180–81

Slavery: oral culture and, 15, 17; visual representations of, 34, 38, 40, 47, 115, 123, 192 (nn. 16, 17), 194 (nn. 26, 31), 198 (n. 7). See also Photography: slave-commissioned

Sligh, Clarissa, 20, 46, 47, 113, 122, 125

Smith, Jon, 22, 89, 178

Smith, Lee, 137, 157, 158, 162–67, 181, 204 (n. 13); Oral History, 137, 158, 162–67

Smith, Margaret Denton, 190 (n. 6)

Solomon-Godeau, Abigail, 85, 107, 116, 188 (n. 8), 196 (n. 18)

Sontag, Susan, 4, 20, 171

Spence, Jo, 4, 194 (n. 2)

Spencer, Elizabeth, 26

Stanton, William, 198 (n. 7)

Stott, William, 29, 30, 140, 144, 188 (n. 6), 191 (n. 12), 202 (nn. 9–11)

Styron, William, 87, 160

Sullivan, Walter, 156, 204 (n. 19)

Swanson, Gillian, 111

Tagg, John, 20, 44

Tate, Allen, 87, 98, 163

Tate, Linda, 161, 162

Thomas, Kelly, 141

Till, Emmett, 31, 46, 57, 191–92 (n. 14)

Trachtenberg, Alan, 34, 188 (n. 6), 192 (n. 17), 193 (n. 23), 198 (n. 7)

Transnational contexts: the South in, 10, 27, 185, 188 (n. 9)

Trash. See White trash

Trauma, 132, 134–35, 151, 184

Trethewey, Natasha, 6, 24, 156, 157, 158–60, 161, 162, 168–72, 173, 176, 181; Bellocq's Ophelia, 6, 24, 158, 168, 170–72, 176; Domestic Work, 158, 168–70

Tseng, Kwong Chi, 46, 80

Tucker, Mary Louise, 190 (n. 6)

Tyler, Ann, 6, 24, 157, 158, 160, 162, 168, 172–75, 176, 181, 203 (n. 3), 204 (n. 16); Earthly Possessions, 6, 24, 158, 168, 172–75; Tin Can Tree, 204 (n. 16)

Ulmann, Doris, 29–30, 42, 44, 52, 137, 191 (n. 8)

Visuality, 3, 7, 9, 13, 16, 18–19, 22, 90; and writing, 19–21, 162

Walker, Alice, 5, 23, 89, 114, 115, 118, 129–35, 137, 157, 195 (n. 7), 197 (n. 2), 198 (n. 9); "Everyday Use," 114, 129–30, 131–32, 157; *Meridian*, 114, 129, 130–31; *The Temple of My Familiar*, 5, 114, 132–35
Walker, Kara, 116
Walker, Margaret, 193 (n. 22)
Wallace, Michelle, 18–19, 113
Warren, Robert Penn, 98, 158, 159, 160
Weems, Carrie Mae, 113, 194 (n. 31)
Welty, Eudora, 11, 12, 13, 42–43, 75, 160, 188–89 (n. 11), 194 (n. 29), 203 (n. 9)
Werner, Craig, 18
Whiteness: and southern identity, 109, 139, 141, 200–201 (n. 2); and southern womanhood, 91–94, 96
Whiteness studies, 200–201 (n. 2)
White trash, 1, 8, 23, 31, 39, 42, 43, 136–57 passim, 165, 176, 200 (n. 1), 201 (nn. 2, 3), 202 (n. 12)

Wiegman, Robyn, 4, 115, 193 (n. 23), 198 (n. 8)
Williams, Carla, 47, 196 (n. 1)
Williams, Megan Rowley, 187 (n. 3), 188 (n. 6)
Williams, Susan S., 4, 187 (n. 3), 188 (n. 6)
Williams, Tennessee, 87
Williamson, Joel, 202 (n. 12)
Willis, Deborah, 47, 122, 188 (n. 6), 196 (n. 1), 199 (n. 21)
Wilson, Charles Reagan, 14, 189 (n. 15), 191 (n. 14)
Works Progress Administration (WPA), 137, 165, 204 (n. 12)
Wray, Matthew, 139–40, 201 (n. 1)
Wright, Richard, 119, 193 (n. 22)

Yaeger, Patricia, 94, 95, 161, 162, 202 (n. 15)
You Have Seen Their Faces, 30, 140, 142, 143–44, 145, 146, 148, 191 (n. 10)

Zealy, J. T., 34, 38, 61, 113, 116, 194 (n. 31), 198 (n. 7)